Cities and Photography

Photographs display attitudes, agency and vision in the way cities are documented and imagined. *Cities and Photography* explores the relationship between people and the city, visualized in photographs. It provides a visually focused examination of the city and urbanism for a range of different disciplines: across the social sciences and humanities, photography and fine art.

This text offers different perspectives from which to view social, political and cultural ideas about the city and urbanism, through both verbal discussion and photographic representation. It provides introductions to theoretical conceptions of the city that are useful to photographers addressing urban issues, as well as discussing themes that have preoccupied photographers and informed cultural issues central to a discussion of city. This text interprets the city as a spatial network that we inhabit on different conceptual, psychological and physical levels, and gives emphasis to how people operate within, relate to, and activate the city via construction, habitation and disruption. *Cities and Photography* aims to demonstrate the potential of photography as a contributor to commentary and analytical frameworks: what does photography as a medium provide for a vision of 'city' and what can photographs tell us about cities, histories, attitudes and ideas?

This introductory text is richly illustrated with case studies and over 50 photographs, summarizing complex theory and analysis with application to specific examples. Emphasis is given to international, contemporary photographic projects to provide focus for the discussion of theoretical conceptions of the city through the analysis of photographic interpretation and commentary. This text will be of great appeal to those interested in Photography, Urban Studies and Human Geography.

Jane Tormey lectures in Critical and Historical Studies in the School of Arts at Loughborough University, UK. Her research explores the exchange of ideas between art practice and other disciplines and the ways in which conceptual and aesthetic traditions can be disturbed by and through photographic/filmic practices.

Routledge critical introductions to urbanism and the city

Edited by Malcolm Miles, University of Plymouth, UK and John Rennie Short, University of Maryland, USA

International Advisory Board:

Franco Bianchini
Kim Dovey
Stephen Graham
Tim Hall
Phil Hubbard
Peter Marcuse

Jane Rendell
Saskia Sassen
David Sibley
Erik Swyngedouw
Elizabeth Wilson

The series is designed to allow undergraduate readers to make sense of, and find a critical way into, urbanism. It will:

- cover a broad range of themes
- introduce key ideas and sources
- allow the author to articulate her/his own position
- introduce complex arguments clearly and accessibly
- bridge disciplines, and theory and practice
- be affordable and well designed.

The series covers social, political, economic, cultural and spatial concerns. It will appeal to students in architecture, cultural studies, geography, popular culture, sociology, urban studies and urban planning. It will be trans-disciplinary. Firmly situated in the present, it also introduces material from the cities of modernity and post-modernity.

Published:

Cities and Consumption – Mark Jayne
Cities and Cultures – Malcolm Miles
Cities and Nature – Lisa Benton-Short and John Rennie Short
Cities and Economies – Yeong-Hyun Kim and John Rennie Short
Cities and Cinema – Barbara Mennel
Cities and Gender – Helen Jarvis with Paula Kantor and Jonathan Cloke
Cities and Design – Paul L. Knox
Cities, Politics and Power – Simon Parker
Cities and Sexualities – Phil Hubbard
Children, Youth and the City – Kathrin Hörshelmann and Lorraine van Blerk
Cities and Photography – Jane Tormey

Forthcoming:

Cities and Climate Change – Harriet A. Bulkeley
Cities, Risk and Disaster – Christine Wamsler

Cities and Photography

Jane Tormey

Routledge
Taylor & Francis Group

LONDON AND NEW YORK

First published 2013
by Routledge
2 Park Square, Milton Park, Abingdon, Oxon OX14 4RN

Simultaneously published in the USA and Canada
by Routledge
711 Third Avenue, New York, NY 10017

Routledge is an imprint of the Taylor & Francis Group, an informa business

© 2013 Jane Tormey

British Library Cataloguing in Publication Data
A catalogue record for this book is available from the British Library

Library of Congress Cataloging in Publication Data
Tormey, Jane.
 Cities and photography/Jane Tormey. – 1st ed.
 p. cm.
 Includes bibliographical references and index.
 1. Street photography. 2. City and town life – Pictorial works.
 3. Photography – Social aspects. I. Title.
 TR659.8.T67 2013
 778.9′4 – dc23
 2012019302

ISBN: 978-0-415-56439-7 (hbk)
ISBN: 978-0-415-56440-3 (pbk)
ISBN: 978-0-203-86285-8 (ebk)

Typeset in Times New Roman and Futura
by Florence Production Ltd, Stoodleigh, Devon

MIX
Paper from
responsible sources
FSC
www.fsc.org FSC® C013056

Printed and bound in Great Britain by
TJ International Ltd, Padstow, Cornwall

Contents

List of boxes vii

Photographs and Acknowledgements viii

General introduction xiv

PART 1
Contexts **1**

1 Cities and urbanism 3

2 Photography concepts 29

3 Photography and/in/of the city 57

PART 2
The documented city **89**

4 Walking the city 91

5 Social and political practices 123

PART 3
The metaphorical city **153**

6 Postmodern megalopolis 155

7 City and subject 183

8 Psycho-geographies and the city 212

Selected bibliography 249

Index 261

Boxes

Box 1.1 Symbol of modernity: Paris 6
Box 1.2 Cities in miniature 12
Box 1.3 Triadic city space 19
Box 2.1 Formal analysis 30
Box 2.2 The photograph and deception 39
Box 2.3 Eugène Atget: author and interpretation 48
Box 3.1 Social surveys 59
Box 3.2 The agency of exhibition 70
Box 3.3 Ravi Agarwal: photographer, activist, sociologist 72
Box 3.4 Metaphor, power and surveillance 82
Box 4.1 The *flâneur* 93
Box 4.2 A mental landscape: Breton's *Nadja* 105
Box 4.3 Counter-sites: heterotopia 116
Box 5.1 Politics and photo-juxta-position 127
Box 5.2 South African photography 140
Box 6.1 Weapons of mass communication 166
Box 6.2 Hybridity 172
Box 7.1 Phenomenological geographies 192
Box 7.2 Virtual worlds 195
Box 8.1 Deleuzian space 216

Photographs and Acknowledgements

Photograph 1.1 Charles Marville, *Rue des Bourdonnais de la rue de Rivoli, Paris*, 1865. Albumen silver print (31.1 × 27 cm). The J. Paul Getty Museum, Los Angeles. 6

Photograph 1.2 Sze Tsung Leong, *Luohu District, Shenzhen*, 2008. From the series *Cities*. Chromogenic Colour Print. © Sze Tsung Leong, Courtesy Yossi Milo Gallery, New York. 16

Photograph 2.1 Lewis Hine, *Self Portrait with Newsboy*, New York City. 1908, Gelatin silver print image (irregular), 13.8 × 11.8 cm (5 7/16 × 4 5/8 in.). The J. Paul Getty Museum, Los Angeles. 30

Photograph 2.2 Ernest Eugène Appert, *Faked photograph of execution by firing squad: Crimes de la Commune.* Gelatin silver print, 1871. © Victoria and Albert Museum, London. 39

Photograph 2.3 Eugène Atget, *Shop front of Courone d'or, Quai Bourbon, Paris*, 1922. Gelatin silver print. The Metropolitan Museum of Art, David Hunter McAlpin Fund, 1962 (62.548). © The Metropolitan Museum of Art. 43

Photograph 2.4 Alexander Rodchenko, *Assembling for a Demonstration*, Moscow, 1928. Gelatin silver print, 19 1/2 × 13 7/8 in. (49.5 × 35.3 cm). © Rodchenko & Stepanova Archive, DACS, RAO, 2012. © Digital image 2012, The Museum of Modern Art, New York/Scala, Florence. 46

Photograph 2.5 Eugène Atget, *15, rue Maître-Albert*, Paris, 1912. Gelatin silver print. The Metropolitan Museum of Art, Rogers Fund, 1991 (1991.1233). © The Metropolitan Museum of Art. 49

Photograph 3.1 Samuel Coulthurst, *Angel Street, Rochdale Road*, 1900. Courtesy of Manchester Libraries, Information and Archives, Manchester City Council: www.manchester.gov.uk/libraries; Local Images Collection: www.images.manchester.gov.uk. 60

Photograph 3.2 Samuel Coulthurst, *Blackfriars Street*, also named *Victorian Working Class Costume*, 1900. Courtesy of Manchester Libraries, Information and Archives, Manchester City Council: www.manchester.gov.uk/libraries; Local Images Collection: www.images.manchester.gov.uk. 62

Photograph 3.3 Thomas Annan, *Close No. 118, High Street, Glasgow*, 1868. © The British Library Board. 65

Photograph 3.4 Anonymous, *Manchester Ship Canal construction*, 1890. Courtesy of Manchester Libraries, Information and Archives, Manchester City Council: www.manchester.gov.uk/libraries; Local Images Collection: www.images.manchester.gov.uk. 68

Photograph 3.5 Ravi Agarwal, from *Down and Out and Living Under Global Capitalism* series, 1997–2000. Black and white reproduction from original colour image. Courtesy of the artist. 73

Photograph 3.6 Ravi Agarwal, from *A Street View* series, New Delhi, 1993–95. Black and white reproduction from original colour image. Courtesy of the artist. 73

Photograph 3.7 Ravi Agarwal, from the series *Alien Waters*, 2006. Black and white reproduction from original colour image. Courtesy of the artist. 75

Photograph 3.8 Ann Sofi-Sidén, *Station 10 and Back Again*, 18-channel Video Installation, 2001. Installation Shot Norrköping Museum. Photo by Pelle Wichmann. Courtesy Galerie Barbara Thumm. 84

Photograph 4.1 Gary Winogrand, *New York*, 1969. Gelatin silver print (27.94 × 35.56 cm). San Francisco Museum of Modern Art; Gift of Carla Emil and Rich Silverstein. © Garry Winogrand Estate. 96

Photograph 4.2 Helen Levitt, *New York*, c. 1940. Gelatin silver print (19.05 × 11.75 cm). San Francisco Museum of Modern Art, purchase through a gift of Paul and Prentice Sack. © Estate of Helen Levitt. 98

Photograph 4.3 Luc Delahaye, from the series *L'Autre*, 1995–97. Courtesy of the artist. 101

Photograph 4.4 Pete Ellis, *Corbett Street, Bradford, Manchester*, 2011. Courtesy of the artist. 108

Photograph 4.5 Pete Ellis, *Richard Johnson & Nephew Wireworks, Mill Street, Bradford, Manchester*, 2011. Courtesy of the artist. 108

Photograph 4.6 Pete Ellis, *The Park Inn, Mill Street, Bradford, Manchester*, 2011. Courtesy of the artist. 109

Photograph 4.7 Pete Ellis, *St. Brigid's R.C. Church, Mill Street, Bradford, Manchester*, 2011. Courtesy of the artist. 109

Photograph 4.8 Alnis Stakle, work from series *L.S.D. Living Space Daugavpils*, 2001–06. Courtesy of the artist. 112

Photograph 4.9 Alnis Stakle, work from series *Place for Dreams*, 2001–06. Courtesy of the artist. 114

Photograph 5.1 Hackney Flashers, from the series *Who's Holding the Baby?*, 1978. Courtesy of Michael Ann Mullen. 126

Photograph 5.2 Jodi Bieber, *David*, 1995. © Jodi Bieber. Courtesy of the artist. 133

Photograph 5.3 Sabelo Mlangeni, *Invisible Women*, 2006. Silver gelatin prints. © Sabelo Mlangeni. Courtesy of STEVENSON. 136

Photograph 5.4 Sabelo Mlangeni, *Ma Mbatha*, 2006. Silver gelatin print. © Sabelo Mlangeni. Courtesy of STEVENSON. 137

Photograph 5.5 Madoda Mkhobeni, from the series *Trolley Pushers*, 2009. Courtesy of the artist. 138

Photograph 5.6 Madoda Mkhobeni, from the series *Trolley Pushers*, 2009. Courtesy of the artist. 139

Photograph 5.7 Guy Tillim, *Tayob Towers, Pritchard Street, from the 'Jo'Burg' series*, 2004. Archival pigment inks on 300 g coated cotton paper (436 × 655 mm). © Guy Tillim. Courtesy of STEVENSON. 143

Photograph 5.8 Guy Tillim, *Manhattan Court, Plein Street, from the 'Jo'Burg' series*, 2004. Archival pigment inks on 300 g coated cotton paper (436 × 655 mm). © Guy Tillim. Courtesy of STEVENSON. 144

Photograph 5.9 Guy Tillim, *The view from an apartment in Jeanwell House overlooking the intersection of Nugget and Pritchard Streets, from the 'Jo'Burg' series*, 2004. Archival pigment inks on 300 g coated cotton paper (436 × 655 mm). © Guy Tillim. Courtesy of STEVENSON. 146

Photograph 6.1 Qingsong Wang, *Look Up! Look Up!* Chromogenic colour print, 2000. Courtesy of the artist. 156

Photograph 6.2 Joel Meyerowitz, *Smoke in Sunlight. Aftermath – World Trade Center Archive*, 2001. © Joel Meyerowitz. Courtesy Edwynn Houk Gallery. 161

Photograph 6.3 Marcos López, *Plaza de Mayo, Buenos Aires, Argentina*, 1996. Black and white reproduction from original colour image. Courtesy of the artist. 164

Photograph 6.4 Alexander Apóstol, *Residente Pulido series: Royal Copenhagen*, 2001. Black and white reproduction from original colour image. Courtesy of the artist. 169

Photograph 6.5 Alexander Apóstol, *Residente Pulido: Ranchos 01*, 2003. Black and white reproduction from original colour image. Courtesy of the artist. 171

Photograph 6.6 Weng Fen, from the series *On the Wall*, 2001–02. Chromogenic colour print (125 × 173 cm). Courtesy of the artist. 175

Photograph 6.7 Sze Tsung Leong, *Nanshi, Huangpu District, Shanghai*, 2004. From the series *History*. Chromogenic colour print. © Sze Tsung Leong. Courtesy Yossi Milo Gallery, New York. 177

Photograph 7.1 Takuma Nakahira, from the book *For a Language to Come* (Published by Fudosha, 1970. Republished by Osiris, 2010). © Takuma Nakahira. 184

Photograph 7.2 Takashi Homma, *Tokyo Children 3*, 2001. 188

Photograph 7.3 Kyoichi Tsuzuki, *Anna Sui*, from the series *Happy Victims*, 2003. Courtesy of the artist. 189

Photograph 7.4a Tomoko Sawada, detail from the series *ID400* (#1–100), 1999. © Tomoko Sawada. Courtesy of MEM, Tokyo. 198

Photograph 7.4b Tomoko Sawada, from the series *ID400* (#1–100), 1999. © Tomoko Sawada. Courtesy of MEM, Tokyo. 199

Photograph 7.5 Miwa Yanagi, *Ayumi*, from *My Grandmothers* series, 2000–09. Courtesy of Miwa Yanagi/Yoshiko Isshiki Office. 202

Photograph 7.6 Mariko Mori, *Play with Me*, 1994. Fuji super gloss print (304.8 × 365.8 cm). © Mariko Mori, Members Artists Rights Society (ARS), New York/DACS 2012. 206

Photograph 8.1 Humphrey Spender, 'Pub' from *Mass Observation*, 1937–38. © Bolton Council from the Bolton Library and Museum Service collections. 218

Photograph 8.2 Ralph Rumney, from *Psychogeographic Map of Venice*, 1957. © Éditions Allia, 2012. 221

Photograph 8.3 Alnis Stakle, from the series *Lost: Paris*, 2010. Courtesy of the artist. 225

Photograph 8.4 Aglaia Konrad, *Cairo*, 2004. Courtesy of the artist. 227

Photograph 8.5 Aglaia Konrad, *Exhibition view: Cities on the Move, PS1*, 1998. Courtesy of the artist. 228

Photograph 8.6 Aglaia Konrad, *Cairo*, 2001. Courtesy of the artist. 229

Photograph 8.7 Aglaia Konrad, *Beijing*, 2000. Courtesy of the artist. 230

Photograph 8.8 Valérie Jouve, *Untitled, No. 6* (100 × 130 cm), 1994–95. Courtesy of the artist. 234

Photograph 8.9 Valérie Jouve, *Untitled, No. 17* (120 × 150 cm), 1996. Courtesy of the artist. 236

Photograph 8.10 Walid Raad, *Sweet Talk Commissions (Beirut) Plate 101*, 1987/2010. Digital photographic print (111.8 × 188 cm). Edition of 7 + 1AP. Copyright the artist, courtesy Anthony Reynolds Gallery, London. 238

Photograph 8.11 Walid Raad, *Sweet Talk: Commissions (Beirut) Plate 445*, 1987/2010. Digital photographic print (111.8 × 188 cm). Edition of 7 + 1AP.

Copyright the artist, courtesy Anthony Reynolds Gallery, London. 240

Photograph 8.12 Walid Raad, *My Neck is Thinner Than a Hair: Engines* [cat. AGP] Thin Neck Photographs_001–100, 2000/2003. Digital prints, 100 plates (25 × 35 cm). Edition of 5 + 1AP. Copyright the artist, courtesy Anthony Reynolds Gallery, London. 241

Photograph 8.13 Walid Raad, Untitled, 1982–2004, from the series *We Decided To Let Them Say 'We Are Convinced' Twice. It Was More Convincing This Way.* Inkjet print (121 × 179 cm). Edition of 3 + 1AP. Copyright the artist, courtesy Anthony Reynolds Gallery, London. 241

General introduction

Rationale and scope

Photographs display attitudes, agency and vision in the way a city is documented and imagined. *Cities and Photography* gives visual focus to theoretical conceptions of the city through the analysis of photographic commentary. It provides different perspectives from which to view social, political and cultural ideas about the city, via both verbal discussion and visual practice. In particular, *Cities and Photography* discusses the relationship between people and the city, visualized in photographs. It adopts a trans-disciplinary approach to complex arguments about our relationship to the objects and spaces that surround us. It interprets the city as a space that we inhabit on different conceptual, psychological and physical levels, and gives emphasis to how people operate within, relate to, and activate the city via construction, habitation and disruption. Its content aims to be relevant for a range of different disciplines: photography, fine art, and across the social sciences and humanities, and provides introductions to theoretical conceptions of the city useful to photographers addressing urban issues, and photographic themes that have preoccupied photographers and which inform cultural issues central to a discussion of city. The case study approach, using international and contemporary examples of photographic practice, enables examination of a selection of relevant aspects.

The city has been used as a locus for cultural debate within sociological, anthropological and geographical contexts. 'City' initiates a discourse, and provides a literal location within which to frame disciplines (in this instance photography). It thus provides a literal location for cultural analysis and acts as interlocutor for a number of cultural debates such as the 'postcolonial' city or the 'institutional' city. Similarly, photographic representations translate the city for us and contribute to how we conceive it, as they visualize changing attitudes to the world and ourselves. *Cities and Photography* aims to

demonstrate photography as providing an additional dimension to the consideration of our conceptualization of the city. To that end, the critical reading of images aims to provide parallels between urban theory and photographic depiction, such as the role of photography in envisioning modernity or the postmodern condition. It bridges theory and practice and emphasizes photography as extending arguments and ideas. It aims to demonstrate the potential of photography as a contributor to commentary and analysis and considers what the medium of photography provides for a vision of 'city', and what photographs can tell us about cities, histories, attitudes and ideas. The analysis *of* photography, and photography used *as* commentary and analysis, drives each chapter.

Cities and Photography works horizontally across ideological and imaginative frames, so that each chapter relates to history and traditions in the context of a particular interpretation of the city. Chapters are flexible encounters with the concepts, intentions and effects that impact on the making of photographic projects, so that content is structured thematically rather than being driven by the photographer's authorship. As this book uses photographs to discuss ideas, it gives emphasis to how cities have been visualized, idealized and conceived in metaphorical terms within theoretical discourse. Theoretical focus develops from themes that have consistently preoccupied photographers, and which echo those of cultural theorists, such as the street, the everyday and social conditions. For example, Chapter 4 establishes two types of experiencing the city – the voyeuristic and the immersive – which are echoed in the context of photography, and reoccur in later chapters of this book. Because my focus is that of the individual *living* in the city, my references are broadly cultural and philosophical, rather than specifically geographical, and are not concerned with statistical aspects of urban theory. Reference includes commentators such as Walter Benjamin, Jean Baudrillard and Gilles Deleuze. As central texts, I use Henri Lefebvre's ideas about 'social space', David Harvey's measured address to social justice and urbanism and Edward Soja's interdisciplinary interpretation in the context of the late twentieth century.

As the book aims to be useful to a broad range of people, I concentrate on those discussions described as interdisciplinary and which are influential for cultural practices generally. Rather than reiterating simplified versions of extensive discussions on urban theory and cultural geography, I identify key debates that impact on both city and photography, such as social experience and everyday life. I concentrate on thinkers, described loosely as cultural theorists, whose influence has relevance for the social sciences, urban theory and photography that addresses issues relating to urbanism. These are broad-based discussions that cross traditional subject boundaries, or are difficult to

pin down to any established 'discipline', or which introduce a new approach to addressing a subject, or which contribute to reconfiguring representation or thought, such as Lefebvre's introduction of 'social space', Michel de Certeau's assertion of the significance of the small practices in everyday living or Donna Haraway's consideration of the difference machines make to our lives. As Lefebvre, who is described variously as a 'meta-Marxist' and a philosopher of the everyday, explored the production of space and the influence of capitalism on people's everyday lives, I respond to the overarching political project influenced by Marxist analysis, encapsulated by Lefebvre and extended by Soja, so that theoretical discussion and my choice of photography in later chapters leans towards a political context.

Rather than repeating a general photographic history available elsewhere, *Cities and Photography* concentrates on a restricted number of photographers, each pertinent in some way to the issues addressed. My choice of photographic projects is determined by the extent to which the photographs engage with the debates concerned with urbanism and the city, and focuses on the manipulation of their reference to the world to make commentary. Many examples are 'projects', rather than individual images, which work as an extended discourse that engages with theoretical perspectives – visually. Whilst I make use of what is referred to as 'art photography' rather than journalism in the main, discussion is not led by the artists' 'oeuvre' or authorship. Rather, photography is discussed in the context of spatial theories and in terms of what it can offer to ideas about living in cities. My premise enlists an intellectual response rather than an elitist preciousness that is commonly associated with art and photography. Focusing on their content rather than what is generally referred to as their 'aesthetic qualities', I consider how they add to our understanding of certain conditions of space and the city. In many instances however, the photograph's very visual qualities may also invoke visceral and emotive responses; I distinguish therefore between what is referred to in the image, and responses provoked by the sensational impact of the photograph's material qualities. My discussion acknowledges the difficulty in establishing how a photograph describes an experience, or contributes to a debate, other than by illustrating objects or events. Thinking of the photograph as provocation, rather than a presentation of facts, comes closest to my approach to discussing its content, so that I make use of the photograph in much the same way as I do written text. In emphasizing photography as provocation, I define contemporary aesthetics as including the critical, discursive and conceptual uses of visual imagery, besides its formal and sensible qualities. My discussion of photography is therefore predicated on shifting the division that tends to exist between art and the social. I argue

that photography (as art) participates in the social – photographs need not merely provide a pretty backdrop to debate. Walid Raad's work (Chapter 8) exemplifies this. The whole premise of the book is to acknowledge photographs as having the capacity to speak beyond the literal reference to objects.

Case study analyses facilitate consideration of the exchange between subject matter, attitude and theoretical debate. Whilst a range of photographs may be referred to in establishing contexts, each chapter makes use of a limited number of photographic projects as a means to examine the selected focus for that chapter. And each aims to discuss different issues by referring to different aspects of the photograph. For example, I return a number of times to photographs of Manchester, Paris and Los Angeles, each time with a different focus for discussion. Or a particular 'scene' can be interpreted from a different perspective, such as Joel Meyerowitz's photographic archive of Ground Zero (*Aftermath* 2006), which reverberates in different ways with Jean Baudrillard's prophetic reference to the twin towers in his discussion of contemporary society, political systems and capitalism, and with the implications of Michel de Certeau's observation from the top of one of the towers, of being 'out of the city's grasp'.

Cities and Photography does not offer a comprehensive survey of photographers renowned for photographing cities, who are largely from Europe and the United States. My selection deliberately includes a cross section of international examples of photographic practice. And in order to provide additional focus, I have deliberately restricted the range in later chapters (South Africa in Chapter 5, Latin America and China in Chapter 6, and Japan in Chapter 7). Choices are thematic rather than chronological or relating to genres or the *auteur*. However, for the most part, the three introductory chapters focus on modernist conceptions of photography, and later chapters discuss projects that offer a postmodern perspective on the city. Having to choose a limited range of photographs has meant that many whom I mention have had to be left out. For these, I have given web references where possible. At the end of each chapter and in addition to the suggested reading, I list photographs and photographic series that will extend consideration of the issues discussed in the chapter.

Structure and format

Because I weave concepts of the city with concepts of photography and because they overlap, I make use of boxes to separate issues that will be

referred to in more than one chapter (e.g. 'Symbol of modernity'). The boxes focus on aspects that are repeated in history (e.g. 'The photograph and deception'), or inform context (e.g. 'South African photography') or explain a central theme (e.g. 'The *flâneur*'). In the initial chapters, the boxes tend to focus on photographic examples that amplify the main text. In the later chapters, discussion of photographic projects tends to be within the main text and the boxes focus on broader cultural issues or concepts. The reading lists/photography lists that follow each chapter introduce useful texts that will expand and clarify some of the ideas introduced. I give some brief annotation to indicate how they may be useful. Throughout the book and bibliography, I use square brackets to indicate the date of original publication.

The book is divided into three parts. The first part, 'Contexts', consists of three chapters, all of which are introductory discussions. Chapters 1 and 2 can work in parallel, so that a student of photography may choose to start with 'Cities and urbanism', whereas a student of cultural studies or the built environment may start with 'Photography concepts'. Chapter 3 presents a more integrated discussion of how the photograph works in the urban context. In order to establish an exchange between urban and photographic theories, the first three chapters introduce a number of themes in common. Chapter 1: 'Cities and urbanism' establishes a historical and contextual base from which to commence discussion of photography in the city. It outlines the main features of modernity and introduces contrasting perspectives on the notion of postmodernity. It introduces how the city has been conceptualized in the development of urban theory, and some of the theories useful to photographers addressing issues relating to urbanism. It establishes the central theme of the book as 'social space', and introduces those ideas, which will feature in a number of sections in the book: Lefebvre and Harvey with regard to urbanism, and Pierre Bourdieu and de Certeau with regard to the everyday practices of living. It introduces the emphases that different academic fields can bring to photographic interpretation and explains the 'city' as a trans-disciplinary concept that gives focus to urban studies, and as a metaphoric theme addressed by photography. Chapter 2: 'Photography concepts' outlines the recurrent photographic themes of 'objectivity', 'document' and 'truth'. It introduces key issues for the analysis of photographs and the related arguments of 'transparency' and mediation with reference to a range of analytical approaches. It outlines the debates emerging in early photographic modernism that establish the aesthetic traditions from which later photography attempts to deviate. I introduce the 'everyday' as one of the major themes of modernity, with reference to Baudelaire, and in the history of photographic practice, with reference to John Roberts' political perspective. Chapter 3: 'Photography

and/in/of the city' discusses the agency of the photograph, which contributes to our understanding of the city as a social construct, by embodying a point of view in the very fact of its context, perspective and frame. The chapter establishes the different functions of photography in the urban sphere, such as its use for political and social agency and its ubiquitous use for commercial purpose, and distinguishes between photography as part of the fabric of the city (i.e. CCTV, advertising etc.) and uses that purposefully comment on, and visually discuss, aspects of the city, such as social survey. It considers the photograph's relationship to the social production of meaning with reference to Michel Foucault, and Bourdieu's sociological analysis. After outlining a more critical analysis of photographic representation that interprets photography as an instrument of institutional power and social order, with reference to, for example, John Tagg and Allan Sekula, it introduces the additional mechanisms of constructing photographic meaning, using absent reference and allegory, which can insert a critical inference.

The chapters in Part 2: 'The documented city' aim to discuss the ideologies, traditions and implications of photographic documentation. They also begin to correlate theoretical ideas with visual conceptualization more directly. Chapter 4: 'Walking the city' considers issues relating to how photographs can represent the *experience* of living in the city, rather than what it looks like. It considers the complex network of familial hierarchies and political structures embodied in the way people behave in their everyday lives, with reference to Bourdieu's *habitus*. Using de Certeau's discussion of walking in the city, it establishes distinctly different perspectives on the street: of objectivism, *flânerie*, voyeurism and participative ethnography. The chapter features case studies that engage the contrasting positions of expression or commentary, and of distanced observation or subjective visions, which incorporate memory or participation. The chapter establishes the tradition of 'street photography' as exemplifying debates concerning the 'street' as a focus for theoretical debates about urbanism, and photography as social documentary. Chapter 5: 'Social and political practices' discusses photography as an ideological practice in historical and contemporary contexts: it outlines the worker photography movement between the wars, the emergence of a political use of photography in the UK in the 1970s, and Johannesburg's Market Photo Workshop established in the 1980s during apartheid. It extends consideration of the tensions between politics and aesthetics, and the debate embedded in photographic traditions and social values. Photographic projects discussed focus on Johannesburg and raise a number of socio-political issues such as the consequences of migration and the city's peripheral expansion. Okwui Enwezor's discussion of Guy Tillim's project *Jo'burg* (2004)

confronts the postcolonial dissolution of urban modernity with attempts by people in extreme poverty to re-appropriate city space.

Part 3: 'The metaphorical city' considers the influence of philosophical conceptions of space, the city as psychological metaphor, and the emergence of photographic practices that are concerned with the spatial, the psychological and the political. It extends aspects introduced in Parts 1 and 2 and explores them in more depth with reference to photographic projects that are characterized by a typically complex contemporary construction. These chapters rely more on the content of the photographs to lead the commentary. De Certeau's reference to the 'metaphorical city' indicates a city as being much more than a collection of buildings beautifully photographed; it is a network of relationships, systems and power. The city is frequently interpreted as metaphor for modernity (Eugène Atget's Paris), or for postmodern banality (Marcos López's Buenos Aires). Chapter 6: 'Postmodern megalopolis' considers the features of globalization and mass communication and their significance for the large metropolis. It discusses the impact of social, economic and political conditions on city life towards the end of the twentieth century, typified by Los Angeles, and discussed here in the context of developing cities in South America and China, where projects are concerned with the consequences of rapid urbanization and social change. It introduces perspectives provoked by Guy Debord's society of the spectacle, Jean Baudrillard's discussions of *hyperreality*, and Paul Virilio's 'panic' in response to the 'weapons of mass communication'. It notes the contrast between the visual evidence of globalized capitalism and the realities of local experience. And it introduces an implicit critical content in many con-temporary photographic representations. Chapter 7: 'City and subject' extends discussion of the postmodern megalopolis by focusing on its impact on the individual's psychological experience. It discusses the dialectic between mental and social space with reference to Georg Simmel and extends the notion of phenomenological encounter with reference to Gaston Bachelard's 'poetic space'. The chapter considers descriptions of the city from a range of subjective perspectives with reference to changing attitudes influenced by feminist thinking, such as the idea of a culturally constructed and multi-faceted self, which disturbs the rational city ideal. It explores a range of Japanese photographic projects that picture the experience of Tokyo as a psychological space, and which establish the play of the objective and subjective as an important theme for photography. Chapter 8: 'Psycho-geographies and the city' outlines the city as a complex network of interaction with reference to Lefebvre, Manuel Castells, and Gilles Deleuze and Felix Guattari's concepts about space, which have infiltrated the discipline of architecture. These have

fostered more fluid visions of space, buildings and the city that encompass both physical and social representation. The chapter outlines representational systems that resist the linear and the logical or chronological, such as Walter Benjamin's Arcades Project (1927–40), the Mass Observation project of 1937, and the Situationist International's notion of psycho-geography in the 1950s and 1960s. This chapter discusses projects that encompass networks and processes, a very different perspective from the more individual and existential vision discussed in Chapter 4. It proceeds to explore photographic systems that can accommodate social, psychological and political aspects, and which are essentially interdisciplinary and extend many of the themes and issues introduced in earlier chapters.

—▷ Henri Lefebvre
– Michel de Co metaphorical City –

⌐▷

Part 1
Contexts

1 Cities and urbanism

'Cities and urbanism' introduces how the city has been conceptualized, and the theoretical issues useful to photographers addressing issues relating to urbanism. First, I outline the principles of modernity and postmodernity that determine the historical contexts and circumstantial differences in the relationship between photography and the city. Second, I introduce the concept 'city' as providing a literal location within which to frame different cultural debates. Third, as this book's main focus is the relationship between people and the city, I introduce a range of theorists who have framed 'living' in the city as social space – in particular Henri Lefebvre, Michel de Certeau and Edward Soja – and whose interdisciplinary approach is useful for the photographic exploration in later chapters.

Modernity/postmodernity

> The project of modernity formulated in the 18th century by the philosophers of the Enlightenment consisted in their efforts to develop objective science, universal morality and law, and autonomous art according to their inner logic . . . The Enlightenment philosophers wanted to utilize this accumulation of specialized culture for the enrichment of everyday life – that is to say, for the rational organization of everyday social life.
>
> (Habermas 1985: 9)

The age of modernity runs parallel with the growth of city expansion throughout the nineteenth century as a result of industrialization and the growing dependence on capitalism and production. Most commonly, the term 'modernity' is used to distinguish the 'modern' from the 'ancient', and from an era prior to the Enlightenment, which is understood as the pursuit of a rational social order and the desire for progress. It is associated with the

increasing secularization of society that replaces the religious state and the assertion of scientific explanation replacing superstitious 'primitivism'. In the nineteenth century, modernity incorporates mechanical production, industrialization and the development of consumerism. Increasing urbanization and consumption results in the consequent development of mass marketing, advertising and fashion and of new systems of communication (telephone) and of transport (underground rail networks) (Harvey 1990: 23). The invention of photography (1839) and its increasing appropriation for the promotion of state operations and capitalist expansion adds a further dimension, which I will discuss in Chapter 3. The positive aspects of modernity are the desire for a civilized and ordered society with a concern for humanity and justice, which become in practical terms the aspiration for improved social conditions. The negative aspects can be seen as the imperialist attitude to spreading these 'civilizing' influences across the globe, with no regard for the value of cultural difference. In addition, the rational attitude's drive to assert a reasonable society, is seen as being increasingly instrumental in attempting to dominate nature, in exercising social power and in encouraging the divide between the disciplines of science, art and philosophy.

The terms 'modernism' and 'modernist' are used more specifically to refer to the products that arise from the cultural debates that characterize modernity – such as art, literature and architecture. Jürgen Habermas (1985: 5) describes aesthetic modernity as finding a common focus in the consciousness of the time, which is seen manifested in the drive to assert progress in a series of avant-gardes that each claim superiority over the one that precedes it (e.g. Futurism, Surrealism). In literature, the classic figure of modernity, and pertinent to this discussion, is that of the *flâneur* – epitomized by Charles Baudelaire and in the literary work of Gustav Flaubert. Baudelaire [1863] expresses the modernist aspiration to push forward, to move on from the past and to look for the quality that is particular to 'the age, its fashions, its morals, its emotions' (Baudelaire 1964: 3). He describes two characteristics of modernity that are of particular importance for a consideration of cities and photography: the relationship of the individual to the crowd in the metropolis, and the veneration of the 'everyday'. He promotes the 'modern' artist as defining (his) vision by using subjects of everyday city life, rather than resorting to mythical or religious allegory in (his) search for eternal meaning (see also Box 4.1: The *flâneur*). As a consequence of the desire for rational order comes the drive to deliberately modernize urban living space, because modernist space is seen as a logical means to facilitate new ways of living. Modernist aspirations find validation in what is understood as urban progress and are made visible in concrete manifestations such as architecture and town

planning. The idea that restructuring the physical city will 'confront the psychological, sociological, technical, organizational and political problems of massive urbanization' in order to progress social conditions, is an essentially modernist aspiration and is indicative of the modernist compulsion to progress (Harvey 1990: 25). Georges-Eugène Haussman's rebuilding of Paris in the mid-nineteenth century is described as the quintessential example of this (see Box 1.1). Similarly, Le Corbusier's revolutionary architectural vision is conceived in utopian terms [*The City of Tomorrow*, 1924]. He envisaged city planning on a grand scale to the extent, for example, of establishing different functional zones in his conception for the Ville Contemporaine (1922). However, as Fredric Jameson observes, modernist reconstructions of city space can fail to be realized in practical and human terms, sometimes only succeeding in translating an abstract logical system into a concrete form (Jameson 2009: 163). And Henri Lefebvre comments that Haussman's reordering of the city reduced Paris from the human to the strategic management of people (Lefebvre 1991: 312). Utopian influences, such as Le Corbusier's, can be compromised to the extent that they merely effect the appearance of an ideal. In the UK, the investment in visions of modernity and progress were realized in the high-rise estates built in the 1960s – the City of Manchester was typical in re-housing residents in estates outside the city in Wythenshaw, Langley, Heywood and Worsley. Many such developments subsequently proved to be failures in social terms, resulting in rapidly deteriorating environments, alienated communities, centres for crime, and eventual demolition in the 1980s and since.

Postmodernity is generally understood to relate to the latter decades of the twentieth century – particularly the 1980s. There are no clear distinctions between modernity and postmodernity and, in many ways, conceptions of the postmodern depend on how we conceive modernity. For example, Jürgen Habermas [1981] interprets modernity as a project that is not yet fully realized and is suspicious of postmodernism because of its impulse to negate the positive and utopian aspects of the Enlightenment. He argues that what he calls the 'project of modernity' is not an era but an ideology. Similarly, Jean-François Lyotard's notion of the postmodern condition [1979] is conceived as a dynamic that interrupts tradition – that prefaces modernism – in a cycle of tradition and anti-tradition. Habermas states that 'modernity revolts against the normalizing functions of tradition' and persists in the habit of 'rebelling against all that is normative' (Habermas 1985: 5). He goes further and suggests that postmodernism is the most recent version of modernism and just another 'abstract opposition between tradition and the present' (1985: 4). He suggests that instead of giving up modernity as a lost cause, 'we should

BOX 1.1

Symbol of modernity: Paris

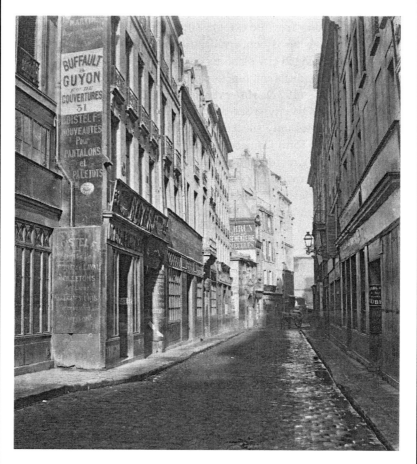

Figure 1.1 Charles Marville, *Rue des Bourdonnais de la rue de Rivoli, Paris*, 1865. Albumen silver print (31.1 × 27 cm). The J. Paul Getty Museum, Los Angeles.

Something very dramatic happened in Europe in general, and in Paris in particular, in 1848. The argument for some radical break in Parisian political economy, life, and culture around that date is, on the surface at least, entirely plausible. Before,

there was an urban vision that at best could only tinker with the problems of a medieval urban infrastructure; then came Haussman, who bludgeoned the city into modernity.

(Harvey 2003: 3)

David Harvey characterizes Paris as the ultimate exemplar of modernity, and of the 'creative destruction' that is associated with the implementation of its ambitions (Harvey 2003: 16). Following the uprising of 1848, Haussman was assigned the job of reconstructing Paris's street system. He demolished large areas of Paris with the intention of creating something new and progressive. Harvey describes this process of rational progress as creating the myth that there was 'no alternative to the benevolent authoritarianism of Empire' (Harvey 2003: 10). This project, executed on behalf of government and promoted as being of benefit to the welfare and prosperity of the city, is an example of an exercise of institutional power made manifest in concrete reality. Walter Benjamin's commentary [1935] on Haussman's city planning describes the long perspectives down broad straight thoroughfares as a common nineteenth-century ideal and strategic move whereby 'The institutions of the bourgeoisie's worldly and spiritual dominance were to find their apotheosis within the framework of the boulevards'. Benjamin asserts that the true goal of Haussman's projects was to secure the city against civil war: 'Widening the streets is designed to make the erection of barricades impossible, and new streets are to furnish the shortest route between the barracks and the workers' districts. Contemporaries christen the operation "strategic embellishment"' (Benjamin 2002: 11–12).

Charles Marville (1816–79) was one of a team of photographers commissioned by Haussman in 1853 to record the city prior to its demolition and renewal. Held as a permanent record of the time in the Photothèque des Musées de la Ville de Paris, it is an early example of photography employed to produce a historical record for official posterity.

learn from the mistakes of those extravagant programs which have tried to negate modernity' (1985: 12). In these terms, modernity is still very much alive. In discussing attitudes to postmodern ideas, he identifies the difficulty in distinguishing those who reject all that modernity stands for, from those who regret the decline of reason and the clear distinctions between different disciplinary enquiries, from those who welcome contemporary developments, which problematize reason, and changes in attitude such as the assertion of

difference over the pursuit of universal meaning. Habermas's argument with classifications of postmodernism highlights the problem with attempting to define its characteristics. All-encompassing terms, such as postmodernism, are problematic if not qualified by whose interpretation, and tend to be oversimplified and reduced to a few features which, in the arts and architecture, are taken to be paradox, irony, hybridity and self-conscious appropriations from popular culture and historical traditions.

Importantly, the condition of postmodernity, including its cultural products and associated ideas, represents a reaction to modernism's vision of progress, absolute truths, rationalism and social order by giving consideration to difference and indeterminacy, the irrational and subjectivity. Modernism defined itself through the exclusion of mass culture, and postmodernism renegotiates high and popular forms of culture. Modernism is characterized by a utopian desire and commitment to radical change, and postmodernism – which questions the presumptions of modernism – by critique, demystification and the significance of difference. Jameson [1991] attempts to classify divisions in attitude by distinguishing between a postmodernism that is essentially anti-modern, and a modernism that is anti-postmodern, neither of which depends on a historic break but on ideological differences (Jameson 2009: 58–9). In this way of thinking, the condition of postmodernity can retain the 'good' attributes of modernity, whilst allowing for the many post-structural theories that have questioned the extremes of modernist assumption such as the new is good no matter what. If the utopian ambitions of high modernism (e.g. Le Corbusier's *City of Tomorrow*) are recognized as being unrealizable, contemporary postmodernism may be described as merely the transference of modernist ideologies to reinvigorate contemporary processes with 'fresh life' (Jameson 1984: xx; 2009: 60).

As postmodernism is interpreted in very different ways, so too are its effects on society. Jameson's analysis of the far-reaching implications of postmodernism and David Harvey's suspicion of its most extreme forms provide two such examples, which attract criticism. And these perspectives are very different again from those cultural theorists generally referred to as postmodern (e.g. Jean Baudrillard, Paul Virilio), to whom I will return in Chapter 6. Both Jameson's and Harvey's scrutiny of postmodern culture incorporate analysis of aesthetic, cultural and political aspects, and are useful for a book that considers the exchange between the experience of urbanism and its depiction. Jameson's evaluation makes direct use of cultural products such as photography to focus his socio-political assessment. His contention that culture is characterized by an *interaction* between political, social and

economic elements is significant for a discussion of ideas visualized in photographs. And many of the photographic projects selected here address the consequences of 'late capitalism' and its effects.

> The problem of postmodernism – how its fundamental characteristics are to be described, whether it even exists in the first place, whether the very *concept* is of any use, or is, on the contrary a mystification – this problem is at one and the same time an aesthetic and a political one. The various positions that can logically be taken on it, whatever terms they are couched in, can always be shown to articulate visions of history in which the evaluation of the social moment in which we live today is the object of an essentially political affirmation or repudiation.
>
> (Jameson 2009: 55)

Jameson describes his book [*Postmodernism, or The Cultural Logic of Late Capitalism*, 1991] as an attempt to theorize the logic of cultural production that is symptomatic of late capitalist development, generally named 'post-industrial', but which he highlights as being 'multi-national'.[1] He situates his discussion within a Marxian historical materialism and in relation to Ernest Mandel's analysis of the three stages of capitalism that develop with global expansion: market capitalism, monopoly capitalism and late multi-national capitalism [Mandel, *Late Capitalism*, 1975]. He draws parallels between these stages of capitalism and changes in the city, for example: classical market capitalism with Haussman's geometrical ordering of urban space, and late capitalist expansion in the city with the disorientation of individual experience (2009: 410–13). As a Marxist critic, Jameson is concerned with issues of class structure, modes of production and the difficulties in organizing political action in response to new social formations. His discussion raises questions for living and working in the city in the face of multi-national societies dominated by new technologies, and the development of a form of commodity production that satisfies the needs of the consumer, whilst simultaneously driving material desires. Jameson emphasizes multiple perspectives for explanation of the postmodern phenomenon and compares a number of theoretical possibilities – a method he refers to as 'transcoding' (394). He thereby contributes an interdisciplinary approach to cultural critique, which characteristically focuses on what is problematic or what subverts the norm, rather than attempts to find a 'truth' or a resolved position. However, Jameson's method of reference to diverse discourses attracts the criticism that such wide-ranging analysis does not give sufficient focused address to key postmodern concerns such as agency or issues relating to cultural difference (Dear 2000: 65), or to the practical effects of the economy on art and culture (Gregory 2004: 83).

Jameson's analysis gives emphasis to the political implications of late capitalism and the exchange between economy, history and culture. His appraisal establishes a cultural politics that incorporates everything in social life, from economic value and state power, 'to the very structure of the psyche itself' (Jameson 2009: 48). Significantly, his use of the term 'postmodernism' refers to both the general social condition (postmodernity) *and* to the aesthetic features associated with it (postmodernism). Postmodernism is therefore identified as a socio-economic period, following the post-war boom and the transitional period of the 1960s, in which a new type of social life takes hold – a new international order of neo-colonialism, computerization and electronic information (Jameson 1985: 113). Where other commentators [Hutcheon 1989: 25] are careful to separate 'cultural postmodernism' from 'philosophical and socio-economic realities', Jameson asserts that a cultural politics derives from the socio-political. In consequence, what becomes an issue for debate is the extent to which this cultural logic is characteristic of late capitalism and to economic transformation, or the other way round (Gregory 2004: 80).

Speaking from the more specific perspective of geography and social theory, David Harvey is implicitly critical of postmodernist thinking and, like Habermas, contends that the good aspirations of modernism can be sustained. His position is one driven by a desire for social justice and making the world a better place. He asks:

> If, as the postmodernists insist, we cannot aspire to any unified repre-
> sentation of the world, or picture it as a totality full of connections and
> differentiations rather than as perpetually shifting fragments, then how can
> we possibly aspire to act coherently with respect to the world?
> (Harvey 1990: 52)

He is critical of what he perceives as the 'relativism and defeatism' of a postmodernism that relinquishes any attempt at consensus or will to progress, and which problematizes the possibility of a 'centred sense of personal identity' in order to think coherently about a better future (Harvey 1990: 52–3). Harvey scrutinizes society's adaptation to the increasingly flexible modes of capitalist production, commercial and technological innovations and what he calls 'time-space compression' whereby, as a result of electronic communication and the reduction of transportation costs, space and time have effectively shrunk. However, he argues that, whilst cultural and political practices have changed since 1972, these changes are not signs of an entirely new post-industrial society (ibid.: vii) but are symptomatic of new configurations driven by the forces of capitalism: 'Since money and commodities are entirely bound up with the circulation of capital, it follows that cultural forms are firmly

rooted in the daily circulation process of capital' (ibid.: 299). Harvey's criticism of postmodernism is motivated by his concern to confront the realities of political economy and to find practical means to tackle the powerful global processes that result from de-industrialization and flexible labour markets, and which affect daily life (ibid.: 191). Whilst he acknow-ledges the postmodernists' challenge to male bias and to universalizing presumptions, and acknowledges the importance of, for example, Michel Foucault's influence over much of contemporary thought, he concludes that the insistence on localized struggle and 'the rejection of any holistic theory of capitalism' fails to find 'progressive attack upon the central forms of capitalist exploitation and repression' (ibid.: 44–8). Statements such as 'postmodernism swims, even wallows, in the fragmentary and the chaotic currents of change as if that is all there is', and postmodernism 'shuts off other voices from access to more universal sources of power by ghettoizing them with an opaque otherness' invoke criticism (ibid.: 116–17). Whilst Harvey provides a commonsense appraisal of the postmodern condition and the influence of globalization in particular, he (and Jameson) have been criticized for ultimately upholding patriarchal values – and binary thinking.[2] He is accused of not engaging with feminist theory or developments in cultural geography or history, and of suppressing alternative theories that do not conform to Marxian social theory. However, Harvey does identify the importance of many of the ideas associated with postmodernism – such as dialectical modes of enquiry, the necessary address to difference and 'otherness' and the attention to aesthetic and cultural practices – to the progress of historical-geographical materialism in understanding social change, and to the promotion of 'a more liberatory politics' (ibid.: 353–5).

In his aspiration for a socially concerned geography – effectively a geo-politics – Harvey incorporates the fundamental and underlying shifts in understanding promoted by postmodernism. The political geographer Edward Soja [1989] extends discussion of the issues raised by postmodern critique and refers to a radical postmodernism as the restructuring of conventional ways of thinking about things. His postmodernism is neither an anti-modernism (nor anti-postmodernism) nor a rejection of all modernist aspirations and avoids reductionist or simplistic, essentialist views. Instead, Soja invites a 'place of critical exchange where the geographical imagination can be expanded to encompass a multiplicity of perspectives' (Soja 1996: 5). This approach avoids the privileging of any one perspective over any other. It is significant for this book, that thinking is increasingly envitalized by a good deal of interdisciplinary exchange that could be described as a feature of post-postmodernity and which brings science, art, philosophy and politics together in an upsurge of interdisciplinary approaches to thinking. This book will

demonstrate that the photograph validates successive changes in attitude in its visual celebration of new orders of the city. It follows that photography has to a large extent contributed to its production in terms of the conceptions of cities.

BOX 1.2

Cities in miniature

Modernity: Paris arcades

Benjamin describes the Paris arcades, built in the early decades of the nineteenth century, as radiating 'throughout the Paris of the Empire like grottoes' and as a refuge of the bourgeoisie. Quoting an *Illustrated Guide to Paris*, Benjamin uses the Paris arcades as a metaphoric lens through which to examine aspects of the phenomenon of modern life – such as the advent of consumerism:

> These arcades, a recent invention of industrial luxury, are glass-roofed, marble-paneled corridors extending through whole blocks of building, whose owners have joined together for such enterprises. Lining both sides of these corridors, which get their light from above, are the most elegant shops, so that the arcade is a city, a world in miniature, in which customers will find everything they need.
>
> (Benjamin 2002: 873)

Benjamin's *Arcades Project* [1927–40] comments on the significance of the modern metropolis. Implicitly critical, it includes reflection on the physical appearance and experience of shopping, as well as its economic and political impact. *The Arcades Project* amounts to a picture of an era – of industrial capitalism and of consumerism. It encompasses an experience – physically and conceptually – that is dependent on, and a consequence of, the values of the day. Arcades were a forerunner to the department store – a centre for retail enterprise and pleasure. Artificially lit and giving shelter from the weather, they become a symbol for the increasing separation from our natural condition and our move toward a desire for a fabricated reality reliant on industrial production. They mark the onset of 'shopping' as a leisure pastime, which will emerge again, revitalized, in the late twentieth century in the expansion of elaborate shopping malls.

Postmodernity: Los Angeles shopping mall

> The Bonaventure aspires to being a total space, a complete world, a kind of miniature city; to this new total space, meanwhile, corresponds a new collective practice, a new mode in which individuals move and congregate, something like the practice of a new and historically original kind of hypercrowd.
>
> (Jameson 2009: 40)

Where Paris is seen as the quintessential modern city, both Jameson and Soja use Los Angeles to demonstrate a number of aspects of postmodernism. Jameson adopts the Westin Bonaventure Hotel and shopping mall, designed by John Portman and opened in 1977, as a microcosm of postmodern features – an inner world disjointed from the main city. He describes [1991] a space that '[expands] our sensorium and our body to some new yet unimaginable, perhaps ultimately impossible dimensions' and which 'aspires to being a complete space – a kind of miniature city' (Jameson 2009: 39). Just as Benjamin describes the Paris arcades as separated from the city outside, Jameson describes the peculiarly saturated and contradictory space of Bonaventure with its glass skin that 'repels the city' and its complex alternative entrances that link to, and yet separate the building from, the rest of the city that surrounds it: 'for it does not wish to be part of the city but rather its equivalent and replacement or substitute' (40–2). Spaces such as this produce 'a radically different spatial experience' that marks a technological translation of walking through an arcade: 'Here the narrative stroll has been underscored, symbolized, reified, and replaced by a transportation machine which becomes an allegorical signifier of that older promenade we are no longer allowed to conduct on our own' (42). Instead we are transported in glass lifts, 'emblems of movement', that shoot up through the ceiling and outside and along one of the four symmetrical towers. From here Los Angeles is 'spread out breathtakingly, and even alarmingly, before us' (43). A structure such as this creates a kind of global, rather than local, identity that is aligned with global capitalist pretensions rather than contributing to the fabric of the surrounding city (http://www.starwoodhotels.com/westin/property/overview/index.html?propertyID=1004).

Urban studies

Social attitudes are characterized by the ideas associated with 'modernity' and 'postmodernity'. In the nineteenth century urban study focused on a consideration of social conditions – poverty, pollution, crime and homelessness with a view to improving them. Sociologists began to ask questions about what characterizes living in the city specifically, as distinct from rural environments, and what effects city structures had on human relationships and community interaction. In his essay 'The Metropolis and Mental Life' [1902–3] (in *The Sociology of Georg Simmel*), Georg Simmel anticipated many of the concerns of social psychology with respect to the difference that living in the city makes to the 'the sensory foundations of sensory life'. Kurt Wolff introduces his work as having contributed to the establishment of a 'sociological viewpoint', the recognition of 'sociological production' and more specifically the significance of the experience of the city on individual psychology (Simmel 1964: xxxi). The development of specific theoretical disciplines during the course of the twentieth century introduced very different perspectives from which to study the city: Sociology – concerned with the study of societies and the processes and institutions that distinguish them; Geography – concerned to study the earth, its features, resources and inhabitants – and human geography, which gives emphasis to the impact of human culture and economic exchange and to the ways that people inhabit their environment; Anthropology – concerned with the study of humankind and in particular the behaviours and ideologies that distinguish different peoples and groups. Since the 1960s, the 'urban' has become more theoretical, rather than descriptive or based on the statistical analysis typical of earlier examples of sociological study. Increasing urbanization and disorder in cities provoked a more politicized scholarship that focused on the social relations of class and power underlying capitalism (e.g. Jameson and Harvey). Urban theories attempted to understand the impact of the increasing use of the automobile, mass consumption and consumerism, increasing segregation, mass suburbanization and the rapid growth of the middle class (Soja 2000: 97–8). Henri Lefebvre [1974] introduced a radical spatial dimension to an emphasis on historical materialism, which reinvigorated Marxist analysis and ultimately reconceptualized urban studies. David Harvey's *Social Justice and the City* [1973] championed a Marxist perspective that built upon both sociological and geographical imaginations and which related social behaviour to the way in which the city assumes a specific geography. His discussion insists on the need to 'formulate concepts which allow us to harmonize and integrate strategies to deal with the intricacies of social process and the elements of spatial form' (Harvey 1975: 27). Harvey establishes that questions of moral

and social justice are contingent on the social processes that operate in the city, such as the distribution of income. He considers how 'distributional effects' and issues of privilege create tensions in the process of urbanization, and how a just distribution of resources might be achieved (1975: 51–5). Manuel Castells (1977) directed attention to the relation of social processes to capitalist industrialization and criticized the 'myth of urban culture' and the over simplistic explanation of all social life as a result of cityness (Soja 2000: 103). Towards the end of the twentieth century theoretical study increasingly transgresses disciplinary boundaries. Studies of phenomena, such as the city, cut across different concerns, so that what is termed 'urban studies' has adopted methodologies from the distinct disciplines of sociology, geography and anthropology. At the same time, in order to accommodate the range of consideration necessary for discussion, geographers, for example, have become increasingly specialized. Phil Hubbard observes:

> Urban geographers now prefer to identify themselves as cultural geog-
> raphers, feminist geographers, population geographers, economic
> geographers, social scientists and so on. Although urban geography
> remains one of the largest speciality research groups in both the Institute
> of British Geographers and the Association of American Geographers, it
> is also one of the most diffuse. As a result, the intellectual developments
> that have swept over and transformed the discipline since the mid 1990s
> are usually associated with cultural, economic or feminist geography,
> even if many of them have been urban in text and context.
>
> (Hubbard 2006: 4)

The city as social space

As the central focus of this book is the relationship between people and the city, it is Lefebvre's conception of the construction of social space that introduces my general approach to considering the relationship between cities and photography. Lefebvre's discussion serves to introduce three aspects that have become central to urban studies: an interdisciplinary approach; a response to Marxist analysis and the impact of globalization; the emphasis on the significance of 'living' over the manufacture of space. Lefebvre's writing crosses disciplinary boundaries by describing the physical together with the more difficult notion of social practice, which is not confined to the evidence of objects but resides in networks and relationships. *The Production of Space* [1974] explores how we conceive space as reaching beyond the physical city, to encompass the conceptual, the psychological, the ideological

and the social. Lefebvre is concerned to clarify different conceptions of space, and how theoretical and practical spaces interrelate (Lefebvre 1991: 4). He explains social space in terms of a matrix that presents the many facets of capitalism: 'landed capital, commercial capital, finance capital', which each manifest themselves in the fabric of the city, in the circulation of money and in its institutions and agencies (1991: 10). Whilst Karl Marx and Friedrich Engels outlined how the forces of production and the instruments of labour, technology and knowledge forge the city, Lefebvre's discussion introduces the divisions and interrelationships that operate within the city as local, regional and global (1991: 90). Jameson describes Lefebvre as adjusting a modernist imbalance with regard to the experience of space and time, by emphasizing the importance of our *experience* of urban and global systems. He describes Lefebvre as calling for 'a new kind of spatial imagination capable of confronting the past in a new way and reading its less tangible secrets', in all its cultural, economic and linguistic forms (Jameson 2009: 364–5).

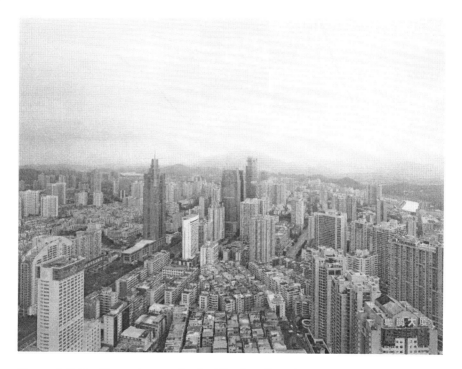

Figure 1.2 Sze Tsung Leong, *Luohu District, Shenzhen,* 2008. From the series *Cities.* Chromogenic colour print. © Sze Tsung Leong, Courtesy Yossi Milo Gallery, New York.

Lefebvre's book *The Urban Revolution* [1970] contributes to the development of urban debate with regard to the global spread of urbanization. It explores the production of space in urban capitalist society, with an emphasis on how people negotiate and organize space; it focuses on what realities, ideologies motivate production and effect in the city. Neil Smith introduces Lefebvre's significant identification of not only the historical shift from an agricultural to an industrial economy and towards the beginnings of globalization, but a changing ideology of the urban. What Lefebvre calls the 'urban problematic' becomes the motivating force of historical change – an irrepressible force that moves in the direction of 'the complete urbanization of the world' (Smith in Lefebvre 2003: x–xxii). Lefebvre's urban revolution, describing the transformations that are unique to urban society, is one of an optimism that anticipates an alternative to the reverence of capitalism. Lefebvre's writings express a desire for change and the possibility of a utopian ideal that looks forward to a 'globalized creativity' liberated from the 'economic and ideological slavery' to the worst features of capitalism (ibid.: xxiii). Lefebvre points to the passivity of those living through the increasing globalized economy and what he sees as a constrained imagination and a resulting repression. In his desire for progress, Lefebvre's utopian vision extends a call for activism, urging us to engage with the problems and conflicts of living in cities in the modern world and with the strategies that produce them (Lefebvre 2003: 182–8). Both Lefebvre and Harvey see urbanism as determined by the interrelatedness and self-sustaining nature of its structures. Urbanism develops from spatial organization and once urban structure is created, it affects the future development of social relationships and the organization of production (Harvey 1973: 307). It is a cyclical process. However, where Lefebvre asserts that urbanism now dominates industrial society, Harvey whose analysis of the city and social justice focuses on the power of capitalist economies, sees urbanism as still 'channelled and sustained' by economic forces and production and modified by the changing dynamics of capitalism and industry, not by the evolution of urbanism itself (Harvey 1973: 311–12).

As 'natural space' has disappeared, space becomes less passive and more deliberately constructed – hence Lefebvre's emphasis on the *production* of space. He asserts that the reality of physical space is determined by the energy deployed within it (Lefebvre 1991: 11–13). Ideological pressures operate through the mechanisms of urbanism and the establishment of its systems; the interrelationships of power structures, of ruling institutions and the operations of commerce determine the material organization of space and its use. Every society produces its space to coincide with its dominant ideology

so that, for example, the maintenance of the ruling classes and their position exerts influence over the configuration of city space. Lefebvre warns of the reductive effects of abstract models of the city when applied to urban planning. Abstract analysis imposes ideological strategies in the name of progress that dehumanize and deny any meaningful knowledge of peoples or individuals (1991: 105–7). He refers to architects and city planners as thinking in abstract terms 'within a space of paper and ink' rather than being motivated by the practice of everyday life or lived experience (2003: 182). Planning can become a 'blind field' operation in which everything is reduced to what is quantifiable – ideologically, technologically and politically – and everything else is eliminated; it is these tensions that accentuate repressive space.

Lefebvre offers a conceptualization of space and the city that avoids the abstract, emphasizing 'living' instead, and equating 'humanity' with what it *does* in 'social practice'. He points to the misconception that space exists innocently or naturally, where in fact it is socially produced and politically determined. He urges a 'criticism of space' that will 'rip aside' the apparent transparency of its appearance to expose the complexity of its infrastructural dependence (1991: 92). 'Reality' can be presumed to be decipherable in its representations – in speech, writing and photography – whereby physical space can seem obvious to us despite the fact that we may have no idea of the rationale, purpose or politics of its construction (27). Social space is not a 'thing' but subsumes not only things, but the relationships between them (73). Lefebvre discusses the divisions that exist between physical, social and mental spaces, and between the ideal space and the actual – when in fact they are interdependent and therefore not divided. Space serves as a tool of thought and action – (social) space is a (social) product – a materialization of work and product. Social spaces manifest the desires that are revealed in the particularities of public and private spaces and as such cease to be indistinguishable from mental space (26–7). Lefebvre's analysis emphasizes the interwoven complexity of the city, which is social, spatial and historical; it is threefold in a number of respects, making distinctions between: the rural, the industrial and the urban; the environment, the neighbourhood and the immediate contact with the body; the global, the local and the private; the physical, the mental and the social.

Michel de Certeau's *The Practice of Everyday Life* [1980] examines social representation in order to better understand how we live. He discusses the 'methods, categories and perspectives' from which sociological study has described everyday social practices. He gives emphasis to everyday practices which, more than merely providing a background to a city, make the culture of that city explicit – those 'innumerable other practices that remain "minor"'

BOX 1.3

Triadic city space

A contemporary consciousness of spatiality is characterized by Edward Soja's expansion of Lefebvre's discussion of three different kinds of spaces: perceived space, conceived space and lived space. Like Lefebvre, Soja avoids reductive perspectives and aims to maintain an openness in rethinking the city by introducing terms that suggest alternatives to binary divisions, such as the abstract and concrete, subjective and objective, real and imagined, mind and body, consciousness and unconsciousness (Soja 1996: 56). He offers an application of Lefebvre's approach to examples of the postmodern city (10). His conception of a 'third space' incorporates a range of ideas and meanings that are indicative of a trans-disciplinary approach to understanding our relationship to space, which break the boundaries between domains – inside and outside, suburbs and centre, cars and people. In *Thirdspace*, Soja explains Lefebvre's conception of triadic space (63–6). A first space perspective focuses on 'concrete materiality of spatial forms' by which a society gives material form to the social order of the day, as with Haussman's regeneration of Paris or the urban development in post-war Europe. It refers to the practical ordering of society by means of roads and communication links within the city. First space can be perceived, described and measured and relies on analytical deciphering and objective materiality. In these terms, the photograph manifests spaces as we might see it – specularizes it, objectifies it and makes us believe that we have transparent access to it via images. A panoramic view of the city, presented as iconically beautiful, might be an example of this attitude (see Figure 1.2).

Second space manifests a reaction to first space and focuses on conceived forms rather than existing spaces that can be seen; it is entirely ideational and imagined, generating projections of possibility (79). Second space representations are conceived by planners and manifested in the designs that influence the ordering of space – for example, the visions of Le Corbusier. Second space is ordered by the symbolism used in its configuration within a particular society and is representative of power and ideology, of control and surveillance or evident in the creative imagination of artists, writers and photographers. Photographs can visualize imagined space by illustrating utopian ideals. They can help

to promote ideas and commodities as realizing our desires, as for example in the glamorous and glossy photographs of shopping malls.[3] In contrast photographs can also expose how we conceive space by manifesting the assumptions we have made in its production by depicting the priorities and what we understand as 'reality' (see *Plaza de Mayo* in Chapter 6). First and second space can be described as correlating the principles of modernity in terms of rationality and order and the aspirations of modernism and postmodernism with regard to ideality.

Soja's term 'third space' draws on both of these and equates with Lefebrve's 'spaces of representation', which embody the 'complex symbolisms' that contribute to the construction of lived space. Third space combines the real and the imagined on equal terms. It suggests that views need not be reduced to either this or that, need not privilege one aspect over the other, and promotes resistance to the dominant order by foregrounding the relationships between space, knowledge and power presented in 'subliminal imagery' (68). A critical urban studies recognizes that each specific and local element of a space conceals a host of social relationships. The reality of space is to be seen in experience, and in the evidence of practice. Photographs depict the space we live in, the evidence of experience in what we do and the exchanges we make and the dreams and desires we hold – simultaneously. The case studies in Part 3 explore this possibility.

but are always there (de Certeau 1988: 48). His outline of what the French thinker Michel Foucault and sociologist Pierre Bourdieu have contributed to the development of urban theory, and to studying the city specifically, articulates fundamental changes in attitude. Foucault's focus on procedures, mechanisms and power structures traces the origins of contemporary systems and their functions back through history. His analysis informs our understanding of how, for example, institutional procedures, obeying a logic commensurate with those institutions, inevitably exert their power and affect our lives in numerous ways (de Certeau 1988: 46–9). De Certeau describes Foucault as being interested in *what practices produce*, rather than the fixed customs of everyday life, whereas Bourdieu is interested in *what produces practices* (58). Where Foucault focuses on procedures (panoptic, penal, clinical), Bourdieu focuses on the *genesis* of structures and practices that are learnt and interiorized – what is 'second nature' or 'common sense' to any cultural group. What Bourdieu calls *habitus* is the observable evidence of that

learning in individual, localized and collective practices. His book *Outline of a Theory of Practice* [1972] focuses on the 'strategies' adopted in a system, such as the family, which perpetuate the order of that system and which generate the implicit principles (the rules) by which the family is governed. For example, the divisions of labour, objects, consumption and parent–child relationships can be observed in a familial system (Bourdieu 2010: 54). Members of the same family, group, culture share a *habitus*, a set of procedures, rules and habits. *Habitus* generates 'thoughts, perceptions, expressions and actions' and the principles that organize everyday practices. *Habitus* is a form of law that develops through history, in accordance with the processes and memories of the past that produced it, with our interaction with each other, and with the rest of our environment; its structures therefore are continuously in the process of change (55). This perspective provides an interesting dimension for how we observe day-to-day living. Chapter 4 will consider the implications of observation for photographing other people and their activity.

The city as model – theoretical frame

Space is conceived in both abstract and social terms and as such the city represents a philosophical symbolism of our relationship to the world. The city serves as a focus for the exploration of ideas and as an example with which to explain theories about living. The city represents a fixed centre – a hub – a focal point that embodies its beliefs – in its cemeteries, 'the height of its towers' and its aspirations for civic order – in its streets and institutions (Lefebvre 1991: 235). As far back as Plato (*Republic*, *Critias*), the city has been used to explore philosophy and the utopian state. As urban life has become increasingly commonplace in the Western world, ideals have been played out and explored through the streets of the city. As the reconstruction of Paris testifies, cities can be understood as the products of imagined ideals and the power that realizes those dreams and ideologies. As the modern city grows, it promotes the generalization of ideals because it integrates and unifies specific elements; it becomes 'abstraction in action'. 'City' is more than its physical reality; it becomes 'a vast machine, an automaton, capturing natural energies and consuming them productively' (345). And, as a transdisciplinary concept, 'city' can be examined across ideological and imaginative frames, as well as in terms of its statistical components or its historical development.

In addition to the disciplinary methods of sociology, geography and anthropology, late twentieth-century examination of the city is coloured by

different critical thinking – for example, feminist and postcolonial theories, which provide a series of overarching perspectives from which to photograph the city. Feminist standpoints have emphasized aspects of urbanism such as the psychological, social and cultural constituents that had hitherto been omitted by default, or actively ignored (Soja 1996: 111). Feminist theory reminds us that space is not neutral, that it is invested with the consequences of gender difference that are embedded in social structures. Latterly, feminism has moved from focusing on the gender divide to contributing a radical rethinking of how we engage and live in space, in ways that incorporate multiple cultural representations that include gender, race, class and the tensions between them. Space is always constructed in relation to people and it is lived in by people (Meskimmon 1997: 1). A feminist perspective demands questions such as: who organizes the space, who inhabits the space, who moves in that space? Feminist theories insert the very bodily realities of lived space, which demand a breakdown of the hierarchy of the space/body divide. In discussing the human body Barbara Hooper says:

> I do not mean either a product of culture nor a creation of biology: it is both of these and more. It is a concrete physical space of flesh and bone, of chemistries and electricities; it is a highly mediated space, a space transformed by cultural interpretations and representations; it is a lived space, a volatile space of conscious and unconscious desires and motivations—a body/self, a subject, an identity: it is, in sum, a social space, a complexity involving the workings of power and knowledge and the workings of the body's lived unpredictabilities.
>
> (Hooper in Soja 2000: 362)

In broad terms, feminist discourse challenges the universal and the transcendent typified by white, male, middle-class domination and gives emphasis instead to a subject who changes in response to cultural influences and agency (Meskimmon 1997: 18). In the Western world, the modernist era has seen the movement from the woman's containment in domestic space towards an increasing access to spaces of power. Meskimmon emphasizes the importance of spatial metaphor to encompass this movement and change. Linda McDowell's discussion is more specific in the context of human geography. It situates discussion in the practical context of the home and refers to the houses in which we live as a 'social construction of meaning and subjectivity' (McDowell 1999: 72). The spiritual and the physical is 'reified' in the home, which is a 'place' marked by its specific habitation.[4] Places are not defined by spatial boundaries but are cultural, rather than physical. Places such as the 'home' embed symbolic meaning in their construction. The home becomes an extension of our bodies in that it identifies our location within a

particular part of a particular nation. The home manifests physical and emotional relations and the social and cultural differences that define us. The significance of the home's locale prompts questions such as: 'Does it matter where I was born or where I live now? How are the relationships between identity and place being altered in an increasingly interconnected world?' (McDowell 1997: 4). Here the significance of place is always dependent on specific local issues and the social relationships that influence them. Feminist geography asks questions such as: How do social changes change attachment to a place? How do attitudes change expectations of a place? What are the influential factors? How do they affect consumption and expectations of everyday life? Space has become a construction that is no longer only dependent on geographical features. As we begin to understand the city as an operation that is bigger and more complex than its constitutive parts, we lose sight of the individual and the particular. The city is a combination of effects and influence in which the individual can lose control to a certain extent. Theories can lead us to believe in the power of the city as an autonomous system – as a 'machine'. It is this that feminist thinking has brought back into critical consideration.

As feminism introduces the consideration of subjectivity and in response to environment, postcolonial discourse focuses on the significance of place in relation to power structures and to the negotiation between subject and object. 'Postcolonialism' refers to the consideration of experience following colonialism and has come to represent a political position in response, and a resistance to colonialism. Theorists such as Frantz Fanon (*Black Skin, White Masks*, 1952) and Edward Said (*Orientalism*, 1978) have forced recognition of the implicit powerbase of Westernism and its imposition of culture, politics and society, which are visibly evident in a city's architecture. Postcolonial theories have emphasized a concern for the relationship between the individual self and the negotiation of place in response to history, cultural dominance and diaspora. Said's term 'orientalism' is indicative of postcolonial critiques, which point out dominant ideologies that can be assumed to be the norm in society. It refers to a style of thought based on the distinction between the 'Orient' and the 'Occident', characterizing European colonialism in the nineteenth and twentieth centuries as a Western style for 'dominating, restructuring, and having authority over the Orient'. The romance of foreign places (the Orient) was a European invention and helped to define it by its difference, geographically and culturally. Said points out that 'the Orient' is only an idea – there is no division between 'East' and 'West'. It is a constructed notion, reconfirmed by history, war and religion that differentiates Europeans from those that are 'different'. Cultures and histories are configured

by the processes of power originating from the European ascendency of the Renaissance. Evidence of this hegemony is available to see in any European city's museum, which displays artefacts as 'anthropological', 'ethnographic', 'racial' and 'historical'. These reductive arrangements demonstrate implicit attitudes as emblematic of, or motifs for, whole peoples:

> [Orientalism] is a *distribution* of geopolitical awareness into aesthetic, scholarly, economy, sociological, historical and philological texts; it is an *elaboration* of a basic geographical distribution; it is a certain will or intention to understand, in some cases to control, manipulate, even to incorporate, what is a manifestly different world; it is a discourse that is . . . produced and exists in an uneven exchange within various structures of power.
>
> (Said 2003: 90)

Different academic fields bring different emphases to understanding the city: geography, with regard to the exchange between people and the physical environment in configuring space and place; social sciences, with regard to socio-political encounters and to the impact of global and local processes; feminism with regard to the relationship between identity and locality; post-colonialism in terms of difference and displacement. Different perspectives – physical, social, political – lend a different weight to its description; different ideological revisionings are manifested in stone and concrete (Haussman and Le Corbusier); 'space' and 'city' become metaphors for understanding concepts. Similarly, space and city can be understood variously by assigning different metaphors to them such as network, exchange, encounter or system. Different elements within the city can be defined more precisely by referencing a specific aspect, and can serve as a metaphoric lens through which to view historic change, such as the 'arcades' or 'walking in the city'. Michel de Certeau's chapter 'Walking in the city' [1980] serves to introduce a number of aspects central to this discussion. First, the manner in which the city can be used as a metonym or interlocutor for wider cultural issues relating to the way people live in the city. Second, it introduces the themes of the 'everyday' and the '*flâneur*' both of which are themes of modernity (reinterpreted in postmodernity) and key to the theoretical focus here and the photographic projects that I will discuss in Parts 2 and 3. Third, de Certeau is speaking as if looking down on the city from the World Trade Center in New York, introducing a specific focus that is emblematic of global concerns – and gives an example of how the city can refer to far reaching events, consequences beyond its physicality. The city becomes a kind of anonymous subject – a city of networks, relationships, systems, power

(de Certeau 1988: 94). De Certeau speaks of the city in a lyrical metaphoric way that uses the experience of seeing the city as a means to discuss desire and representation and the blindness of walking the city. His response to the city is immersive – it indicates an equivocation of objective observation with subjective response.

> The ordinary practitioners of the city live 'down below', below the thresholds at which visibility begins. They walk – an elementary form of this experience of the city; they are walkers . . . These practitioners make use of spaces that cannot be seen; their knowledge of them is as blind as that of lovers in each other's arms. The paths that correspond in this intertwining, unrecognized poems in which each body is an element signed by many others, elude legibility. It is as though the practices organizing a bustling city were characterized by their blindness. The networks of these moving, intersecting writings compose a manifold story that has neither author nor spectator, shaped out of fragments of trajectories and alterations of spaces: in relation to representations, it remains daily and infinitely other.
>
> (de Certeau 1988: 93)

The quote above indicates a number of metaphors for the consequences for immersion in city life: 'blindness' relates to an unkowingness or what Bourdieu refers to as interiorization of strategies and process; 'legibility' is analogous with the sort of process we engage in understating our surroundings – one that is distanced and generalized or one that is difficult to see because we cannot see all at once (blindness again); 'poem' and 'story' describes a kind of history or process that can take all sorts of thematic direction that shape the spaces we inhabit; 'looking down below' offers a strange perspective on something familiar, which may lead to a different interpretation.

A conceptual configuration has become a feature of interdisciplinary thinking, particularly in the field of Visual Studies. Irit Rogoff describes the advantage of being able to centre methods of analyses around an issue – a cultural problematic rather than disciplinary traditions or history (1999: 23). This is a similar argument to Mieke Bal's expansive discussion of concepts (*Travelling Concepts in the Humanities*, 2002) which considers any subject as part of a field of cultural analysis. 'Cultural analysis' does not indicate an analysis of 'culture' *per se* but rather the viewpoints from which one looks at one's subject that exist in culture. The cultural 'object' (the city) operates as an interlocutor that can engage with and contribute to the wider cultural discourse (2002: 9). Bal promotes initial exploration of subject-matter without the constraint of any one disciplinary field and demonstrates an

approach that shifts our starting premise by sidestepping direct address to the object or discipline and focusing on the 'concept' and its relation to history and traditions instead. This tactic allows a more flexible encounter with whatever subject-matter is being considered. It is a recognizable feature of Jameson's consideration of postmodernism and Lefebvre's demand to incorporate physical, ideological and social considerations in thinking about space and urbanism. Focus moves from one that gathers statistical facts to one that considers a range of considerations. Instead of an analysis of the product or its quality, Bal's thesis proposes an analysis of the concepts, intentions and effects that impact on, and result from, its making. Concepts are complex, extend beyond clear categories and operate more in the way of framing an object in different ways. Consideration of concepts lends any number of varied dimensions to the city, such as emotional resonance, economic value and bodily experience. In contrast to defining an object or fact, one's expectation of a field is to destabilize traditional limitations. A conceptual field of enquiry is seen as crossing a number of neighbouring disciplines, so that 'knowledge' is more dependent on the interconnections between those disciplines and the relationships between elements of knowledge. If we conceive the photograph as a space of conceptual operation, interpretation cannot be restricted to any one perspective.

Specific theories have influenced urban theory and echo the photographic themes discussed in the following chapters. Photographs can celebrate or critique presiding ideology and privilege. More specifically focused views can adopt metaphoric frames that serve to emphasize particular aspects of experience: the 'institutional city' and the place of power (Chapter 3); the 'everyday city' of the street (Chapter 4); the city of social practice or the site of diaspora (Chapter 5); the 'hybrid or global city' (Chapter 6); the 'engendered city' (Chapter 7); the 'networked city' or the psycho-geographic (Chapter 8). Just as the city can be theorized in different ways, so can it be presented photographically in different ways: geographically – describing the evidence of its economies in the buildings and infrastructures; anthro-pologically in describing evidence of its culture; sociologically in describing examples of interaction. A city is all these things, so that a photograph can also be read from different perspectives (feminist, postcolonial) or with a different focus in mind. 'Space unleashes desire' and photography can express that desire through its supposed transparent access to the real world (Lefebvre 1991: 97). We may imagine that photographs can simplistically illustrate social spaces because they apparently present for us practice in a series of visual evidence. But if we are to be critical we have to be aware of the ways in which depiction can be manipulated (see Chapter 3).

Further reading

Donald, J. (1999) 'Metaphor and Metropolis', in *Imagining the Modern City*, University of Minnesota Press: Minneapolis, pp. 27–62.

Hubbard, P. (2006) *City*, Routledge: London, New York.

Jameson, Fredric (2009) description of Hotel Bonaventure in *Postmodernism or the Cultural Logic of Late Capitalism*, pp. 38–45.

Miles, M., Hall, T. and Borden, I. (eds) (2000) *The City Cultures Reader*, Routledge: London, New York.

Hubbard's *City* (2006) provides an accessible overview of urban theory. It takes a thematic approach, which will amplify some of the issues introduced here. Donald's approach in *Imagining the Modern City* (1999) gives an interdisciplinary perspective on concepts of the city with many excerpts from literature. The chapter 'Metaphor and Metropolis' (pp. 27–62) discusses how images and metaphors shape our conceptions of the modern city. Jameson's description of the Hotel Bonaventure in *Postmodernism or the Cultural Logic of Late Capitalism* (pp. 38–45) provides an example of a city space representing much more – in this case a raft of ideas associated with postmodernism. Miles, Hall and Borden's *City Cultures Reader* is a useful collection that explains the many multi-disciplinary aspects of the city. Its 12 sections are varied and grouped in terms of physical fabric and industry, urban politics and social justice, culture and technology, and imagination and identity.

Further photographs

David Harvey's *Paris, Capital of Modernity* (2003) has a lot of early photographs of the city, including some by Charles Marville (France, 1816–79).

Eugène Atget (France 1857–1927) – *Atget's Paris* (Taschen 2001) provides a good introduction to Atget's visions of Paris at the turn of the century. Museum of Modern Art: http://www.moma.org/collection/artist.php?artist_id=229; George Eastman House: http://www.geh.org/fm/atget/htmlsrc/ATGET_SLD00001.HTML.

Brassai (Gyula Halász, Romania 1899–1984) – Brassai (2001) *The Secret Paris of the 30s*, Thames and Hudson: London; Morand, P. (2011) *Brassai: Paris by Night*, Flammarion: Paris.

Notes

1 The first chapter 'The Cultural Logic of Late Capitalism' of this book was first published in *New Left Review*, 1984.
2 See for example, Roslayn Deutsch (1991) 'Boys town', *Environment and Planning D: Society and Space* 9 (1): 5–30; bel hooks (1994) *Outlaw Culture: Resisting Representations*, Routledge: New York.

3 The Toronto photographer Christopher Dew is employed by architects to photograph shopping malls for promotional purposes. See: http://www.shopping centrephotography.com/.

4 'Place' is generally used to refer to a specific localized space marked by its use, and 'space' as something more conceptual or physical. De Certeau however reverses this and uses 'place' to denote the restrictive and unhomely and 'space' as a form of freedom in which to try new things (Buchanan and Lambert 2005: 3). Yi-Fu Tuan defines 'place' in (2007) *Space and Place: The Perspective of Experience* [1977]: 'Space is transformed into place as it acquires definition and meaning' so that strange spaces become 'neighbourhoods' through familiarity, and spatial order is imposed by means of a grid and the establishment of a pattern of significant places (136). 'Place is a special kind of object. It is a concretion of value, though not a valued thing that can be handled or carried about easily; it is an object in which one can dwell' (12).

2 Photography concepts

This chapter outlines the recurrent photographic themes of 'objectivity', 'document', 'truth' and the 'everyday' that originated in the early days of photography's development, and indicates their significance for the interpretation of cities. It introduces key issues for the analysis of photographs and how they engage with ideas. In this chapter I focus on more formal considerations and the application of semiotics to the interpretation of photographic meaning, the way we 'read' images and respond to them and the assumptions we make as a result of what we imagine photographs do. Because photography's historical influences emerge in Europe and the United States, I use Eugène Atget and Lewis Hine as two key examples whose subject-matter consistently centred on the city.

Transparency and mediation

Eugène Atget's reference (1926) to his photographs as 'simply documents I make' provides focus for the complex issue of photography's supposed ability to mirror the world. Photographs are commonly understood to tell the truth, as they must make reference to what appears as reality.[1] Atget assumes that photography can be depended upon to give an authentic record of the world in front of the camera. And to a degree it can, but it is not a 'simple' operation. Much of the debate about photography's objectivity centres around what is seen as most important in a photograph – the subject-matter depicted or the significance of the photograph as a representation. Atget's statement assumes the simple transparent act of documenting the world. The conception of the photograph as 'transparent' results from our ability to imagine beyond what is in front of us – we 'see through' an image to what is referred to by that image – so that we might say, for example: 'This is my house' when it is in fact a photograph of my house. Some contend that it is the photograph's

BOX 2.1

Formal analysis

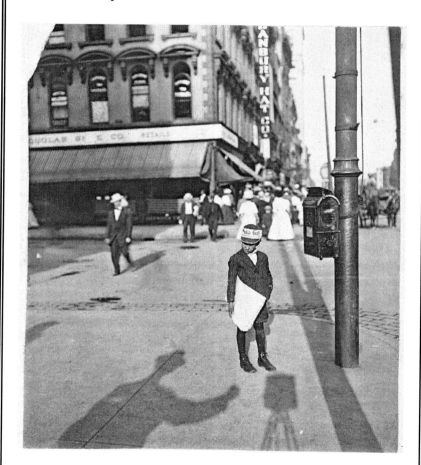

Figure 2.1 Lewis Hine, *Self Portrait with Newsboy*, New York City, 1908. Gelatin silver print image (irregular), 13.8 × 11.8 cm (5 7/16 × 4 5/8 in.). The J. Paul Getty Museum, Los Angeles.

First, it shows a street scene and what appears to be an ordinary day – people going about their business – shopping, working. The formal structure of the photograph, in terms of line, shape and division within the frame, is dominated by the position of the lamp post: the lamp post, and what looks like a post box or litterbin fixed to it, is a focus to the

right of the photograph and suggests the established infrastructure of a city. The lamp post too provides a strong vertical frame to an increasingly dispersed scene to the left. The background features are out of focus so that the photograph imitates the eye's vision, with its focus on the central figure. The focal interest of the photograph is the newsboy standing to the left of the lamp post, accentuated by the post and by the contrasting white dresses of the women walking away behind him. He looks sideways at the photographer from beneath the rim of his peaked cap advertising 'Celery-Cola'. He is wearing long leather boots, his left hand is in his pocket and he holds the newspapers under his right arm. He appears at ease with what presumably is not an everyday event – that of a photographer with camera, tripod and trigger mechanism. We know this because, to the bottom left of the image, we see the shadow of the photographer himself with hat, overcoat and arm outstretched pressing the shutter release.

Lewis Hine's approach displays a confidence with his role as photographer as he assumes the right to stand before strangers in a street and 'take' a photograph. He is not concerned at this time with notions of power and agency, which are to develop as a debate later in the century. He assumes that a street scene will be of interest, but that a central figure will add significant and necessary focus – perhaps because of their occupation or individual character. Hine displays an attitude of humour in the inclusion of 'self portrait' – his shadow – in the resulting image. The apparent casualness of the boy's pose is significant as it distinguishes an attitude that regards a more realistic impression will result from a chance encounter and natural expression found in the street, than from the more formal preparation characteristic of the studio.

transparent rendition of the world that sustains interest and not the artistic sensibility in representing it. This point of view sees photographs as lacking any meaning beyond their reference to interesting subject-matter. But to refer to the photograph as transparent ignores many of the factors that exist between the 'house' as it exists and the photograph that is testament to its existence.

In terms of its production, a photograph is made with some intention that will dictate its meaning, even if it is casual and seemingly purposeless. This can include formal aesthetic concerns, or the purposes of persuasion, deception, emotion, nostalgia and so on. Even without commentary, the choice of subject-matter will describe attitudes in themselves and the frame

will betray an affiliation with particular photographic philosophies, so that the content can point to or make use of irony, sentiment, spectacle or revelation. Photographs will implicitly display the photographer's motives. Knowing a little of Hine's other work and writings will suggest that his motives may be social or political (much of Hine's work was originally published in a journal devoted to social welfare); whereas Henri Cartier-Bresson's attitude gave emphasis to the photographer's ability to recognize the most revealing moment in which to press the shutter. Cartier-Bresson's 'decisive moment' [1952] describes the collision of the transitory, objective moment with the photographer's subjective vision, so that it is the 'photographer's vision' that becomes central:

> Sometimes you have a feeling that here are all the makings of a picture except for just one thing that seems to be missing. But what one thing? . . . You wait and wait, and then finally you press the button – and you depart with the feeling (though you don't know why) that you really got something.
>
> (Cartier-Bresson 1981: 385)

At its birth, photography was thought to show the truth by providing us with the empirical evidence of our own eyes and therefore replacing the subjectivity of painting. Victor Burgin's *Thinking Photography* (1982) features a number of theorists such as Simon Watney, John Berger, Allan Sekula and John Tagg, all of whom expose the notion of transparency as a fallacy. A photograph's meaning cannot be separated from its discourse or its spatial or temporal context, which are interdependent (Sekula 1982: 84–7). Photography is analogical rather than structural because it resembles the world, and yet its meaning is always ambiguous. Berger, for example, questions the degree to which photographs can record definite fact, and further states that facts do not constitute meaning because one photograph can lead us to completely different meanings. Photographs are 'culture's constructions', which, he says, quote from appearances and so their truth can only be limited and cannot be relied upon. And when photography lies, it can appear truthful and so lies very well [Berger and Mohr 1982: 97]. Berger distinguishes three uses of photography: scientific, political and communication but points out that, because the three functions are generally conflated, the notion of truth is oversimplified [Berger and Mohr 1982: 100]. Different kinds of content require a different order of truth. If used as a means of communication, the nature of 'truth' becomes subjective and complex. If no distinction is made between communication and politics, no distinction is made between differ-ent kinds of truth. His analysis exposes the photograph's 'naturalness', and

transparency, as a myth. The photographer's interventions at the outset insert too much mediated content for the photograph to be used as a literal message; if it is a form of communication, it is by no means simple (Barthes 1977: 44). In Chapter 3 I will return to consider the cultural, social and political influences that govern our reading of images and the consequences for attitudes to photography.

Our response to the photograph will be dictated to some extent by physical properties – its size, its condition, its placement and presentation – its formal qualities – spatial organization, light and dark, contrasts of texture – which will in turn have been dictated by the purpose in the production of the image. Its subject-matter, which refers to the world somehow, will be understood by the viewer in different ways. The photograph, or any representation, will always mediate what is depicted. In the simplest terms, the two-dimensional photograph frames, and thereby abstracts, one fragmented view from a complex four-dimensional experience. And the manner in which this is done follows conventions. Photographs adopt a style according to their purpose – for example, an urbanscape for the purpose of promotion or a photo-journalistic survey of living conditions for the interests of social welfare – so that, in recognizing the style or genre or mode of presentation, we will respond in the manner we have learnt from seeing previous examples of that genre. A glossy black and white photograph in a beautifully produced book of 'Skyscrapers of New York' will invite us to admire each photograph in those terms and to comment on the examples of modernity they represent or the contrasting tones and shapes that the photograph amplifies.[2] Further, if the context is one of architecture, we will focus on the structure and style of building, its characteristics and the different features, which distinguish it from others. If its context is tourism and travel, we may respond to the desirability of location and our consideration of what it might be like to visit it. We can determine the style of the photograph and thus the school of thought – the institution to which it belongs, such as art or advertising or journalism. And once this is identified, it is difficult to respond without reference to the traditions of that genre. In addition, subject-matter pre-empts our understanding by more analytical means.

Analysis

Roland Barthes describes the photograph as always contingent on the facts that it presents (Barthes 1993b: 28–9). In Hine's photograph, what people are wearing and the style of the shop fronts indicate an approximate era and

a city location. People's demeanour or haircut will indicate perhaps the status a person might have and clues can be found in the slightest gesture. The photograph is a 'text' that can be interpreted and reinterpreted depending on cultural location, historical circumstances and invested interest. The meaning of a photograph depends on context, intention and knowledge and can prompt different interpretations, as we see with Appert's (see Box 2.2: 'The photograph and deception'). Knowledge of context will change response, so that when we are told that the newsboy's name is John Howell, an Indianapolis newsboy, who in August 1908 earned 75 cents some days and who began work at 6 a.m. on Sundays and lived at 215 West Michigan Street, we look more closely for signs that distinguish him as an individual rather than a 'type'. I might look at an image with no knowledge of the significance of street name, and focus on the particular look of the central figure's face and gesture. At another time, I might have looked at that same image, having been to that location and therefore look for the familiar signs that I might recognize. Or I might be aware of the significance of location in terms of its history and therefore the focus might lie beyond the image itself and more on what it represents – what I might notice is the irony or poignancy that the particular contrasting elements present and juxtapose. For example, an early photograph of New York gathers a sinister resonance since 2001, if we know that it was taken close to the area we now call Ground Zero.[3] So there are three perspectives: the framing of the photograph and the 'facts' it presents; the choice, purpose and context of the selected frame; the context and perspective with which we view and approach interpretation. My projected position as the viewer is determined by my physical location in relation to the image; an aerial view simply forces me to look down. In contrast, the subject might be viewed from below, which forces a very different attitude – that of physically 'looking up' and by implication 'looking up' to something greater than myself. These apparently simple physical positionings can disguise a complex mesh of power relations, which we may not notice ordinarily. All photographs force the viewer into some position – they are deceptively persuasive. The same photograph can be approached in different ways. The subject itself tells one story and the choice of subject and how they are photographed tells another. In general terms, our response to a photograph is influenced by our knowledge and experience at the moment we look at it.

The development of a sustained and critical analytical reading of photography developed from the 1970s. Here in 'Looking at Photographs' [1977], Victor Burgin, who was instrumental in this process, borrows from film theory in effectively describing the power relations involved in 'looking':

Our conviction that we are free to choose what we make of a photograph hides the complicity to which we are recruited in the very act of looking . . . we may identify four basic types of look in the photograph: the look of the camera as it photographs the 'pro-photographic' event; the look of the viewer as he or she looks at the photograph; the 'intra-diegetic' looks exchanged between people depicted in the photograph; and the look the actors may direct to the camera.

<div align="right">(Burgin 1982: 148)</div>

The possibility of 'reading photographs' derives from semiology – the study of signs and their meaning – which owes its development to adaptations of Ferdinand de Saussure's theories of signs, *Course in General Linguistics* (1916) and Charles Sanders Peirce's *Collected Writings* (published posthumously 1931–55), which each contribute a different emphasis to understanding meaning production. Saussure's model has two elements (*signifier* and *signified*), which together constitute the *sign*. It does not have a term for what is in the real world and therefore emphasizes that representation is not to be confused with the real world and can only be constructed. The physical *signifier* provokes a concept in our mind; it establishes the arbitrariness of the relationship between the *signifier* and the concept it refers to; it points to how one sign readily leads to another in a chain of signification. This importantly indicates that the production of meaning is dependent on locality and the cultural context in which it appears. Hine's street scene signifies not only New York culture at the time but a whole history of photographic tradition – as an early example of 'street photography'. Peirce's model has three elements: *representatum* (the photograph), *interpretant* (the sense or meaning in the photograph) and *object* (what is referred to in the real world – the *referent*). This model does not assume that meaning is linguistic and emphasizes the relationship between its three elements and how they generate meaning in visual representations. Peirce identifies a complex system of interrelating classifications defined in terms of the kind of relation between the sign and object. *Icon, index* and *symbol* are the most commonly referred to: *icon* refers to a relationship that depends on some sort of resemblance or similarity, so that a photograph of a person, a 'portrait', is an *icon* of that person. *Index* refers to a factual or causal relationship between *sign* and what is *signified*, for example, smoke is an *index* for fire. The frequently used term 'indexical' refers to the physical and causal relationship between light and the photographic image. A *symbol* is a *sign* that is conventionally or culturally recognizable as such (e.g. in 1908 the sort of hat worn symbolized the status and occupation of the person wearing it).

Different forms of analysis, using different terminologies, have been applied to photography, each contributing to our understanding of the difference between resemblance and representation, between looking at and interpreting an image from looking at the same object in the real world. Roland Barthes's earlier essays extend Saussure's semiology, particularly in terms of what is referred to besides the literal aspects of the photograph. For example, 'The Photographic Message' [1961], 'The Rhetoric of the Image' [1964] and 'The Third Meaning' [1970], distinguish aspects that indicate facts from aspects that impart quality, and between the photograph's reference to real things and its rhetoric – that is its treatment, its genre and its aesthetic frame. Above all he establishes that the photograph is not free from values and thereby cannot be transparent, despite it appearing to be so. Barthes uses models for the many levels of signification in an image, from informational to symbolic: *denotation* refers to what is discernible as informational meaning – the objects referred to, the focus of the image, the formal facts of position, lighting and shapes; *connotation* is more 'obtuse' and refers to the historical, ideological and cultural, symbolic meaning dependent on cultural knowledge or relating to a particular genre: reportage, landscape or family snapshot. Barthes identifies a third level of meaning that confronts the paradoxical nature of the photograph due to there being no equivalence between sign and concept as there is with language. Thus John Howell's hat denotes the generic concept of 'hat' as well as connoting its cultural location and the very particular manner in which it is worn. Barthes asserts that the photograph is a 'rhetoric' that depends on the relationships between countless elements. His discussion introduces questions about photographic signification that are useful today: How do we read a photograph? What do we perceive? In what order? How does meaning get into the image? Where does it end? And if it ends, what is there beyond? (Barthes 1977: 28, 49). With this in mind, I use the term 'reading', not because the photograph can provide a precise meaning, but because photographs require the reader to be more actively engaged than 'looking' passively.

Extreme forms of structural analysis suggest we can *learn* how to interpret images, because they are not natural, but culturally coded, and therefore are a readable language and decipherable. Umberto Eco [1970] responds to Barthes's discussion of the 'rhetorical' nature of the image as possessing countless elements, and proposes an extensive categorization of *rhetorical codes* itemizing different functions within the photograph, explaining the ideas of metonym, metaphor, the value and layers of meaning and demonstrating the enormous complexity of implication available to photographs. Further to this, John Tagg argues that a photograph is not a mysterious phenomenon

that satisfies existential desires, but can be explained by means of history and the specific context in which it is found. His approach is not one of assessing the image aesthetically, but in terms of its cultural value and what it tells us about the referent. Tagg emphasizes the photograph's ideological existence as a material object and as a historically specific social practice. When we deal with photography as ideology, we are not dealing with something 'outside' reality (Tagg 1988: 188). We need to ask how subjectivity is incorporated and to what degree that subjectivity is self-conscious and deliberate. This thinking prompts questions such as: If this is not a transparent picture of the world, what is mediating it? What knowledge (e.g. political situation) would it be useful to have to understand it better? (1988: 3–4). Tagg explores the photograph as culturally dependent, whereas Berger and Barthes's later work describe the photograph's ambiguity and contradictory aspects: the enormous difference between what is realistically depicted and the figurative significance (as in metaphor and metonym) potentially available to us when looking at a photograph [Berger and Mohr 1982: 87]. In complete contrast to Tagg, and to his own earlier structural analyses, Barthes's last book *Camera Lucida* [1980] describes in detail his subjective response to photographs. He uses the term *punctum* to discuss the wholly qualitative element that inserts potency in a photographic image. Fundamentally, *punctum* can be an entirely personal recognition, provoked by a singular experience of an apparently insignificant detail, which confronts each of us differently. Its characteristics are not part of the image that are coded or explicable, and supplement the more culturally recognizable signs in an image, which he names *studium*. Barthes's 'sensitive' or sharp little point characterizes the condensation of meaning to be found in chance elements that are provoked by incongruity, irony or repellence or which invoke a sense of place or 'a kind of tenderness' (Barthes 1993b: 43). As such, *punctum* is unlikely to be a result of the photographer's intention and arrives by accident, not artistry; we cannot identify it precisely or point to it as a substance or 'thing'. The newsboy's hat gathers a number of elements – the sideways tilt of the head, his mouth slightly open – it is endearing because it gives him a jaunty air, whilst an incongruity points to a wholly different world of capitalist enterprise of which the boy would likely not have understood. The *punctum* amplifies the photography's power of metonymy – its capacity to present a part of something that points to much more beyond what is shown (and a photograph is always only a part of its referent). Barthes's approach relies on the notion that the photographic reference is 'haunted' by the referent, which follows the image in its absence and reverberates, so that in his terms, metonymic reference inhabits the object's absence and it is the uniqueness of its having-been-there that lends it its poignancy.

Whilst his early writing added to the structural analysis of images, Barthes was consistently concerned to expose the role that culture plays in our understanding representation and is therefore attributed, along with Jacques Derrida and Michel Foucault, with contributing to a post-structural alignment of thinking. Post-structural and postcolonial thinkers of the 1960s–80s introduced the reading of culture (including the visual) as text, and redefined thinking in a way that questioned traditional attitudes to subjectivity and representation. They challenged aspirations for absolute truth and rationalism by incorporating consideration of difference (race, gender, class), the irrational and the mutability of the subject. Barthes thereby suggests the impossibility of grasping the image in any immediate sense (i.e. transparently) and that, rather, it is immersed in cultural connotation and mediated by ideological and aesthetic values. He suggests that analysis of photographic codes, which may appear as 'trans-historical' or obvious, can tell us more about the society in which they are found than the specific elements may suggest. The criteria that we use betrays what is important to us; for example, the formal rituals of portraiture in the late nineteenth century tell us that demonstrating an awareness of modern technology (photography) and status was an aspiration. As the photograph is always subject to the constraints of context and time, it is unlikely that we could ever establish a complete inventory of distinctive elements or available meaning. Just as society changes, so signification within that society develops and changes so that 'photographic language' depends on the reader's knowledge at any one time (Barthes 1977: 27).

The way that we look at and talk about photography is driven by the cultural context, ideology and the language we use. Photographic practice inherits conventions, and derives as much from discussion about it as from the work itself. The history of photography persistently confirms values that are dependent on the equivalence of its physical properties with documentary truth and the photographer's integrity. Commentators follow each other's conceptions of photography so that, for example, the assumed necessity to capture someone's essential character in a portrait has been constructed by previously stated principles. Any current convention will dictate emphasis, purpose and expectation, which will be defined in turn by that genre. Our understanding of photographs will be dependent on the manner of previous descriptions and the philosophies that dictate the thinking of the time. Michael Baxandall (1985: 1–11) gives examples of two very different ways of describing pictures: in the fourth century Libanius focuses on the information evident in the subject-matter rather than the style or quality of painting; in 1951 Kenneth Clark describes the manner of representation and the effect which it has. Each explanation of a 'picture' (or photograph or genre) becomes part of our

BOX 2.2

The photograph and deception

David Harvey (2003: 308) describes the Paris Commune as perhaps the most extraordinary event in capitalist urban history. The political unrest of 1867–71, the war and siege of Paris by Prussia and the ultimate defeat of France resulted in the formation of a monarchist government by Adolphe Thiers. When the government in Paris negotiated a deal with the German Empire in 1871, the working people of Paris supported by the National Guard seized the canons, which the French army had been sent to remove. Ordered to fire on the crowd by General Lecomte, the soldiers raised their rifles and fired into the air. Generals Lecomte and Thomas were taken away and shot by the Communards.

Gen Doy's essay 'The Camera against the Paris Commune' presents evidence of the myth of objectivity by relating several ways in which the photograph was used to 'document' the activities of the Paris Commune with deliberate deception. In 1871, photography presented

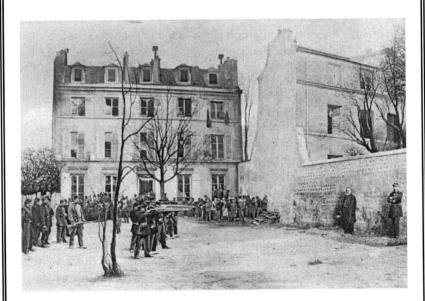

Figure 2.2 Ernest Eugène Appert, *Faked photograph of execution by firing squad: Crimes de la Commune.* Gelatin silver print, 1871.
© **Victoria and Albert Museum, London.**

contradictory opportunities. Whilst thought of as objective and democratic, the limitations of the technology at the time prevented the possibility of any spontaneous record being made. The elaborate preparation involving wet plates resulted only in either delayed record or the necessity of reconstruction of momentous events. Because the appearance of photography belied its construction, the process facilitated deception. Doy describes the cover of *The Illustrated News*, June 24, 1871 in which 'a photographer attempts to photograph the scene as firemen try to extinguish the flames which have already destroyed the building. The photographer stands in the midst of the chaos, accompanied by his young assistant who holds the plate ready for him. Neither the firemen nor the homeless mother and child in the foreground pay any attention to him. The "objectivity" of the camera in this case suggests its invisibility, or perhaps even its irrelevance' and could be deliberately manipulated (Doy 1979: 15).

Doy itemizes a series of photographs composed from a number of negatives that purported to show events as they 'truly' existed, but which were used for propaganda purposes. Eugène Appert (1814–67), a photographer working in Paris, was made welcome by the Communards 'eager to pose for posterity on the barricades and ruins'. Appert's photograph of the killing of the two Generals – Lecomte and Thomas – was designed to demonstrate the Communards' brutality (Doy 1979: 19):

> Appert's 'faked' photographs look so obviously propa-gandist to anyone who knows the background to the events they depict that it is difficult to imagine that they were accepted as faithful recordings of actual incidents. However it may be that the political stance of the people who bought such prints made them want to believe the reality of what they saw depicted, even if they realize the images had been manipu-lated. Also, given the relationship of photography to other visual media available at the time, it may be that contempor-aries in a materialistic and positivist age were not inclined to question apparently transparent mechanisms of understanding visual images which were mechanically recorded. The status of the photograph at this time is an intermediate one. It can, at the same time exploit and negate the myth of its perceptual innocence, its 'democratization' of what it records.
> (25)

The artist Mark Wallinger curated an exhibition at the Southbank Centre, 2009, which explored 'thresholds between physical, political or metaphysical realms' and included this same image by Appert. The commentary lends a very different slant from that of Doy's:

> This supposedly documentary photograph is not what it seems. A composite image, created in the studio from other photographs, it was made in the wake of the Paris Commune of 1871. It purports to show the assassination of two French generals, and was intended to discredit the communards. But in fact the generals were not executed together. They were shot one after the other, and not by a single volley of gunfire, but military-style, with each rifleman taking a shot in turn. Paradoxically, the truth was worse than the crime the manipulated photo aimed to show, since it took 15 rounds to kill the elderly general.
>
> (http://www.southbankcentre.co.uk/minisite/ mark-wallinger-curates/exhibition/)

Commissioned to document Haussman's regeneration of Paris (*Travaux (Public Works)* 1876–77), Charles Marville's photographs provide a more subtle example of photographic deception than Appert's in which his use of a landscape frame and precise perspective emphasized the grandeur of the new boulevards. Visually persuasive, if not quite propaganda, the photographs presented compelling evidence of rational progress and justification of the modernist urban development envisaged by Haussman:

> The emphasis placed on the bright and hygienic aspect of the new Paris was reinforced by the display also of Marville's photographs of the city's new streetlights and public urinals. By contrast the squalid back streets . . . are executed in portrait style, thereby emphasizing their narrowness and darkness. Marville is even known to have sprayed the cobblestones in these old streets and alleyways with water in an attempt to render them unsanitary in appearance.
>
> (Wilson 2005: 57–8)

perception in subsequent encounters, which in turn dictates our response. As we explain the characteristics of a photograph within the context in which we define it, the description justifies previous descriptions and the process becomes self-perpetuating, so that it is difficult to distinguish between what we think we see and the knowledge we have of it. Interpretations can be seen to be implicit in the use of language. Mieke Bal (1998: 79) describes interpretation as being embedded first in the image and then in the language describing the image. If we look carefully at the adjectives that are used to describe facts, or the adverbs that are used to describe actions, we can see what is important to the writer. In describing Hine's photograph above, I tried to objectively outline what was there before me and to eliminate qualifying adjectives and adverbs. But I use the term 'ordinary', thereby establishing an approach to understanding what sort of image it is. I use 'strong, vertical frame' and so suggest that some visual statement is required in a photograph based on my previous knowledge of 'good' photographs, and 'increasingly dispersed' suggests an expanse, which is weaker and does not hold my attention. My description of the boy as 'at ease' is a subjective appraisal, gained largely from my intuition and the clues of gesture and stance provided. My supposition that this is not an 'everyday event' confirms a distinction between 'everyday' and 'extraordinary' as possibly being some sort of marker for genre, as does my preliminary observation that categorizes it as a 'street scene'. In similar fashion, descriptions and titles that accompany a photograph can colour how we read it.

'Simply documents'

The assumption that photography can document and thereby tell a kind of truth has lent its history an ongoing relationship with the photographer's 'objectivity' or 'subjectivity', which has led to a series of subsequent philosophies determining the role of the photographer's distance from, or commentary on, what is being photographed. The physical properties of photography that determine its nature (its ontology) drive the attitude of engagement and intention in its traditions. Early historical development of the photograph relied on these properties and process, which are mechanical and chemical (i.e. scientific) and thereby assumed to be objective and a reliable source of evidence. The photographic debate originating in its ontological relation to science and light prompts attitudes to photography. Understood as the 'Pencil of Nature' [William Fox Talbot, 1844] and thought of as having direct access to the essence of things, initiates the themes of 'true' and 'essential' very early on:

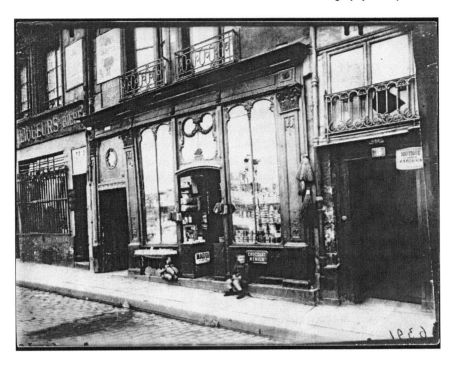

Figure 2.3 Eugène Atget, *Shop front of Courone d'or, Quai Bourbon, Paris,* 1922. Gelatin silver print. The Metropolitan Museum of Art, David Hunter McAlpin Fund, 1962 (62.548). © The Metropolitan Museum of Art.

> If we imagine the distinctness with which an object is reflected in a positively perfect mirror, we come as near the reality as by any other means . . . the variations of shade and the gradations of linear and aerial perspective are those of truth itself in the supremeness of its perfection.
>
> (Edgar Allan Poe [1840] speaking of the daguerrotype in Trachtenberg 1980: 38)

In a radio broadcast [1931], the photographer August Sander assumes an uncompromising stance in the belief of photography as true and demonstrates a faith in the universality of the natural sciences and the transparency of photographic representation:

> Today with photography we can communicate our thoughts, conceptions and realities, to all people on the earth; if we have the date of the year we have the power to fix the history of the world . . . No language on earth

speaks as comprehensively as photography, always providing that we
follow the chemical and optic and physical path to demonstrate truth . . .
('Photograph as a Universal Language', trans. Anne Haley,
Massachusetts Review, Vol. XIX, No. 4, Winter 1978,
pp. 674–5 quoted in Sekula 1984: 84)

Photography's alliance with reality via scientific, and thereby 'natural' means,
initiates the subsequent debate as to whether the photographer should aim
to present as realistically and 'simply' as possible, or to present ideals
and commentary. This debate is coloured by a simultaneous concern with
photography's status as art, which is unavoidable, but not a focus of this
book. Christopher Phillips's *Photography in the Modern Era* (1989) collates
a range of idealistic views from the beginning of the twentieth century,
concerning how photography could (and should) be used. For example, Lazlo
Moholy-Nagy [1927] asserts a purity that derives from photography's unique
properties:

> The fact of photography does not grow or diminish in value according to
> whether it is classified as a method of recording reality or as a medium of
> scientific investigation or as a way of preserving vanished events, or as
> basis for the process of reproduction, or as 'art'. The photographic process
> has no precedent among the previously known visual media. And when
> photography relies on its own possibilities, its results too, are without
> precedent . . . the first and foremost issue is to develop an integrally
> photographic approach that is derived purely from the means of the
> photograph itself. . .
>
> (Moholy-Nagy in Phillips 1989: 83)

The proclamations expressed in Phillips's collection consider what photog-
raphy could bring to our understanding of the world – whether it should
'simply' document or whether it should be used for aesthetic or political ends.
By 'aesthetic' I mean a self-referential concern for the formal qualities of the
photograph, such as light, contrast, composition, dictated by the photographer's
methodology. Most significantly for this discussion of the portrayal of urban
life, the collection of contested views demonstrates photography as never
simple and highlights the developing division for its use as high art or as a
tool for social engagement. Different avant-garde positions move between
the extremes of aesthetics and utilitarianism: sentiment and politics; formalism
and cognition; fetish and fact; art and utility. Principally, *Photography in the
Modern Era* identifies the establishment of opposing principles for photog-
raphy that centre on whether it should be used – to inform – to persuade –
to criticize – to expose – to exploit the technical capacity of photography for
aesthetic ideals or for the purposes of ideology.

Confirming a major feature of photography to expose the significance of the ordinary and the 'everyday', much commentary celebrates the potential of the photograph to 'teach us to see' (Louis Aragon [1936] in Phillips 1989: 75); it is the task of the camera 'not to imitate the human eye but to see and record what the human eye normally does not see' (Ossip Brik [1926] in Phillips 1989: 219); to show 'familiar things in a way that forces us to ponder them more deeply' (El Lissitsky [1926] in Phillips 1989: 226). Alexander Rodchenko [1928] indicates a direction, which aims to 'revolutionize' visual thinking through photography in order to shake up habits of perception (Phillips 1989: 256). His attitude concentrates on the physical possibilities for using the camera – often translated in terms of camera-angle and the use of unusual viewpoints in order to expand the 'conception of the ordinary everyday object' 'as if encompassing' it (247). The sharply focused quality of Albert Renger-Patzsch's photographs represents the *Neue Sachlichkeit* ('new dispassion'), and a concern for emotional distance in the photographer's attitude, which venerates the notion of an 'objectivity' by means of 'pure' photographic form (Renger-Patzsch [1927] in Phillips 1989: 105). Renger-Patzsch's images of industrial production find beauty in modern technology's mechanical forms and machines. In America, Paul Strand explores objectivity via a precise observation of simple objects and a belief in their potential to display poetic qualities. He asserts [1917] that the photograph's strength is its purity and objectivity: 'This is an absolute unqualified objectivity . . . the very essence of photography, its contribution and at the same time its limitation' (Strand 1980: 141–2). This principle of a modernist vision – the 'new objectivity' in Europe, and what becomes known as 'straight' photography in the United States – aims to avoid painterly effects or pretentious authorial expression, and to assert a photographic integrity that adopts the most direct approach.

Beyond its capacity to document the appearance of things, photography is assumed as a tool for ideological means and a 'weapon of revolutionary struggle'. The Czech artist Karel Tiege [1931] desires a photography that accomplishes 'documentary, reportorial, scientific, pedagogic, propaganda and agitational tasks', as opposed to one that excludes itself from social life by aspiring to emulate painting: 'photography is a service, a helper to science, civilization and culture . . .' He extols the efforts of Soviet photography to 'know things as they are!' (Tiege in Phillips 1989: 319–21). In these terms, photography was believed to be a potential source of real evidence and, as such, 'art' is seen as indulgently dependent on the artist's expression. But a realism tasked to serve utilitarian ideals, as championed by the Association of Artists of Revolutionary Russia (AKhRR) [1922–32], is decried by the

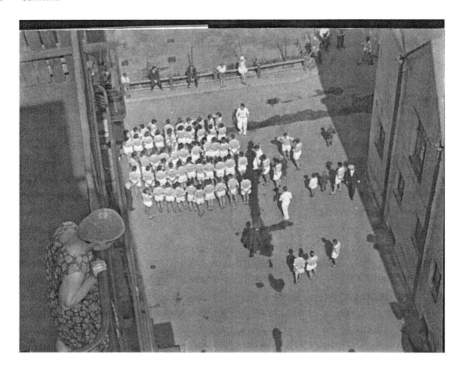

Figure 2.4 Alexander Rodchenko, *Assembling for a Demonstration*, Moscow, 1928. Gelatin silver print, 19 1/2 × 13 7/8 in. (49.5 × 35.3 cm). © Rodchenko & Stepanova Archive, DACS, RAO, 2012. © Digital image 2012, The Museum of Modern Art, New York/Scala, Florence.

October Photo Section [1931] for turning towards 'the interminable sickly sweetness of smiling heads, jingoism in the form of smokestacks, tedious workers with hammers and sickles' (Phillips 1989: 284). The October Photo Section (included El Lissitsky, Rodchenko, Sergei Eisenstein, Varvara Stepanova) proclaimed that, if photography was to speak ideologically, it had to separate itself from 'art' and the traditions of autonomous painting. They preferred to use the term 'photo-worker' than artist, and advocated the methods of 'political literacy, sophisticated, photo-technical literacy'. And in contrast to Renger-Patzsch or Moholy-Nagy, they see the notion of a 'new photography' as a 'pure art form' and the aesthetics of the abstract, as displaying 'false pathos and old bourgeois stereotypes':

> For the photo-worker, only the concrete participation in industrial production guarantees the social significance of his work . . . we are for a

revolutionary photography, materialist, socially grounded and technically
well equipped, one that sets itself the aim of propagating and agitating for
a socialist way of life and a communist culture.

(October Photo Section in Phillips 1989: 284)

In these terms, photography must be linked to production and avoid degener-
ating into a 'nice little technical aesthetic school'. Interesting dichotomies
develop between a photography that can express ideas and be effective, and
one that is merely self-referential and decorative, and between an attitude that
holds a certain reverence for the photographer who is assumed to be able to
put subjectivity to one side, and one that insists on the photographer's artistic
expression that transforms the world for us.

Walter Benjamin's essay 'The Work of Art in the Age of Mechanical
Reproduction' [1936] confronted both the photographer's aesthetic starting
premise and the consideration of political issues resulting from its use. His
influential discussion of the loss of the unique factor (aura) in a work of art
establishes a critical issue resulting from 'the first truly revolutionary means
of reproduction' – the photograph. He discusses the photograph's peculiar
phenomenological capacity to present us with something past – its 'uniqueness
and duration' (Benjamin 1980: 210). However, in response to the belief that
photography does not need supplementary commentary, he warns of the
dangers of removing the photograph from context and that a photograph
without verbal commentary has the power to infer something very different
from the social reality of a situation. Speaking about the difference between
reality and the representation of reality, he quotes Bertolt Brecht's example
that an apparently objective photograph of a factory will reveal almost
nothing about what goes on, socially, morally and economically, within that
institution (Benjamin 1980: 213). On the other hand, photography provides
the social function of making images more available to the masses, because
it is so easily reproduced. From a photographic negative, for example, one
can make any number of prints, so to ask for the 'authentic' print makes no
sense. Instead of being motivated by the ritual conventions of making
'authentic' art or artistic expression, photography has the capacity to be
founded in other principles such as politics. Benjamin's critique highlights
the social function of art and importantly indicates a division that perpetuates
– between the commercial and social and between politics and aesthetics. He
points to the significant impact that the introduction of photography has on
the desire for authentic originality in art practice. And because the criterion
of authenticity ceases to be important for photography, its potential becomes
something else other than compositionally beautiful. The potential that

BOX 2.3

Eugène Atget: author and interpretation

In contrast to the earlier works of Charles Marville, commissioned to document the districts that were to be demolished in the regeneration of Paris (see Box 1.1), Eugène Atget focused on fragments and detail that in a way sidestepped the modern metropolis:

> Atget almost always passed by the 'great sights and the so-called landmarks'. He did not, however, pass by a long row of boot lasts; or by the Parisian courtyards where from evening until morning handcarts stand in rows and groups; or by the uncleared tables and uncollected dishes, which were there at the same time by the hundreds and thousands all over; or by the bordello at No. 5 Rue . . . whose gigantic five appears in four different places on the building's façade. Most noticeably, almost all of these pictures are empty.
>
> (Benjamin 1980: 210)

This contrast in approach clearly demonstrates the intervention of authorship in the mechanical process of the camera. Marville was of a school that saw photography as something to be controlled in order to achieve the desired effect. Space and perspective were handled with skill:

> Architectural photography depends almost exclusively on the photographer's ability to control perspective in order to locate mass in its spatial context and to structure the composition. Baldus, Marville, and Collard carefully chose the positions for their camera to maximize the power of the lens to reorganize parallel lines so that they appear to converge in the distance.
>
> (Naef 1995: 62)

Atget's photography of Paris during the late nineteenth and early twentieth century represents more than a document of streets, buildings and parks. It depicts a period at a time when Paris was at the heart of European culture. And yet his pictures ignore the more grandiose pretensions of modernity and industry, and focus on details of Old Paris. Championed by Man Ray and the Surrealists, and later by Walter Benjamin, his photographic style is out of step with the composed

and conventional architectural photography of the time. Benjamin [1931] describes Atget as using the city's physical fabric as a backdrop for the life of the people living there. He looked for what was unremarkable and forgotten in a way that worked against the exotic or romantic and celebrated the messy and incidental aspects of everyday

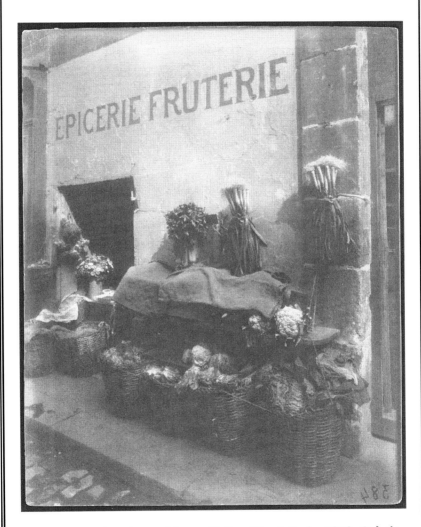

Figure 2.5 Eugène Atget, *15, rue Maître-Albert*, Paris, 1912. Gelatin silver print. The Metropolitan Museum of Art, Rogers Fund, 1991 (1991.1233). © The Metropolitan Museum of Art.

life. He ignored the 'great sights and so-called landmarks' and photographed from the perspective of standing in the street rather than attempting all encompassing panoramas displaying architectural features. His simple and straightforward style is consistently cited as an example of the pure straight photography, which became the norm for photography and a model for later photographers such as Walker Evans.

The book *A Vision of Paris* (1963) juxtaposes Atget's photographs of Paris alongside various extracts from Marcel Proust's *Remembrance of Things Past*, which recalls in minute detail the significance of relationships and sensations. Trottenberg describes both their responses to life in Paris at the turn of the century as if:

> It was a vast stage setting, which not only provided a proscenium for the actors but in many cases provided the visual stimuli for their movements. *Remembrance of Things Past* is concerned with people and the significance of their relationships, and much of Proust's microscopic examination of these relationships is colored and in part motivated by his exceptional sensitivity to the visual world. This same sensitivity characterizes the work of Eugène Atget, and the two artists, with lens and pen, provide a uniquely strong statement about time and place.
>
> (Trottenberg 1963: 11)

The conception of the book assumes the power of words and photographs as equivalent, not only describing appearance and experience, but engaging our imagination. It serves also to demonstrate how words placed beside a photograph will provide a ready series of associations that colour our reading of that photograph. As one moves from page to page, it demonstrates different nuances of tone and focus that force a particular reading of the photograph. Without the words, our direction may have been entirely different, because photographs can lead us to focus on the silence and emptiness of the street that seems so peculiarly resonant, or to imagine the noise that accompanies the trams depicted or to look at the contrast between the street at dawn and the noise and bustle of the street at midday. The same photograph can be read from different perspectives – in terms of historical viewpoints or cultural context or poetic reverie. We recognize buildings of a certain era, which to us mark the historic heritage of Paris, but to Atget and Proust might have signalled a nostalgia for something more ancient and not shattered by modern transport.

Benjamin envisaged was exploited, not in mainstream modernist photography, but in avant-garde movements such as Dada (Hannah Hoch, John Heartfield) and Surrealism (André Breton, Georges Battaille), which explored other possibilities for photography than 'document', such as collage and fragmentation expressing fantasy and satire.

The everyday

The 'everyday', as a central idea of modernity and a recurring theme in the history of photography, develops several associated elements. The ideas attached to the 'everyday' identify some key factors influencing attitudes to representation and to making and interpreting photographs. It serves therefore to bring together a number of the threads to be pursued in this book. John Roberts's exploration of the significance of the 'everyday' for photography and its functions, outlines its emergence in nineteenth-century debates in Europe concerning realism, painting and photography. Together with Manet's candid paintings of proletarian life and the new urban photography (Charles Marville), novelists such as Gustav Flaubert were attempting to describe 'real' events rather than romantic themes (Roberts 1998: 14). At this time, the 'everyday' develops a meaning beyond the simply 'commonplace', which encompasses an aesthetic significance replacing traditional moral values. Conceptions of the 'everyday' developed alongside the increasingly secular developments of modernity and provided an alternative focus to the spiritual. In 'The Painter of Modern Life' [1863], Baudelaire describes the artist-*flâneur* as a kind of solitary hero of modernism, 'gifted with an active imagination, ceaselessly journeying across the great human desert . . .' looking for a meaningful yet transitory quality (Baudelaire 1964: 12). He proclaims that artists should seek modern alternatives to the metaphysical concerns of the great master painters of heroic and religious subjects. He searches for a vision that is particular to *modern* life – to be found in the everyday subjects of city life – in the *present* (see also Box 4.1: The *flâneur*). His statement, asserting that what is most interesting is not what is projected onto the image as valuable (such as 'beauty') but 'the essential quality of being present', is characteristic of the modernist aspiration to mark a distinction from the past. He suggests that what is valued as modern is concerned with the 'passing moment and of all the suggestions of eternity that it contains' (1964: 5). Here is the crux of the 'everyday' – the possibility that we might find eternity in the passing moment, the ordinary or insignificant. And here too is what is venerated in the photograph – as Ossip Brik states – that it can reveal to us

what is not noticed and that it might transcend the banality of appearance. Together, the notion of the 'everyday' and the candid photograph demonstrates the power of metaphor to signify more than facts. The heroes of mid twentieth-century street photography (see Chapter 4) were to exemplify this search to find what is extraordinary through the eyes of the camera, making it accessibly familiar and significant for the present.

The 'everyday' is related to other factors that affected attitudes to 'art' and its relation to 'life': art's development as an autonomous practice, and the awareness of unconscious life. In the mid nineteenth century, art had begun to aspire to something beyond representation and beyond realism; in order to achieve autonomy, art had begun to divide the aesthetic from the social function of art – what was art was not life (Habermas 1985: 10). And the concept of the 'everyday' focused a prevailing division between the two. Whilst later movements such as Surrealism attempted to reconcile art and life through their veneration of the everyday, they have been interpreted as increasing that separation. For example, Lefebvre distances himself from the Surrealists' investment in finding the marvellous and weird in the ordinary and mundane, and distinguishes his 'critique of everyday life' [1947] as being revolutionary rather than akin to the 'trivializing poetics' of the Surrealists (Lefebvre 2008a: 29). In this early writing, his analysis centres on a 'social foundation of thought', and argues that practical, everyday life is absolutely essential to 'real' meaningful relations (239). His argument identifies a contrast between an art that might refer to daily life, but which succeeds in trivializing it, and an art that immerses itself in everyday life in order to function as its critique (25). He states that 'socialism can only be defined concretely on the level of everyday life' (49) and that, contrary to what philosophy has taught us to believe, everyday life is not trivial and therefore inauthentic: 'The myth of the triviality of everyday life is dispelled whenever what seems to be mysterious turns out to be really trivial, and what seems exceptional is exposed as manifestly banal' (239). In this regard, photography focuses two very different positions: one that celebrates its capacity to expose the marvellous and extraordinary in the everyday, and one that makes use of the potential to address what is meaningful in the everyday – such as the practical realities of urban life. John Roberts recounts Lefebvre's interest in the capacity for photography to engage the dialectics of culture by documenting everyday unofficial truths and experiences – those alternatives to the facts of history and reigning institutions. He summarizes the persistent tension between art and critique:

> The job of the dialectical cultural theorist and the job of the artist is to draw out these tendencies and impulses in an imaginative engagement with

everyday forms and practices . . . [Lefebvre's] 'critique of everyday life' studies the negative and positive aspects of capitalist culture which confront each other on a daily basis.

(Roberts 1998: 8)

At the turn of the century, the notion of the 'everyday' accommodated another dimension. Modernity's concern for the rational was disturbed by Freud's theory of the unconscious which, recognizing a very different internal reality, asserted its influence in the early twentieth century and was adopted as a source of reference and inspiration in art and literature. Freud's *Psychopathology of Everyday Life* [1901] gives a degree of scientific credibility to what seems fractured and irrational. The unconscious establishes a realm that, as part of everyday experience, recognizes the significance of what seems insignificant or hidden. Thereby the everyday becomes aligned with different levels of association – what is mundane or fleeting and hidden, the material trials of everyday life, the trivial preoccupations of the unconscious, the political realities of everyday social practice. As a concept, the 'everyday' provides a means to communicate what is difficult to describe: the 'element whose quantity it is excessively difficult to determine' (Baudelaire 1964: 3). Used to frame the experience of everyday life, it becomes a metaphor for a higher condition – the aspiration of the modern individual to transcend physical existence. In his reflection on modern experience, Benjamin [1939] suggests that the experience of the everyday is characterized by distraction and the 'shock' of technological and industrial forms, that can be found in the city, in the crowd, industry and traffic. The 'everyday' is both practical and romantic – practical in the sense that it is inescapable/unavoidable and available, and romantic in its accretion of myth – the noble working man, the integrity of everyday achievement, its access to a higher condition.

In a political context, the 'everyday' is aligned with social reality and, following the development of Marxist ideology, with the concerns of working life and class struggle encapsulated by Friedrich Engels's description of the factory assembly line: 'the wearisome routine of endless drudgery in which the same endless process is ever repeated' (Engels 1968: 178).[4] It becomes symbolic for escaping the constraints of the bourgeoisie and their aspirations; it represents a redirection from the modernist values of progress and improvement to the demands of the masses. In the first two decades of the twentieth century, following the Russian revolution, the 'everyday' is increasingly appropriated as essentially political – more than an illustration of everyday occupations. The 'everyday' and its representations take an increasingly critical turn that coalesces a number of factors: it represents an alternative ideological premise to what is seen as the province of the privileged classes;

it assumes a more confrontational association with the 'brute facticity of everyday life' (Roberts 1998: 16); it signifies that art is available to all, via photography and film [Benjamin 1936]. How this might be done using photography is contentious. Statements that celebrate the photograph for seeing 'what the eye fails to discern' (Aragon in Phillips 1989: 75), that emphasize its ability to expand our understanding of the everyday object (Rodchenko) and to show us familiar things in a different light (El Lissitsky) all assume the ordinary as metaphorically representing what is essential to life, a desire for recognition of the value in the everyday, and the camera as amplifying this phenomenological desire. Film and photography offered something else than the hierarchies of individual expression, and a way to make ideas more accessible. However, the early decades of the twentieth century demonstrated the political intentions for photography as fundamentally divided: the AKhRR champion a use of the 'everyday' that pictures and upholds the values of socialist revolution in an increasingly representational way – socialist realism; the October Photo Section pronounce that 'photography-workers' should contribute to the process of social change. A concern for the political responsibility of context and social function re-emerges in the 1970s, in works by, for example, Allan Sekula, Martha Rosler, Victor Burgin, Jo Spence. I will return to these uses of photography in Chapter 5.

In its early history, photography invents and aspires to something more than documenting reality. Everyday life is considered to be what most characterizes 'reality'. What else would a medium, thought to be the most objective in representing reality, take to be its subject? In 1896, Robinson's essay 'Idealism, Realism, Expressionism' recognizes that however realistic photographs may appear to be, they cannot be separated from the fact that they are socially constructed and that notions of realism are interchangeable with our imagination and ideology:

> [Realism] is the fashion to yearn for Nature, and to select her as bare, bald, and ugly as she is made, the particular kind being that which is the outcome not of nature, but of the errors of civilization. But when we examine the matter closely, we find that no art to be successful, however it may try, can entirely dispense with idealism.
>
> (Robinson 1980: 92–3)

Whether they seek to attain an objective realism or to express ideas, photographs operate through agency: through their production, their purposes for consumption, the social context in which they are viewed and the theoretical perspectives (conscious and unconscious) assumed for their appraisal. I will return to these aspects of image content and viewing context in more detail in the next chapter.

Further reading

Barthes, R. (1977) *Image: Music: Text*, Fontana Press: London.

Bate, D. (2009) *Photography: The Key Concepts*, Berg: Oxford, New York.

Burgin, V. (1982) 'Looking at Photographs', in *Thinking Photography*, Macmillan Press: London, 142–53.

Edwards, S. (2006) *Photography: A Very Short Introduction*, Oxford University Press: Oxford.

Phillips, C. (1989) *Photography in the Modern Era: European Documents and Critical Writings, 1913–1940*, The Metropolitan Museum of Art, Aperture: New York.

Rose, G. (2001) *Visual Methodologies: An Introduction to the Interpretation of Visual Materials*, Sage: London.

Wells, L. (ed.) (2000) *Photography: A Critical Introduction*, Routledge: London.

Edwards's introduction to what photography is and how it represents does exactly what the title suggests and is a good place to start. Bate's *Key Concepts* takes a broader stance and introduces the photograph's role in society as well as its history and development of theory. Wells's *Critical Introduction* has a number of contributors and methodically considers debates concerning aesthetics, technology, the subject, and photography as commodity, documentary and art. These are all excellent introductions to photography's concepts and debates. 'The Photographic Message' and 'The Rhetoric of the Image' in *Image: Music: Text* are good examples of Barthes's earlier structural analysis. Whilst not specifically concerned with photography, Rose comprehensively identifies methods of analysis in *Visual Methodologies* and explains the different aspects of the photograph's production of meaning (pp. 16–28) with reference to Robert Doisneau's photograph *An Oblique Look, Paris* (1948).

Further photographs

There are numerous books on most of the photographers mentioned in this chapter.

Henri Cartier-Bresson (France 1908–2004) – Magnum Photos have 50 images on their website. The images *Behind the Gare Saint-Lazare* (1932) and *Coronation of King George VI, London* (1937) are typical of his search for the 'decisive moment': http://www.magnumphotos.com/HenriCartierBresson.

Lewis Hine (America 1874–1940) – Rosenblum, W. and Trachtenberg, A. (1997) *America and Lewis Hine: Photographs, 1904–1940*, Aperture: New York, and at MOMA: New York: http://www.moma.org/collection/artist.php?artist_id=2657.

László Moholy-Nagy (Hungary 1894–1946) – Ware, K. (1995) *In Focus: László Moholy-Nagy*, Getty Publications: Los Angeles, or (2001) *László Moholy-Nagy,*

Phaidon: London and George Eastman House: http://www.geh.org/fm/amico99/htmlsrc2/.

Albert Renger-Patzsch (Germany 1897–1966) – Wilde, A. (1998) *Albert Renger-Patzsch: Photographs of Objectivity*, MIT Press: Cambridge, MA.

Alexander Rodchenko (Russia 1891–1956) – Tupitsyn, M. (1992) *The Soviet Photograph, 1924–37*, Yale University Press: New Haven, CT.

Moscow House of Photography: http://www.mdf.ru/english/search/authors/rodtchenko.

Notes

1 In 1926, Man Ray used one of his photographs for the cover of *La Revolution Surrealiste*. Atget says 'Don't put my name on it. These are simply documents I make.' Ray recalls this in an interview with Paul Hill and Tom Cooper in *Camera*, vol. 74, February 1975, p. 40; cited in Ben Highmore 'Walls without Museums: Anonymous History, Collective Authorship and the Document', in *Visual Culture in Britain*, 8 (2) Winter, 2007: 1–20.
2 Panoramic photographs of cities: http://www.thefineartcompany.co.uk/photos/PHOTOGRAPHY-lw11.htm.
3 For example, Walker Evans's *Girl in Fulton Street, New York*, 1929.
4 Engels's quote [1845] of Dr. J. Kay (1968: 178) is repeated by Marx [1867] (1990: 548).

3 Photography and/in/of the city

This chapter will establish how photography operates in the urban sphere, by identifying the different roles that photography assumes in different contexts within the city environment. It introduces a more critical analysis of photographic representation and discusses photography as an instrument of power and social order, of institution and of critical stance.

Photography IN the city: functions

If, as we established in Chapter 2, photographs are not transparent and do not access 'truth' in any reliable way, then they must operate via the agency of those who use them. Photography assumes different roles according to the nature of its appropriation, each of which exploits a different aspect of photography's 'realism'. Advertising makes use of its capacity to illustrate our desires and fantasies; governments and the law make use of the apparent evidence of historical or political truth; popular culture makes use of its facility to mythologize through familiarity; the social sciences make use of its role as a signifier for contemporary life. The medium of photography traverses a range of cultural contexts – advertising, fashion promotion, internet blogs, visual ethnography, art-photography, each having different intentions. What these functions share is the fact that they use photographic media – and that is all (Tagg 1988: 63–4).

Because photography has been described as a 'pencil of nature', its 'natural' realism persuades the viewer to ignore the *process* of signification. And whilst different photographic methodologies exist, their identification is not rigorously categorized, so that discussion can tend to assume a sort of photographic universalism that crosses genres and contexts, and brands photography in general terms. The use of photographs in journalistic or commercial contexts is very different from those used in an art context,

so that to compare across photographic genres without mention of the different motivations and traditions, is problematic. There are further complications: the documentary tradition absorbs both the aesthetics of art photography and the intentions of photo-journalism, so that sometimes the motives are not clear; the same image can be used for different purposes – for nostalgia, for advertisement, for mythmaking. The functions of photography can be positioned in relation to a number of disciplines and to inform many cultural debates, so that we could explore it exclusively from the perspective of how its ubiquitous presence is assumed as a symptom of city life or how it catalogues history in terms of depictions of 'everyday life' and contributes to our understanding. In order to unpack the complexity of its use in the city, I differentiate between photography *in* the city/*and* the city/*of* the city. First, we can identify different roles that photography assumes *in* the city – commercial, social, political, cultural – that are a result of urban capitalism. It can be understood as an integral part of the city fabric (i.e. surveillance cameras, advertising etc.) in which its principle function is to observe, to persuade or to entertain. Second, cities *and* photography establishes that photography's application exists besides and in addition to the city fabric and contributes to established conceptions of the city. Its complex social function operates both as an end (e.g. family record) and as a means to distribute information by different agencies, and can serve different purposes. Third, photography *of* the city introduces the photograph as documenting the city (which will be explored more fully in Chapters 4 and 5) and which can represent all sorts of ideas about the city – as allegory. For example, it can function as a signifier for modernity or postmodernity or as a site of ethnographic knowledge in social research.

Institutional agency IN the city

Photographs are used to promote cities, their industries and infrastructure, and to control their operations. The Manchester City Council (MCC) website, for example, illustrates a number of functions. In 2010, I observe that it is organized under a number of headings listed alphabetically (Advice and Benefits, Business, Community and Living, Education and Learning, Environment and Planning, Housing, Jobs and Careers, Leisure, Libraries and Culture, Health and Social Care, Travel and Roads) and each section is headlined by a photograph. The website introduces a number of key issues; it functions to promote the public face of Manchester City and thus serves as agent for the city's political agenda; it uses the ubiquitous nature of photography and its alliance with truth to naturalize what is considered to

BOX 3.1

Social surveys

The German socialist philosopher Friedrich Engels worked in Manchester for two years managing his father's cotton factory (Victoria Mill of Ermen and Engels at Weaste, in Salford). During this time he systematically walked the streets of the city observing working lives and the patterns of urban construction. At that time Manchester, recognized as one of the first cities to develop as a result of industrial capitalism, had a population of about four hundred thousand. Engels's social study *The Condition of the Working Class in England in 1844* [1845], describes in graphic detail the living conditions of the working people and instances of urban development that clearly establish separate territories marking the divide between the classes. Whilst not built to an official plan, Engels observes that the 'shutting out of the working-class from the thoroughfares, so tender a concealment of everything which might affront the eye and the nerves of the bourgeoisie' (Engels 1968: 47). He points out that the owners of the 'cattle-sheds for human beings' rented them for high prices, plundering the poverty of the workers, undermining the health of thousands 'in order that they *alone*, the owners may grow rich' (53–4). He describes his experience in Manchester as representing a phase in the development of Communism, which helped to formulate its philosophy. With Karl Marx, Engels contributed to the foundation of modern Communism, and the writing of the *Principles of Communism* and *The Communist Manifesto* (1848), which begins 'The history of all hitherto existing society is the history of class struggles.'

The excerpts below are typical of Engels's style, which describes and comments simultaneously. His evidence underlines his message that 'all the disadvantages of the state must fall upon the poor' (25).

> [Manchester] is peculiarly built, so that a person may live in it for years, and go in and out daily without coming into contact with a working-people's quarter or even with workers, that is, so long as he confines himself to his business or to pleasure walks . . . And the finest part of the arrangement is this, that the members of this money aristocracy can take the shortest road through the middle of all the labouring districts to their places of business, without ever seeing that they are in the midst of the grimy misery that lurks to the right and the

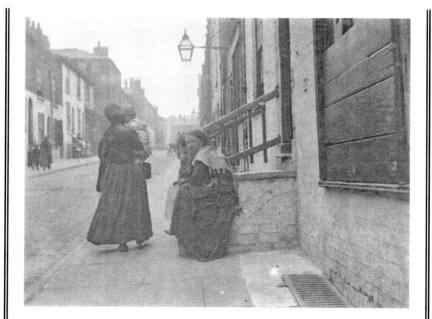

Figure 3.1 Samuel Coulthurst, *Angel Street, Rochdale Road*, 1900. Courtesy of Manchester Libraries, Information and Archives, Manchester City Council: www.manchester.gov.uk/libraries; Local Images Collection: www.images.manchester.gov.uk.

left. For the thoroughfares leading from the Exchange in all directions out of the city are lined, on both sides, with an almost unbroken series of shops, and are so kept in the hands of the middle and lower bourgeoisie, which, out of self-interest, cares for a decent and cleanly external appearance and *can* care for it.

(46)

Above the bridge are tanneries, bonemills, and gasworks, from which all the drains and refuse find their way into the Irk, which receives further the contents of all the neighbouring sewers and privies. It may be easily imagined, therefore, what sort of residue the stream deposits. Below the bridge you look upon the piles of debris, the refuse, filth, and offal from the courts on the steep left bank; here each house is packed close behind its neighbour and a piece of each is visible, all black,

smoky, crumbling, ancient, with broken panes and window frames . . . The whole side of the Irk is built in this way, a planless knotted chaos of houses, more or less on the verge of uninhabitableness, whose unclean interiors fully correspond with their filthy surroundings. And how could these people be clean with no proper opportunity for satisfying the most natural and ordinary wants? Privies are so rare here that they are either filled up every day, or are too remote for most of the inhabitants to use. How can people wash when they have only the dirty Irk water at hand, while pumps and water pipes can be found in decent parts of the city alone?

(50–1)

Photographic surveys of street life and working conditions developed in the nineteenth century alongside increasing urbanization. They were motivated by two concerns: to provide documentary evidence for the purposes of social improvement and to preserve a record of city life for posterity:

Portions of the city are in a constant state of transition and in a few years hence the people who take our places will have but a vague notion of the general character of the streets and buildings as they are today unless we, or some other society, come to their rescue.

(George Wheeler addressing MAPS at one of
its meetings in Moorhouse)

For example, Manchester Photographic Society (MAPS), founded in 1855, established the tradition of recording the city with the works of Alfred Brothers and James Mudd (*River Irwell from Blackfriars Bridge Manchester*, 1859). With the increasing availability of the camera, amateur societies spread throughout Britain and MAPS was the largest. In 1889, it initiated two surveys of Manchester and its surrounding areas, systematically recording buildings prior to their demolition. In 1892, the 'Record and Survey' project was invigorated by the work of Samuel Coulthurst, who was more concerned to record 'the business life, habits of the people, and how the poor live' (Westerbeck and Meyerowitz 2001: 101). Coulthurst, very typically, saw it as important to be as unobtrusive as possible in his surveillance, disguising himself as a rag and bone man and hiding the camera under a pile of junk. We can see in the examples of *Angel Street* and *Blackfriars Street*, how Coulthurst used a candid approach and relied on the signs of the 'worker' in their dress (the shawls,

the hats) to indicate their status and 'habits of people'. Besides Samuel Coulthurst, other key figures in establishing this tradition in Britain were Thomas Annan (Glasgow) and Benjamin Stone (Birmingham). The Amateur Photographic Societies and the later Workers Film and Photo Leagues in Britain were to develop a more self-conscious direction and contribute to the establishment of 'street photography' as a genre.

The City of Manchester's Archives and Local Studies have digitized their collection, which is held at the Central Library available for public use. Interestingly, photographs describing the worst conditions in Manchester no longer exist.

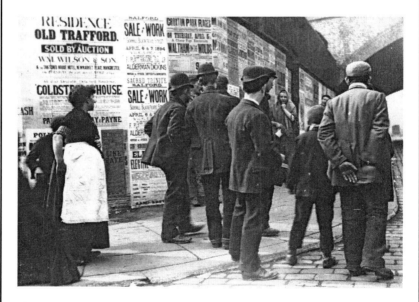

Figure 3.2 Samuel Coulthurst, *Blackfriars Street*, also named *Victorian Working Class Costume*, 1900. Courtesy of Manchester Libraries, Information and Archives, Manchester City Council: www.manchester.gov.uk/libraries; Local Images Collection: www.manchester.gov.uk.

be a desirable norm; it contributes to expectations of the conditions of contemporary life in terms of housing, shopping, education etc.

Not only does this structure confirm the priorities and organizational structures within the city, but the website design uses images to encapsulate its attitude to the delivery of these services. For example, the section 'Visit Manchester' pictures a range of available cultural experiences in the city, evidenced by photographs emblematic of ideas about people, such as 'bohemianism' (alternative life styles) and 'label lovers' (designer fashion). It pictures a 'treasure trove' of desirable items characterized by photographs of elaborate jewellery enticingly displayed in shop windows; its political agenda is fronted by the 'leader's blog' headed by a photograph of his laughing face. He is apparently friendly, approachable and has the best interests of the city and its people at heart. 'Community and Living' features a photograph of a mixed race couple with one child, facing the camera with confidence and contentment. Their demeanour is casual, at ease with themselves, and thereby their environment – Manchester. It is an innocuous image in many ways but tells us a lot about how MCC wants to be perceived – racially tolerant and providing for the community and people's needs; this is how people can live in Manchester – successfully and happily. This image is clearly not merely informative, but is decorative in the sense that it is bland and hardly noticeable, inoffensive and without idiosyncrasy but presenting the desirable political view. It is a photograph that projects desires – an ideal. But it can be viewed differently: on the one hand a constituent who is comfortable will be reassured to know that their way of life is confirmed and valued. However, for someone who does not have these privileges, who is not comfortable and does not feel they are well served by MCC, it may become a source of irritation and even provocation, and for an observer of visual culture, it becomes an ironic image (http://www.manchester.gov.uk/, 3 April 2010).

Photography, social agency AND power

> Photography as such has no identity. Its status as a technology varies with the power relations which invest it. Its nature as a practice depends on the institutions and agents which define it and set it to work. Its function as a mode of cultural production is tied to definite conditions of existence, and its products are meaningful and legible only within the particular currencies they have. Its history has no unity. It is a flickering across a field of institutional spaces . . . Like the state, the camera is never neutral. The representations it produces are highly coded, and the power it wields is never its own. As a means of record, it arrives on a scene vested with a particular authority to arrest, picture and transform daily life.
>
> (Tagg 1988: 63–4)

Agencies such as city councils manage our consumption of imagery and exert a force that is simultaneously material and symbolic. Photographs are mediated by their mode of production and can be understood as being entirely instrumental – as agents for social control, or the promotion of consumerism or style. They are affiliated with power because they provide what is understood to be evidence, which lends authority to our beliefs by whatever institution – family, government – chooses to use them for whatever purpose – consumption, production, communication or history (Sekula 1984: 78). Photographs that are used for more public purposes are the most likely to serve as instruments of power and social order. So with regard to the MCC photographs, we could say that, on accepting them as truthful examples of life in Manchester, the city has executed power and influence over its citizens. Michel Foucault indicates the implicit presence of power relations in any transaction, institution or communication, which can be subtle and indirect, so that it is not always a simple relationship in which one individual exerts power over another, but that power relations are a 'complex interplay' of actions that act upon and which modify other actions (Foucault 1982: 788–90). Power is the dynamic that moves between groups and individuals, so that power relations are embedded within social structures, such as we see on the MCC website.

John Tagg (1988) applies Foucault's consideration of power to the examination of photographs and describes how photographs contribute to the writing of history and how they are used by institutions to record (scenes of crime), to control (traffic), observe behaviour or assess blame (surveillance cameras). By giving examples of nineteenth-century official photography, Tagg exposes its use as an instrument of power. Because photography emerges at the same time as state functions were expanding, it was put to work for the promotion of the state's institutions – hospital, asylum, school, prison, police (Tagg 1988: 61). Used as a means of surveillance or as historic record, photography played an important role in the establishment of the modern state and its operations in advancing modernity via reason, justice and progress. In this context, photographs of people are used as symbols for disease or poverty; photographs that describe urban ghettos, working-class slums and scenes of crime serve to transform complex situations into readable spaces, which can be measured against a contrasting ideal space seen as healthy and orderly (64). The process of translation is to a large degree not acknowledged. For example, we might suppose that Thomas Annan in Glasgow and Samuel Coulthurst in Manchester each considered their photographs as simply evidence of reality: Annan in the belief that it contributed to an evidential truth about the social conditions in Glasgow and Coulthurst in the belief that he was recording everyday life

of Manchester. Viewed subsequently, they reveal motivations at the time in the way that they are photographed. These are underlined by the title, which in naming a photograph, establishes the status and purpose of what is described and lends an unspoken authority; catalogued in the British Library

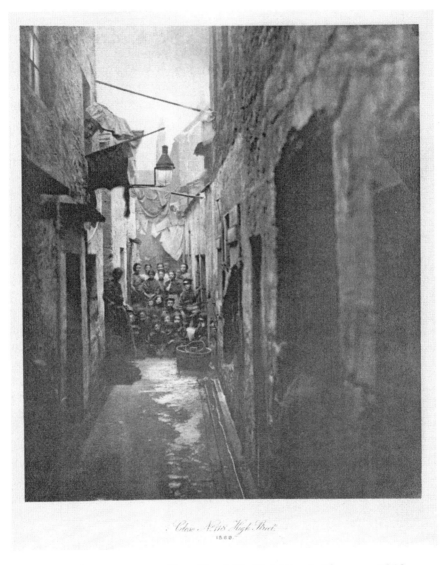

Figure 3.3 Thomas Annan, *Close No. 118, High Street, Glasgow*, 1868.
© **The British Library Board.**

as *Close No. 118, High Street, Glasgow*, Annan's photograph focuses attention on the authenticity of location. It amplifies the physical conditions in which the people were living by deliberately placing them in an exaggerated way so that the situation is simplified and translated for the viewer, whose response is invisibly influenced. In the context of state operations therefore, photography functions as physical evidence, ideological justification and as legal 'proof' or 'identification'. Tagg establishes that photographs, used as evidence, not only serve as a substitute for truth, but are claimed to have the status of knowledge. In this way, truth, knowledge, observation, description, representation, record are inextricably linked (76–8). A photograph of an event constitutes knowledge of that event, so that it can be a powerful tool of persuasion or deception (see also Box 2.2: The photograph and deception).

Foucault's influence has been instrumental in the development of thinking about what constitutes knowledge, causing us to re-appraise assumptions about the perspective from which we regard our relationship to any subject. In *The Order of Things: An Archaeology of the Human Sciences* [1966], Foucault critiques modernity, representation and our procedures of thought and demonstrates that knowledge is dependent on culture, location and whatever ideology or philosophical discourse is current.[1] Rather than being stable, meaning is ordered by our words and images (Foucault 2003: x). Foucault's analysis describes how histories, contexts and meanings change in different locations and eras, and establishes that generalized or ahistorical reductions of subjects, practices or events are problematic. Foucault highlights the complex 'functional conditions' that determine discursive practices and thereby our habitual response to photographs. His discussion forefronts two significant issues for the reading of photographs – the implicit meaning, which often goes unrecognized, and the changing condition of whatever is photographed. He signals the importance of recognizing how we frame our reading of anything and questions assumptions about our conception of any subject and its contexts. In order to analyse any discourse, we need to be familiar with the laws and traditions that govern it, its place and its role in culture. What assumptions are being made? What rules does it follow? Who controls this discourse? What attitude and perspective shapes this knowledge? What validates these ideas? (Foucault 1998: 314). It is a process that attempts to set aside bias or assumptions by insisting that knowledge is something besides that of a physical fact and depends on context. Tagg applies Foucault's questioning to photographs specifically – Why were these photographs taken? 'By whom? Under what conditions? For what purposes? Who is pictured? And how were the pictures used? What did they do? To whom were they meaningful? And what were the consequences of accepting them as meaningful, truthful or real?' (Tagg 1988: 119).

Allan Sekula aims to understand what he calls the 'traffic' of photography that involves its social production, circulation and reception, and the way that its discourse is characterized by it moving back and forth between the objectivity of the document and the subjectivity of the photographer (Sekula 1999a: 155). Like Tagg, he asserts that the basis for photography's supposed truth lies in its metaphoric association with evidence, and the repetitive confirmation of common values, a process that can be seen manifested in the MCC's use of photographs. In 'Reading the Archive' [1983] he describes the photograph as paradoxical in several respects. First, the analogy drawn between photography and knowledge contradicts its dependence on context for its meaning, making it unreliable. Second, it is a medium that supposedly records the smallest details of time and place, and yet delivers these details through the mediation of whoever is using it, so that the photographer's particular interpretation of 'knowledge', whilst it may appear natural and obvious, is not acknowledged. Third, the relationship between photographic culture and economic life – its 'imaginative economy' and its capacity to give pleasure and to influence – serves two contrasting functions, which feed off each other: its use to legitimize power relationships by serving to justify authority and its use as a means of escape from the realities of life such as work or family. If we understand a photograph's meaning as being contextually dependent and as having neither universal nor intrinsic meaning residing wholly within the image, it is then unreliable as a source of knowledge or evidence (Sekula 1999b: 182–4). It is always dependent on layout, captions, text and its neighbouring images, but more confusedly its meaning can change according to the context in which it is seen or read, and because photography moves between disciplines and contexts, it is particularly volatile.

By looking at their use in the ethnographic museum, Elizabeth Edwards (2001) discusses the way that photographs provide context, explain and authenticate, and are used in a didactic way to show how something is used or made or operates (Edwards 2001: 186). Context dictates the expectancy of the viewer so that the expectation of documentary in an institutional archive is different from record in a family album. In the context of the museum, the expectancy is one of an unseen authority and knowledge, because photographs are seen as being 'informative', rather than 'formative' (185). This expectancy is supported by labelling such as 'Victorian Working Class Costume' that defines people by what they wear and functions as signifier for *all* working-class people. Edwards suggests that the relationship between curators and audience amounts to a collaboration that maintains an uncritical realism that explains in ways that 'confirm the status quo of cultural visioning, rather than

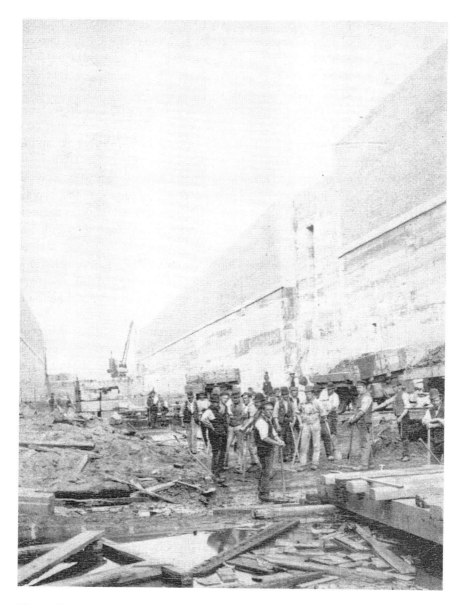

Figure 3.4 Anonymous, *Manchester Ship Canal construction*, 1890. Courtesy of Manchester Libraries, Information and Archives, Manchester City Council: www.manchester.gov.uk/libraries; Local Images Collection: www.manchester.gov.uk.

challenging it' (184). In the context of anthropology, Edwards scrutinizes how photographs help to construct knowledge (5). She considers photographs as agents in making history and shaping discourse. Because photographs are incorporated into the fabric of cultural institutions such as the museum, she emphasizes that they display the norms and attitudes of a specific culture at a particular time and, rather than being evidence of history, they *are* 'social objects' or 'social actors' (17). Her use of the term 'performative' gives emphasis to their *active* role in making meaning and constructing histories. Their 'performative qualities' operate in several ways (20). First, through the theatrical presentation of form evident in the dynamic of framing: for example, the vertical framing device of Annan's *Close No. 118* emphasizes the limited living space by squashing people at the end of the alley, whereas the frame of Coulthurst's *Blackfriars Street* encourages focus on the narrative dynamic of something happening *across* a space. Second, the making of a photograph includes a political relationship in which the subject is ascribed a role beyond and besides the individual – that of 'worker' or 'pauper'. Third, Edwards relates the common ethnographic method of literal enactment in order to demonstrate a cultural process or condition, which both of these photographs display. Annan's photograph is particularly performative in the way that its subjects, having been directed to gather in that unnatural position and to fix their attention on the photographer, contribute to marking a specific situation, time and place, and to producing response in the viewer. Its theatricality amplifies what one imagines as the squalor and the cramped unsanitary conditions. At the same time, there is an aura of oddity as they are presented as curiosities, both watched specimens and watching actors, as if on a stage or in a circus tent – gathered together as spectacle.

If cameras are always invested with some authority or power of surveillance, photographs are not merely passive instruments for contemplation but can be actively put to use to evoke emotion and to motivate political change. Any simple description of their use is confused by its multifarious functions, which disguise its political and commercial purpose. Photographs can be lifted from their original contexts and assume a new set of entirely distorted meanings, so that one photograph can serve different agendas if contextualized differently. Take any one of MCC's images out of its original context and present it in a gallery with a series of similarly bland photographs and one might see a commentary on living in a metropolis like Manchester. In presenting a series of similar or contradictory pairings, the visual impact of contrast can make a visual argument in a powerful manner (see also Box 5.1: Politics and photo-juxta-position). Simon Watney goes so far as to describe

BOX 3.2

The agency of exhibition

Photographs are never 'evidence' of history; they are themselves
the historical. From this point of view, exhibitions such as
The British Worker must appear not only incoherent, but
entirely misleading in their purpose, eliding as they do the
complex differences between the images they assemble –
between their contrasting purposes and uses, between the
diverse institutions within which they were made and set to
work, between their different currencies which must be plotted
and mapped.

(Tagg 1988: 65)[2]

Photographic documents can generalize and thereby very easily reduce
the significance of situations. And exhibitions, which collate documents,
can misleadingly imply evidence of history, because they always classify
elements of history by itemizing and reorganizing fragments. They
conflate a multitude of contrasting evidence gathered from diverse
sources and framed by different intentions. Therefore, to respond
critically, we must consider from what contexts the elements have been
drawn, what changes have been effected as a result of the construction,
and look for the contradictions that might interrupt assumptions made
as a result of the homogenizing process. Edward Steichen's 'Family of
Man' exhibition (1955) is often quoted as promoting a generalized view
of the human condition, ignoring differences between peoples and
cultures. Barthes [1957][3] and Sekula [1983] use it to illustrate the ease
with which photography betrays implicit ideology and thereby creates
mythologies that validate that ideology. Barthes describes it as a
humanist presentation that depicts the differences in human morphology
and culture, whilst stressing an underlining myth of community (Barthes
1993a: 100). It relies on photography to act as 'a miraculous universal
solvent', which is assumed to broker differences between peoples and
implicitly challenge the relevance of class difference (Sekula 1984: 95).
John Tagg (1988: 65) expresses similar concerns about the 1981 Arts
Council exhibition 'The British Worker: photographs of working life
1839–1938' (curated by Colin Osman). The repetitive photographic style
of 'The British Worker' demonstrates how we come to recognize certain
signs of 'reality': 'workers' are photographed more often than not,

stopped in the process of their work, looking at the camera with the signs of the mine, factory, yard as a backdrop behind; their status and identity is defined by the tools of their work, for example, leaning on their shovels as they do in *Building of the Manchester Ship Canal* (1900). The regularity of pose diminishes their individuality; women look exhausted, men look bemused, proud or resigned. The exhibition structure contributes to the establishment of myth – a 'naturalization of the cultural' by means of repetition and familiarity (Barthes 1977: 51). In this instance, photographs were presented under headings and sub-headings such as 'Early Days'; 'Victorian Achievements'; 'Urban Reality' ('life in the streets', 'recording for reform', 'charitable bodies'); 'Earning a Living' that neatly package the hugely complex structure of capitalist production.

Exhibition summaries further promulgate generalization: for example, *Art Bibliographies* describes 'The British Worker' as a survey that 'charts the lot of the British worker but also demonstrates the development of photography and of photographers' attitudes to their subjects.' The 'British Worker' is identified as working class and defined by the 'sweated industries'. Exhibition catalogue essays establish themes and arguments. The essay by David Englander begins 'Class in Britain is an obsession' and proceeds to describe Victorian photographs as having a quality that evokes 'the symmetry of man and machines, their celebration of the harmony of capital and labour' that 'capture a mood among the middle classes' for the wonder of 'great feats of engineering' (Englander 1981).

Photography serves the purposes of the curator in providing evidence for a compelling argument. And exhibitions confirm the values of the prevailing political climate. In 1955 America, in the shadow of the Cold War, it was comforting to present individuals, anywhere in the world, as having a common humanity. In the 1980s, 'The British Worker' recalls an era where the division of 'them' and 'us' was very clearly defined and assumes this division as historical, whilst revelling in the pleasure of looking at a bygone age. Images of work are presented as homogenous, when in fact the issues of work and labour are complex and diverse. Photography fuses in a single moment of visual truth and visual pleasure – it constructs a single moment of blissful identity and in so doing it assumes the attitudes of viewers and photographic meaning as being universal (Sekula 1984: 90).

BOX 3.3

Ravi Agarwal: photographer, activist, sociologist

Ravi Agarwal[4] describes himself as a photographer and social activist. His work illustrates how the photograph's social function and agency can operate on several levels simultaneously. His photographic projects focus on the impact of globalization on different aspects of the urban environment and encompass a range of geographical dimensions – physical, economic, environmental and human. The photographs can be discussed from different points of view – the activist's in terms of rhetorical provocation, the sociologist's in terms of social analysis, the photographer's in terms of genre and aesthetic, and the individual's in terms of personal experience. Framed by different theoretical discourses introduced in this book, the consequences of *state operations* (see Foucault) are illustrated in local *behaviour* (see Bourdieu in Chapter 4) displayed in the realities of *everyday life* (see Lefebvre). The photographs' social function (Bourdieu), which dictates how we view the photograph, is therefore complex. As documents, they relate a grim existence; as objects, they are colourful and compelling; as *social objects*, they are active in making meaning (see Edwards); as photographs of the city, they deny expectations perpetuated by panoramic views of skyscrapers associated with modern progress and material prosperity.

For the *sociologist*, India presents an example of urbanism characterized by a migratory worker population that moves back and forth between rural village and city. In collaboration with the sociologist Jan Breman, *Down and Out Labouring: under global capitalism* (1997–2000) tracks the sparse existence of workers living on the fringes of the city Surat, whose lives are dictated by changes to the pattern of industries and their operation (Breman and Agarwal 2002). Agarwal's concern circulates around what economic capital means to the lives of these people – to what extent they are served or exploited. The 'facts' presented by photographs are testament to the poverty caused by urban development and the modes of employment on which they depend. In detailing the specific and local conditions that govern their work and living, Agarwal's photographs demonstrate the distance between ideals of material progress and the local realities of flexible labour markets that are without government monitoring or union organization (see Harvey in Chapter 1).

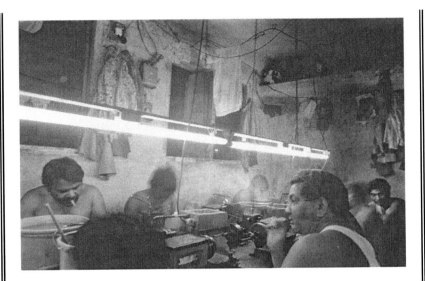

Figure 3.5 Ravi Agarwal, from *Down and Out and Living Under Global Capitalism* series, 1997–2000. Black and white reproduction from original colour image. Courtesy of the artist.

Figure 3.6 Ravi Agarwal, from *A Street View* series, New Delhi, 1993–95. Black and white reproduction from original colour image. Courtesy of the artist.

Agarwal's projects move through a series of conventions. The function of social documentary drives his purposeful selection that aims to expose living conditions (*A Street View*, 1993–95), whereas the 'performative' qualities of later projects exploit the capacity of the digital image to assemble images gleaned from a range of perspectives (*Urbanscapes*, 2008). As a *photographer*, his views are mediated by formal choices, which are reliant on his investment as a technician, an activist, an individual and an artist. As he photographs people who are marginalized economically and politically, he is forced to confront his privileged position in relationship to them. He questions the validity of the documentary photograph to present any objectivity or truth about a situation and concludes that the photographs are 'more about the photographer and his "reality"'. His practice moves towards what he calls a 'personal ecology' in which he explores 'how an "artist" can aestheticize the political and politicize the aesthetic in the same gesture' (http://www.raviagarwal.com/).

In the context of *environmental activism*, photographs can motivate action on the basis of their subject-matter and their emotive impact. *Another Place* (2008) records the physical changes in a city making way for new roads, new malls and the commonwealth games (Delhi 2010). Agarwal strives to understand the changing economy that was once determined by the fertility of the land and which is now overtaken by 'the fertility of capital'. His methodology exemplifies the continuing debate concerning the relation between art and life. His method of address is poetic and his political agenda is implicit, rather than demonstrably explicit as with Annan's formal construction. Like Engels's writing about Manchester, Agarwal's photographs describe and comment simultaneously. Empty deserted sites of defunct industries (facts) become material symbols (ideas) for the consequences of global economic expansion; a river running through the city represents its emotional heartland and its industrial heritage. *Alien Waters* (2006) functions as a metaphor for a contemplation of the river's journey and purpose in the reconfigured city. Agarwal researches, analyses, probes to understand the reasons for the river's filth in a context of 'vicious municipal politics', 'schemes of massive financial and infrastructural investment' and 'visions of profit'. As it is cleansed in the process of urban development, the river is 'reborn, not as the life-giving artery it once was, but as a sparkling necklace to adorn a new globality'.

See Agarwal's website for statements about all his projects (http://www.raviagarwal.com/).

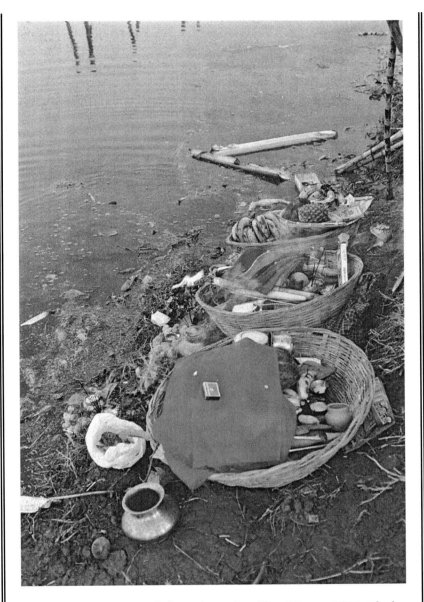

Figure 3.7 Ravi Agarwal, from the series *Alien Waters*, 2006. Black and white reproduction from original colour image. Courtesy of the artist.

photographs as being 'fragments of ideology' rather than evidence of the visual world, because they are dependent on the knowledge which validates our conceptions. He examples the difference between taking a picture *of* a political demonstration as record and then using that photograph *for* political ends – within the legal system or in the gallery or in the commercial sector (see also 'Photography, politics and protest' in Chapter 5). Because photographic meaning is mobile, Watney states that it will be defined by its use – that photographic meaning *is* use, and is created each time a photograph is used in a different context, time or location (Watney 1999: 144–8). Photographs are promiscuous in the sense their meaning changes from day to day. Tagg, Watney and Sekula's post-Foucauldian views are highly critical of attempts to align photographic semiotics with any sort of universal language, and indicate that any implication that its use is evidence of anything should be regarded with scepticism. When recognized as material 'social objects' in a continuous process of meaning construction, photographs can be used to tell different stories in different ways; their ambiguity can therefore be used deliberately to address a particular issue. By purposefully not offering a closure of meaning, nor providing an authoritative answer, photographs can engage a viewer in the co-construction of knowledge through raising questions. They can address the discourse rather than 'speaking about' this or that or these people. In this way, photographs can be utilized within critical discourse and are as much to 'think with as they are empirical, evidential inscriptions' (Edwards 2001: 2). Many of the contemporary photographs in this book, such as Ravi Agarwal's, Walid Raad's or Aglaia Konrad's, can be seen to do this by drawing attention to their mediation or their fabrication or by disrupting realist assumptions and expectations.

Photography AND the social production of meaning

Since the establishment of the social sciences, the world has become something to be studied. During the nineteenth century, photography was symptomatic of the camera's objectifying function. Emerging at the same time as the growing desire to analyse and to categorize knowledge, it was appropriated to provide evidence for particular notions of human nature and society, because its 'realistic' representations illustrate social analysis and lend weight to systematic categorization. Scientists and anthropologists used photography to facilitate analysis of situations and peoples. The discursive frame of the social sciences underlines the view that photographs follow historical conventions. In the early 1960s, Pierre Bourdieu researched the

photograph's social function by talking to people about their response and attitude to photographs. He established the principle that our understanding depends on established conventions: a picture is always reliant on our recognizing a type of photography – as a publicity photo, a documentary photo or an educational photo – and is always 'judged with reference to the function it fulfils for the person who looks at it'. And any photographic form and its content is embodied in our already formed ideas, for example, of 'glamour', 'youthfulness' or 'femininity'. What Bourdieu terms the 'social function' restricts the conditions in which something is viewed so that, if it follows the rules of convention, the politics of its making will slip by without being noticed or questioned (Bourdieu 1999: 171). Different discourses develop the 'order of things', which dictate our normative way of thinking. He describes the social uses of photography as circulatory because photography defines its social meaning at the same time as it is defined by photography (165). For example, documentary photography is confirmed as being realistic and objective because it exploits its mechanical operation in order to emphasize an objective, and therefore 'realistic', viewpoint. Alternatively, a family photograph presupposes the suspension of aesthetic judgement because the private character of subject-matter and the relationship between the photographer and that subject-matter unconditionally justify it. What is important is the photograph's role in celebrating these relationships (173); it has no meaning or use for anyone besides 'those who took it and those who are its objects' (Bourdieu 1990: 87). The rituals of vernacular photography are linked to deep-rooted cultural values of respectability, and being respectful, and central to the process in which the person being photographed addresses the viewer as an 'act of reverence and courtesy'. In turn the process demands that the viewer obeys the same conventions. Its social function regulates the image and dictates its reception (85).

A sociological analysis of photographs is rational because it seeks explanation and understanding of the photographer as an agent of social force. Simon Watney's appraisal of professional and amateur photography adds a different perspective from which to view vernacular photography. For example, photojournalism and advertising can be seen as providing 'patterns of conformity', which contribute to how we think reality is constituted (Watney 1999: 159–60). He points also to photography's dependence on multi-national corporations (Fuji, Kodak) and their commercial operations, which to some extent dictate what is good and desirable in photographic technology and the standards of the image itself. The history of photography confirms these social forms of organization and categorization. We share a 'pho-culture' worldwide.

The influence extends beyond individual views because it encourages passivity in the consumption and use of photography:

> In this manner, photography constructs and reconstructs, as if by nature, all the major divisions within the social formation, between blacks and whites, women and men, adults and children, heterosexuals and gays, always aligning us to specific pre-determined social positions and ranks.
>
> (Watney 1999: 152)

Watney's emphasis and terminology is different from Tagg's, but effectively stresses the same principles – that photography plays its part in maintaining social divisions. However, Watney is concerned not to forget photography's psychological dimensions. He points out that as a result of its use by the social sciences and the subsequent development of 'cultural studies' and its Marxist legacy, any use of photography is understood in terms of a process of distribution and consumption, so that it has been interpreted solely as a commodity like any other (141–3). This approach to analysis focuses on intentionality and sees photography only as a form of cultural production and its ideological 'contents', which can be explained by 'economic' or 'social' determinations. Watney asserts that 'ideology' and the 'unconscious' are as important as 'context' and that a more significant approach to reading photographs should make full use of the photograph's 'rhetorical' meaning – the communicative power of the photograph itself in terms of desire, fantasy and metaphoric meaning (150).

Instances of sociological analysis demonstrate Foucault's warning about changing perspectives and histories. In the 1960s, Bourdieu is concerned to situate photography as a cultural practice and places it in the middle of his scale that differentiates a hierarchy between 'vulgar' and 'noble' practices. In 2011, most families own a camera, many individuals own mobile phones with a camera. This facility is taken for granted, its purpose ignored and the ubiquitous ease with which we can take digital photographs has developed an ever-increasing casualness of style. Photography can be said to have broken Bourdieu's conception of hierarchy to some extent [1965]. The distinction between 'barbarous' and 'good' taste is now confused, since vernacular practice has been appropriated by 'art photography' and has assumed a role as a legitimate artform; for example, the family archive has become a 'style'. It has confronted issues of 'objective' document along-side its uses for metaphoric and ideological purpose. As I will explore in the following chapters, photography has absorbed a complexity of functions and is used in a self-conscious way to point to the assumptions of power, difference and representation.

The city AND the ubiquitous photograph

The 1970s saw the development of contrasting approaches to looking at images – the adoption of semiology, the post-structural recognition of the subjective process in differentiating meaning, the development of cross-disciplinary approaches that embraced 'visual culture', sexual politics and psycho-analysis. 'Visual culture' is concerned with visual products that demonstrate representation and identity and with the questions they raise regarding our motivations and desires. The study of visual culture places images centre stage, so that more than analysing photographs as illustrations of theories, developments and events, photographs can serve as a starting point for analysis. Cultural meaning is confirmed, or sometimes revealed, by means of photographs. The visual, and the photograph, is embedded in everyday life of the city. In an intensely visual age, everyday life *is* visual culture (Mirzoeff 1999: 125). Photography provides the visual equivalent of the bland musical background of the shopping mall. Photographs surround us in the city – large, small, advertising hoardings, shop windows, leaflets, books, and each exert influence. Informational graphics contain photographs with the purpose of giving us facts and are apparently simple and unadorned. But they too are framed, pre-selected and may purposefully have included or excluded some elements. Because we do not pay much attention and assume that these images are merely factual and there to help us, these kinds of ubiquitous images can be subtly and persistently influential in forming our opinions about our culture and our society. Sometimes this occurs incidentally and sometimes it results from a deliberate operation by the photographer.

Visual culture is powerful and our increasing awareness of spectatorship (the look, the gaze, the glance, the practices of observation, surveillance and visual pleasure) colours our 'vision' of the world (Mitchell 1995). Mitchell aligns Foucault's differentiation, between power that is exerted over things and the ways people can exercise power over others, with the power of pictures as spectacle and as surveillance. Spectacle and surveillance epitomize the basic dialectic in contemporary visual culture: 'Spectacle is the ideological form of pictorial power; surveillance is its bureaucratic, managerial and disciplinary form' (Mitchell 1995: 327). Having made this distinction he then describes a feature of contemporary visual culture as its convergence in television news and films. Even though we use photographic representation to establish a kind of power over the world, the spectator can be deceived because of its realism, which can be illusory and has the capacity to exert power over our understanding of that world. Perhaps the distinction can also be expressed in terms of the nature of 'spectating' – whether passively or actively. As active consumers of visual culture, we can ask what do these representations do?

Photographs can be viewed as 'transparent means to knowledge' or can be viewed more critically or for their own sake. Irit Rogoff (1999: 15) asks what sort of images are prevalent and who and what is *not* represented. Rather than circulating old knowledge and mythology, she asks what questions should we ask? Traditionally photography has sought out what is hidden, whereas this sort of approach suggests that photographs can also picture the city in a way that asks a range of questions.

My attitude is allied to what is termed 'visual studies', which has been partly responsible for the expansion of cross-disciplinarity in approaches to looking at photographs. The discursive frame of visual studies encourages an approach that centres methods of analysis around an issue – a cultural problematic rather than the constraint of traditional disciplines. Thereafter, discussion of 'art' photography need not be confined to the narrow confines of the history of photography but can be discussed not only from different theoretical perspectives but in more self-reflexive terms.

Photography OF the city: allegory and metaphor

In Chapter 1, I outlined a range of theoretical perspectives with which to view the city. I indicated that a focused study of a specific element of the city and society lends insight for a much wider context. For example, Foucault and Bourdieu offer two very different perspectives on relationships and power; Foucault focuses on procedures (panoptic, penal, clinical) and Bourdieu focuses on localized inhabitants and their behaviours. The same principle applies to the interpretation of photographs whereby one photograph can serve to represent several issues. In Chapter 2, I described the photograph's metonymic capacity to refer to what is beyond the frame – to what is absent or what is desired. The material visualization of space and the city establishes a kind of logic in that photographs are always only elements of something much greater. For example, a photograph of a skyscraper or a crowded piazza refers us to the concept 'city', acts as a substitute for the word 'city' and is its metonymic visual equivalent. A photograph of a skyscraper can accentuate its verticality and thereby accentuate the phallocentric aspiration of its modernist construction – visually. And metonymy can be exploited, so that advertising that uses photographs amplifies the association of objects with ideas and feelings – cars with status or beautiful people with desire. In this chapter, I have emphasized the implications of hidden agencies and institutional choices, which may be represented but not depicted explicitly. A photograph functions as part of a complex mechanism of meaning construction – semiotically and through agency.

Useful to an understanding of the city and urban life is the way a photograph *shows* us our relationship to other people, objects, buildings and space. Sometimes this occurs incidentally and sometimes it results from a deliberate operation by the photographer. The mechanisms of metaphor and allegory functioning within the photograph refer to more extended ideas, so that isolated elements can stand in for, or come to symbolize, a much greater concept. Evans and Hall (1999: 1) suggest that a host of visual metaphors (e.g. spectacle, simulacrum, the gaze, fetish) have become central to much contemporary debate and, of course, photography is well placed to demonstrate these themes. For example, a photograph of a traffic snarl up in a city symbolizes the realities and pressures of modern life; a river represents 'globality' (see Agarwal). Metaphor is the principle means of figurative meaning and shares with the photograph its main feature – resemblance. It is a process of substitution, where meaning from one context shifts to another, in which one thing speaks in terms of another. A metaphor is divided into two parts: the primary subject or the literal frame (the surveillance camera in the street) and the metaphoric subject or figurative concept (power). This process requires some element of similarity for it to work, so that we can apply our existing knowledge of what something conventionally means, and then adjust, according to the given context. Resemblances invite us to search for possibilities, which are similar but not the same. And metaphor is the process that makes connections, and is related to our capacity to process thought, language and concepts. The process enables the possibility of seeing an object in a wholly different way. We are used to this process in verbal poetry, which constructs figurative meaning by using words in ways that encourage imagery to reverberate and new ways of understanding. Poetry is expected to incorporate reference to real, psychological and imaginative worlds – simultaneously, whereas photography is associated with facts, and the process of figurative meaning is less familiar.

Photographic documents *of* the city are assumed to display the presence *of* its subjects. However, an allegorical use of photographs is one in which photographs are used to deliberately present another set of ideas beyond the objects/events depicted. For example, family photographs of children at play can represent a system of values or define the success and happiness of family life. A series of photographs such as Sylvia Grace Borda's *Capital Cities* (1997–2002)[5] addresses systems of transport in London and Tokyo, and Sekula's diverse series *Fish Story* (1990–95) and *TITANIC's wake* (2003) provide an extended discussion of maritime industries and their impact on people's lives in small communities and cities across the world. Allegory

BOX 3.4

Metaphor, power and surveillance

> The 'eye' is the subject, 'I' the mindful centre of a human being who surveys the world around (him). The lens is the technological 'eye' which because it is without mind is objective and without prejudice. And the photograph is the magic trace of an image of the world as it was once there before us – a true replica.
>
> (Batchen 1995: 277)

The camera and the photograph embody ideas associated with looking and being looked at. The camera, the eye, the lens, the photograph operate metaphorically on several levels. The camera is the one that looks – that exerts technological power on the one that is observed. The camera assumes the character of surveillance, both literally and metaphorically; the photograph represents evidence and is testimony to the power of looking.

In *Discipline and Punish* [1975], Foucault describes a number of models of control, containment and surveillance for achieving the perfectly governed city (Foucault 1977: 198). He states that all authorities exercise control over the individual by dividing and branding different categories of citizens as mad/sane; dangerous/harmless; normal/abnormal, and differentiating people in terms of: 'who he is; where he must be; how he is to be categorized; how he is to be recognized; how a constant surveillance is to be exercised over him in an individual way etc.' (Foucault 1977: 199). Foucault adopted Jeremy Bentham's Panopticon as a metaphor for ultimate control. The Panopticon (an eighteenth-century plan for a model prison) was a structure with a central tower designed in such a way as to command a view of all the cells that surround it. All that was needed for total surveillance was to place a supervisor in the tower, from which he would be able to observe the occupants of the cells.

Surveillance and traffic cameras are today's markers for looking, their major effect being to induce in the citizen a 'state of conscious and permanent visibility that assumes the automatic functioning of power' (201). As with the Panopticon, the surveillance camera 'is a machine

for dissociating the see/being seen dyad . . . one is totally seen, without ever seeing . . . [or] one sees everything without ever being seen. It is an important mechanism, for it automizes and disindividualizes power' (210–12). The effect of surveillance is always visible, but unverifiable – we always know the cameras are there, but we never know exactly when we are being looked at or photographed. And as we are subjected to its visibility, we enter into a form of unspoken contract that assumes a degree of complicity in the constraints of power: we inscribe in ourselves the power relation in which we simultaneously play both roles, and 'become the principle of [our] own subjection', both looked at and looking (202–3). In the twenty-first century, metaphors for the camera and the photograph are extended to include cyberspace.

We can see today how the mechanisms of power are brought to bear on individuals and communities. The surveillance camera is a powerful symbol of contemporary observation and power in the city and lends insight into the many dimensions to relations within it. Two exhibitions utilize it as a central focus for a discussion of issues relating to surveillance – ZKM (Centre for Art & Media, Karlsruhe) – *The Rhetoric of Surveillance: from Bentham to Big Brother* (2002) presented a number of projects each of which responded to the notion of surveillance, one of which was Ann Sofi-Sidén's *Station 10 and Back Again* (2001), which records the daily routine in a fire station in the city of Norrköping, Sweden:

> A surveillance camera is installed in almost every room of the fire station. Some shots are fixed, some make a pan through the room. We see response headquarters, the garage with the fire engines, the offices, the corridors and common rooms. We become witnesses of the course of events in a fire station, we observe the firemen going about their daily tasks, getting ready for a mission, taking a shower, talking easily with colleagues, cooking together, making their beds, or having their evening meal in the common room. Sometimes you see hectic movement, swift responses prior to a mission, other times you see only empty corridors and empty rooms in which nothing happens . . . Documentary reporting is replaced by the live images that confront us with life itself. Of course, what we see are recordings, but the effect surveillance cameras produce creates the impression of being actually present. Video surveillance functions as a code signifying *reality*. But precisely

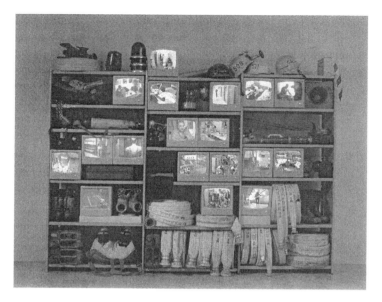

Figure 3.8 Ann Sofi-Sidén, *Station 10 and Back Again*, 18-channel Video Installation, 2001. Installation Shot Norrköping Museum. Photo by Pelle Wichmann. Courtesy Galerie Barbara Thumm.

because these are recorded events, we are cut off from the reality we expect to see on video surveillance screens.

(Sabine Himmelsbach: http://
ctrlspace.zkm.de/e/)[8]

The exhibition *Exposed* (Tate Modern, 2010) began with the idea of the 'unseen photographer':

Much of *Exposed* focuses on surveillance, including works by both amateur and press photographers, and images produced using automatic technology such as CCTV. The issues raised are particularly relevant in the current climate, with topical debates raging around the rights and desires of individuals, terrorism and the increasing availability and use of surveillance.

(http://www.tate.org.uk/modern/exhibitions/
exposure/default.shtm)

depends on absence to give force to its ideas. Ed Ruscha's *Every Building on the Sunset Strip* (1965)[6] and Martha Rosler's *The Bowery in Two Inadequate Descriptive Systems* (1974–75)[7] are examples of a deliberate and powerful use of metaphor, absence and substitution, which approach documentation by not photographing its subject directly. Both attempt to describe the system within which an urban phenomenon occurs, rather than its appearance. *The Bowery*'s subjects of discussion are the structures, agencies and the set of relationships that cause homelessness in New York City, rather than a homeless person, who may be used to represent 'homelessness'. The series comprises 45 black and white images representing Bowery façades, alongside a series of nouns that describe life in the area and adjectives that play metaphorically with the idea of intoxication. It demonstrates the function of metaphor as well as the point that photography (despite its transparency) cannot adequately describe the material reality of a situation (Sekula 1984: 62). It displays the gap between description and what we consider to be the certainty of visual transparency. The absence of subject (homeless person) displaces the photograph's relationship to resemblance and the expectations of objective account.

The functions of metonym, metaphor, allegory, agency and mythology operating in photography are closely related and simultaneous. Chapters 2 and 3 have considered how photographic meaning cannot exist independently from the wider cultural debate; meaning results from a combination of influences, conventions, mythologies and histories, which are always in the process of being rewritten in the light of present ideologies. Photographic descriptions can simplify complex processes or reduce local differences – as does Manchester City Council's. Because photographs isolate visual and momentary fragments, they can eliminate their specific context and history by defining history in terms of visually notable moments. And because photographs can be reproduced endlessly, they can reduce their subjects through familiarity to a generalization, as we see with 'The British Worker'. Because photographic accounts are habitually associated with objectivity and evidential proof, and because a sequence of images suggests a linear progression from past to present, photographic accounts of history can be biased and dependent on whoever frames them. These considerations establish a number of conflicts that will be explored in the next five chapters.

Further reading

Burgin, V. (ed.) (1982) *Thinking Photography*, Macmillan Press: London.

Fried, M. (2008) *Why Photography Matters as Art as Never Before*, Yale University Press: New Haven, London.

Mirzoeff, N. (ed.) (1999) *The Visual Culture Reader*, Routledge: London, New York.

Roberts, J. (1998) *The Art of Interruption, Realism, Photography and the Everyday*, Manchester University Press: Manchester, New York.

Tagg, J. (1988) *The Burden of Representation: Essays on Photographies and Histories*, Macmillan: London.

Watney, S. (1999) 'On the institutions of photography' [1986] and 'What is Visual Culture?', in Evans, J. and Hall, S. (eds), *Visual Culture: The Reader*, Sage Publications, Open University: London, Thousand Oaks, New Delhi, pp. 141–61 and 1–8.

Westerbeck, C. and Meyerowitz, J. (2001) *Bystander: A History of Street Photography*, Bullfinch Press: Boston, New York, London.

Roberts's *The Art of Interruption* (1998) is rather more difficult than Edwards and Bate, but an excellent overview of the photograph's political implications. Burgin's *Thinking Photography* contains key photography texts by Watney, Sekula, Eco, Tagg as well as the influential Benjamin text 'The Author as Producer', each of which explain photography as a subject of cultural production. Tagg (1988) is essential reading for an understanding of the photograph's institutional agency. Evans and Hall present a multi-disciplinary collection of essays about the image from the perspective of visual culture, as does Mirzoeff, which also starts off with an essay 'What is Visual Culture?' (pp. 3–13). Westerbeck and Meyerowitz gives a comprehensive and historic overview to photography in the city, explaining the emergence of a modernist genre in America and Europe.

Further photographs

Thomas Annan (Scotland 1829–87) – (1977) *Photographs of the Old Closes and Streets of Glasgow, 1868–77*, Dover Publications; V&A: http://www.vandaimages.com/results.asp?W=2&F=0001&Step=1&screenwidth=1232.

John Thomson (Scotland 1837–1921) – (1994) *Victorian London Street Life in Historic Photographs*, Dover Publications; see examples http://spitalfieldslife.com/2011/03/28/john-thomsons-street-life-in-london/.

Shirley Baker (Manchester 1965) – *Streets and Spaces*, The Lowry, 2000.

Thomas Coulthurst, Manchester Archives and Local Studies: http://www.mcrh.mmu.ac.uk/pubs/pdf/mrhr_17i_archives_moorhouse.pdf. Coulthurst depicts life in Manchester at the end of the nineteenth century, Shirley Baker in the 1960s and early twenty-first century, and Thomson and Annan are characteristic of nineteenth-century social surveys using photography.

Emily Jacir (Palestine 1970) – Linz Diary (2003) – a webcam records Jacir in an Austrian square at 6 p.m. every day over a month.

Allan Sekula (America 1951) – (2003) *TITANIC's wake*, Liege: SNEL. Sekula's *TITANIC's wake* provides an accessible introduction to Sekula's approach to photography, as well as an example of a photographic series used in an allegorical way for the discussion of much bigger issues, in this case globalization.

Thomas Struth (Germany 1954) – has since 1978 consistently photographed city streets emptied of people and leaving the fabric of the city exposed: http://poulwebb. blogspot.com/2011/03/thomas-struth-street-views.html.

Catherine Opie (America 1961) – *Wall Street* series (2001): http://www.stephen friedman.com/#/exhibitions/past/2001/catherine-opie-wall-street.

Weegee (American, b. Arthur Fellig Poland 1899–1968) – (2002) *Naked City* [1945], Da Capo Press, Cambridge, MA.

Whitechapel Gallery/Fotomuseum (2010) *Where Three Dreams Cross*, Steidl – offers a 150-year history of photography developing in India, Pakistan and Bangladesh.

Notes

1 Foucault's use of the term 'discourse' refers to the arena within which a particular context and its language exists, as with photographic discourse, geography or sociology. In consequence, analytical procedures switch focus from the author- itative author-subject who is understood to be at the originator of knowledge, to a 'discursive practice', which places the contested debates associated with any discourse as central.
2 Edwards, S. and Tagg, J. (2003) *The Camera at Work*, Tate: http://channel.tate. org.uk/media/26186150001. John Tagg and Steve Edwards (24 June 2003) discuss the instrumental use of photography, and how exhibitions can misleadingly imply evidence of history. *The Camera at Work* series explores historical, sociological and aesthetic issues related to the photographic representation of work. It coincided with Tate Modern's major exhibition Cruel and Tender.
3 See Barthes's short essay 'The Great Family of Man' in (1993a) *Mythologies*, Vintage: London, pp. 100–2.
4 Ravi Agarwal (New Delhi, India 1958).
5 Sylvia Grace Borda (Canada 1974): http://sylviagraceborda.com/capitalcities. html. See also *Every Bus Stop in Surrey* (2004).
6 Ed Ruscha (America 1937): http://thephotobook.wordpress.com/2010/04/05/ed- ruscha-photographer/; http://www.reframingphotography.com/content/ed-ruscha.
7 http://www.sfmoma.org/explore/collection/artwork/15418; http://www.museumas hub.org/neighborhood/new-museum/bowery-two-inadequate-descriptive-systems.
8 Ann-Sofi Sidén (Sweden 1962).

Part 2
The documented city

4 Walking the city

This chapter considers the 'street' as a site of social encounter and display. It establishes different orders of representation driven by the attitudes that motivate documentation and its presentation. Chapters 2 and 3 have established the significance of agency and the roles of the author, function, culture and context in determining the representation of objects and ideas. Chapters 4 and 5 will discuss the 'documented city' in relation to conceptions and productions of space. Both consider how photography can describe the process of living in the city rather than merely its visual appearance. This chapter discusses what and how something can be documented, in terms of how we observe and what we represent, and uses de Certeau's metaphoric description of walking in the city to focus different attitudes. Chapter 5 will focus on the use of the photographic document for social and political ends.

Different orders of representation

How the city – its constituent elements and the inhabitants who live there – is documented contributes to how a city is perceived. Lefebvre's discussion asks how can space be represented, read or understood? He stresses a concern for the 'dialectical character' of space that is evidenced by practical relationships, and the interaction and conflicts 'between "subjects" and their surroundings' (Lefebvre 1991: 17–18). Similarly, we can ask what and how can photographic documentation tell us about attitudes to, and interaction with, the urban environment? Speaking about appearances, realities and illusions, Lefebvre doubts that photographs can expose the real problems that are represented by the *appearance* of specific spaces, and says, for example, that because photographs fragment space, they are more likely to reinforce illusion than reveal underlying practical realities. He says that illusion already resides in the photographer's eye, gaze and lens, so that photographs are suffused

with the photographer's inflection or prejudice (96–7). Lefebvre then suggests that occasionally the photographer can transcend this conundrum and 'transgress the limits of the image' so that something emerges that answers to other criteria than clarity or readability. This possibility of transcendence echoes the aspirations of modernist photography.[1] Photographs are contradictory in that they facilitate our need to filter the wealth of visual information that we are confronted with and, in so doing, they abbreviate that information. They can reduce subjects to a generalization, ignoring the specifics of history, and merely confirming held opinions and superficial views. At the same time they can be used as a mechanism for focus and concentration – their perspective and frame can direct attention and force us to consider particular fragments or moments – as with Coulthurst's photographs of 'how the poor live' in Manchester. The problem is that, not only do photographs visualize the city as we imagine or conceive it, but they *reduce* the complexity of relationship and practice to the appearance of objects. The challenge for reading photographs of the city, is how can we understand what is implicit in a photograph or how can details tell us about what is important? And the challenge for the photographer is *how* can photographs demonstrate social practice when they can only refer to what lies beneath the surface of appearance, by implication? How can people's social interaction, day-to-day struggles, desires, memories or mental strife be represented? How can photographers depict more ephemeral feelings, impressions, behaviours and events?

De Certeau differentiates between two modes of experiencing the city, represented by *observing* (voyeurship) and *walking* (*flânerie*). I use this division to help distinguish the different orders of attitude to documentation. Like Benjamin's commentary on the *flâneur*, de Certeau's essay 'Walking in the City' (1988: 91–110) offers metaphoric perspectives from the point of view of the *flâneur* who walks in the city, and the voyeur who looks down on the city and observes rather than participates (see also Chapter 1: Cities and urbanism). His descriptions echo contrasting attitudes to photography: distanced observation or invested engagement; authorial expression or political commentary. The *flâneur* epitomizes the phenomenological tradition that places the subject (photographer) at the centre of [his] world – in this case the city. The general assumption of the modern thinking individual is that the world can be understood by focusing on [his] experience, and roving round the city's streets as a *flâneur* follows that same premise. Walking in the city finds its photographic equivalent in 'street photography', where the existential encounter is central to understanding experience and characterizes the photographer's attitude to what he sees. The photographer-*flâneur* adopts

different personas (photographic styles): for example, the distant or amused observer, the 'photography-worker', the social commentator, the participator. *Flânerie* requires immersion in the experience; voyeurism requires distance. Photographs of the street, in whichever tradition or era, have elements of both attitudes – street photography can be distanced specular vision or more personal and idiosyncratic. Whilst the main thrust of documentary photography is social critique, the emphasis of art photography is traditionally the photographer's 'idea' or 'expression'. Both document everyday life.

BOX 4.1

The *flâneur*

> The lover of universal life enters into the crowd as though it were an immense reservoir of electrical energy.
> (Baudelaire 1964: 9)

Charles Baudelaire's metaphoric figure of modernity – the *flâneur* – brings together a number of elements characteristic of living in the modern city: being modern; being alone but among others in the crowd; experiencing the everyday; being free to roam, to survey, think and create. He describes [1863] the 'perfect flâneur', the 'passionate spectator', whose element is the crowd, who gazes upon the landscapes of the great city and who values the passing moment and all the possibilities it suggests (1964: 4). The *flâneur* searches for the quality of 'modernity' by which he means 'the ephemeral, the fugitive, the contingent', the transitory element that changes at every moment (13). Baudelaire understands imagination as needing to penetrate beneath the surface of material appearance in order to discover the hidden analogies behind. Equating the wandering *flâneur* with the creativity of the artist or poet, he describes an artist, such as Honoré de Balzac, as being an 'observer, philosopher, flâneur' whose 'insatiable appetite' for everything around him translates into 'pictures more living than life itself' (9). He conceives the artist of modernity as defining his vision by observing subjects of city life and finding the eternal in the everyday rather than in stylistic romantic themes.

Benjamin's commentary [1935] extends Baudelaire's metaphors so that Paris and the city wanderer become an allegorical focus indicative

of private individuals and their experience of metropolitan life every-
where (894).

> Paris becomes the subject of lyric poetry. This poetry is no
> hymn to the homeland; rather, the gaze of the allegorist, as
> it falls on the city, is the gaze of the alienated man. It is the
> gaze of the flâneur, whose way of life still conceals behind
> a mitigating nimbus the coming desolation of the big-city
> dweller. The flâneur still stands on the threshold – of the
> metropolis as of the middle class. Neither has him in its power
> yet. In neither is he at home. He seeks refuge in the crowd
> . . . The crowd is a veil through which the familiar city beckons
> to the flâneur as phantasmagoria – now a landscape, now
> a room. Both become elements of the department store, which
> makes use of flânerie itself to sell goods. The department store
> is the last promenade of the flâneur.
>
> (Benjamin 2002: 10)

The city of the *flâneur* is an entire world that encompasses every
dimension of external and internal life – artistic vision, mental landscape
and material desires. His fantasies are materialized in the trappings of
modern life: the seduction of the department store and of smiling
women, the tempo of Paris traffic. Each description lends a different
analogy; as he traverses the asphalt (the solid materiality of earth), he
is led by 'the magnetism of the next street corner' (the hypnotic attraction
of the city) into a 'vanished time' (an understanding of history or another
perspective). Every street is precipitous (potentially dangerous), experi-
ence of the big city is alienating and his gaze is distanced; the crowd
becomes a form of psychological protection in which he can hide. The
aimlessness of walking intoxicates him as each step gains momentum
(Benjamin 2002: 879–80). Benjamin aligns strolling the city with
a political attitude that recognizes the domination of capitalism and
the manifestation of consumerism that dictates city life and its culture,
the exclusion of the working man from urban constructions such as
Haussman's or le Corbusier's, and the awareness of the individual and
his relationship to community.

Different qualities of wandering and watching can be seen in a series
of subsequent written encounters, each pertinent to their time – Breton's
Nadja [1928], Umberto Eco's *Travels in Hyperreality* [1986] or Jean
Baudrillard's *Cool Memories* [1996].

However, whilst the histories of these two genres interrelate, their motives and interaction with the city and street are different: Annan's photographs aim to *expose* what is there, whereas Gary Winogrand's aim to *enjoy*. This distinction highlights different attitudes to 'looking' and to 'photographing' the city.

Street photography

The genre known as 'street photography' has a long history originating with, for example, Charles Nègre in France (1850s), John Thompson in Britain (*Street Life in London*, 1877) or Joseph and Percy Byron in New York (1890s). It is associated in twentieth-century Europe with the works of Eugène Atget, Brassai and Henri Cartier-Bresson, and, in America, with Walker Evans, Helen Levitt, Gary Winogrand, Robert Frank and many others. As another metaphor for the 'everyday', the street provides a backdrop or stage on which all manner of encounter takes place. Joel Meyerowitz's description exemplifies two characteristics of 'street photography' – immersion in the crowd and the search for the exquisite moment:

> It's like going into the sea and letting the waves break over you. You feel the power of the sea. On the street each successive wave brings along a whole new cast of characters. You take wave after wave, you bathe in it. There is something exciting about being in the crowd, in all that chance and change – it's tough out there – but if you can keep paying attention something will reveal itself – just a split second – and then there's a crazy cockeyed picture!
> (Meyerowitz in Westerbeck and Meyerowitz 2001: 2–3)[2]

The central significance for photography in the street is the attitude of the photographer who can be motivated in different ways, such as seeking out instances of injustice, aesthetic congruence or entertainment. The manner in which the photographer intervenes in taking the photographs, and the manner in which individuals, spaces or objects are presented, determines the level of commentary, expression or subjectivity. Gary Winogrand is typical of the distanced photographer who is disengaged from his subjects and focuses on spontaneous vision and ultimately the integrity of the picture rather than specific social concerns. This attitude of distance and spectatorship is recognized as being the mark of the photographer 'as artist':

> The fact is, when I look in the viewfinder, if I do see it as a picture, I'll do something to change it. Because, in the end, the pictures that you see

when you're working are the pictures that you know already. Either somebody else's made them, or you've done it already. I'm not interested in that.

(quoted in MOMA 2001: 14)

Robert Frank's series *The Americans* [1958] demonstrates a different exchange between the document and artistry. Whilst not being documentary that pointedly describes social conditions, *The Americans* is ambivalent and complex, and perceived at the time as being critical. It expresses an ambiguous and unspoken view, so that it is hard to pin down how it makes comment exactly (Westerbeck and Meyerowitz 2001: 354).

Methods that maintain distance vary with the attention given to looking or developing a narrative, the level of personal engagement with street life, and the use of chance or studied attention. The issue of authorial control has consistently occupied photographers and remains a central theme today. For example, in contrast to Cartier-Bresson's persistent concentration on defining a moment, twentieth-century advances in technology and the growth of amateur photography encouraged the ambition of snatching confluences of circumstance or uncanny juxtaposition, which have since been adopted by

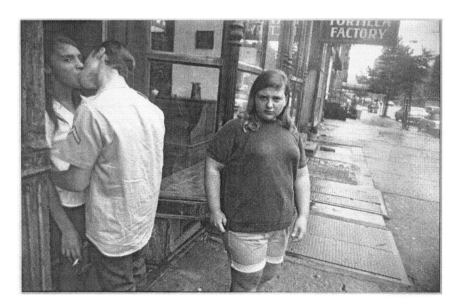

Figure 4.1 Gary Winogrand, *New York*, 1969. Gelatin silver print (27.94 × 35.56 cm). San Francisco Museum of Modern Art; Gift of Carla Emil and Rich Silverstein. © Garry Winogrand Estate.

professional photographers as a 'style'. The candid shot, which captures a chance encounter or the strangeness of people, is a central feature character-ized by Gary Winogrand's image of a smartly dressed couple carrying chimpanzees through *Central Park Zoo, New York City*, 1964. Martin Parr continues the tradition in his pursuit of the peculiarity of the English (*Think of England*, 2000). The photograph's capacity to reveal what the eye does not see prompts the photographer's aspiration to expose something extra-ordinary or the 'true character' of the subject as a marker for 'reality'. This tradition searches for ever more unlikely and unattractive aspects of a city. Street photography claims its status as art by aspiring to a depth of meaning exemplified in work such as Evans's 'lyrical documentary style' [1964],[3] which articulates a documentary form touched with expression (the artist's mark) and suggests that photography can be both simply factual and yet still transcend the everyday. Whilst 'street photography' depicts what people are doing in cities, the photographer's idea supersedes the specific reality of content – fragments, even abstract shape, can represent a full range of human experience, frailty, alienation and exchange.

The photograph transforms the transitory and accidental into permanent record, making it appear normal or even typical or essential. As such, it has the capability of creating myths. By pointing out the endearing qualities of humanity in its many peculiarities, it thereby provides a comforting reassurance that in the face of adversity, people 'pull together', they are tough and resilient or enjoy life. The photograph shows us extremes and ultimately makes the world appear as cruel or kind, beautiful or safe. Helen Levitt's work is typical of black and white street photography with respect to her focus on everyday life on the streets of Spanish Harlem in New York and the joyful respect she shows for the subjects she presents.

> The streets of the poor quarter of great cities are, above all, a theatre and a battle ground. There unaware and unnoticed every human being is a poet, a marker, a warrior, a dancer and in his innocent artistry he projects against the turmoil of the street, an image of human existence.
>
> (from an introduction to the film *In the Street* (1945–46)
> by James Agee, Helen Levitt, Janice Loeb
> in the streets of Harlem, New York)

> [Levitt's] photographs were not intended to tell a story or document a social thesis; she worked in poor neighborhoods because there were people there, and a street life that was richly sociable and visually interesting. Levitt's pictures report no unusual happenings; most of them show the games of children, the errands and conversations of the middle-aged, and the observant waiting of the old. What is remarkable about the photographs

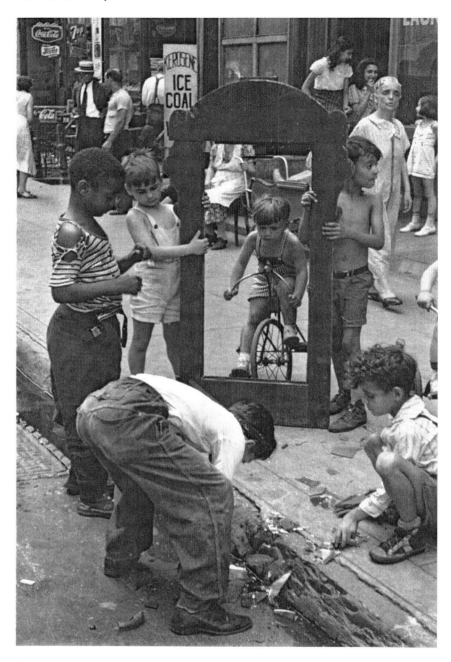

Figure 4.2 Helen Levitt, *New York*, c. 1940. Gelatin silver print (19.05 × 11.75 cm). San Francisco Museum of Modern Art, purchase through a gift of Paul and Prentice Sack. © Estate of Helen Levitt.

is that these immemorially routine acts of life, practiced everywhere and always, are revealed as being full of grace, drama, humor, pathos, and surprise, and also that they are filled with the qualities of art, as though the street were a stage, and its people were all actors and actresses, mimes, orators, and dancers.

(Szarkowski 1980: 138)[4]

Perspectives on the street: objectivism and the voyeur

Seeing Manhattan from the 110th floor of the World Trade Center. Beneath the haze stirred up by the winds, the urban island, a sea in the middle of a sea, lifts up the skyscrapers over Wall Street, sinks down at Greenwich, then rises again to the crests of Midtown, quietly passes over Central Park and finally undulates off into the distance beyond Harlem. A wave of verticals. Its agitation is momentarily arrested by vision. The gigantic mass is immobilized before the eyes. It is transformed into a texturology in which extremes coincide – extremes of ambition and degradation, brutal oppositions of races and styles, contrasts between yesterday's buildings, already transformed into trash cans, and today's urban irruptions that block out its space.

(de Certeau 1988: 91)

The city in its entirety is not visible, but looking down upon the city from the top of the Twin Towers lends a specular emphasis to the experience, whereby 'the spectator can read [the city] as a universe that is constantly exploding' and whose 'agitation is momentarily arrested by vision'. From this distant elevated position, the city is more readable because it is reduced to 'an optical artefact'. The distanced spectator escapes the city's 'grasp' and gains the advantage of apprehending the 'panorama-city' as a total conception spread out before him (91–3). Spectatorship assumes the camera as a phenomenological extension to our eyes in the sense that when we look, or hold up a digital camera to see the frame, we minimize the 'view' spatially, and we abstract and reduce the experience conceptually. A specular perspective of the city demonstrates the voyeurship of both the viewer as spectator, and the photographer as *auteur*. At the centre of the optical response is 'pleasure'. The photograph is a source of pleasure and as an object to be looked at, it is therefore problematic as a reliable document. De Certeau's description of an optical city suggests the superficiality of photography's testament that can reduce the enormity of a city's activity to one beautiful cityscape. For example, Sze Tsung Leong's photograph of Shenzhen presents the city as an object entirely constituted by physical fabric and organized

structure; it translates the city into an optical artefact that excludes any reference to its inhabitants.

Adding another dimension to de Certeau's metaphor, this specular perspective can be seen to work on a more intimate level, one in which the act of photography creates a distance between photographer and the object of representation. The photograph visualizes the position of power that is involved in looking and being looked at, and which resides in the active role of the subject who 'takes the picture' of someone/something else (the object) who is implicitly in their possession. We assume the right to look at anything or any person that is presented to us. Our attitude turns whatever and whomever into an 'object' for discussion because it is now 'captured' in an image and therefore translated into an object available to us all. Different photographic styles demonstrate degrees of distance in relation to the subject, and of the power exerted in relation to authorship. And situations in which subjects are unaware of being photographed can be viewed as examples of clandestine surveillance and objectivism (see also Box 3.4: Metaphor, power and surveillance). An extreme example is illustrated by observations using a long distance lens[5] or taken anonymously with hidden cameras on the *Subway* (Walker Evans, 1938–41) and *Metro* (Luc Delahaye, 1995–97).[6]

Both of these series involve an indiscriminate surveillance that relinquishes any authorial social commentary or psychological translation. As with Evans before him, Delahaye secretly conceals the camera, controlling the shutter from his pocket and relinquishing responsibility for any sort of image construction, other than the decision to press the shutter. Both series present a twentieth-century context for Baudelaire's ambivalent relationship to the crowd, of 'being alone among others'. In the Metro carriage we are pressed up against one another, forced into an encounter that is both physically close and psychologically distancing. *Metro* visually isolates individuals in such a way that displays Benjamin's 'gaze of the alienated man', as it emphasizes the contrast between the exterior face of the 'other' and their impenetrable internal life, which we cannot know. These individuals appear to be so immersed in the experience of being alone in the crowd that they have lost themselves; they stare away from us vacantly, not looking at anything but their internal reverie. The series illustrates the unspoken contract between people in the city who protect themselves from any real intrusion by others. With no acknowledged visual contact between photographer and subject, it is a contradictory confrontation in which the external mask of self-consciousness meets the unself-conscious mask of absence (Baudrillard 1999b). But how can they *not* know that they are being photographed? They appear, if only unconsciously, to be complicit in a strange joint enterprise.

Delahaye concedes this element of collusion to the point where he mirrors their behaviour: 'I am sitting in front of someone to record his image, the form of evidence, but just like him I too stare into the distance and feign absence' (Delahaye 1999). As a mechanism for getting closer to a subject

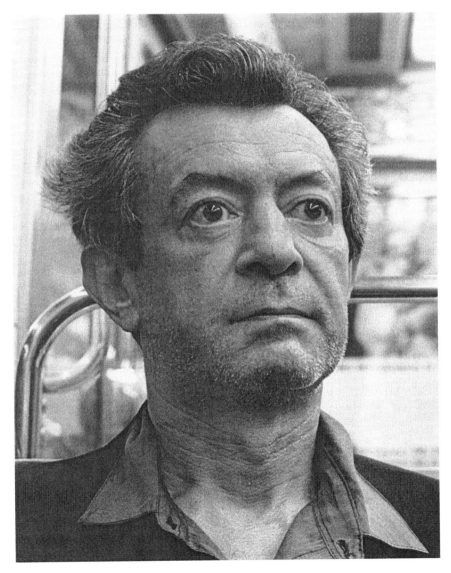

Figure 4.3 Luc Delahaye, from the series *L'Autre*, 1995–97. Courtesy of the artist.

without the necessity for face-to-face encounter, the anonymous photographer can be interpreted as presenting total spectacle.

Delahaye's *Metro* is an extreme example, whereas most observations of people are somewhat more complex and lie somewhere between objective and subjective positions. For example, Agarwal's approach is driven by his commitment as a social activist, whilst his photographs are dictated by his process as a photographer. Bourdieu's discussion [1980] of sociological study offers another perspective on voyeurism and the ethical questions ever present in photographing people. In observing objects or other people, we apply existing attitudes to that observation and proceed as if they were solely there to provide evidence for, and confirmation of, our point of view:

> Objectivism constitutes the social world as a spectacle offered to an observer who takes up a "point of view" on the action, and who, putting into the object the principles of his relation to the object, proceeds as if it were intended solely for knowledge and as if all the interactions within it were purely symbolic exchanges.
>
> (Bourdieu 2010: 52)

An objectivist view sets out to establish objective regularities in structures, laws and relationships (25). And to establish a coherent picture of any society, traditional ethnological study attempts to impose a distanced objectivity in order to gather information and knowledge of any cultural group by observing their behaviours. It sees the social world as a representation, in which observed practice 'acts-out' and confirms a series of roles. What can be observed in behaviour (*habitus*) represents for us the wider spectrum of practice – the small part or gesture represents the whole. Photographs work in the same metonymic way. In looking at a series of images, we can determine that the behaviour displayed is typical and fail to pursue or notice differentials in behaviour. Photographic representation of people easily lends itself to the fabrication of stereotypes or sentimentality, so that someone's attributes override their individual subjectivity. Immortalized in a photograph, which doesn't describe an individual anymore, but an idea of a particular *type* of individual, an individual can become representative of a condition. An individual is diminished and becomes a symbol for 'poverty' or 'work', for example. We can be seduced by stereotypes, by oddities or the uncanny, and assume them as being typical. We can imagine these people as always being in this room, in this house, in this city: workers in Surat permanently exist in these hot, sweaty and dimly lit conditions (see Agarwal in Chapter 3). We define them according to their appearance and circumstance, and form a generalized view on the basis of these few observations (Bourdieu 2010: 55) (see also Box 3.2: The agency of exhibition).

Bourdieu contributes to the understanding that sociological study requires awareness with regard to this so-called 'objectivity', which presumes to 'know' a society by observing its practices. To avoid reducing knowledge to a singular instance or self-perpetuating view, we have to recognize our own subjectivity, and to situate ourselves in a practical relation to the world. Bourdieu's focus on the *active* presence of structures evident in *habitus* attempts to understand the processes of change in social practices and to move beyond the opposition that tends to exist between an objective position and a wholly subjective one. Because *habitus* is locally specific, there are limitations to what can be understood from observation and to what can be deduced or generalized (de Certeau 1988: 57–9). But, if *habitus* is interiorized and unconscious, it is difficult to observe it ourselves. Thus traditional ethnological study assumes that knowledge of a societal system requires the unconsciousness of the group studied. Bourdieu states: 'It is because subjects do not know what they are doing, that what they do has more meaning than they realize' (quoted in de Certeau 1988: 56). Similarly, being observed without knowledge, which is a tradition in documentary photography, assigns privilege to the observer (both photographer and viewer).

In discussing photography's use in visual ethnography, Sarah Pink identifies the difference between the nineteenth century's objectifying gaze of imperialism and the attitude used in projects such as the Farm Security Administration [1935–44] in the United States, as being that of 'intervention' or 'participation'.[7] Social intervention might range from using visual practice to empower research participants with new levels of self-awareness, to promote a specific cause to a target audience, or to provide decision makers in business or policy contexts with 'evidence' that will inform their work (Pink 2007: 7). The key elements are seen as using visual anthropology as a 'problem solving practice' that invokes collaboration with 'participants', who are not merely looked upon as evidence or facts, but are collaborators in a self-reflexive exercise – with the aim of change (Pink 2007: 11–12). Contemporary ethnographical studies have developed procedures, which involve the participation of the culture being studied. Rather than studying behaviours and theorizing generalities from them, sociologists are careful to acknowledge the significance of difference, and the power relations involved in observation. The difference in approach in twenty-first-century photography largely resides in a self-conscious use of photography informed by postcolonial and socially political theories. A different sort of knowledge is gained through photographic operations that similarly involve participation (see also Box 5.1 and 'Market Photo Workshop' in Chapter 5).

Perspectives on the street – *flânerie* and immersion

An alternative to an objectivist response to the city is represented by de Certeau's description [1980] of the immersive experience of walking. The photographer and theorist Victor Burgin describes walking through the city for the first time as a primitive encounter in which we 'go looking for the city', which ultimately eludes us (Burgin 1996: 7). Life in the city is elusive and confusing – we pass objects that we cannot wholly see, catch glimpses, encounter people head on. We are unable to separate ourselves sufficiently from the experience to *see* the systems that exist, and in that sense the city is unreadable, ungraspable. At the same time, walking a path through the city forces a reaction to the space encountered, and in the course of that process the city is rewritten by happenstance, expedience and habit (de Certeau 1988: 98). Walking in the city confronts the daily practices that escape the visual and cannot be totalized by observation, so that the city retains a strangeness that counters and confuses the visible (93). De Certeau is concerned to locate those particular practices that are not 'visual, panoptical or theoretical constructions', which are found in the particular quality of individual footsteps – metaphorically and physically – that mark the city. The direction of walking, which indicates purpose, appropriates the topography encountered and activates a relationship between the pedestrian, the space and others in that space. De Certeau aligns this enunciative function of walking with the meaning of words and with the 'speech act', indicating that the effect of the pedestrian cannot be only defined by geographical mapping, just as speech cannot only be defined by the words uttered: gestures, deviations and hesitations add another dimension of meaning that is difficult to define or wholly comprehend (see also 'Systems of representation: psycho-geography' in Chapter 8).

De Certeau's 'rhetoric of walking' is used figuratively to explore the possibility of displaced meaning in the same way 'a tremulous image confuses and multiplies the photographic object' (100). By their nature, photographs reference beyond what is seen: 'the bicycle or the piece of furniture in a store window stands for the whole street or neighbourhood' (101). Because photography acts metonymically it can illustrate all aspects of living and thinking in the city; photographs of statues and monuments illustrate mythologies and traditions; depictions of living conditions indicate morals and values; physical structures, detritus and communication systems are testament to a city's spiritual life. A city's politics can be represented by its governmental buildings, its power enforcement by prisons, its social welfare by hospitals, its cultural activity by its artistic life and its libraries. In all cases,

photographs of 'things' represent much bigger things – ideologies, values, economies. A specific place in the city is an idea as well as a place that, in a sense, does not exist – a 'poetic geography' (104–5). For example, a photograph of the World Trade Centre in New York signifies world economy and the mechanisms of capitalism, the ironies attached to the term 'world' and, after 9/11, the differences between the 'west' and the aspirations of radical Islam. These 'things' become symbols for whole systems.

BOX 4.2

A mental landscape: Breton's *Nadja*

> I have begun by going back to look at several of the places to which this narrative happens to lead; I wanted in fact to provide a photographic image of them taken at the special angle from which I myself had looked at them. On this occasion, I realized that most of the places more or less resisted my venture so that as I see it the illustrated part of Nadja is inadequate.
>
> (Breton 1994: 151–2)[8]

André Breton's Paris, described in *Nadja* [1928], is one of an internal world of reflection and oddities of the unconscious. Where Baudelaire's *flâneur* is excited by the 'electrical energy' of the city, Breton's *flânerie* is self-conscious and obsessive, motivated by chance and the singular incident. His story relates a series of observations of his day-to-day life, episodes and encounters, reflections of what people say to him and the associations provoked: 'a world of sudden parallels, petrifying coincidences and reflexes peculiar to each individual' (1994: 19). It recounts his experience of encounters with Nadja, whom he describes as 'this always inspired and inspiring creature who enjoyed being nowhere but in the streets, the only region of valid experience for her, in the street' (113, 102), and whose whims he follows, and with whom he wanders through the streets – together but separately.

Breton's city is an example of an attempt to conceive reality differently from one that centres on vision and objectivity. His sense – at the limits of his existence and 'quite unknown' to himself – is of an inadequacy that prevents him experiencing what is in front of him:

> Perhaps my life is nothing but an image of this kind; perhaps
> I am doomed to retrace my steps under the illusion that I am
> exploring, doomed to try and learn what I should simply
> recognize, learning a mere fraction of what I have forgotten.
>
> (12)

His loss of self is in some respects deliberate, striving as he does toward lacking 'presence of mind' and being at the mercy of chance (39). Breton's objective chance is symptomatic of the Surrealist's awareness of the unconscious motivations that drive our existence everyday in ordinary, yet marvellous, activities. It is a pursuit of a kind – of desperation, of illogic, of 'intellectual seduction' – a kind of test that abandons him to the 'fury of symbols' and leaves him 'prey to the demon of analogy' (108).

Breton's *Nadja* highlights the tension between immersion and spectatorship. His use of deliberately unremarkable photographs by Jacques-André Boiffard, attempts *not* to describe his experience of the city but to parallel it, to document the city in a way that eliminates all thoughts of aesthetics or symbolism. They are indicative of an attitude that avoids pictorial effects. The objective, of avoiding the insistent voice of narration, is to keep the description simple and clinical. He does not describe what things look like but rather lists what happens and seeks out facts – 'slope facts' and 'cliff facts' – 'which belong to the order of observation', which cannot be pinned down to any one signifier, and yet are of an 'unexpected, violently fortuitous character' (19–20). Breton presents the city like a 'cryptogram' that has to be deciphered (112). Each scene acts as a mnemonic or metonym that points to the exchange that took place there or that prompted the dialogue or the intimate reverie. He is concerned with associations and the 'mental landscape' they provoke. Because they are empty of human presence, the banality of the photographs inserts a space for contemplation – a mindful roving of the imagination. They are significant for what the photograph leaves out – the presence suggested by absence.

See Jacques-André Boiffard, *Nous nous faisons servir dehors par le marchand de vins* [*We have our dinner served outside by the wine seller*], Place Dauphine in *Nadja*, 1928: http://www.centrepompidou. fr/education/ressources/ens-subversion/ens-subversion.html.

Perspectives on the street: memories and dreams

In 2001, the Photographer's Gallery installed the works of Richard Wentworth and Eugène Atget simultaneously and described them both as:

> Authors of photographic compendia which describe the great cities of London and Paris poised at two very different moments of change – at the twentieth century's beginning and at its end. For both, the city is a vivid yet fugitive place, continually undergoing cycles of renovation, disintegration and renewal once more. Its pavements are a 'stage' for social activity, and its physical details, however fleeting, full of meaning about the nature of an urban society – and what the individuals within it, own, do, make and improvise.
> (Photographer's Gallery 2001, exhibition information)

What the works of these two photographers have in common is an economy of content and a reliance on simple objects or empty space. They demonstrate that the photograph presents physical and symbolic aspects of the city, and provokes associations and ideas beyond the objects depicted, in several ways. First, photographing objects in an unusual place or juxtaposition is a typical method used to 'elevate' the everyday. Transforming the forgotten, hidden and ordinary object to something extra-ordinary can be seen as a common theme throughout the twentieth century, from the very straight photographs of objects by Paul Strand (*Wire Wheel*, 1917 or *Black Bottle*, 1919)[9] or Brassai's more playful *Involuntary Sculptures* (1933) to, for example, Keith Arnatt's *The Tears of Things* (*Objects from a Rubbish Tip*) (1990–91), the poetic juxtapositions of Gabriel Orozco (*Pinched Ball* or *Breath on Piano*, 1993) or Richard Wentworth's *Making Do and Getting By* (1974–2001).[10] Second, a photograph can represent desire or provoke memory. By representing the past in the appearance of things, photographs keep it present, and give an illusion of retrieving the past, so that the photograph ('memory-object') serves as a substitute for something else (Lefebvre 2008c: 133). The photograph, as fetishistic object, not only compensates for, but accentuates the loss or lack of something, particularly in images of people whom we know or have known, or of places that were once there but are no longer. Photographs betray desires implicitly by metonymic association, and by what is absent. However, the photograph's facility to fetishize objects and create mythology is seen as a problem, particularly if it claims to document some semblance of truth (see, for example, comments by the October Photo Section in Chapter 2). Third, the photograph can be used to represent aspects of psychological life. The use of inanimate objects to indicate something significant and the acknowledgement of the unconscious world are key legacies of the Surrealists, who positioned the parallel activity of unconscious

Corbett Street, Bradford, Manchester, 2011

Silent meditative images of the 'then' and the 'gone' and the 'not there' that shadow the new now. Bricked up lamentations for redundant journeys of industrial function whose dusty echoes still faintly reverberate from thinly tarmacked cobbles littered with broken glass and faded unknown narratives and destinations.

Richard Johnson & Nephew Wireworks, Mill Street, Bradford, Manchester, 2011

One Saturday afternoon returning from the Royal cinema where I watched Zorro escaping amazingly once again, I met my Dad, the welder, and he took me on an impromptu tour of his workplace. The smell of hot metal and oil, smoke, large gas fuelled vats of sulphuric acid and molten zinc with moving strands of steel wire being pulled through them, the forge and furnace, the dark dust deep cooling tunnels with mobile rows of metal coils, the factory cat and its kittens in their home, an upturned dustbin lid. I still see it all with poignant love and respect; a big brilliant kinetic adventure that filled and fills me with wonder.

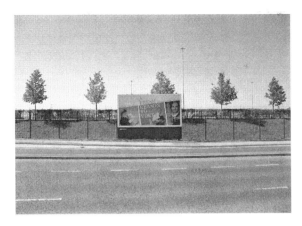

The Park Inn, Mill Street, Bradford, Manchester, 2011

A place of startling characters, conversation, argument, specific stories and anecdote. A space to watch and listen in, drinking cool lager in small, crowded, animated rooms with my Dad; just opposite the night-time dark mystery of Philips Park on Mill Street.

St. Brigid's R.C. Church, Mill Street, Bradford, Manchester, 2011

My years as an altar boy here genuflecting to the sound of a bell, in procession down and round the aisles through clouds of incense, holding candles, saying a novena with my Mam, singing in the choir with Rita Deegan and Mr. Murray as Joe or John pumped the organ, reading my missal in front of a flower filled multi-candle lit altar and feeling very small. Now there's lots of sky where the church stood.

Figures 4.4 to 4.7 Pete Ellis, from the *Bradford Manchester* series, 2011. Courtesy of the artist.

thought alongside everyday experience, and promoted the reality that is present in dreams, as being as valid as that of everyday life. In these terms, everyday life is permeated by dreams, which speak to us in a different but equivalent way [Breton 1924]. And walking about in the city intersperses concrete appearances and encounters with involuntary reverie and memories. An immersive experience of the city, which recognizes the physical and the psychical, requires an order of representation that accommodates unconscious dimensions. However, whilst photographs can give literal appearance to experience, once a photograph of an object, scene or person is seen to represent a memory or idea, it simultaneously reduces that memory to that object, scene or person.

Photographs evoke memory and provoke thought, by either providing detailed evidence of the past or of what is absent from the present. The series by Pete Ellis attempts to use photographs to recall experience, by returning to the area of East Manchester in which he grew up. The photographs present both the potency and the limitation of photographs, which document physical presence, to represent the loss in time.[11] Bradford (M11), within walking distance of central Manchester, once consisted of a teeming meandering of little terraced streets surrounding a coal mine (with the deepest pit shaft in Britain), a steel wireworks and a scattering of lively exuberant street schools amongst the busy pubs, corner shops and a market that had magical hotdogs. Heavy industry was maintained by an indigenous working class with a fiercely socialist heart, until it was dispersed to the badlands of Wythenshaw, Langley or Whitefield where there was and is absolutely no danger of any industry whatsoever. What was once there is now replaced by anodyne, vacuous, characterless spaces avenued with cenotaph trees, determinedly and evenly placed, but lacking any sensible meaning of place; places are utterly abbreviated as they measure out a new 'nice' urban space between recently arrived, but enigmatically remote, and alienating buildings. 'Bright' redevelopment and enterprise blanket and muffle a zillion miniscule but threaded histories, presently and distantly dim but once a blaze of vivid, vital vibrancy. Only the location endures, endlessly re-edited and re-mapped by successive conceptions of function and urban design. Memories of older dwellings, factories, churches, pubs, schools and shops are dislocated by a dispersed virtual recall, a free-falling reverie of the emotional expanse that still haunts him.

Living spaces

I am interested in the urban environment as a phenomenon which is basically a product of social experience. The existence of any city is rooted in basic

human needs – to be warm, safe and part of one's community. Nowadays, however, the cities have turned into immeasurable agglomerations in whose social and consequently architectural constructions people have found not only shelter and security, but also disorder, alienation and loneliness.

(www.alnisstakle.com)[12]

The work of Alnis Stakle reiterates many of the issues raised in this chapter. Like much street photography, his photographs centre on people and their interaction with their surroundings. However, his focus on social experience relinquishes the conscious pursuit of the *extra*ordinary event, characteristic of the American tradition, and does not display the more obvious *signs* of the city, such as crowds or municipal buildings. He does not wait for uncanny moments, but is seemingly more aimless. His process echoes the principles of *flânerie* – the immersion in spaces – both in terms of the most private spaces of day-to-day living and of his shared culture. Like Breton, his use of photographs emphasizes absence and initiates a subjective contemplation. The series *L.S.D. Living Space – Daugavpils* (2002–08) depicts commonplace suburban landscapes on the fringes of Daugavpils (built during the Soviet era and Latvia's second largest city) and shows us something about what it is to live in a Baltic state following the collapse of Soviet control in 1991. *L.S.D. Living Space* presents contradictions – between what is visibly 'there' and what is also there but not visible, and demonstrates the photograph's capacity to show us aspects of living that are ungraspable and which speak of associations and memories. The series demonstrates a photographic potency whereby absence of any event or significant object presents a desire for what is missing or a nostalgia for the past and what has gone before – in this instance a Socialist past. Taken at early morning or dusk, the scenes are barely light. Yet points of colour – green car doors, garage doors, pink and green washing hanging, orange hat, blue coat and pink coat – are illuminated by lighted windows or by their sharp contrast with the dull and uneventful surroundings. Drab scenes, lacking in content, force easy metaphors for the collapse of a former way of life, a failed vision: Swain describes these sparse scenes as a 'place where glimmers of hope can be found amongst the residues of the past' (Swain 2006) and Vilnis Auzins as 'a story of unconscious emptiness' (Auzins 2003).

Stakle's implicitly political commentary is characteristic of many series that reinterpret the 'everyday' in the face of political collapse and social change. His work is typical of a development in 'documentary type' photography, notably common in Central and Eastern Europe, which has a strong tradition

of social documentary. Twenty-first-century emphasis retains features inherited from the many photographers in Eastern Europe who, working under communist regimes and in the face of censorship, recorded the stark realities of daily life (e.g. Antonas Sutkus, *Daily Life Archives*, 1959–93).[13] Contemporary projects continue to eschew the heritage of Socialist Realism with its sentimental idealism that bears little resemblance to the realities of living. A post-Soviet development is one of stark frankness, a gloomy straightforwardness without pretensions to the uncanny or candid, and which does not appear to make any formal effort. As social commentary, their style can be particularly bald in this respect (e.g. Boris Mikhailov's *Case History* of Kharkov, 1999). Rooted in autobiography, they can be seen as peculiarly

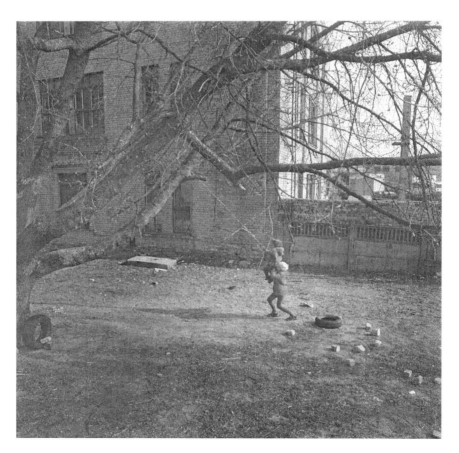

Figure 4.8 Alnis Stakle, work from series *L.S.D. Living Space Daugavpils*, 2001–06. Courtesy of the artist.

inward looking in their focus on establishing a new sort of identity. David Bate characterizes the style as possessing a form of poetics, peculiarly un-Western, which is 'compulsively irritating' in its depiction of seemingly 'pointless scenes' that juxtapose unremarkable elements such as 'a dog and a tree' or a 'house and a blanket' (Bate 2006: 50–1).

Stakle's projects focus on a peripheral world, physically and metaphorically. Whilst images are drawn from an immersion in the material city of Daugavpils, Stakle refers to the process as 'subjective documentation', 'meditative emptiness' and 'inner cartography', somewhere between a wholly subjective position and an objective observation of real space. He sees the outer world as a reflection of the inner world. Auzins (2003) describes the work as an essay about a particular place at a particular time, which records a collective memory of its people. Stakle's *Broken Line*, for example, documents the lives of his parents, as they adapt to living in a post-Soviet city, after having spent much of their lives under a communist regime. Stakle's perspective relates a story of a particular kind of existence and a specific experience. It describes a de-centred experience, in which the subjective is projected outwards onto a world of objects and space. Photography here operates as a psychic projection of inner subjectivity. It refers to an interior consciousness that introduces a psycho-geographic perspective, which I will discuss in more detail in Chapter 8.

Production of city space: transitory resistance

> Consider the city once again. It is more than a set of relationships and a congeries of buildings, it is even more than a geopolitical locale – it is a set of unfolding historical processes. In short, a city embodies and enacts a history. In representing the city, in producing counter representations, the specificity of the locale and its histories becomes critical. Documentary, rethought and redeployed, provides an essential tool.
>
> (Deutsche 2000: 201)

This statement by Rosalyn Deutsche [1991] points to the necessary considerations for contemporary documentation: relationships, historical process and specificity. Stakle's series demonstrate these features. Examples of street photography (in its broadest sense) from the Baltic nations give common focus to hinterland spaces. Whilst assuming some of the characteristics of classic street photography, their frequent absence of people inserts an additional sense of vacancy or vacuity, which accentuates a sense of waiting

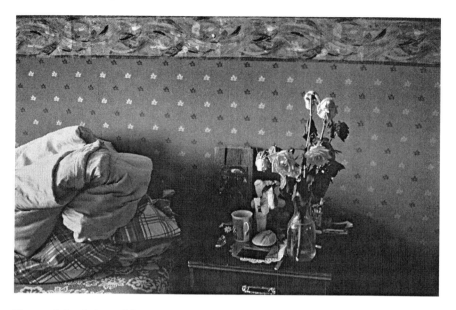

Figure 4.9 Alnis Stakle, work from series *Place for Dreams*, 2001–2006. Courtesy of the artist.

for something to happen or to be inhabited. Speaking about the series *Half Life*, Stakle describes these transitory spaces as 'between the wild and the modernized, the dead, the living and its traces, the meaningful and the absurd' (www.alnisstakle.com). These spaces are not representative of infrastructure or institution, and refer obliquely to the *absence* of governmental management of space. These are not coherent purposeful spaces supporting regime structures but escape government or bureaucratic organization, and express a sort of escapism where space serves as a metaphor for refuge from power. These are unclaimed spaces that resist categorization by function or uniformity, and serve no economic purpose save as the resting place for discarded property, and for all manner of aimless encounter, social exchange and play. In *Talking Cities*, Peter Lewis describes spaces such as these as 'counter-sites to effect' that embed 'an imaginary "utopian" form in liveable, innovative ways', and which bring together 'a sort of mixed, joint experience in which the real sites within a culture are simultaneously represented, contested and inverted' (Lewis 2006: 26–7).

Following years of suppressive regimes, Baltic photographers celebrate, non-spaces and 'economic voids' that escape official control. Lefebvre, de Certeau

and Bourdieu each explain that the 'urban' cannot be conceived as a totality and must ultimately escape understanding. And Lefebvre and de Certeau emphasize the significance of aspects of everyday living that escape the authority of the presiding regime. Discussing Marx's 'mode of production' in relation to different social structures, Harvey explains that each society prioritizes a 'particular patterning of social relationship' and economic integration. Some societies coordinate activity through 'kinship'; Western systems typically base theirs on property ownership, market behaviour and a 'stratified class society'; socialist societies may seek to replace a market mechanism with a centralized planning system.[14] Whichever mode of production is engaged, it has to create conditions to sustain itself in ways that are consistent with its economic and ideological system (Harvey 1975: 199–200). The production of city space can be explained as therefore being dictated by those in power, reflecting the values held by those in power, and serving the interests of those in power. *Half Life* illustrates that urban space cannot be entirely controlled or managed for governmental, economic or social purpose. Besides deliberately planned urban spaces, the production of space responds to political policies more indirectly.

De Certeau echoes Lefebvre's focus on people, the practice of everyday life, his insistence on the *differences* of gender, race and culture in society, and the pursuit of equality without levelling diversity (Lefebvre 2008c: 84–8). Daily life is a chaotic collection of emotions, sensations and interactions, subject to spontaneity and disorder. Lefebvre's 'revolution' insists that the movement, change and action of living should not be obscured by the organizing factors that influence daily life: the homogenizing factors of law, order and time; the habitual factors that separate public from private, nature from technology, foreigners from fellow citizens; the signs of hierarchy such as income, visualized by possessions. And de Certeau asserts the heterogeneity of culture and the resistance to political systems by everyday creative practices such as talking, reading, walking, shopping, cooking (de Certeau 1988: xvii–xxi). He asks what small and popular procedures of everyday life can obstruct the dominant systems of power; how can society resist being reduced by the 'mechanisms of discipline' that constrain lives? His is a more radical demand: how can everyday 'ways of operating' re-appropriate organized space; how can 'these procedures and ruses of consumers compose the network of antidiscipline' (xiv–xv)? East European photographic practices such as Antonas Sutkus's describe a resistance to one regime, and Stakle's projects a resistance to another. Stakle's many different dimensions lend an ironic emphasis to the chaotic details of living and the undemonstrative resistance to the production of space by political systems. Stakle's *Place for Dreams* gives an uncensored account of the most private spaces found in

BOX 4.3

Counter-sites: heterotopia

Utopias, dystopias and *heterotopias* are common themes in photography. Urban *utopias*, if they do not reconcile abstract ideals with the practicalities of living, can result in failed utopias, places where everything is bad and which become the *dystopias* that are recognizable in failed modernist projects – such as the Heygate Estate Elephant & Castle. *Heterotopias* are more ambiguous spaces that have utopian and dystopian attributes. Soja draws parallels between Foucault's *heterotopia* [1967], Bhabha's *hybridities* and Lefebvre's *trialectics*, all of which challenge conventional modes of spatial thinking. Foucault describes the twentieth-century epoch as characterized by simultaneity, juxtaposition and dispersal and the foregrounding of spatiality over a preoccupation with history (Foucault in Soja 1996: 155).[15] He describes *utopia* as somewhere dreamt of (a world that can only be imagined) and, therefore, no-where. To illustrate heteropia he uses the mirror as an example of something that is there (in material form) but not there (in its reflection) at the same time, and the 'boat', which is a self-sufficient place and yet not at rest in one place. *Heterotopias* function like counter-sites that appropriate and disturb 'real sites'. Even though it may be possible to indicate their location in the material world, 'places of this kind are outside of all places' (Foucault in Soja 1996: 157–61). He describes the characteristics of *heterotopia* as contradictory, accumulative, displaced and appropriated, and to be found in: intersections of space and time (museums and libraries), where norms of behaviour are suspended (hospitals), transitory spaces (bus shelters), spaces of passage (edgelands), discarded spaces (wastelands), invented spaces that displace time (see Shanghai's Xintiandi in Chapter 6), spaces that exist outside time or which can be described as places of compensation (shopping malls).

Early photographic examples can be seen in the works of Ed Ruscha and Gordon Matta-Clark, typical in the late 1960s of a very calculated documentation that prioritized concept and idea over photographic aesthetics. In 1967, Ruscha photographed *Thirty-Four Parking Lots* on a Sunday from the air. Useless and bare without cars, city parking lots

become merely 'machines for oilspots' because that's all we see. Yve-Alain Bois describes Ruscha as 'the great census taker of these little nothings that eat away at the city' and which are characteristic of capitalism and mass media (1997: 228). In 1970 Ruscha photographed twenty-five empty property lots in Los Angeles. These were 'negative' non-spaces in a state of transition and destined eventually to be regenerated into something else (*Real Estate Opportunities*). In 1973, Matta-Clark purchased a series of 'economic voids' – kerb-stones, gutter spaces – physically visible but almost imperceptible and of no 'real' value and therefore 'fake commodities'. The title (*Reality Properties: Fake Estates*) points to the contradictions of value and reality. Contemporary photographers have continued this fascination with interstitial spaces, which have since gathered new associations as emblems of the global metropolis, described as *heterotopia*.

These marginal sites that defy definition are typically surveyed in systematic fashion and are seen in the present trend of producing taxonomies of empty or neglected space such as garages, bus shelters, cul-de-sacs: abandoned Chinese Assembly Halls for displaced ideology (see Mu Chen and Shao Yinong in Chapter 6); redundant spaces, rediscovered as a new condition (Stakle's edgelands in *L.S.D.* or abandoned industries following the dissolution of the Soviet regime – *Ex-Pride*).

Postmodern utopias equate with forms of dystopia – of degeneration and superficiality, aspects of which are explored in photographic projects such as *Leisurelands* (Anna Zakalka), second life (Cao Fei) and Dan Houldsworth, *Autopia* series (1996–98). We could describe districts of Johannesburg as either *dystopia* – an antithesis to the one-time modernist dream city, or *heterotopia* – an inverted appropriation of a past utopian dream (see Tillim's *Jo'burg* in Chapter 6). See also projects such as Nicholas Cobb, *The Office Park* (2009), Adam Broomberg and Oliver Chanarin, *Ghetto* (2003): http://blackdog collective.net/?p=1115, and Selina Ou, *Serving You Better* (2001) and *Enclosure* (2002). See also Mauro Bottaro, *Mainliners* (Heygate Estate): http://www.maurobottaro.it/work.php?number=6; http://www.guardian.co.uk/society/gallery/2010/mar/26/elephant-castle-housing-estate-heygate-redevelopment.

his immediate and intimate surroundings, and presents what is recognized every day by everyone – the debris of daily activity in the home, the aftermath of *habitus* – table tops, unmade rumpled beds still showing signs of occupancy, unwashed clothes. Whilst the hidden processes of everyday life underline the superficiality of photography as testament, photographs lend some insight to those spaces in between what can be quantified and those experiences of everyday life that cannot. Photographs present, simultaneously, the specific minutiae of difference and the paradoxes and ironies that cannot be generalized into any kind of totality. Stakle's series are a complicated mixture of possibilities that include: the physical 'factual' appearance of spaces; the banal contradictions of everyday practice; the evocation of memories by spaces; the manipulation of space evident in manufactured space; the evidence of desires in play and social interaction; the absurdities of everyday individual living experience.

De Certeau's distinction between looking and walking in the city provides a parallel between those photographers who maintain a distance and those who record a level of participation; between artistic vision which aims for a totalizing effect and those who aim to understand the details within a city's whole system, such as Rosler's representation of the *Bowery* or Agarwal's representation of 'vicious municipal politics' visualized by a river. It also confirms the impossibility of encountering the city objectively. An understanding of space must accord with our relationship to it, and the relationship of the photographer to the subject in a photograph demonstrates a relationship to the space depicted, and beyond to an attitude to the world. Much of the subsequent discussion will look at the contradictions between appearance and context and what the photographer chooses to include or exclude.

Further reading

Berger, J. and Mohr, J. (1995) *Another Way of Telling* [1982], Vintage Books: New York.

Breton, A. (1960) *Nadja* [1928], translated by Richard Howard, Grove Press: New York.

Burgin, V. (1996) *Some Cities*, Reaktion Books: London.

de Certeau, M. (1988) 'Walking in the City', in *The Practice of Everyday Life* [1980], trans. S. Randall, University of California Press: Berkeley, Los Angeles, London, pp. 91–110.

Fini, C. and Maggia, F. (eds) (2010) *Contemporary Photography from Eastern Europe: History Memory Identity*, Skira Editore: Milan.

Howarth, S. and McLaren, S. (eds) (2010) *Street Photography Now*, Thames & Hudson: London, Paris, New York.

Walker, I. (2002) *City Gorged with Dreams: Surrealism and Documentary Photography in Interwar Paris*, Manchester University Press: Manchester.

John Berger's *Another Way of Telling* includes a reflection on the relationship between the photographer, the photographed and the viewer in photographing a community of people; a photo-essay and an essay with examples of analysis (pp. 85–103) that explain photographs as 'ambiguous'. It asks questions about how we understand the meaning of photographs. Victor Burgin's *Some Cities* presents a succession of anecdotal impressions and reflection about cities alongside a series of photographs. It provides an interesting complement to de Certeau's 'walking' in the city from a photographer's perspective. Walker's *City Gorged with Dreams* provides amplification of discussion in this chapter about the role of memory and the unconscious in photographic meaning. Howarth and McLaren (2010) updates the contexts introduced in Westerbeck, and Fini and Maggia (2010) extends my discussion of the characteristic themes in Eastern European photography.

Further photography

American Street photography 1970s: http://www.public-life.org/portfolio/70-s-black-and-white-american-street-photography/56/.

Andrej Balco (Slovak Republic 1973) – *Moscow* series (2004), *Suburbs* series (2004), *Women workers in Antracit, Ukraine* (2010) documents women who earn very little working in the tube and pipe works *Slavsant* factory: http://www.choiceimages.org/index.php?src=project&id=1&projectid=132; http://www.andrejbalco.com/; http://www.andrejbalco.com/articles/articles_002.pdf.

Rochelle Costi (Brazil 1961) – Costi's approach is ethnographical in its systematic surveillance of the details of everyday life, living space and eating habits in and around São Paulo, the largest city in Brazil – *Quartos* (Rooms, 1998) and *Praticos Tipicos* (Typical dishes, 1994/1997): http://www.carearts.org/lessons/image-bank/o-t1/quartos-são-paulo-rooms-são-paulo.html.

Luc Delahaye (France 1962) – (1999) *L'Autre*, Phaidon – a series of portraits in black and white taken anonymously on the Paris Metro.

Walker Evans (America 1903–75) – *Many Are Called*, Yale University Press, 2004 – taken anonymously on the New York subway: http://yalepress.yale.edu/book.asp?isbn=9780300106176.

Robert Frank (Switzerland 1924, moved to United States 1946) – *The Americans* [1958] published by Scalo, 1998.

Anthony Luvera (Australia 1974) – *Assisted Self-Portraits* series (2007) is a participative project working with residents at King George's Hostel in Westminster: http://www.luvera.com/old/.

Beat Streuli (Switzerland 1957) – Groys, B. and Pfab, R. (eds) (1999) *Beat Streuli: City*, Hatje Cantz: http://www.beatstreuli.com/.

Ed Ruscha (America 1937) – Rowell, M. and Weinberg, A.D. (2006) *Ed Ruscha, Photographer*, Steidl.

Lucia Nimcová (Slovakia 1977) – *Instant Women* (2002–05) is a project documenting women of all ages in current-day post-communist countries: http://www.lensculture. com/nimcova.html and http://www.visegradgroup.eu/main.php?folderID=1099& galleryID=9.

Dayanita Singh (India 1961) – *Dream Villa* series presents a subjective array of content that includes nightscapes, dark alleys, high streets, corners, bushes, illuminated houses, trees, blossoms and children: http://thephotobook.wordpress.com/2010/07/10/ dayanita-singh-dream-villa/.

Antanas Sutkus (Lithuania 1939–99) – *Archives of Daily Life* (1959–93): http://www. noorderlicht.com/en/archive/antanas-sutkus/. Samman, N.J. (ed.) (2009) *Antanas Sutkus: Lithuanian Portraits/Signs of Time*, White Space Gallery.

Verve Photo: The New Breed of Documentary Photographers: http://vervephoto. wordpress.com/.

Notes

1 Walker Evans, in interview with Leslie Katz, 1971 in Goldberg, V. (ed.) (1981) *Photography in Print, Writings from 1876 to the Present*, Simon & Schuster: New York, pp. 358–69: 'Unless I feel that the product is a transcendence of the thing, of the moment in reality, then I haven't done anything, and I throw it away' (362).
2 Meyerowitz (New York 1938): http://www.joelmeyerowitz.com/photography/ index.html.
3 Walker Evans, 'Lyric Documentary', transcript of a lecture delivered at Yale University Art Gallery, New Haven, 11 March 1964, p. 38, in Walker Evans Archive, Museum of Metropolitan Art, New York: 'My thought is that the term documentary is inexact, vague – even grammatically weak as used to describe a style in photography which happens to be my style. Further, that what I believe is really good in so-called documentary approach of photography is the addition of lyricism.'
4 Helen Levitt (America 1913–2009): http://www.youtube.com/watch?v=vx2VVw BP0gU – http://www.youtube.com/watch?v=kb0XEBLM3qM&feature=related.
5 *Beat Streuli, City*: http://www.beatstreuli.com/88.html.
6 Walker Evans, *Subway Portraits*, New York, 1938–41: http://yalepress.yale. edu/book.asp?isbn=9780300106176; http://www.masters-of-photography.com/ E/evans/evans_subway_portrait.html; Luc Delahaye: http://www.phaidon.co.uk/ store/photography/lautre-9780714838427/.

7 The Farm Security Administration was a US government photography project. Photographs in the Farm Security Administration – Office of War Information Photograph Collection form an extensive pictorial record of American life between 1935 and 1944.
8 Many of the photographs are provided by Jacques-André Boiffard, a fellow Surrealist – some are by Man Ray.
9 http://www.photonet.org.uk/index.php?pxid=149.
10 Keith Arnatt (Britain 1930–2008) – Hurn, D. and Grafik, C. (2007) *I'm a Real Photographer: Photographs by Keith Arnatt*, Chris Boot: London; Gabriel Orozco (Mexico 1962) – Fineman, M. (2004) *Gabriel Orozco: Photographs*, Steidl/ Hirshhorn Museum and Sculpture Garden; Richard Wentworth (Britain 1947): http://core77.com/reactor/03.07_parallel.asp.
11 My thanks to Pete Ellis (Manchester 1950) for his contribution to the commentary in this section: http://peteellisartist.co.uk/default.asp.
12 Alnis Stakle (Latvia 1975).
13 See for example, Antonas Sutkus (Lithuania 1939) *Daily Life Archives* (1959–93), and Aleksandr Glyadyelov (Poland 1956).
14 Harvey [1973] quotes Marx: 'The mode of production of material life conditions the general process of social, political and intellectual life. It is not the consciousness of men that determines existence, but their social existence that determines their consciousness . . . Changes in the economic foundation sooner or later lead to the transformation of the whole immense superstructure' (1975: 197).
15 Published posthumously in 1986 from lecture notes ('Of Other Spaces') made in 1967, and discussed by Soja 1996. It can be found at: http://foucault.info/ documents/heteroTopia/foucault.heteroTopia.en.html.

5 Social and political practices

Chapter 2 outlined the debate concerning the disputed principles for the use of photography. Chapter 4 discussed different orders of photographic representation and the significance of objective and subjective perspectives. This chapter focuses on the socio-political dimensions of the contemporary photograph, with particular reference to photography from Johannesburg, and the documentation of specific instances of life in a city that has been radically changed by its politics.

Photography, politics and protest

How photography should be used – for aesthetic or ideological purposes – is highly contested. In the early twentieth century, film and photography enabled the avant-garde to continue its more radical aspirations, validated by the use of new 'modern' technologies, as the 'perfect medium for affecting the broad masses' and providing the means 'to stimulate and reveal the struggle for socialist culture' (October Photo Section in Phillips 1989: 283). Whilst on the one hand, Rodchenko's experimentation with photomontage signified both revolution and the avant-garde, his abstraction was also accused of high aestheticism. For example, Sergei Tretyakov [1928] championed a functional and purposeful photography and argued against the aesthetic principles of Rodchenko. However, like Rodchenko's advocacy of unusual viewpoints, Tretyakov's idealism translates into literal instructions with regard to contrived technical applications for photographing political subject-matter:

> When a demonstration is being photographed, any of several different aims may be operating: If you want to show the crowds of people, it's best to take the photograph from above, vertically. If you want to show

the crowd's social composition, you should shoot point-blank, selecting points where a person's clothes indicate his profession, and people in the foreground should be taken close-up. If you want to show the demonstration's impetuous forward rush, feet might prove to be the most effective element; and an angle of gradient might create the illusion of human lava pouring forth (a purely aesthetic assignment). If you want to show the demonstration's demands you should photograph the posters in as large a scale as possible, and make sure the captions come out distinctly . . . To assert the primacy of the raw, unworked, unorganized fact is to threaten the practical, professional skill of the photographer.

(Tretyakov in Phillips 1989: 272)

This quote demonstrates the agency of the photographer at work in documenting events in the city – in this case class protests. Note the emphasis on 'what the photographer wants', which exposes the deliberate intentional operation (or deception) that may lie behind a superficially objective shot. It is clear that the use of photography for ideological means is not straightforward.

The German worker photography movement (*Arbeiter-Fotografie*), which developed between the two world wars and spread across Europe, also argued against what was seen as the artistic avant-garde idealism of Moholy-Nagy or Rodchenko. It attempted to re-educate photography away from the tendency for sentimental portraits and 'mood pictures' and toward a 'new way of seeing' that recorded everyday working lives (Körner and Stüber 1979: 73–6). *Der Arbeiter-Fotograf* magazine (1926–31) tasked its readers to be 'worker correspondents' and report social and political cultural life. For example, Franz Höllering [1928] addresses its readers:

In your hands, a camera has meaning only if you use it as a weapon. With its aid you must make a record of your reality . . . learn to see the simple great facts, photograph them plainly and clearly, so that they can't be explained away. That is your task.

(Phillips 1989: 128–9)

Organizations across Europe established links between workers in different industries and in different countries. However, in the early 1930s, the original political principles of worker photography, shunning the avant-garde and aiming to promote the construction of a new socialist world, gradually transformed itself in the USSR into the stereotypical formula of a state endorsed Socialist Realism, in which critique and self-appraisal disappeared. The interpretation of showing how people live became very narrow, reduced to depicting nothing else but 'factual' content as evidence of the construction

of socialism, and a recognizable official style focused on trite ideological symbols, ideal for propaganda purposes (Pospech 2003: 13). The October Photo Section represented the aspirations of the artistic community in the USSR prior to the doctrine of Socialist Realism taking hold and denounced the AKhRR's sentimentality, advocating instead that the 'photo-worker' develop a 'political literacy' in the use of photography. In 1931, they declared that modern photography should make use of utilitarian forms such as 'photo-information, photo-illustration, scientific photography, technological photography, photo-posters': 'We are for a collective method of studying the tasks set by the Party and the special photographic methods essential for the best resolution of these tasks' (Phillips 1989: 271, 285).

The political momentum of photography in the 1930s is also seen in England and across America in the Workers' Film & Photo Leagues (WFPL), which lay the foundation for the subsequent development of the documentary photography and photo-journalism traditions. In America its goals were to record evidence of the class struggle, to provide illustrations for radical publications and to help publicize the work of communist organizations (which lent them sponsorship). For example, the San Francisco FPL published a plan of work:

> We want to seek subjects that are powerful and representative factors in the present struggle of social forces. We want bankers, workers, farmers (rich and poor), white-collar workers, policemen, politicians, soldiers, strikers, scabs, wandering youth, stockbrokers, and so on and so on. We want to see them in relation to those things they do, where they live, how they work, how they play, what they read, and what they think. In other words we want to see them as they are in their most significant aspects. This means seeing them in relation to each other.
>
> (Campbell 1979: 97)

In England, the WFPL attempted to visualize capitalism's social and political ills. As such it used photography as a form of political propaganda. Its principle strategy was to present a united front, to demonstrate the policy of 'class against class' and 'to mobilize and politicize the broadest possible sections of the working class' (Dennett 1979: 100–13). The WFPL Manifesto, 1935 states:

> The League will hold exhibitions of photographs all over the country. It will invite exhibitions from workers of other countries and arrange for British workers' photographs also to be exhibited and published abroad. It will organize competitions of photographs of working class interest which

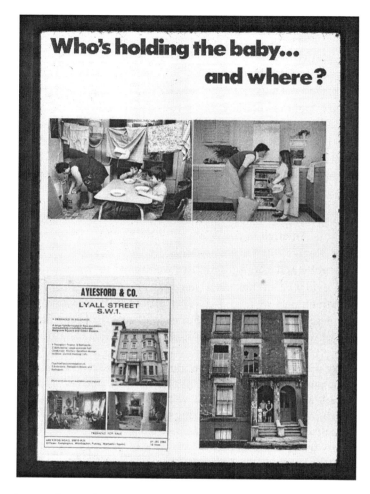

Figure 5.1 Hackney Flashers, from the series *Who's Holding the Baby?*, 1978. Courtesy of Michael Ann Mullen.

will be judged as much on their social value as on their technical merit. It will arrange for shop window displays of news photographs and endeavour to distribute these to the widest possible sections of the press in this country and abroad. It will arrange popular lectures both on films and photography to working class organizations and societies. It will assist local production groups to obtain film and photo apparatus and technical instruction.

(Dennett 1979: 105)

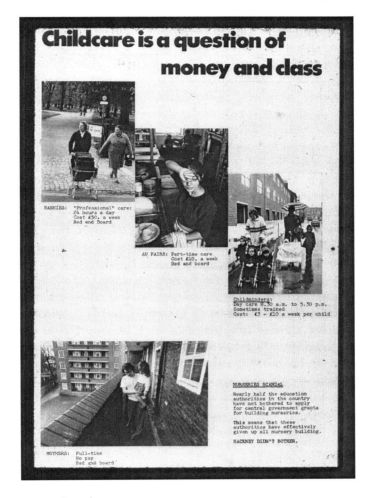

Figure 5.1 *continued ...*

BOX 5.1

Politics and photo-juxta-position

Jo Spence's essay ('The Sign as a Site of Class Struggle', 1986) examines the uses of photography for agitational purposes in Weimar Germany 1922–32 and John Heartfield's dialectical method of photo-montage in particular.[1] Her analysis describes the layers of signification

in photomontage that can reference a range of contradictory historical and material information and force the viewer to consider the reality that lies outside the photograph. She suggests that non-naturalistic methods, such as photomontage, may be the best way to counter photographic histories, to photograph people responsibly and to work with photography politically. Her project with Terry Dennett, *Re-Modelling Photo-History* [1982] uses montage, subversive texts and 'photo-theatre' and explores the role of authorship and the ways in which women and other subordinated groups are represented (Spence 1995: 85). For example, *Colonisation* constructs a critique using fiction and montage by presenting two adjacent images: to the left Spence stands on the back doorstep of an inner-city terraced house somewhere in England, with a towel wrapped round her waist, holding a broom. The large necklace and the two bottles of milk make reference to the anthropological and colonial tradition of depicting people accompanied by the symbolic objects that define them. On the right is a close-up of a foot, under which '5 CM' indicates its physical dimensions and references the practice of marking physical attributes as 'specimens' and as significant of different peoples. Spence and Dennett's work demonstrates a direct visual engagement with theoretical and political concerns, establishing an agenda for evolving approaches to documenting people that must address the city as a 'site of struggle' and the photograph as a political space. It has influenced the strong tradition of British left-wing social documentary and community photography projects, which can be seen as an undercurrent in much contemporary practice.

Collectives such as the Hackney Flashers (1974–early 1980s) wanted to use photographs in an active way, not just to document the conditions of living, which can be useful in campaigns for better housing and services – as they were in Manchester, Glasgow and London in the nineteenth century. They aimed to show people taking collective action rather than as suffering, or as passive victims waiting for someone else to take action. They began to develop a more participative approach to photographing people and adopted another tradition developed in the *Arbeiter-Fotografie* – of photomontage as a means of critique. The Hackney Flashers' exhibitions (*Women and Work*, 1975 and *Who's Holding The Baby?*, 1979) take advantage of the power of juxtaposition in the deliberate placement of contrasting images for the purposes of making a political point, for example: an image of a smiling family outside their suburban middle-class home next to a black and white

photograph of a Hackney family in damp, overcrowded housing. The exhibition *Women and Work* (1975) attempted to counter stereotyped images by concentrating on the areas of everyday life that are 'usually invisible':

> The visible world doesn't so easily yield up the reality of power relationships and institutions. In order to challenge images that serve to maintain women's subordination it is necessary to question the ideas and myths *behind* such images. For example a working-class woman may recognize herself in a photograph of a woman working in a factory. While this self-recognition is important in terms of validating *individual* lived experience, it cannot negate the power of what advertising and other media images represent as *social* reality. These images are not simply a distortion of how we 'really' are, but are part of the process of constructing us and prescribing our feminine role.
>
> (Heron 1979: 130)

See also: Martha Rosler, *Bringing the War Back Home* (1969–72) and *Bringing the War Home: House Beautiful*, new series (2004); Daniel Meadow's *Free Photographic Omnibus* (1973–2001), Heartfield, John, Photomontages: http://www.getty.edu/art/exhibitions/heartfield/.

Photography, politics and aesthetics

The divide between political photography and art photography vocalized earlier in twentieth-century Europe continues to draw debate because the photograph's cultural value as document is confused by its two very different functions – of documentary and aesthetics. As Benjamin points out, photography as a form of social practice must focus on the significance of context, particularly if it is to produce evidence for social change. Echoing Benjamin, Allan Sekula is suspicious of photographs that remove subjects from their specific circumstance, which can so easily generalize and transform meaning into myth. He extends both Foucault's and Benjamin's argument that, as a form of reproduction, photography enables wider access to information and culture and, as a vehicle for argument, can be a powerful political tool. In Sekula's view, which is politically motivated, documentary as 'art' will always subsume what is referred to in the real world and become

a vehicle for the photographer's 'expression' (Sekula 1999a: 123). This has consequences for the photograph's effectiveness for political ends. In the course of his consistent engagement with this issue, he discusses the conflict between individual vision and/or political content with reference to the contrasting works of Lewis Hine and Alfred Stieglitz, both of whom contributed to the American social documentary tradition in the early twentieth century. In his essay 'On the Invention of Photographic Meaning' [1975], Sekula discusses two apparently similar photographs, which represent two different motivations. Hine's work (*Immigrants going down the gangplank, New York*, 1905) was originally published in a journal devoted to social welfare and Stieglitz's work (*The Steerage*, 1907) in an avant-garde art journal.[2] One is concerned with discourse and communication (documentary) and the other uses people and places as metaphors for the artist's feelings so that, in Sekula's view, they function as a form of 'mystic trivia' or 'abstract fetish'. Hine's is concerned with reportage; Stieglitz aims to represent his experience. Sekula points to the facility of the photograph to either provide photographic witness to fact, or to objectify the subject as a formal idea. All photographs move between these extremes. In 1983, he parallels the development of photographic use with the validation of bourgeois society and capitalism and argues that photography has assisted capitalism to expand its economic systems and 'to unify the globe in a single system of commodity production and exchange' (1984: 80). In 1986, Sekula uses an annual report from the Dominion Coal Co. (1956) to illustrate his discussion, but we could just as usefully select a contemporary brochure promoting a development agency or city council or tourist board and look at the way that the photographs are used to promote an attitude to legitimize a perspective or proposal – to persuade (1999b: 181–92).

Methods of social documentary photography vary; they can present without commentary or, with different degrees of protest, point to the impact of living conditions or the injustice of human lives. Ethically responsible depiction must consider the photograph's capacity to objectify and stereotype. Both Sekula and Martha Rosler attempt to avoid its propensity to aestheticize and to use the photograph as a space for discourse that is rooted in social relations rather than an 'ahistorical realm of purely affective expression and experience' (Sekula 1999a: 118). Rosler consistently aims to avoid the universalism that she sees as characteristic of street photography and documentary genre that seduces us into believing that we have a shared humanity, and which can transform the condition of poverty into a subject for aesthetic effect. Instead, Rosler asks: 'How can one represent a city's "buried" life, the lives in fact of most city residents? How can one show the conditions of tenants' struggle,

homelessness'? (Rosler 1991: 31–3). She shifts the focus away from the photograph as an aesthetic object to bigger concerns, 'to the context, to the process of signification, and to the social process'. *The Bowery in Two Inadequate Descriptive Systems* (1974–75) illustrates that homelessness is much more than a representation of homeless people but is a complexity involving governmental institutions, prejudicial attitudes and the specifics of city location.

The photograph's capacity to turn even the most ugly thing into something quaint or beautiful compromises their status as documents. Photographs blur the boundary between aesthetics and politics leaving some to conclude that they should remain separate and that documentary photographs should be political and not confused by aesthetics. In contrast, following an understanding informed by discussion of the photograph's capacity to aestheticize, photographers have made use of this contradictory ambiguity. For example, Robert Polidori's photographs of bombed out *Beirut* (1994–96) can be interpreted as making political and ironic comment, or trivializing destruction and war and conflict.[3]

Photography Workshop: England

In the 1970s, the politics of representation in general and the use of photography for political purpose specifically, was a central concern of disciplines addressing everyday culture – visual culture, media studies, feminist studies – and was reflected in the emerging magazines concerned to address political and feminist perspectives and issues of class and power – such as *Spare Rib*, *Feminist Art News*, *Media Education*, *Screen*. In England, worker photography principles of the 1920s–30s were adopted by a number of collectives using photography as a political tool: Hackney Flashers, Half Moon Workshop, Photography Workshop in London and the Ten 8 collective in Birmingham. The photography magazine *Ten 8* advertises itself as promoting visual literacy:

> Photography affects everyone's life and yet there is very little awareness of the medium and how images are made and used. We shall examine these issues. At the same time we shall be presenting portfolios of work by individuals and projects which might otherwise not be seen. In this way we aim to create greater communication between people making photographs in the hope that this will stimulate new developments, more effective use of resources, and a greater awareness of the possibilities of photography generally.
>
> (in Dennett and Spence 1979: 201)

Following the tradition of the WFPLs, the Photography Workshop, founded by Terry Dennett and Jo Spence in 1974, aimed to provide accessible educational material, to promote interest in the critical use of photography, to encourage self-reliance in photographic users and makers, and to generate collective projects with community and sub-cultural groups. The Photography Workshop asked how photography perpetuates the established social order and how it may it be used to help hasten the arrival of a new one instead (Dennett and Spence 1979: 1). It was founded on the premise that any definition of photography is paralleled by politics and, as a discipline, cannot be isolated from those of economy, society or politics. Education and working with community groups and youth projects were absolutely central to the Photography Workshop's use of photography. Spence describes it as providing a critical model of social practice and investigation, in contrast to most institutionalized photographic practice, which is concerned with status and 'commodity values' (1986: 62). This interest in politics undoubtedly had an effect on the direction of documentary photography in Britain in the late 1970s and 1980s, which saw an emphasis on socially engaged photography concerned, for example, with the consequences resulting from the loss of industries in Northern towns, or with unemployed and disaffected youth in Britain. The journal *Source: The Photographic Review* continues to champion a strong tradition in social documentary.[4]

Market Photo Workshop: Johannesburg

The Market Photo Workshop (MPW), Johannesburg, founded in the late 1980s during apartheid by David Goldblatt, was open to all ethnic groups. Like the Photography Workshop in London, it promoted an awareness of the politics of representation, the social usages of photography and reflected political issues – inevitably those of violence, homelessness, discrimination and the consequences of HIV. It continues today to follow the same ideals of visual literacy, and has since become a School of Photography, offering courses that respond to the developments in a rapidly changing city. The Photojournalism and Documentary Photography Programme (PDP) is an intensive, year-long training course designed to prepare students for the professional world of photojournalism and documentary photography practice. Its structure focuses on 'Photojournalism and Documentary Photography', 'Visual Literacy', 'Media Practice' and 'Techniques'. Many PDP graduates are subsequently employed in the South African media sector.[5] Each of the projects featured in this section identifies an aspect of marginal existence, either in terms of migratory existence or the nature of earning a living.

Figure 5.2 Jodi Bieber, *David*, 1995. © Jodi Bieber. Courtesy of the artist.

The Market Photo Workshop initiates participatory outreach projects, which engage with communities living on the periphery of society. They are often developed in association with other agencies such as the University of Witwatersrand. Jo Vearey states that their exploration of 'the experiences of urban residents in a participatory, visual way has been shown to bring different urban realities to the attention of a wide range of urban stakeholders, including researchers, public health programmers and city officials' (Vearey *et al.* 2011). These projects involve PDP students in running classes and supporting participators in community projects. For example, *Mpilonhle Mpilonde (Good Life Long Life)* 2006, developed with the Mobile Health and Education Units, which provide health and education programmes to help prevent HIV and promote general health.[6] It documents the communities of internal migrants and the conditions of living in makeshift settlements in the peripheral townships around Johannesburg, such as Denver:

> Illegally occupied abandoned factories, sprawling shack settlements and apartheid-era male-only hostels all mesh into a lively settlement grappling with problems of marginalization, listlessness, unemployment and HIV . . . Denver is located within a ten kilometre radius of the Johannesburg CBD, yet few know – or care – about its existence. The people of Denver,

all 30,000 of them, could well have been living in another city. Denver appears to have grown a life of its own. Vearey says, a typical hostel unit would house six to eight men from the same village in KwaZulu-Natal, South Africa's biggest province and original home to Zulu speakers. A hostel dweller could also own any number of nearby shacks that he lets out . . . HIV infection among women in Denver is estimated at 56 percent for women – more than twice the national average . . . At the end of two weeks we had amassed a huge archive of images depicting different faces of Denver.

(Wilson Johwa, one of the MPW project managers 2007: 98–9)

Working the City: Experiences of Migrant Women in Johannesburg (2010) was a collaborative project with the Forced Migration Studies Programme (University of Witwatersrand) and the Sisonke Sex Worker Movement.[7] The project sought to document the experiences of migrant women involved in sex work working in violent areas of inner-city Johannesburg. Women involved in sex work are currently criminalized under the Sexual Offences Act 23 of 1957. The stories reflect the public health challenges facing South African society, including gender violence, HIV and AIDS, xenophobia, alcohol and drug abuse. The resulting series of posters were displayed on public walls around Johannesburg.

The participants addressed areas of stigma relating to their work, structural violence, abuse, coping strategies, migration histories, and trajectories into sex work that were relevant to them and the urban space in which they live and work. The women focused on their migration histories, their journeys to Johannesburg, and their linkages to home, where family – often including their children remained. Sex work was presented as work, a livelihood activity that enabled money to be sent home to support family members.

(Vearey *et al.* 2011)

This project presented the lives of 11 migrant women, who created a range of photo-stories, accompanied by captions and narratives that visualized and described experiences of work, their journeys to Johannesburg, their relationship with home and the love of family and support of friends:

When I tell my story I am telling my story with my photo. Like when I was telling the story of how people are trying to rob me, I can show the picture of the place and inside me I know that story. I can tell it or not. But to me I am telling my story. This is important. And I like it because it is too important for me to do this.

(Thembile in Vearey *et al.* 2011)

Emerging from the MPW initiative are a number of professional photographers whose documentary photography addresses topics such as migration, sexual politics and the location of identity in a transitional society. Documentary series assume focused themes, which each ask questions about life in South Africa after the end of apartheid. A number, such as Believe Nyagudjara's *Living in Limbo* (2010), record the life of traders who move back and forth across borders in order to buy in South Africa and sell or trade back home in Zimbabwe, for example.[8] Others, such as Jodi Bieber's extensive study of the poor neighbourhood Vredapark (*David*, 1995), follow the tradition of documenting the everyday life of one individual:

> When I met David Jakobie he was nineteen. He lives in an area west of Johannesburg called Vredapark, also known as 'Fitas'. Once a predominantly Afrikaans-speaking white working-class area, its racial make-up slowly changed post-1994. Houses are no longer 'exclusively' allocated to white families. The majority of people in the area are on welfare and live in council flats and houses. The youths I came across hadn't completed school and very few of them worked. Many were involved in crime, including robbery, house-breaking and prostitution. 'Every man for himself' was the attitude I came across, yet there was also a surprising sense of loyalty among friends.
>
> (Bieber 2007: 56)[9]

Sabelo Mlangeni's project *Invisible Women* (2006) documents the women who clean the streets of Johannesburg at night. The series records the detailed routines of their work, over a period of eight months.[10] The numbered *Invisible* series shows the women out of focus and in movement, like ghosts or fairies. Others are simple portraits in which individuals like Ma Nkosi stand tired, curious and looking at the camera. In a review of the exhibition in 2007, Mdand observes that Mlangeni slowly won the women's trust despite the fact that photojournalists often take images of workers in order to expose poor working conditions, which 'frequently backfires, causing more harm than good to some workers'. Mlangeni was concerned to understand how the women worked at night in areas of Johannesburg renowned for high levels of crime, and how they felt about having to come to the city to find work, leaving behind children and husbands. The series focuses on three distinct aspects of their situation: the rubbish left behind in the city streets after a day's trading, around the Bree Street taxi rank, for example; the women, gloved and wrapped in plastic bags, moving through the streets sweeping and clearing away the trash; the women again in various states of rest, going home, leaving a clean and serene city behind (Mdand 2007). Both Bieber's and Mlangeni's series are in black and white and required the participation of its subjects: the first

Figure 5.3 Sabelo Mlangeni, *Invisible Women*, 2006. Silver gelatin prints.
© Sabelo Mlangeni. Courtesy of STEVENSON.

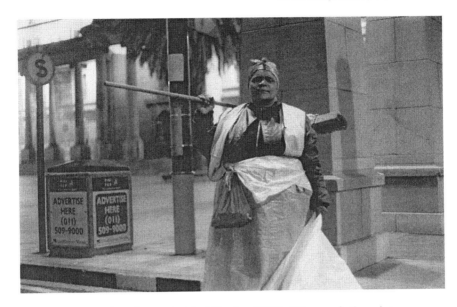

**Figure 5.4 Sabelo Mlangeni, *Ma Mbatha*, 2006. Silver gelatin print.
© Sabelo Mlangeni. Courtesy of STEVENSON.**

documents David's experience and uses his words as commentary 'Why worry about tomorrow. I live for now. If I die I die. I enjoy my life while I can' (Bieber 2007: 56); the second is a more lyrical and 'aesthetic' interpretation relying on the contrasts of focus and presentation to narrate experience.

Two projects describe situations of transitory existence in Johannesburg. Mack Magagane's series *Periphery* (2009/10), like Rosler's *Bowery* (1975), does not photograph homeless people directly, but their improvised living spaces within the city: 'These informal structures and found spaces become peripheral environments, particularly when viewed in the context of the World Cup. They are located outside of the center or mainstream, where the wealth that is being generated by the national event is focused. These spaces do not represent the ideal city' (Magagane/Market Photo Workshop 2009/2010).[11] In contrast, Madoda Mkhobeni's *Trolley Pushers* (2009) focuses on groups of homeless men who use trolleys to transport material picked up from different locations to sell to scrap yards, and to carry the few belongings that they have. It shows in detail their daily routine and the hard process of earning a living. The series makes use of the trolleys as metaphor for a way of life that must constantly adapt to circumstance, by changing the location of their home:

depending on where money can be made, on the weather or where the need for security might carry them on each particular day. [They] often form small communities for security and for companionship. They eat together and shelter where they can, but move alone in search of means to earn a living and get by each day.

Commentary alongside the photographs includes the following observations:

A homeless man known as 'Slander' makes food to share with the other homeless men he stays with; A homeless man tries to make himself a place to sleep after his belongings were burned by the metro police; As dusk descends, the men scrounge for material with which to make a shelter for the night; With the approach of the soccer World Cup, the men attracted the attention of Metro Police who subsequently evacuated them and their belongings from the area as part of a campaign to clean up overpopulated and dirty inner-city spaces; The group of homeless men living next to Bree Taxi Rank formed close and protective relationships; Each day the men gather to share stories from their day.

(Madoda Mkhobeni 2010)[12]

Figure 5.5 Madoda Mkhobeni, from the series *Trolley Pushers*, 2009. Courtesy of the artist.

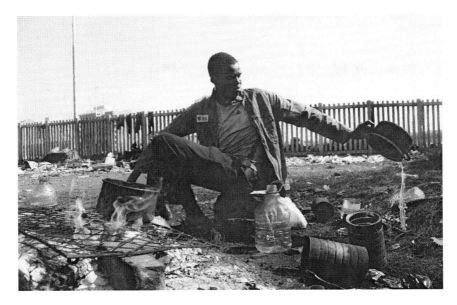

Figure 5.6 Madoda Mkhobeni, from the series *Trolley Pushers*, 2009. Courtesy of the artist.

Jo'burg

> Windows were broken and not repaired. Lifts froze and their shafts became tips. The relationship between tenants and owners or their agents deteriorated with disputes over the state of the buildings, and in some cases resulted in unpaid rents and dues. The buildings started looking like fire hazards, and the City Council began closing on them for unpaid utilities. In between the needs of City Council and the aspirations of developers anticipating the bloom of an African city lies the fate of Jo'burg's residents. The outcome will decide whether or not Johannesburg becomes, again, a city of exclusion.
>
> (Tillim 2004)[13]

Guy Tillim's photographic project *Jo'burg* (2004) describes the downtown Johannesburg suburb of Hillbrow, an inner-city area of apartment blocks built in the 1960s. What was once a thriving community, secure during apartheid, very quickly declined after its white residents left in the 1990s. The visible decay of once proud modernist apartments indicates the breakdown of

BOX 5.2

South African photography

The roots and influences of South African photography can be seen in works, for example, by Peter Magubane (*Flame-Throwers*, published in *Drum*, January 1957, and *The Sharpville Massacre*, 21 March 1960) and Ernest Cole (*House of Bondage*, 1967). Speaking about the iconographic power of many South African images at that time, Patricia Hayes comments that political photography may have started with the Sharpville massacre, but 'it was seared into place by press photographer Sam Nzima's absolute icon from the Soweto student protests in June 1976: the police shooting of the child Hector Pieterson, often likened to the Pieta' (Hayes 2007: 18). South African photography has a history of socially committed documentary: *Drum* magazine pioneered the work of black photographers in the 1950s–60s, and the *Afrapix* collective provided a focus for photography as a 'weapon of struggle' during apartheid and aimed to avoid the more sensational media photography depicting the fight for democracy. Like the workshop movement in the UK, the *Afrapix* photographers wanted to show people in a position of strength rather than as victims. The 1980s saw the development of more simple documentary work. For example, Santu Mofokeng's studies of everyday life in Soweto focus on the relationships between people and the spaces around them, rather than the more violent subjects associated with photojournalism. Hayes remarks on the particular direction and quality of this work:

> The photographic discourse of truth-telling and exposure assumes that the real and the visible are contiguous. [Mofokeng] presents another order of things. The term 'spirituality' does not quite get the 'profundity' of this move: effectively Mofokeng was almost single-handedly pushing for an Africanisation and desecularisation of politics and photography from the 1980s.
>
> (Hayes 2007: 20)

His slide and text essay *Black Photo Album/Look At Me* (1998) attempts another sort of political 'reality' that presents the history *implicitly* held in a collection of abandoned images. It is a collection of found or purchased, portraits, family photographs, re-photographed and researched:

These are images that urban black working and middle-class families had commissioned, requested or tacitly sanctioned. They have been left behind by dead relatives, where they sometimes hang on obscure parlour walls in the townships. In some families they are coveted as treasures, displacing totems in discursive narratives about identity, lineage and personality. And because, to some people, photographs contain the 'shadow' of the subject, they are carefully guarded from the ill-will of witches and enemies. In other families they are being destroyed as rubbish during spring-cleans because of interruptions in continuity or disaffection with the encapsulated meanings and the history of the images. Most often they lie hidden to rot through neglect in kists, cupboards, cardboard boxes and plastic bags.

(Santu Mofokeng: http://www.barrybester. com/santumofokeng.htm)

Conscious of the danger of recording individuals involved in political activism (identifiable in photographs by the Security Police), Chris Ledochowski developed work in contrast to the ubiquitous black and white photographs of bad living conditions, misery and violence. He produced hand-coloured prints with the intention of forcing the viewer to look at events differently (Nelson Mandela delivering his first speech at the Parade, Cape Town, 1990). Since the 1990s there has been a trend towards addressing issues of race, gender and memory in relation to urban identity and South Africa's apartheid past. Post-apartheid, photography has moved towards more subjective and intimate subject matters concerned with coming to terms with the 'truth and reconciliation' programme, a changing regime and governmental processes seen in everyday life in the city. However, Peter McKenzie observes that freed to explore the 'ordinary' aspects of living, photographers are still confronted by the realities of the social: 'we see kids sniffing glue at traffic lights' (McKenzie in Ractliffe et al. 2007: 134). Jo Ractliffe interestingly makes the point that South African photography is always, and must be, politicized – not just in terms of its subject matter or media contexts, but also in terms of its intentional use in representing that subject-matter. Even in 'work where the intention was not socio-political commentary, the political is still embedded in our reception, the way we understand how things mean' (Ractliffe et al. 2007: 131). Whilst the focus changes, subject matter is still charged with political tension, whether it be individual portrayals or studies of everyday life. The context of South Africa's institutionally divided past pervades all subsequent photographic projects.

infrastructural services as a result of neglect and lack of investment. It is an area in which the remaining residents and the influx of poor black migrant workers from surrounding countries such as Mozambique, Congo and Zimbabwe live in very poor conditions with no services or amenities. Some of these buildings are occupied illegally, and periodically its inhabitants are evicted from buildings designated as 'bad buildings', while others may be up-graded. The blank façades of glass of the high-rise buildings reveal dereliction – some of them seemingly redundant, others obviously inhabited as washing hangs from windows, provide a background for the series. Many show a view across the city from the height of the apartment block, which seems to accentuate their sense of isolation. Close-up views of interiors describe the level of dilapidation: broken glass, broken windows covered in plastic sheeting, fire blackened windows, discarded possessions and barbed wire dividing one area from another, the squalor of dark wet corridors covered in debris, interiors of stairs, walkways and communal spaces – quiet and often empty. Against this backdrop we see individuals and isolated details of everyday living: a bundle of blankets which appear to cover a sleeping resident; a woman walking down the stairs; two men lying on the floor of a roof top sleeping; a group of men smoking and playing cards; a man putting his key in the door whilst looking suspiciously to his right down the corridor; Mathew Ngwenya, originally from Zimbabwe, sitting on a chair in a bare room in Sherwood Heights, Smit Street, who, we are told, is unemployed but cleans the building in exchange for donations from residents. Where there are people, they are seldom talking; they seem quite separate, as if leading solitary existences.

Living conditions are crowded, but rooms are bare, habitation seemingly impermanent. And yet we see attempts to make comfortable spaces – an organized kitchen area with makeshift shelves made from cardboard boxes resting on a table covered with a clean white cloth. Neatly stacked bowls, cups are stored there – saucepans hang on the wall, kettle placed on the window ledge. The cracked window is grimy. There are simple ironies, such as the tidy interiors and abundance of washing that contrast with the ruin and neglect. A young woman looks over a walkway wall to the courtyard below in which washing is hanging. We see her through the broken glass window from an adjacent passage. We see someone else's hand resting on the broken window casing. An ordinary everyday scene – we can imagine a once pleasant living environment. Another example (*Thulani Magome and Sheila Thabang's place in Al's Tower, Joel Road, Berea*) shows a startling contrast to most of the interiors as it is suffused with the light coming through the orange curtain,

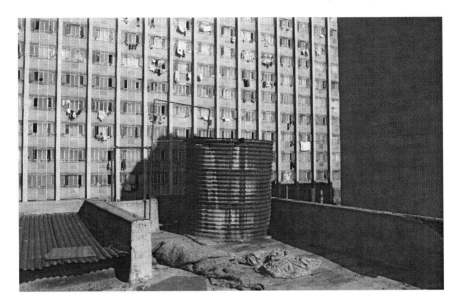

Figure 5.7 Guy Tillim, *Tayob Towers, Pritchard Street, from the 'Jo'Burg'
series,* 2004. Archival pigment inks on 300 g coated cotton paper (436 x
655 mm). © Guy Tillim. Courtesy of STEVENSON.

and falling on the blue laundry basket, purple plastic stool and red tablecloth.
An electric bar fire glows. I notice the signs of ordinariness that contrast with
this reality; dirty walls plastered with colourful pages from magazines, some
with faces and figures carefully cut out; another plastered with headlines
from the *The Star* – 'Fury over hijack hoax', 'Suspect saved from necklace',
'Mob justice spreads'; a fragment of mirror shows a man's reflection or a
photograph, below which is written 'BE GOOD . . .' I find that, in imagining
something of what it means to live here, I am searching for these glimmers
of resilience, a traditional trope of Western documentary photography, but a
rarity in this series of photographs.

Tillim's captions (2004) clearly intend his work to be informative. We are
left in no doubt as to the circumstance of the people he photographs. Many
residents are unsure who owns the flats they live in. Some say they simply
walked in off the street, found an abandoned flat and fixed it up. But once
designated a 'bad building', electric and water supplies are cut off, and
residents are threatened with eviction on the grounds that buildings are
unhygienic. The Better Buildings Programme (BBP) defines a 'bad building'

as one that has a market value less than the outstanding debt on the building, or has living conditions that are hazardous to the occupants, or where the city has initiated legal proceedings in an attempt to evict the tenants. Tillim tells us that legislation, under the Building Regulations Act, does not require the City Council to provide alternative accommodation. Some of the photographs show members of Wozani Security, known as the 'Red Ants', effecting such evictions – from the Chelsea Hotel and Crest House, Main Street, Jeppestown.

Guy Tillim's project is not an objectivist or impartial view. It comments on the translation of a modernist vision, re-appropriated by the poor and dispossessed in Johannesburg. It displays the political consequences of the relationship between landlords and tenants and the complex history that forces one exodus and another migratory influx. It visually questions Johannesburg's approach to the regeneration of the city and the private lives of the people who transform these decaying apartment blocks. The buildings relate a contrast between the history of a deliberate production of space designed for professional classes, with the reality today. Hillbrow is testament to the constant production of space in the face of, or in spite of, degeneration. The project exposes a reversal of situation, from comfortable living in

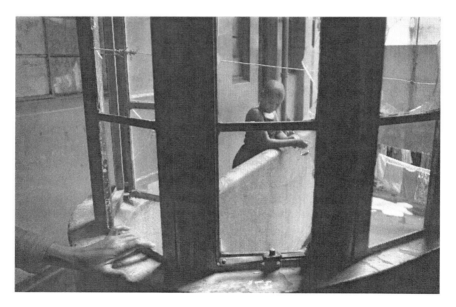

Figure 5.8 Guy Tillim, *Manhattan Court, Plein Street*, from the *'Jo'Burg'* series, 2004. Archival pigment inks on 300 g coated cotton paper (436 x 655 mm). © Guy Tillim. Courtesy of STEVENSON.

aspirational modernist apartments to one which is testament to the efforts of people on the fringes of a society. Two metaphors predominate in the series – separateness and broken-ness – epitomized in the image of Pinky Masoe at her home in Sherwood Heights, caught reflected in the broken glass amid the broken façades and broken windows. *Jo'burg* describes another kind of hinterland zone from that of the Baltic states – this being a space of migration and the transience of a city's fabric. At the same time, it marks an extended metaphor for the process of urban transition itself.

Specious modernity

In a lecture at Tate Britain (April 2008), Okwui Enwezor discusses the collision of two positions (Western 'super-modernity' and 'postcolonial modernity') and describes Tillim's *Jo'burg* as confronting the postcolonial dissolution of urban modernity with attempts by people in extreme poverty to re-appropriate city spaces now in ruin. His discussion provides a background to the series, and to the issues of social commentary. He (2007) says of Tillim's photographs:

> Is it possible to read these images as a measure of Tillim's immersive style, or merely as a product manifesting the sensationalistic frisson inherent in living dangerously, but only temporarily, in situations where the odds of social visibility are largely elusive for the inhabitants? Do these images exploit the subjects? Is the photographer taking ethnographic liberties with the state of the communities embedded in this context? Is the photographer, through his cosmopolitan access, exploiting the situation? In asking these questions, it is worth observing that one striking thing about even some of the portraits is that they tell us precious little about the inner lives of the individuals; instead, many come across as merely specimens in a larger social landscape. Questions such as these tend to be asked of images that make us uncomfortable, images that do not depict their subjects in faux heroic style, or employ manufactured empathy to paper over the photographer's ambivalence.
>
> (Enwezor 2007)

Enwezor views Tillim's *Jo'burg* from the perspective of its representation and against a background of a present modernity that is fraught with complexity and which continues to be 'produced'. He sees present modernity as a collision of irreconcilable positions between democratisation and antagonism, and as manifesting aspects of capitalism, in which technology and aspiration is partly disseminated by images of modernity exported by the

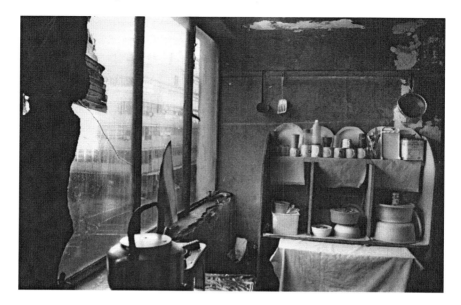

Figure 5.9 Guy Tillim, *The view from an apartment in Jeanwell House overlooking the intersection of Nugget and Pritchard Streets*, from the *'Jo'Burg'* series, 2004. Archival pigment inks on 300 g coated cotton paper (436 x 655 mm). © Guy Tillim. Courtesy of STEVENSON.

West. He relates a hierarchy of modernities that define different relations between capitalism and power. The first category is of a Western 'super-modernity' broadly defined by its advocacy of rationality, freedom, progress and empiricism and synonymous with a world system that has capitalism at its core. The second is a hybrid form of modernity that develops in Asia, and which mirrors the first but without the global structures of power. He describes the modernity of Islamic nations that expresses itself in terms of the rebellion following the collapse of the Shahs in 1979, that is antagonistic to Western structures of power and which proposes an alternative world-view. The last category is Africa, a place where modernity never really happened, an 'after-modernity', a postcolonial modernity that is defaced or erased. Each form of modernity mirrors the other – it is a deeply entangled process that is visualized in Tillim's *Jo'burg*.

Enwezor describes the separateness evident in *Jo'burg* as emblematic of the condition of South Africa marked first by apartheid, and now by its migrating communities. He describes Johannesburg as a microcosm of South Africa and its legacy of apartheid – a 'fortress city' characterized by the contrasts of gated communities and areas such as Hillbrow where the inhabitants are unprotected and vulnerable:

A city such as Johannesburg exemplifies the brutal asymmetry of the social condition of urban architecture. Its urban environment is marked by sharp contrasts: in the outlying northern suburbs, for example, pleasure palaces are hidden from view by high, electrified fences, a device employed less for privacy than for security. Johannesburg is a microcosm of South Africa as a fortress society. Though apartheid is officially over, social segregation is just as deeply resilient. This is revealed in Johannesburg as a city framed by palpable fear of violence. In Johannesburg, the universal issue that bedevils everyday life centres around issues of safety and security. This feeling of insecurity has spurred its own lexicon of architectural and spatial distortions that have become naturalized within the iconography and structures of urban design, transforming the spatial context of the city into one under siege, what Mike Davis describes as an ecology of fear with regards to Los Angeles.

(Enwezor 2007)

Apartheid produced an entirely controlled space in which its occupants were told where they could go and where they could not. No mixed audiences, and no access to public spaces. Under apartheid, blacks were restricted from living in the inner city area in which they worked. They could not live in designated white areas and were restricted to undeveloped and crowded townships. The city of Johannesburg was completely controlled by zones of forbidden entry. This control of space can be seen to continue in Hillbrow post-apartheid, where laws of restriction have been removed but conditions and circumstance of privilege and politics persist. Hillbrow is a space of ironies as it perpetuates restrictions in a strangely reverse way. The whites move out, the blacks move in, and the privileges and services move out. Enwezor suggests a circuit of global forces, not just those of consumerism and production, but also of ideologies and insurgence. The process of modernization cannot be separated from capitalism but it is so 'entangled' that it undermines original aspects of culture such as freedom. The meaning of these terms is displaced – freed from apartheid but not poverty, which is still contained and controlled.

Tillim's work, described by Enwezor (2008a) as an ethnography of ruin and abjection that shows 'extreme forms of incarceration' of violence and poverty, can be either seen as oversimplified reportage or as a magnification of a specific historicity. These areas of downtown Johannesburg, once exemplary of modernism at the cosmopolitan heart of the city, now experience an extreme contrast in living conditions. A further twist to its history is that developers now see it as an area ripe for development, which prompts the move to 'clean up' this area and make it modern again – hence the evictions. *Jo'burg* shows an 'archive of neglect' and an aspiration of modernity reversed. However, one could argue that, in the state of apartheid, it was only ever a pretence of

progress. Modernity either never really happened here or it was a failed modernity, now forming part of a memory of the past. Broken structures, of absence and ruin pervade this space of 'specious modernity'. Where the production, emblematic of modernity, can be seen to be reproduced in Asian urban regeneration such as China, in *Jo'burg*, nothing is new, and everything is appropriated.

Okwui Enwezor has curated several exhibitions 'on Africa'. In making this simple statement, I have already betrayed an attitude that assumes the right to consider 'Africa' as a generalized totality, which Enwezor seeks to counter in his curation and his writing. He insists that the exhibition *Snap Judgments: new positions in contemporary African photography* (2006) at New York's International Center of Photography is 'not photography on Africa, it is African photography' (Enwezor 2008b). He describes contemporary African photography as 'analytical' and a generation of photographers who have grown up using photography in order 'to think about issues of identity'. He speaks to Zwelethu Mthethwa about his photography, who, in attempting to make a contemporary history of Cape Town, tries 'to portray people in a different light' – as 'decent human beings, as just people like any other people'. Enwezor asks him what his ethical commitment is to the use of photographs in relation to his subjects, and whether he is aestheticizing poverty. Mthethwa does not really have an answer and resorts to relating technical decisions, such as not using flash, 'which glamorizes things', or tripod because 'people get bored'. He says 'It's a difficult dance' to avoid exploitation (Aperture Foundation 2010). The problem remains that photographers who are politically conscious want to avoid photographing people as victims. Enwezor points out that Tillim (and David Goldblatt) make a point of specifying the particular historicity of what they are photographing; and avoid elevating the photograph into generalized mythic images that transcend the context in which they are taken. Speaking about Goldblatt:

> The consistent quality of all his work is its historicity. In every image, [Goldblatt] begins with a single challenge: how does one produce an image that allows both photographer and viewer to think historically about a given subject? Despite the fatigue of post-apartheid chronicles, Goldblatt's photographic choices are never overarching, generalizing, or moralizing. He pinpoints and isolates inchoate moments, dissociating the critical gaze from the dependency on the apartheid past.
>
> (Enwezor 2007)

Jo'burg serves as an example of photography that confronts the concerns of ethical documentary photography, which will always be difficult. It avoids any one image assuming iconic proportions, because it is the nature of

photographic series to force a prolonged consideration of content. However, for all its careful contextualizing, their positioning as art objects pushes their content into an uncomfortable relationship with the market: The Photographer's Gallery sells works from Tillim's later series *Avenue Patrice Lumumba*, which depicts several countries in Africa, including Mozambique, Angola and The Democratic Republic of Congo – from €2300, and the book *Jo'burg* is available from Amazon in 2011 for over £200.

Production of city space: migration and peripheries

Urbanism is a result of spatial organization and the movement of peoples. South African photography addresses the sprawl of urbanization and the resulting problems, which are not determined by the needs of production, but by the processes of urbanization. The rapid growth in urbanization alters the structure of a city's economic base, and forces the increasing suburbanization and the growth of shanty-towns. Urbanization perpetuates the spread of urbanization, which causes the continuing process of migration from rural areas to the peripheries of the city, and translates rural poverty into urban poverty. The peripheral townships of Johannesburg, such as Denver, are an example of the growing numbers of inhabitants who live on the margins of cities, and whose influx is not driven by the needs of the city to exploit resources but by its expansion that subsumes the countryside. Life in the city is favoured over rural life and is a magnet for migrant labour, however poor the conditions. Urbanization also perpetuates a flow into the city of owners of small businesses seeking opportunities and better lives. Hillbrow's central location, for example, affords the tenants income opportunities that feed off this process, such as the informal trading of fruit, vegetables, sweets, cigarettes and newspapers in the central business district. Other jobs include collecting scrap metal, paper and cardboard for recycling, cleaning and odd jobs in the adjacent suburbs of Yeoville and Houghton.

Both Lefebvre and Harvey see the city as a 'totality of inner-relatedness' where everything relates to everything else; the city sustains and reinvents itself but cannot be wholly grasped [Harvey 1973: 307]. Whilst the modern city responds to its prevailing ideology and market forces, Harvey suggests that the production of space appears to its inhabitants as being out of their control, and fashioned by alien forces [Harvey 1973: 310]. However, in this conception of production, a city's process cannot be fully explained by its economic forces, and institutional processes are interrupted by everyday life in the city. For example, it is difficult to sufficiently understand urban phenomena like Hillbrow, which seems to have evolved as a result of political change and in

spite of institutional policies. The evidence of Hillbrow, as Tillim describes it, demonstrates the impact of ideological and social change and the involuntary construction of a social space; it demonstrates the interrelatedness of political change on the internal structures of the city; it visualizes the production of space in process, not only in terms of the effects on living but also in broader terms of control. It is doubly significant as it demonstrates a reversal of process – of de-gentrification.

Lefebvre [1974] warns of the reductionism that can result from a 'blind field' of analysis that is ultimately dehumanizing and does not keep up with the practice and necessity of everyday life (1991: 105–7). And Harvey [1973] identifies that an analytical focus on problems '*in* the city' can blind us to problems that arise from the complex relationships as a result '*of* the city' [Harvey 1973: 304]. Hillbrow is testament to a situation beyond analysis. It demonstrates a perpetual process whereby urban structures affect the development of further structures and the social relationships resulting from them. *Jo'burg* and Baltic street photography demonstrate this underlying principle whereby the tension between production and its organization as a top-down process, in which inhabitants and inhabited space are determined according to the decisions of those in control, is countered by a bottom-up process in which urban living and relationships affect the future development of social relationships and urban organization (see also Box 4.3: Counter-sites: heterotopia). South African and Eastern European constitutions are examples of changes in the patterns of urbanization. Baltic photography uses space as a metaphor for change that describes a defiance of a sort in its vacancy – a sort of limbo of production constrained by an adjustment to the logic of a capitalist economy – a top-down process. South African photographers use the dispersion of people as indicative of change.

Further reading

Biemann, U. and Holmes, B. (2006) *The Maghreb Connection: Movements of Life Across North Africa*, Actar: Barcelona.

Enwezor, O. (2008) *Snap Judgments: New Positions in Contemporary African Photography*, Steidl: Göttingen.

Enwezor, O. (2008) 'The Indeterminate Structure of Things Now: Notes on Contemporary South African Photography', *Bedeutung magazine*, 1 (1): http://www.bedeutung.co.uk/magazine/issues/1-nature-culture/enwezor-indeterminate-structure/.

Levi-Strauss, D. (2003) *Between the Eyes: Essays on Photography and Politics*, Aperture: New York.

Newbury, D. (2009) *Defiant Images: Photography and Apartheid South Africa*, Unisa Press: Pretoria.

Rosler, M. (2004) 'In, Around, and Afterthoughts (On Documentary Photography)' [1981], in *Decoys and Disruptions: Selected Writings 1975–2001*, MIT Press: Cambridge, MA, London.

Sekula, A., 'Dismantling Modernism, Reinventing Documentary (1976/78)', in (1999a) *Dismal Science: Photo Works 1972–1996*, University Galleries, Illinois State University: Normal.

Newbury (2009) contextualizes the historic development of African photography, whilst the two texts by Enwezor extend discussion of contemporary work. Biemann and Holmes (2006) addresses issues relating to the migration from Africa to Europe in a particularly visual way as it is the result of a collaborative art project that integrates social commentary with visual research essays. Sekula's seminal essay [1976] comprehensively addresses the tensions between the traditions of art photography and documentary, whilst Rosler's essay amplifies her influential photographic series *The Bowery* of 1974–75, which is concerned with the same issues. There is little contemporary commentary on politics and photography: Levi-Strauss (2003) collates a number of his commentaries in response to the moral issues in photography with reference to a range of works that includes Jim Goldberg, Alfredo Jaar and Sebastiao Salgado.

Further photography

Jodi Bieber – *Between Darkness and Light* (1993–2004): http://www.goodman-gallery.com/exhibitions/207 and (2010) *Soweto*, Jacana Media: http://www.jodibieber.com/.

Mauro Bottaro (Italy 1976) – *Mainliners* (Heygate Estate, London): http://www.maurobottaro.it/work.php?number=6.

British Council exhibition, *No Such Thing as Society: Photography in Britain 1967–1987*, included photographs by John Davies, Paul Graham and Chris Killip. Mellor, D.A. (2007) Hayward Publishing. Exhibition commentary: 'The human costs of de-industrialisation and globalization were the great central themes of the documentary photographers active in the North of England in the late 70s and 80s. The social disasters captured in Chris Killip's work extended into the darkly coloured, claustrophobic interiors of DHSS offices photographed by Paul Graham, and Martin Parr's lividly coloured documents of holiday makers in New Brighton, Liverpool. Killip's, *Youth on wall, Jarrow, Tyneside* 1976 is typical of an era of British social documentary in the 1970s': http://collection.britishcouncil.org/exhibition/future/11/15688; http://manchesterphotography.blogspot.com/2009/06/chris-killips-youth-on-wall-jarrow.html.

Ernest Cole (South Africa 1940–90) – (1967) *House of Bondage*, Random House.

David Goldblatt (South Africa 1930) – *Cosmo City* (2009), *The Women's Hostel, Alexandra, Johannesburg* (2009) and *Ex Offenders at the Scene of the Crime* series (2010): http://www.goodman-gallery.com/exhibitions/193; Goldblatt, D. and Vladislavic, I. (2010) *TJ: Johannesburg Photographs 1948–2010/Double Negative*, Contrasto.

Santu Mofokeng – *Soweto Townships* (1982–89), *Black Photo Album* (1998), *Child-headed Households* (2007).

Morris Mohanoe – Soweto photo-diary, 'Man's Influence on Nature or Nature's Influence on Man?': http://morrisartstudio.blogspot.com/.

Zwelethu Mthethwa (South Africa 1960) – *Zwelethu Mthethwa* (2010), Aperture.

Notes

1 Jo Spence, 'The Sign as a Site of Class Struggle' [1986], in Spence, Jo, Holland, Patricia, Watney, Simon (eds) (1986) *Photography/Politics: Two*, Photography Workshop, Comedia: London.
2 Alfred Stieglitz, *The Steerage* (1907): http://moma.org/collection/artist.php?artist_id=5664.
3 http://www.christineredfern.com/2010/08/robert-polidori/.
4 http://www.source.ie/index.php.
5 http://www.marketphotoworkshop.co.za/Home/tabid/659/language/en-US/Default.aspx.
6 Wilson Johwa (one of MPW's project managers) speaking about *Mpilohle*: http://www.mpilonhle.org/index.php.
7 http://www.marketphotoworkshop.co.za/PROJECTS/WorkingtheCity/.
8 http://www.escapade.co.za/zen/index.php?album=The+Urban+Spaces.
9 http://www.jodibieber.com/.
10 Sabelo Mlangeni (Driefontein, Johannesburg 1980): http://www.stevenson.info/exhibitions/mlangeni/invisiblewomen.htm.
11 Mack Magagane (Soweto 1990) – Mack Magagane/Market Photo Workshop: http://www.escapade.co.za/zen/index.php?album=The+Urban+Spaces.
12 Madoda Mkhobeni: http://www.escapade.co.za/zen/index.php?album=The+Urban+Spaces%2FTrolley+Pushers. Accessed July 2011.
13 Guy Tillim (Johannesburg 1962): http://www.stevenson.info/exhibitions/jhb/jhb1.htm.

Part 3
The metaphorical city

Introduction

These last three chapters consider the city as metaphor. Chapter 6 focuses on the physical features of globalization and electronic communications, whilst Chapter 7 considers the consequences in terms of the subject's sense of disorientation. Chapter 8 explores how we navigate through this disjointed space. They each feature a series of photographic projects that illustrate and extend discussion of the spatial, the psychological and the political. City space has visual impact: Lefebvre [1974] describes 'the arrogant verticality of skyscrapers', especially of public and state buildings, which introduce a 'phallic element' in purposeful display designed to convey an impression of authority. Further to this, he speaks of a logic of 'metaphorization' which assaults our bodies, our needs and our desires. People living in cities are immersed in a 'web of analogous images, signs and symbols' that seduce us. Our spatial environment feeds us, 'via the eyes, every kind of appeal, incitement and seduction' (Lefebvre 1991: 98–9). De Certeau explains the city as being a network of relationships, systems and power – much more than a collection of buildings that can be beautifully photographed.

The conception of 'city' is used as a metaphor for whatever is significant, or in crisis, at any one time – such as modernity, decadence, globalization – and which is manifest in the evidential reality of the city. For example, Jameson and Soja use Los Angeles as characterizing the quintessential postmodern condition; Tillim's *Jo'burg* presents Johannesburg as a metaphor

for postcolonial degeneration and adjustment; Tokyo can be seen as the embodiment of the hidden underside of desire and the psychological (Homma). Almost any aspect of the city can be translated as an allegory – 'suburbia' for the condition of living in sprawling cities; 'edgelands' for contemporary city heterotopias; 'migration' for the effects of globalization. In addition to the varied perspectives influenced by, for example, Marxism, feminism or postcolonialism, late twentieth-century examinations of the city are coloured by vivid descriptions of postmodernism, conceived in the extreme by Jean Baudrillard and Paul Virilio. The self-consciousness of photography demands irony – even fiction and fabrication – rather than innocent document. Subsequently, all projects can be described as metaphoric, explaining the city as network, exchange, encounter or system, or representing subjectivity and the psychological in spatial metaphors. The last 20 years have seen a growing trend to construct complex metaphors that mix contrasting dimensions: historical heritage with dystopian fantasy (Lopez) or psychological projection with suburbia (Jouve) or entirely fantasy worlds with the megalopolis (Cao Fei). These chapters pick up the thread of our experience of walking in the 'metaphorical city', coloured by the characteristics of globalization and virtual communication.

6 Postmodern megalopolis

This chapter returns to consider the impact of the postmodern city on our experience of living, and some of the material and conceptual features that characterize it: globalization, mass communication, simulation and hybridity. The projects featured in this chapter aim to reflect and parody these themes, which are evident in Los Angeles, and cities in Latin America and China. Conceptions of postmodernism are conceived in different ways: Soja describes a radical change in the way that we think about things – a postmodernism which encompasses multiple perspectives and is essentially interdisciplinary; Harvey suggests that the postmodern shift in thinking only superficially changes the processes of economy and production; Jameson's description translates the 'walking in the city' experience of Baudelaire and de Certeau into one transformed by communication and globalism; Donna Haraway and Celeste Olalquiaga point to the destabilizing influence of high technologies. Guy Debord's account of the plethora of visual information, Jean Baudrillard's of simulated meaning and Paul Virilio's of the consequences of global communication result in an experience that Olalquiaga describes as being 'lost in space'.

Postmetropolis

Soja's term *postmetropolis*, which incorporates the concepts associated with 'postmodernism' and the 'metropolis', refers to the enormous impact of urbanization, global communication and late capitalist economies on contemporary living. The *postmetropolis* not only describes a model of contemporary social and economic development but incorporates a ' "metaphysical reality", a place where the real and imagined are persistently commingled in ways we have only begun to understand' (Soja 2000: 147). Soja explores what is particularly significant about living in the contemporary city and uses

Figure 6.1 Qingsong Wang, *Look Up! Look Up!*, 2000. Chromogenic colour print. Courtesy of the artist.

Los Angeles as a 'symptomatic lived space' to represent the generalized metropolis that is indicative of what is happening in other cities everywhere – to different degrees and according to local circumstances (2000: xvii). He considers the central features of postmodern urban spatiality to be: the postfordist industrial metropolis (*Flexcity*); the globalized and 'glocalized' world city (*Cosmopolis*); the radical restructuring of urban form – decentred and 'turned inside-out and outside-in' (*Exopolis*); an increasing polarization and inequality (*Polaricity*); the phenomenon of fortressed and policed cities (*Carceral*); hyperreal city-scapes (*Simcities*) (1996: 21–2).

By the latter part of the twentieth century, the global population living in cities exceeded 50 per cent. Urban growth continues to take place, particularly on the peripheries of cities in industrial expansion and suburban development, and in squatter settlements or migratory encampments. As the world moves toward nearly three quarters of the world population living in metropolitan regions by 2050, Soja outlines the *postmetropolitan* transformation of urbanization processes that have reshaped cities and urban life everywhere in the world. He describes the process following the Second World War as symptomatic of the 'crisis-generated restructuring process' of capitalism – a cycle in which each crisis has provoked destruction, followed by a regeneration that is manifested in the physical urban landscape. The effect of this on cities takes many forms: the regeneration and degeneration of areas within the city – as seen in Johannesburg; the increasing migration – both internal and across borders; the polarization of poverty and wealth. Globalization and the increasing dependence on new technologies has forced further changes in processes involving capital exchange and production. And newly industrialized countries like China signal the emergence of a different economic world order that also forces changes in the patterns of labour. The global market, and the consequent movement of people, becomes evermore widely dispersed. And with intensive urbanization, either diasporic migrants gather on the peripheries in satellite ghettos like Johannesburg's Denver, or occupy the centre of cities whilst the outer cities become more centrally privileged.

Twenty-first-century globalization is described as the cause of tensions between the local and the global (Manuel Castells) and mass communication causes disorientation and a confused response to the world (Paul Virilio). The *postmetropolis* is characterized by globalization processes in which the city is connected to a global network, whilst at the same time its distinctly local heritage is swamped by a globally shared culture. Social changes like the dispersal of the family unit, increasingly multi-ethnic urban communities and the blurring of distinction between places of work and home, impact on the

formation of city space (Castells 2004: 84). In compensation for the loss of a sense of 'home', Ian Buchanan describes the construction of 'non-places' that re-construct the semblance of past histories, memories and places (Buchanan and Lambert 2005: 17). Harvey refers to the postmodern spectacle as a form of 'utopic degeneration' that replicates ideas of utopia in havens for leisure and shopping, which are merely superficial effects that do nothing to adjust or transform social problems (Pinder 2005: 13). The *postmetropolis* is characterized by the destabilization of a sense of reality and purpose, for which Baudrillard, Virilio and Olalquiaga offer different figurations.

Los Angeles: SimCity

> The only tissue of the city is that of the freeways, a vehicular, or rather an incessant transurbanistic, tissue, the extraordinary spectacle of these thousands of cars moving at the same speed, in both directions, headlights full on in broad daylight, on the Ventura freeway, coming from nowhere, going nowhere: an immense collective act, rolling along ceaselessly unrolling, without aggression, without objectives – transferential sociality, doubtless the only kind in a hyperreal, technological, soft-mobile era, exhausting itself in surfaces, networks, and soft technologies. No elevator or subway in Los Angeles. No verticality or underground, no intimacy or collectivity, no streets or facades, no centre or monuments: a fantastic space, a spectral and discontinuous succession of all the various functions, of all signs with no hierarchical ordering – an extravaganza of indifference, extravaganza of undifferentiated surfaces – the power of pure open space, the kind you find in deserts.
>
> (Baudrillard 1995: 125)

Baudrillard's project presents a reality that is seductive, yet repellent and violent. His description of Los Angeles (*America*, 1995) introduces the central features of the *postmetropolis* as simulation and hyperreality. Most strikingly, it suggests that everyone partakes in the construction of the 'spectacular' city, which is navigated by car. The car carries the wanderer, who is going nowhere in particular, and who becomes part of a collective operation that maintains a ceaseless momentum of movement and spreading urbanization; the *flâneur* no longer walks cruising street corners or perusing shop windows randomly and uninhibitedly. This city has no centre and embodies the loss of a centred order and original purpose. Instead, purpose, direction and meaning are dispersed, characterized by this wandering where everyone is isolated from each other in their cars. Baudrillard's tale of America is a celebratory paradox that heralds a hyperreality, which can be interpreted either as desirable, or as

a pessimistic prophecy of the future: his reference to the World Trade Center (1983: 135–7) as metaphor for the capitalist system, now seems uncanny following its destruction in 2001. He uses powerful images such the Twin Towers, Disneyland and the Gulf War to address a range of contemporary mythologies, which are played out and managed by global media and in images. Disneyland, for example, presents a utopia that hides the fact that Los Angeles is no longer real, but of the order of simulation. In a way geographical imaginings such as this rely on our knowledge of America. We understand what Baudrillard describes because we have seen it for ourselves in countless films, photographs and television programmes, which feed our prejudices and expectations, so that when we experience the place ourselves, the reality fits our imaginings. The images of our imagination, and of ideology, realize our conception of reality.

Baudrillard's discussion of representation and simulacra (*Simulations*, 1983) refers to a hyperreality that disrupts the world of simple meaningful communication, so that we can no longer distinguish between original and copy, or the real and the imaginary. Instead, reality is constructed by the image. Baudrillard identifies a series of conditions that have removed us from direct interaction with reality, which his 'successive phases of the image' describe as an increasing separation through history. The first describes a transparent reflection of a basic reality determined by rational thought; the second is characterized by the belief that the real is masked by appearance, which perverts that basic reality and which psychoanalysis and structuralism have attempted to uncover; the third describes the image as a substitution for reality and thereby masking its absence. This last condition is recognizable in Debord's earlier description in *The Society of the Spectacle* [1967] of a world of images, propaganda, advertising and entertainment, which is easily translated into the 2011 context.[1] Spectacle is at the heart of society's 'unreality'. The spectacle is a product of reality that simultaneously falsifies it, so deeply is it embedded in a cycle of spectacle and production. It is more than 'mere visual deception produced by mass-media technologies'. It has become a materialization of a world-view in which 'mere images become real beings' (Debord 1992: 8–11).

> In societies dominated by modern conditions of production, life is presented as an immense accumulation of *spectacles*. Everything that was directly lived has receded into a representation. The images detached from every aspect of life merge into a common stream in which the unity of that life can no longer be recovered. *Fragmented* views of reality regroup them-selves into a new unity as a separate pseudo-world that can only be looked at. The specialization of images of the world evolves into a world of

autonomized images where even the deceivers are deceived. The spectacle is a concrete inversion of life, an autonomous movement of nonliving.

(Debord 1992: 7)

This quote collates many of the ideas that describe the recognizable consequences of living in a postmodern world. It anticipates Baudrillard's consideration of the simulacral world and Virilio's negative assessment of the consequences of mass communication. It also serves to extend de Certeau's specular perspective discussed in Chapter 4, which gave focus to different ways of experiencing the city. But Baudrillard states that we have moved on from Debord's 'society of the spectacle' – into the fourth phase – one in which the message becomes indistinguishable from the simulacrum. This phase is described as 'bearing no relation to any reality at all', an 'ecstasy of communication', which is recognizable in the twenty-first century as the virtual reality of cyberspace (Baudrillard 1983: 11).

The treacherous image

Baudrillard describes photography as 'irreal', a kind of untruth that embodies the instability of any certain reality, and challenges what seems 'obvious' and 'natural'. There is no adequate analytical system of representation that can refer to the real world as if it were direct or unproblematic. The representation of reality precedes it, anticipates it, modifies it in a 'precession of simulacra' (1983: 2). Where Baudrillard's first phase determined that there was an original something to copy, subsequent phases reveal this as a habitual way of thinking; we construct ideas about reality, truth and knowledge, just as we construct the ideal city. What is conceived as reality has been transformed by the impact of photographic reproduction that provides the means for endless series, copy and fabrication (simulacra), and for a pseudo-realism that presents illusory appearance. Our understanding of a world, which is mediated by imagery, results in the ironic contradiction that photographs can only create a cycle of un-realism.

Writing about the attack on the World Trade Center, Susan Sontag (*Regarding the Pain of Others*, 2003) points out that first accounts of those who escaped from the towers, or watched from nearby, described the experience as 'unreal', 'surreal', 'like a movie' . . . 'It felt like a dream' (Sontag 2003: 19). She says that once a catastrophe is witnessed in a photograph, the experience becomes like the photograph, and that the problem is not that people remember through photographs, but that sometimes they remember *only* the photographs (79). She discusses also the ethical implications of the photograph's capacity to inevitably elevate horrific events such as this into beautiful pictures.

But the landscape of devastation is still a landscape. There is beauty in ruins. To acknowledge the beauty of photographs of the World Trade Center ruins in the months following the attack seemed frivolous, sacrilegious. The most people dared say was the photographs were 'surreal', a hectic euphemism behind which the disgraced notion of beauty cowered.

(Sontag 2003: 67)

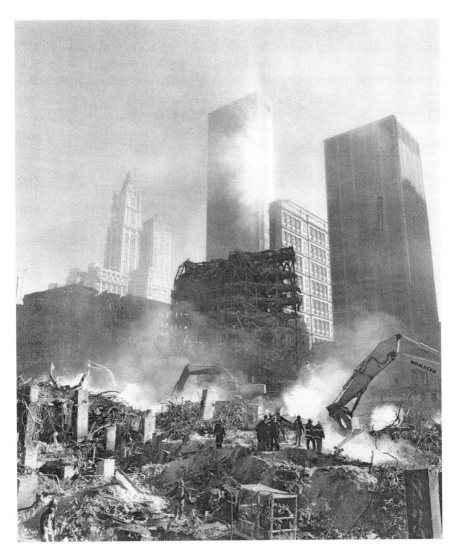

Figure 6.2 Joel Meyerowitz, *Smoke in Sunlight. Aftermath – World Trade Center Archive,* 2001. © Joel Meyerowitz. Courtesy Edwynn Houk Gallery.

The photograph is a contradiction because it 'gives us mixed signals. Stop this, it urges. But it also exclaims, What a spectacle!' (68). We cannot deny the formal dimensions of beauty, which can be difficult to disassociate from the content and context. But photographs can divert attention from the suffering to the picture itself and from any obligation to act. Sontag suggests that to be effective as political instruments or alter opinion or behaviour, photographs need to shock (72). However – another contradiction – we have become immune to effect as a result of the 'mass media conditioning' to which we are all subjected, so that shock wears off. Hyperreality removes the impact of horror. To be responsible and to avoid a generalized objectification of circumstance, photographers must acknowledge the particularity of individuals and their suffering – who they are and what they are photographed to represent – otherwise documents only result in exploitation or false sentiment.

If photographs can never capture reality, there is at best only a figurative correlation between referent and image. The photograph operates like a map that engenders an idea. Baudrillard states the simple fact that we are told about the Gulf War, shown pictures of it, but we do not *know* it took place. Yet we believe and rely on representation and verisimilitude. What results is a process of exchange between idea, reality and fabrication. In an era of postmodern self-consciousness, this is further complicated by the photographer who, being aware of the photograph's capacity for deception, makes ironic use of it. The fabrication of the photograph absorbs the consequences of cause and effect and creates an 'implosion of meaning' that initiates simulation. As a result, society attempts to re-create what we imagine is real in a 'panic stricken production of the real', in its representations, productions and simulated models (Baudrillard 1983: 13). Baudrillard sees banality and nostalgia as inevitable consequences. We search for signs of reality and truth (in the Ellis series, for example), yet attempting to retain or return to past meaning results in nostalgia – another form of reality. Soja describes a cynical American politics that strategically represents democracy in 'image-bites' and makes use of hyperreal fantasies to manufacture a vision of society that justifies the wealth of the fortunate minority. In what Soja calls 'residential hyperreality', the simulated world of the city creates ghettos for specific groups of people. For example, we can taste the food, observe the customs, hear the language of numerous cultures without leaving Los Angeles. Hyper-simulation fabricates idealized cities – such as the theme park *City Walk* (1992), which constructs the ideal 'LA style' but ironically and cynically prohibits entry to some of those on whom the experience is modelled (Soja 2000: 342). This phenomenon can now also be found in Chinese cities, such as Shanghai.

Buenos Aires: cosmopolis

The image *Plaza de Mayo, Argentina*, 1996 appears to be trivially banal, yet it is an example of how a photograph can present a deeply complex network of historical and political references that are simultaneously contradictory. *Plaza de Mayo* exploits the visual spectacles that assault us every day whilst being also implicitly critical of commercial absurdity and of political corruption. It features the main square in Buenos Aires, scene of the 1810 revolution, a bombing in 1955 and numerous mass demonstrations, most significantly those by the group Mothers of the Plaza de Mayo. It depicts the May Pyramid, the oldest national monument in the city that celebrates Argentina's independence from Spain in 1816, and the Casa Rosada, Presidential Government House. The square retains symbols of its Spanish legacy in the architecture and ornate street furniture. In the foreground is a young woman, smiling inanely and wearing the uniform (blue and white as in Argentina's national flag) of perhaps a maid in one of the surrounding buildings or nearby tourist hotel. She is presenting to us the product Procene together with a yellow dustpan – the tools of her trade – in a stance borrowed from familiar advertising campaigns used to promote such products. She appears to be declaring:

> This is the product that will solve all your cleaning problems – it rids you of everything unwanted in the home. It provides the extra force (*potenciadia*) required to cleanse any level of dirt. The city of Buenos Aires and I are here to provide this service for you – you do not have to get your hands dirty. The city is cleansed of all dirt and anything else that is dirty.

Cleanliness, and its antonym 'dirtiness' – in the sense of being underhand, secret, corrupt and the power exerted by a violent regime – is a pertinent issue for Argentina. Argentina's 'Dirty War' (1976–83) conducted state operated repression and assassinations (Operation Condor) under the military dictatorship of Jorge Rafael Videla, aiming at ridding the country of dissidents. Thousands of left-wing activists, journalists and students disappeared during this time. The Mothers of the Plaza de Mayo, formed in 1977 by mothers of the victims (the Disappeared), gather in the square regularly and demand the whereabouts of an estimated 30,000 lost people. They are recognizable by their white headscarves on which they have embroidered their children's names – in contrast to the absurdly large bow worn as a headpiece in this photograph.

Plaza de Mayo is part of the series of photographs entitled *Pop Latino* (1995–2006) by the Argentinian photographer Marcos López who is known

Figure 6.3 Marcos López, *Plaza de Mayo, Buenos Aires, Argentina*, 1996. Black and white reproduction from original colour image. Courtesy of the artist.

for images that are typically suffused with irony and kitsch motifs, and which reference the world of commodity, advertising, globalization, tourism and homoeroticism. They depict the postmodern banality of today's cities, and comment on the contrast between the realities of local experience with the visual evidence of globalization. The series serves to introduce a city symptomatic of the *postmetropolis*, its associated abuse of power and the consequences of a highly globalized capitalist commercialism. López's photographs are extravagantly coloured in contrast to their content that recalls Argentina's history, some of which remains suppressed. He says that the central preoccupations of his images – being fragile and absurd – are essentially poetic. They reflect 'the spirit of the misfortune, of a painted cardboard country' as a result of the suffering and 'the untidiness of racially mixed America'. They exploit visually seductive qualities to represent 'the violence and inequality of Latin America, on the one hand, and the joy on the other'. These photographs are contradictory statements of celebration and critique, made obliquely, because he realizes that:

> To say that the world is bad or to make critical observations, as sharp and
> ironic as the problems themselves, wouldn't do any good. So, gentlemen,
> we hand the documentary to the inner boy. Because when I experience

excesses of irony I end up saying: 'Marcos, wait a minute, let's consider compassion, a tender glance.' It is also an expression of desire.

(López 2011)

The photographs of Marcos López and Alexander Apóstol[2] demonstrate two faces of the *postmetropolis*: hybridity and urban mutation. In Soja's terms, *Plaza de Mayo* depicts a *cosmopolis*, permeated with features from its colonial past, and immersed in a global capitalist present that venerates 'product'. *Cosmopolis* acknowledges what is both universal and particular in a heterogeneous city-region that is fragmented and sprawling (Soja 2000: 229–31). Its references are significant to local history whilst its forms of representation are globally recognizable: tourism, commodity and media presentation. *Pop Latino* illustrates the process of 'symbolic exchange', which Baudrillard [1968] explains as more elusive than the exchange of commodities, and which goes beyond the rational production and commerce of things. Objects (commodities) assume a value that has nothing to do with their use or exchange value, but only in terms of what they represent: their symbolic exchange. Symbolic exchange has more to do with the fetishistic consumption of objects and the substitution of images for what we desire – seen in *Plaza de Mayo* as a desire for a sanitary and comfortable life, the benefits of extravagance and a 'clean world' freed from corruption. Photographs, by their nature, offer a spectacularly visual symbolic exchange (Baudrillard 2003: 15–17). The power of imagery over words is that it invites a chain of possibilities: Procene (if it exists) is clearly not just a cleaning product that satisfies our desire for healthy modern living. It forms part of the multifarious system of production made ever more absurd by its being part of a global communication system. Scouring the internet for details of Procene, I find it encounters a number of possible processes: Procene (pronounced similarly to the Czech word 'prosím' which means 'please') is a 'java library package which provides classes to ease the creation of interactive 3D scenes'; it is a character in a patrolling video game; it is 'a metallocene co-extruded cast polypropylene material engineered for excellent sealability that provides excellent printability and seal strength needed for your packaging solution'. Its many material and symbolic uses are resonant with irony in the context of *Plaza de Mayo*, and are symptomatic of the hybrid world of reference available in cyberspace. Not only does it promise an outlet for creation, it offers an interactive experience that extends my world into some imagined (possibly utopian) place. It also provides diversion in the guise of another better, albeit fictional, life. And it seductively tantalizes me with the wonders that science can offer me to make my world evermore convenient – and clean.

BOX 6.1

Weapons of mass communication

López's image *Plaza de Mayo* displays the influence of global information on a world seduced by what can be seen and what can be consumed, a condition which Debord [1967] describes as the 'society of the spectacle'. The spectacle shows a world, via visual media, that cannot be directly grasped and therefore elevates vision as the dominant sensory influence. Debord describes 'communication' as 'essentially unilateral' – it runs away with itself in that society has become totally dependent on it (1992: 11–13). And this apparent autonomy separates us from the process – it is a powerful means of control because it is hidden:

> The reigning economic system is a *vicious circle of isolation.* Its technologies are based on isolation, and they contribute to the same isolation. From automobiles to television, the goods that the spectacular system *chooses to produce* also serve as weapons for constantly reinforcing the conditions that engender 'lonely crowds'.
>
> (Debord 1992: 15)

The society of the spectacle encourages a separated existence in the midst of lots of people. Where Debord described a separate 'pseudo-world' and Baudrillard presented a lyrical impression of a world prompted by simulation in which we cannot distinguish reality from artifice, Virilio focuses on the negative impact on a world in which mass communication is central.[3]

> It is now a matter of *smashing the mirror of the real* and thereby causing each and everyone of us, whether allies or adversaries, to lose our perception of the *true* and the *false*, of the *just* and the *unjust*, the *real* and the *virtual*, in a fatal jumble of words and images that lead to the throwing up of the last TOWER OF BABEL – which is supposed to achieve revenge, for America, for the collapse of the World Trade Center.
>
> (Virilio 2005: 43)

Like Baudrillard, Virilio also uses the word 'panic' to describe the condition in which we live. As a result of advanced forms of

communication that are camouflaged, insidious and destroy any sense of reality, we have lost control and our sense of direction. Virilio presents a reality reduced to a global conflation of panic in the face of common fears. He frequently uses metaphors of war, so that his phrase 'weapon of mass communication' is an implicit reference to the 'destruction' that comes in times of conflict and racial tension (2005: 34). The city world, served by circulating satellites, is in a state of siege where fear is inflated by images of terror and in which the imaginary is caught in a loop of imagery, which he describes as a 'multi-media magic show' (2005: 87). 'Mass information provides everyone with a dystopic vision of current events' (2002: 22). He aligns the advertising terrorism of an industrial consumer society with a violent onslaught on the masses – a global threat that provides 'the entire terrain of social reality' with a bio-political conditioning of populations (2002: 29–31). And like Baudrillard, Virilio argues that visual information and news is 'prophetic'; it anticipates events, creates events – and in a sense justifies our fears. Media technology damages the truth and the 'fact' of the globalized world (2005: 39); the constant and repetitious barrage produces a 'collective hallucination' (2005: 86). This information revolution in which televised truth takes centre stage, brings a standardization of public opinion – a 'global totalitarianism'.

Carceral cities

The progress of modernity reaches a state of implosion in Virilio's city of panic. He asks: how are we going to approach the impending incarceration brought on by progress without lapsing into the despair that globalization portends (Virilio 2005: 63)? He refers to 'progress' as a kind of disaster and the contemporary metropolis as *the greatest catastrophe of the twentieth century*' (2005: 90). The metacity extends beyond its physical limits and is no longer formed of necessity or demand, but of a self-perpetuating momentum of urbanization in which the peripheries of cities become swamped with displaced persons (Virilio 2002: 79). The 'metapolitical' bubble of globalization caused by communication and finance, and exacerbated by their virtual expansion, is fit to burst (2005: 91). Such impending chaos generates whole districts that become forbidden territories to other ethnic groups, and citadels enforced by privatized security. Virilio presents a crisis of security in cities in which polarized growth (*Polaricity*)

generates a focus for criminality, mafia and urban gangs from which people hide away in segregated gated communities (2005: 93). Mike Davis examines this in some depth in *City of Quartz* [1990]. He expressively describes the development of a socially divisive obsession with security in 'Fortress LA' and what he refers to as the 'militarization' of city life:

> The carefully manicured lawns of Los Angeles's Westside sprout forests of ominous little signs warning: 'Armed response!' Even richer neighbourhoods in the canyons and hillsides isolate themselves behind walls guarded by gun-toting private police and state-of-the-art electronic surveillance.
>
> (Davis 2006: 223)

As a result access to public space is increasingly reduced and segregated, and enforces a removal of pedestrian space entirely so that any sort of direct contact with the street or other ethnic or social groups is prohibited: 'the occasional appearance of a destitute street nomad sets off a quiet panic'. Downtown Los Angeles 'kills the crowd' beloved of Baudelaire. Instead 'to reduce contact with untouchables, urban redevelopment has converted once vital pedestrian streets into traffic sewers and transformed public parks into temporary receptacles for the homeless and the wretched' (Davis 2006: 226). Paul Graham's photographic series *American Night* (1998–2002)[4] illustrates this phenomenon of social division by visualizing a metaphor of social invisibility. It depicts the desirability and safety of deserted American suburbs – colourful and clear with nice homes and nice front yards – the quintessential 'American dream', but devoid of people walking in the streets. These are contrasted with a series of blindingly 'white' images whose content is obscured by deliberate over exposure, so that they are bleached out and lacking in contrast. Solitary walkers pass through these spaces, quietly and unobtrusively, sometimes stopping, standing and looking. They are only just discernible as Afro-Caribbean – almost invisible.

Caracas: polaricity

The deceptive image *Royal Copenhagen* (2001) appears to give homage to the modernist architecture of Caracas in Venezuela. An illuminated 'entrance' gives the impression of invitation, luxury and extravagance, reminiscent of hotel lobbies, department stores or expensive apartment blocks. It could be any of these, and anywhere in the world. Its distinctive feature is the corner structure that resembles a splendid art deco frontage to a Picture Palace and links the front with the back of the building. It extends over four floors, each with a curved balcony giving vista to the city beyond. Whatever it is/was, the building now

has a blank façade; it has no windows or doors that give access to the interior; it is a blind citadel that forbids entrance. It presents a curious contrast to what appears as an almost shack-like structure to the side of the building and the blank entrance at its front that resembles a public convenience.

Figure 6.4 Alexander Apóstol, *Residente Pulido series: Royal Copenhagen,* 2001. Black and white reproduction from original colour image. Courtesy of the artist.

This monument, and title (borrowed from expensive Chinaware such as Delft, Limoges and Meissen), is a fiction that suggests something much more than the reality of such buildings today. It is one of a series by Alexander Apóstol, who has digitally manipulated the original image in order to comment on the urban mutation in Venezuelan cities. They are bland images of buildings across Caracas, taken in the style of simple architectural photographs, in the tradition of Marville – but here digitally mutated, so that by removing all the details of the living, they are dead things, monuments devoid of function. The series 'documents' the remnants of the momentum of progress and urban renewal between 1940–60, which occurred in many developing countries at that time. These are buildings that characterize the building expansion financed by money generated by the oil boom. Metaphorically they represent the demise of modernist organization and idealism; a failed utopia; fictionally they represent the hybridized remains comprised of material reality and technological simulacrum.

In contrast, Apóstol's other series, *Residente Pulido: Ranchos* (2003), presents the façades of humble structures, constructed with a hotchpotch of bricks and breezeblocks of different colours and in different stages of decay and yet visibly built in the modernist tradition. *Ranchos 01* shows a broken façade, with the visible detritus of those who lived there remaining on the 'terrace' to its side. Known as *ranchos*, these are the hybrid structures, now abandoned, that were also built in the boom years with whatever could be found by migrant workers from the rural areas of Venezuela, and from the Andes and the Caribbean. The series is testament to the memories of people and the politics of the city. Today these buildings are at the heart of the poorest areas of the city, which continue to spread into the mountains: 'These areas are absolutely overwhelmed by disorganized or excessive growth of the city, social contrasts dramatically increase in the city, indicated in both houses and in the design of public space' (Apóstol 2003).[5]

Caracas is symptomatic of two key features of the *postmetropolis*: the hybridity and degeneration that results from the increasing migration in response to the needs of industry, followed by its subsequent disappearance. The buildings, and the people, are left to their own devices, no longer looked after, degenerating. What is left is an abandoned utopia seen in the blank façades of aspiration: the metaphorical equivalent to false promises of capitalist enterprise and the consequences of accelerated urbanization. Both series present a visual contradiction in the progress of modernity with the reality of living in the city today; a digital deception portraying 'the development of modernist Venezuela that is actually totally corrupt and decadent' (Apóstol 2003). Together they underline Soja's conception of the *Polaricity* that promotes the extreme contrasts of wealth and poverty, which sustains

the capitalist city. These photographs raise questions about the transitory nature of progress in the city and its consequences for people living in it. They equate with the consequences of *Exopolis* – the extreme restructuring of urban form, which is now decentred and 'turned inside-out and outside-in'.

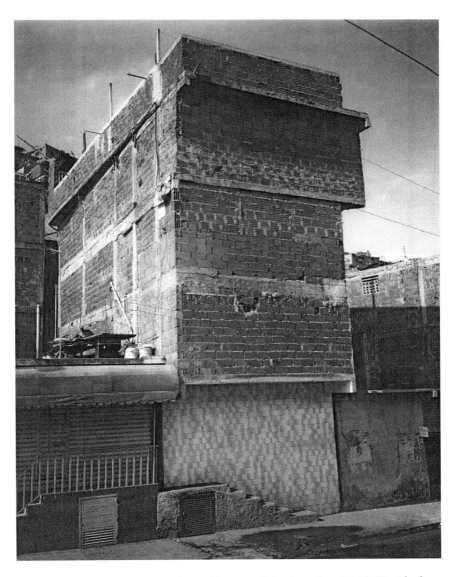

Figure 6.5 Alexander Apóstol, *Residente Pulido: Ranchos 01*, 2003. Black and white reproduction from original colour image. Courtesy of the artist.

BOX 6.2

Hybridity

Hybrid communities are a consequence of rapidly changing cities: in the United States in the early twentieth century; in Latin America in the mid twentieth century; in China in the twenty-first century. Industrialization prompts mass immigration to cities such as Los Angeles, Caracas in Venezuela and Chongqing in China, which in turn creates changed communities. The notion of a hybridized city is nuanced in Latin America by a postcolonial interpretation of its colonial past and the subjugation of its indigenous peoples. Homi K. Bhabha, a cultural theorist concerned with colonial, postcolonial, modern and postmodern debates, uses a number of metaphoric terms, including 'hybridity', to describe ambivalent or transitional conditions. He describes the 'post' in post-modernism and postcolonialism as a 'beyond', an intervening space, a concern with disorientation and change that signals a moment of transition, a sense of beginning. He uses the terms 'between' and 'borderline' to provide focus for representations of cultural and racial difference, incorporating both antagonism and negotiation. His discussion of culture emphasizes that present-ness cannot break with the past, cannot leave a colonial past behind or abandon what has been absorbed and adopted in order to return to the idea of some original experience. Bhabha's focus is on the *processes* of identity rather than fixed narratives of the past. Culture and nation-ness is a construction and an accumulative experience. He emphasizes the articulation of cultural differences and 'the idea of society itself' and suggests the possibility of a cultural hybridity that accommodates 'difference without an assumed or imposed hierarchy' (Bhabha 1994: 4). His is a positive interpretation of postcolonial awareness; his concern is that of a way forward in the face of the past histories of colonialism and subjugation. He points out the dangers in mythologizing and fixing a past history rather than promoting the process of a living culture that continues to change and evolve. In the process of struggle or expansion, particularly in reaction to a past colonial domination or political ideology, cultural identities change; they move between this and that, adopt this, reject that; they are hybrids.

Hybrid urbanism

Mike Davis and Celeste Olalquiaga examine the complex hybrid effects resulting from the increasing immigration from Latin America to cities in the United States such as Los Angeles. For example, Davis states that by 1998, Latinos, mostly of Mexican origin, had outnumbered Anglos in Los Angeles county by over a million. His provocative account of a *Magical Urbanism* (2000) places the impact of Latinos as more centrally important to the future of American cities than the consequences of the global economy. Whilst the cultural exchange works both ways, Davis and Olalquiaga suggest that the extent of the migratory influx increases the development of 'Spanishness' in these groups. Olalquiaga describes a process in which Latin culture infiltrates 'America' to give it an element of exotica – in its food, music and iconography, and points to the emergence of a type of hybridity as a 'mosaic' – a place where elements come together and recreate memories of homeland to construct a panorama of Latin culture, rather than be dissolved in a 'melting pot' (Davis 2000: 77). However, she also suggests that profound cultural divisions in the United States hide behind its diverse cultural communities by exploiting a mythology around its 'colourful traditions' and 'lively' Latino communities.

Olalquiaga characterizes a Latin American version of international culture that has created a hyperrealism comprised of parody. This 'magical hyperrealism' inverts the traditional image of a subservient colonized people into one of a cynical audience that laughs at the absurdities of cultures that cannot see their own self-aggrandizement. Latin American cultures typically dramatize banality as a means to deal with the political changes that 'postcolonial countries are usually forced to face' (Olalquiaga 1992: 75). Olalquiaga suggests that simulation is at the root of a destabilized urban experience, and emphasizes two resulting features that predominate in Latin American cities: a changed self-perception, and the absorption of hybrid identities. Simulation promotes a plurality of imagery that displaces distinctions between the physical, geographical and the imagined so that everything becomes generalized, clichéd and 'flattened out'; it empties out meaning. For example, Olalquiaga describes the evolution of carnival in Rio de Janeiro where the carnival is now paraded in a long stadium that replaces the street, and which the poor watch on television. She describes carnival themes that are the ultimate hybrid construction – a conflation of cultures, ancient, modern and futuristic, the incorporation of global phenomena and consumer products. The humour of the *carros* (carnival cars) captures the irony of contemporary life in the city. Tropicalized high technology celebrates the veneration of consumption and the obsolescence of product, decadence is carnivalized and 'turns postindustrial culture into pop, making its emptiness kitsch' (84).

For example, the carro *Tupilurb* presents a pile of debris (abandoned cars, refrigerators, televisions) painted in gold. It sings – 'Watch all that happiness, it's a smiling city'. 'Even trash is a luxury as long as it's real.'

> The contradictions and exclusions of the process of modernity are often addressed by the carnival *enredos*. One of the most brilliant of such thematic allegories left the issue of national identity . . . aside, focusing instead on the mechanics and consequences of global urban reality. A retrofuturistic Indian metropolis, Tupinicópolis, was the second finalist in the 1987 competition for best 'samba'. Its theme described the Tupi Indians, happy inhabitants of an unbridled cosmopolis where, amid neon and trash, they ride supersonic Japanese motorcycles and play rock music, wearing the Tupi look: bright coloured sneakers, phosphorescent feathers, and blenders as headgear. Its *carros alegoricos* showed a high-tech urban scenario of mirrors, chrome and plastic made in golden, silver, and electric colours and set up in expressionistic diagonals and spirals. In it were highways, skyscrapers, and neon signs: Shopping Centre Boitata, Tupinicopolitan Bank, Tupy Palace Hotel and even a disco.
>
> (Olalquiaga 1992: 83)

Olalquiaga's discussion of Latin American cultures describes a number of movements, such as the Chilean punk movement, that have absorbed the postmodern and the postcolonial in hybrid forms. A mix of hybrid representations reflect global influences, seen manifested in López's *Pop Latino*, which displays the spirit of carnival. This phenomenon of cultural parody can be seen also in examples of contemporary Chinese and Taiwanese digital photography such as Wu Tien-Chang's elaborate burlesque constructions.[6] Tien-Chang's photographs reference the contrast between traditional mythologies and contemporary absurdity. Parodying Taoist scripts he creates a virtual exchange between digital imagery (representing present life) with traditional philosophical language (representing past life). They contrast the spiritual with the banal, and the serious with the humorous (*Life is as Short as a Dream*, 2003). López and Tien-Chang each describe a process in which the act of consuming is presented as ultimately satisfying, and commodity exchange as pervasive and a focus for desire: 'Constant and unmediated consumption then, displaces purpose to the point that commodity fetishism becomes an icon, continually replaying its own fragmentation, alienation and deterritorialisation' (Olalquiaga 1992: xviii).

Chinese dreams

Cities such as Los Angeles have become huge urban regions, less distinct and centralized than they once were, and spreading out over great distances, from

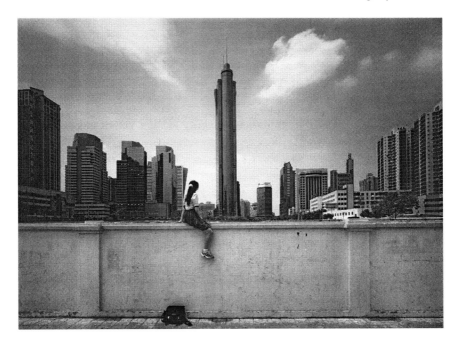

Figure 6.6 Weng Fen, from the series *On the Wall*, 2001–02. Chromogenic colour print (125 x 173 cm). Courtesy of the artist.

and between highways and airports, to create 'edge cities' (Graham 2004: 117). In his essay 'Utopian Cities', Pan Wei identifies that the pattern of Chinese urbanization follows the early twentieth-century US model in which an urban economy developed rapidly under rigorous programmes of city planning, as opposed to the European model which saw a steady transformation through industrialization, or the Latin American model in which agricultural workers were forced into cities as labour for sudden mid twentieth-century industrial development, resulting in the rapid growth of city slums (Pan Wei in Hornsby and Mars 2008: 466–77). It is predicted that by 2020, an urban population of 930 million will shift China from a predominantly rural society to an urban one. Such expansion suggests the possibility, for example, of an urban region, stretching from Beijing in the north to Shanghai in the south. Migration in China varies from the result of governmental 'development zones' that attract high investment, to the more organic development on the edge of cities, which are occupied by non-permanent migrants and not supported by governmental infrastructure (People's Urbanity of China in Hornsby and Mars 2008: 30–89). This process is happening so quickly that the authors of *The Chinese Dream: A Society under Construction* (2008) ask:

> What if you built the whole mass of Western Europe in 20 years? What if 400 million farmers then moved in? What if it happened between now and 2020? What would it look like? How would it work? Would you be able to go to sleep at night? And if you did, would you dream of somewhere else . . .?
>
> (Hornsby and Mars 2008: 2–12)

Whilst the annihilation of cultural identity in the wake of this expansion may seem appalling from a Western perspective, China gives more credence to the history of site, than it does to its architecture. Adrian Hornsby suggests that the horror invoked by the extent of China's urbanization reveals a fear of change to the world order, which is dominated by a Western hegemony that is suddenly confronted by 'this huge, closed, red alien rising' (Hornsby and Mars 2008: 22). And an alternative perspective sees urbanization as the solution to the poverty of rural China and the city as embodying its economic and political aspirations.

Ferit Kuyas has photographed one such Chinese megalopolis, Chongqing, situated in Southwest China's region of Sichuan and which is reputedly the largest city in the world with 32 million people. It expands in every direction with what seems no account of the quality life of those who live there – the many rural workers who have become construction workers. Kuyas's project is entitled *City of Ambition* (2005–08) after a quote by Alfred Stieglitz because, he says, the construction resembles the building of Manhattan in the 1920s:

> I am mainly interested in the outskirts of Chongqing, where the city can't be really seen but sensed, like a tiger moving through the jungle – invisible, but there . . . The fog dominating most pictures is real. The city's nickname in China is *City of Fog*.[7]

Another series, *Chinese Smokers* (2005) offers a more subtle critique that comments on the world expansion of products and the consequent influences on attitudes to social life. The titles of individual photographs in the series make these observations: *Smoking is seen as a good thing*; *Cigarette vendor's displays are very inviting*; *Packages are very decorative*; *Tobacco tax is important for national economy*; *Smoking is socializing* (http://feritkuyas. com/city_of_ambition/; http://www.feritkuyas.com/chinese_smokers/).

Sze Tsung Leong's series *Cities* uses a taxonomic method adopting a consistent viewpoint to show cities across the world (La Paz, Nairobi, Houston, Nagasaki) and to emphasize a global conformity. *Luohu District Shenzhen, from the Cities series*, 2008 (see Chapter 1) has the look of downtown in any city in the world, except it gives the impression of something

huge, even unreal. It is noticeably devoid of any clues that give it cultural identity until we notice the Chinese characters on top of a building at the bottom right of the picture. It has a 'centre' that is marked by a group of particularly tall buildings, upon which the recognizable urban pattern of streets converge. The high vantage point from which each photograph is taken (reminiscent of de Certeau's vista of Manhattan from the top of the Twin Towers) emphasizes the appropriation of modernist architecture. It is not only a city of hybrid cultures, which has assumed the outward signs of the capitalist West; it is described as a 'Nowhere' city.

Leong's series *History Images* (2004) looks closely at abandoned histories and the embrace of a new future. These are large format images three feet high in which the details of domestic life can be seen through windows. They show a contrast of distant vistas with the most trivial details of everyday life. The small dilapidated traditional buildings, two or three floors high at most, abandoned and close to destruction, illustrate a process that erases whole districts across China in a simultaneous destruction and construction.

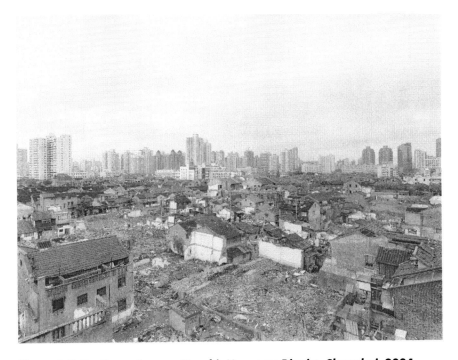

Figure 6.7 Sze Tsung Leong, *Nanshi, Huangpu District, Shanghai*, 2004. From the series *History*. Chromogenic colour print. © Sze Tsung Leong. Courtesy Yossi Milo Gallery, New York.

History here becomes a symbol of cultural achievements and cultural pride and so on. You can see in the monuments that are preserved and promoted, like the Great Wall and the Forbidden City. You can see it in the list of inventions – gunpowder, fireworks, paper, bureaucracy, etc. So there's that history that's very well protected because it's a matter of national identity. Then there's the other type of history that is recorded in the fabric of the cities. This includes the houses that are being destroyed; it has to do with the history of quotidian things, really the layers of history that have slowly accumulated. The loss of this fabric – the spaces and histories particular to different cities – means that the particular cultural value and artistic qualities they contain, are lost.

(Leong 2006)

The image *Nan Shi* looks more like a post-war bomb-site with the incongruous backdrop of new high-rise buildings in the distance. The extent of such a programme of expansion, which seems like a wholesale annihilation of a past and replacement with a future, is unfamiliar in the West, which has been a gradual 'pull something down, put something up' process. The extent of the Chinese accelerated process of transformation is unimaginable: Three Gorges Dam destroyed a number of cities, towns and villages in its construction, forcing populations to be relocated in preparation for the flooding of the Yangtse river. Leong's project suggests that the Chinese identity is subsumed by this desire for economic expansion at the expense of all else. It creates a divide between those who will live in newly built apartments and those who are left behind in rural areas and poverty. Leong's focus on the contrast between the old and the new emphasizes the ironic fact of China's ancient history and the repressive attitude to history during the Cultural Revolution. Leong's images are also testament to the construction of the hyperreality described by Baudrillard and Jameson (Hotel Bonaventure – see also Box 1.2: Cities in miniature):

Today, much of the development is commercially driven, but there's a fuzzy line between developers and the State, since the relationships between them are so intertwined. This is why developers are able to gain control of such large urban areas, drive out all the residents, raze the entire area, and refashion these zones into profitable real estate. In Shanghai, there's a development in one of the historic areas called Xintiandi, a hugely successful shopping mall billed as a preservation project. The mall is built in the style of traditional buildings that used to be there, and what has basically been done is most of the original buildings were demolished, some of the buildings restored but basically rebuilt. It's become so hugely successful as a commercial enterprise because people are attracted to this old, historical, pedestrian type of city life, that now every city wants a Xintiandi. But what is important to remember is that the new 'historic'

area is only a very small portion, albeit the most famous one, of the entire development. Pretty much all of what was there before was destroyed and replaced by an entirely new reality, which is what you see all over China.

(Leong 2006)[8]

Xintiandi has a website inviting us to 'Come through the door and live it large in the *City's Living Room* . . . find a style of your own . . . find time to relax more – why not? . . . life is a bowl of cherries after all.' The very young people shown relaxing on the virtual 'tour' appear to been given a digital mixture of East and West features.[9]

In the wake of the Cultural Revolution, Shao Yinong and Mu Chen's series *Assembly Halls* (2005–06) record the physical evidence of a history of social ideals.[10] They show a range of communal spaces, many of which were constructed as ancestral halls and later commandeered for political meetings by the Red Army during the Cultural Revolution. These are unemotional images taken in a straightforward way in contrast to the complex situation that characterized that period: the conformity, the fear and the violence done to historical traditions. The onslaught of capitalist purpose displaces the ideology that preceded it – in this case the Cultural Revolution. These Assembly Halls look quaintly historic, very much out of step with current expansion; they are redundant as political assembly halls and ironically many of them are used now as cafeterias or karaoke bars. *Assembly Halls* presents a story of history and changing ideologies stretching back through the twentieth century and beyond.

As a result of rapid economic growth and social change, many contemporary Chinese photographers focus on issues of urbanization and globalization. China's modernization and exposure to the West since the 1980s has resulted in a compressed photographic development that displays a complex discursive practice, which has assimilated the features of conceptual art without question, and without the complication of needing to accept or reject the legacies of Western modernist photography. Chinese photographers freely make use of fictional theatricality and the artifice provided by technologies (Hung and Phillips 2004). For example, Jiang Peng-yi's series *Unregistered Cities* (2008–10) coalesces concerns about the rapid destruction of old Beijing city. This series photographs the detritus left in abandoned houses overtaken by unstoppable urbanization. At first glance, a photograph appears to simply depict a corner of a room in the process of demolition: cracked and crumbling plaster, rubble and debris on the floor. Looking more closely we see miniature buildings, 'skyscrapers' alongside a scrape in the dust: a 'highway'.[11] Chinese photography's reference to Chinese history represents an inherently political act – at once a re-visioning, a critique and a protest. It makes use of

recognizably significant sites (Forbidden City) or people (Mao) or events (June fourth movement and Tiananmen Square). Much of the work addresses political issues and self-identity. It speaks of the complex Chinese condition that is attracted to Western ideas and yet is aware of a hiatus in Chinese culture that both embraces and rejects different aspects. It is an attitude that refers with ambivalence to socio-political issues. Wang Qingsong's work is typical of the photographs' relationship to the rapidly changing social environment. Whilst Chinese culture is still rooted in Bhuddism and expectations of responsibility towards others, it is also seduced by the attractions of material life. Qingsong's work expresses suspicion about the nature of the changes in his society and the extent to which they are accepted or assimilated. For example, *Look up! Look up!* (2000) pokes fun at the superficiality of consumerism that worships global brands such as Coca-Cola or McDonald's and is highly critical of the consequences of globalization and its effect on Chinese values. It demonstrates the facility with which photography can show contradictory conditions simultaneously: of poverty and wealth, of history and the present, of tradition and materialism.

Further reading

Baudrillard, J. (1995) *America* [1986], trans. Chris Turner, Verso: London, New York.

Harvey, D. (1990) *The Condition of Postmodernity: An Enquiry into the Origins of Cultural Change*, Blackwell: Cambridge, MA, London.

Hornsby, A. and Mars, N. (eds) (2008) *The Chinese Dream: A Society under Construction*, Dynamic City Foundation, 010 Publishers: Rotterdam.

Hung, Wu and Phillips, C. (2004) *Between Past and Future: New Photography and Video from China*, Chicago: Smart Museum, New York: International Center of Photography.

Soja, E. (2000) *Postmetropolis: Critical Studies of Cities and Regions*, Blackwell: Malden, Oxford, Carlton.

Sontag, S. (2003) *Regarding the Pain of Others*, Hamish Hamilton: London.

Urban-think tank: http://www.u-tt.com/projectsMenu_Urbanism.html# – describes urban projects that address ecological and ethical concerns.

Baudrillard (1995) is one of a number in which he itemizes a series of personal impressions as he experiences different environments. These are an accessible introduction to Baudrillard's uncompromising commentary. On p. 59 he describes the sensation experienced at the top of the Bonaventure Hotel. Harvey (1990) provides a broad exploration of postmodernism and the 'origins of cultural change' from

consideration of economic transformation to the experience of space and time. Soja (2000) is a critical analysis of cities and regions that reinterprets Lefebvre's commitment to the production of space and the promotion of a political practice. It offers a positive and enthusiastic perspective on the transformations that have taken place in megacities in the late twentieth century. Hornsby and Mars (2008) provides a visually dynamic and provocative survey of these effects in China. Sontag (2003) extends the political/aesthetics debate by addressing in depth the ethical aspects of photography with regard to conflict.

Further photographs

Luchezar Boyadjiev (Bulgaria 1957) – *Billboard Heaven: Sofia* (2005) reconstitutes public imagery by pointing out conflicts of interest between global and local interests. *Billboard Heaven 1* is annotated: 'The ultimate fusion of the urban physical reality into the visual image of the city's interface is coming. Looming over the skies of Sofia is the welcomed utopia of unprecedented visuality. Consumers and consumables will be united once and for all!' (Vasif Kortun, in Demos 2006: 41): http://www.eurozine.com/articles/2007–05–25-boyadjiev-en.html.

Tim Davis (Malawi 1969, lives in New York) – *My Life in Politics* series. Davis, T. and Hitt, J. (2006) *Tim Davis: My Life in Politics*, Aperture: New York. It is described on Amazon as a 'treatise on the state of contemporary politics, politics as an aestheticized banality abstracted from real issues of power': http://www.davistim.com/images/images.html.

Paul Graham (England 1956) – Mack, M. (2003) *Paul Graham: American Night*, Steidl Verlag: http://www.paulgrahamarchive.com/americannight.html.

Andreas Gursky (Germany 1955) – Gursky's work demonstrates global markets, high-tech industry, international commerce and concentrated city habitation. Beil, R. (2008) *Andreas Gursky Architecture*, Hatje Cantz: Ostfildern; Galassi, P. (2001) *Andreas Gursky*, The Museum of Modern Art, New York: http://www.saatchi-gallery.co.uk/aipe/andreas_gursky.htm; http://www.moma.org/interactives/exhibitions/2001/gursky/index.html; http://www.spruethmagers.com/artists/andreas_gursky.

Jonathan Hernandez (Mexico 1972) – *Rongwrong* series (2006) are elaborate collages constructed from public press photographs.

Robert Polidori (Canada 1951) – Lappin, C., Pederson, M.C. and Polidori, R. (2005) *Robert Polidori's Metropolis: A Photographer's Search for the Emblematic Image*, Steidl Verlag: Göttingen. Publisher's blurb describes the series as 'not the images the clients necessarily wanted, but rather those that Polidori made to satisfy his own engagement with structures and their social role, both physical and metaphorical'. His image *Samir Geagea HQ, Rue de Damas, Beirut, Lebanon* (1994) presents the ironic contrast of beauty and destruction: http://www.christineredfern.com/2010/08/robert-polidori/.

Nick Waplington (Aden 1970, lives in New York) – *Indecisive Memento* series (1998). Waplington's series *Safety in Numbers* maps a global phenomenon, of a common culture shared by youths in cities of the first world – a 'fusion of youth-culture – of music, drugs, consumerism dominated by global brands that cut across the different nuances of specific culture. Los Angeles, New York, Tokyo – close-up they are indistinguishable. It presents a "state of impasse" and boredom and to a certain extent – privilege'. Sanders, M. and Waplington, N. (2002) *Safety in Numbers: Nick Waplington,* Booth-Clibborn Editions: London.

Wang Qingsong (China 1966) – his large-scale staged photographs address the political, social and cultural issues of a rapidly changing China. For example, his image *Dream of Migrants* (2005) refers to the term 'Migrants' which is very derogatory in China: 'It means aimlessly drifting population from one place to another, mostly from countryside to big cities to look for jobs. This group of people is called an "unauthorized population flow". The term hints at the risk of social instability. This "floating population" has special terms and is marked with demeaning characteristics such as bad personal hygiene, instability, and threats of dangers to others. In Beijing alone, there are nearly 3 million such people. They all hold a dream and look for opportunities when they flow from their hometown into big cities': http://www. wangqingsong.com/; http://www.colectiva.tv/wordpress/lang/en-us/wang-qingsong/.

Weng Fen (Weng Peijun) (China 1961) – *On the Wall* series (2001–02): http:// chngyaohong.com/blog/china/weng-fen-weng-peijun/.

Anna Zahalka (Australia 1957) – the series *Leisureland* (1998–2001) describes many of the features of excess in which reality becomes a sort of fiction. They can be seen as evidence of Baudrillard's 'panic stricken' attempt to produce a reality – of experience, of excitement, of excess and of a sense of place or escape. They are other-worldly and suggest excess: http://www.roslynoxley9.com.au/artists/3/Anne_Zahalka/328/.

Notes

1 See the film (1973): http://www.ubu.com/film/debord_spectacle.html.
2 Marcos López (Santa Fe, Argentina 1958): http://www.marcoslopez.com/; Alexander Apóstol (Venezuela 1969): http://www.alexanderapostol.com/.
3 See for example, *America* [1986], *Cool Memories* [1990].
4 http://www.paulgrahamarchive.com/americannight.html#a.
5 This is a statement (2003) about his work from his website: http://www. alexanderapostol.com.
6 Wu-Tien Chang (1956 Taiwan): http://culture.tw/index.php?option=com_content &task=view&id=2001&Itemid=157.
7 Ferit Kuyas (Turkey 1955): http://www.feritkuyas.com/city_of_ambition/.
8 Sze Tsung Leong (Mexico 1970): http://www.szetsungleong.com/.
9 http://www.xintiandi.com/.
10 Shao Yinong (China 1961); Mu Chen (China 1970). See *Assembly Hall* series: http://www.artscenechina.com/chineseart/artists/chinesephotography/shaoyinong.h tm; http://www.goedhuiscontemporary.com/DesktopDefault.aspx?tabid=45&tab index=44&artistid=108028.
11 http://www.blindspotgallery.com/en/artists/2010/jiang-pengyi/.

7 City and subject

This chapter features Japanese photographic representations that manifest many of the characteristics of living in a *postmetropolis* in the twenty-first century. It considers the dialectic between mental and social space suggested by Georg Simmel and the experience of the individual in adjusting to changing technologies and conditions of living. It introduces changing attitudes to the individual and subjectivity influenced by feminist thinking. Japanese photography is notable for its provocative engagement with individual experience, and the use of contrasting methods to represent subjectivity, desire and the psychological. For example, by depicting extreme intimacy (e.g. Nobuyoshi Araki *Tokyo Still Life* 1963–2001); by removing the individual entirely and displaying possessions (Kyoichi Tsuzuki's *Tokyo: A Certain Style*); and by using fictional accounts (Mariko Mori). I start by presenting three contrasting photographic encounters with Tokyo, which demonstrate the play of the objective and subjective as an important theme for photography. The examples here by Takuma Nakahira (1971), Kyoichi Tsuzuki (2003) and Takashi Homma (1996–2006) show the difference as ostensibly one of distanced perspectives or immersive engagement.

Encounters with Tokyo

Takuma Nakahira was a founding member of the Provoke group (with Takanashi Yutaka, Daido Moriyama, Shomei Tomatsu, 1968–70), whose methods attempted to counter established photographic aesthetics.[1] Recognizing the capacity of the photograph to fetishize and produce metaphor, Provoke attempted to eliminate 'fetishism of the object' and to avoid the self-consciousness of making 'art'. Nakahira spoke of taking photographs in terms of provoking thought and likened it to making diary notes – simple factual statements such as 'today the sunflower has dried up so and so much'

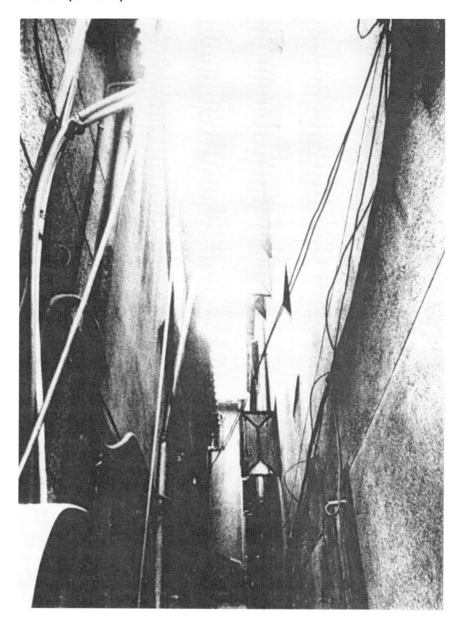

Figure 7.1 Takuma Nakahira from the book *For a Language to Come* (Published by Fudosha, 1970. Republished by Osiris, 2010). © Takuma Nakahira.

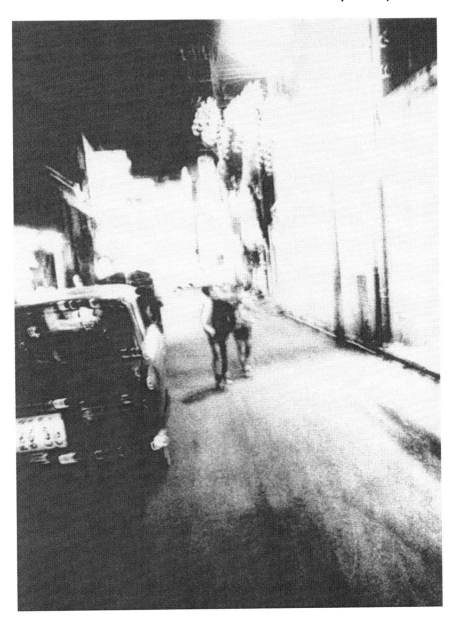

Figure 7.1 *continued* . . .

(Nakahira in Kuraishi 2003: 38). Nakahira's black and white grainy pictures present a collage of visual impressions – nothing complete, everything blurred – which resemble the vague, fragmented and sensual memory of experience more closely than clearly defined photographs. Unfiltered by sophisticated camera technique, they represent a direct confrontational encounter with the streets of the city as if we are looking from the inside at the peculiarities of objects; the sculptural detail of stacked newspapers, plastic wrapped flowers and the pattern of ferns. We become the viewer who happens on others and what they are doing in a way that is intrusive. The photographs provoke a subjective response (in the first person): *I am in a street at night: I become the participator in this vision – in this dream-like world, in which my perception is not ordered by careful framing but where one sight of a building façade blurs with another, where the lights of the city superimpose over that façade; where I cannot separate one vista from another; I cannot organize my experience of walking through my city. I see others walking, standing, talking; they are separated from me and yet part of my experience. I look up at tall buildings, at windows; I look through and past others to the lights of the street and the city beyond. I seem to brush into others, merge with them. I look through a boy as if he were part of me; I become part of the scene – both the viewer and the viewed. I cannot tell what is within me and what is outside me. I encounter surfaces: textured, wet, dark, cold and reflective. I walk past shops displaying lots of hats and corsetry – a kind of surreal encounter. Imagery is packaged; I recall smells. I come close to others; I notice a hand here, a laugh there, a gesture, a movement, an expression.*

It is significant that this attempt to describe sensation in visual language is peculiarly typical of the 1970s, and the 'unself-consciousness' such as Nakahira's is now perceived as deliberately artful. A more self-conscious process is characteristic of contemporary visions of the postmodern condition. Mindful of the impossibility of any authentic truthfulness to photographic documentation, some photographers use entirely different methods to achieve a photography that has no pretensions for interpretation – such as confrontational blandness.

Takashi Homma's series *Tokyo Suburbia* (1998) and *Tokyo* (1996–2006) are characteristic of a deliberately distanced perspective, which acknowledges the agency of the photographer and yet attempts to refuse 'expression'. Spanning ten years, *Tokyo* begins with aerial photographs that present the enormous expanse of the city, in which we see a typical centre of high-rise buildings with glimmers of further high points scattered in the blue haze of far distant reaches. Homma takes us through a journey crossing highways and outlying districts (Yoyogi Park), through residential suburbs (Tama New Town,

Shonan International Village) into the city. These districts do not have any obvious national characteristics; the apartment buildings (Urayasu Marina East), boulevards, green parks and streets, out of town shopping areas appear nation-less. We see McDonald's on the corner of two dual carriageways, as evidence of the influence of global markets just as they appear in the United States, Europe and across the world. A series of vistas display different aspects of the city (*Love Hotel UFO*, *Jonathan's Family restaurant*) – nightscapes, architectural presentations, suburb-scapes, global-scapes, which not only appear without locale but out of time. They are not significantly particular to the late twentieth century, but for the hints of contrast between macro and micro worlds and the highways, service areas and car parks that show us the importance of the car. Some scenes show us glimpses of tranquillity in the middle of one of the largest cities of the world: elaborate façades of reflective glass-fronted modern interiors surrounded by trees. Homma's journey roams quietly and as if from a distance, often at times in the day when there are no people, through model pristine suburbs. He leaves out the noise and the crowds and builds an idea of what it is to live a suburban life.

And then we enter a world of human activity – of children at school and playing video games. His focus on the everyday activities of children (*Tokyo Teens*, 1999; *Tokyo Children*, 2001) gives us specific instances of what it is like for the young people who inhabit a city like this. He presents a series of solitary, sombre portraits which contrast the dynamism of youth with the uneventful and empty space of deep suburbia. The central figure of *Tokyo Teens 2* (1999) is a young girl standing alone in what looks like a deserted car park, marked with parking bays. She looks sideways, almost suspiciously, watchfully, taking a rest, as if waiting for something to happen. *Tokyo Children 3* (2001) shows a young boy in an amusement emporium, wearing a white tee-shirt bearing some sort of slogan in English which we cannot completely see but we can guess at, and holding a cardboard carton drink container with the bendy straw with which we are familiar. We can imagine the drink as from McDonald's and the T-shirt as being Adidas or similar. It is a universal uniform and a universal location, bland and recognizable, signifying local variety only minutely. In the very centre of this global blandness, is a reflective young individual entirely engrossed in consideration of something – or the video game.

These could be children anywhere, but they are Japanese, they live in Tokyo in specific suburbs such as Shinuraya or Tama New Town. Like López, Homma points to a global experience epitomized by the experience of the multi-coloured delight of a McDonald's *McFlurry* (1996). Unlike López, these are studied and isolated incidents. Quiet studies of the individual encounter

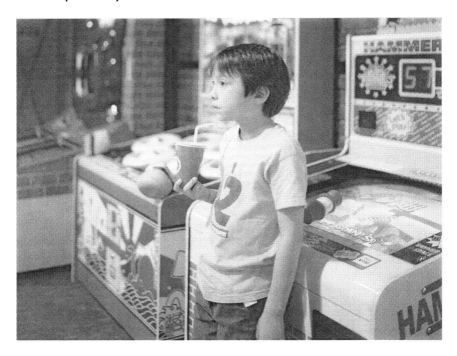

Figure 7.2 Takashi Homma, *Tokyo Children 3*, 2001.

with the contemporary global metropolis, which still resides in momentary interaction – with the spoon in the ice cream, with a discarded plate of food, with a video game, with a deserted car park at a particular time of day. The series appears to show us a picture of ideal lives, beautiful vistas, perfect housing units, as if struggling to represent what it looks like, what it *feels* like to live there. In amongst the empty perfection of these urban spaces, we see the incongruity of softly clasped hands (2001), dog dishes on the floor (1996) and a young girl whom Homma describes as his daughter (but is not) in a highchair (1999) and peering over an open car window (2006). He journeys through the familiarity of global urban signs, through a more localized vision of adolescent experience to the very intimate, familial and, in some respects, fictional. It is significant that this vision is partly fabricated, which suits the subject of deliberately produced suburban space and reflects the psychological impasse that photographs can only represent in fragments.[2]

Coming from the very different perspective of journalism, Kyoichi Tsuzuki's series present taxonomies of living, which scrutinize the material evidence of individual peculiarity. They nonetheless provide an insight to the impact of living in a large metropolis on individual psychology and behaviour.

Tokyo: A Certain Style (1993) focuses on 'style' and pursues the private detail of everyday living with an obsessive calculation that articulates the details of organizing space. Simple in their structure, photographs present straight views of room interiors that display the accumulation of objects and clutter resulting from living in small rented spaces in Tokyo, where space is at a premium and very expensive. However, the views we are given are intimate ones, of private rooms containing private lives. As a series they present a repetition of elements that we all share, together with instances of extreme idiosyncrasy. These are people who prefer to live in 'cubby-holes' in the heart of the bustling city than in more comfort in the suburbs. They make use of their immediate neighbourhoods as 'extended living rooms' by using the nearby public baths or sharing each other's facilities. Tsuzuki's subjects are generally young and working in the creative industries and he demonstrates the ingenuity used in making full use of the space. He points out that the persistent myths about Japan – tea ceremonies and kimonos – are largely redundant with the younger generation: 'our lifestyles are a lot more ordinary. We live in cozy wood-frame apartments or mini-condos crammed to the gills

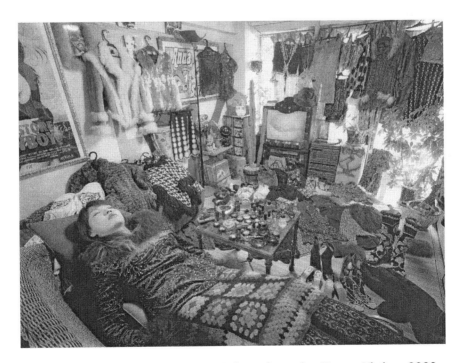

Figure 7.3 Kyoichi Tsuzuki, *Anna Sui,* from the series *Happy Victims,* 2003. Courtesy of the artist.

with things. Formica-topped kotatsu heater-tables plunked down on throw rugs. Western furniture sitting right on top of the tatami mats' (Tsuzuki 1999: 17). Tsuzuki annotates each page with details about the occupants and their space: 'Virtually the archetypal single male's lodgings: a three-tatami-mat room with a small sink area and a futon. This is home to an unfettered young man who spends his days on archaeological digs and his nights at dives. Always dressed like a road worker, he has few possessions besides books and cassettes'; 'cheap pine bookshelves await the next earthquake. Observe the struggle against order'; 'the catch-all corner for spill over from the closet'; 'stuff, stuff and more stuff'; 'the unbeautiful state of the room'; 'utilities for survival all in a row' (Tsuzuki 1999).

Tsuzuki's *Happy Victims* series photographs individuals for whom shopping for designer label clothing has become an obsession. Each photograph is titled after the label chosen – Jean Paul Gaultier, Anna Sui, Vivienne Westwood. The photographs show the level of obsession in tiny rooms that are crammed full, some 'breathtakingly cluttered' and others 'manically ordered' (Photographer's Gallery, 2003). This time the owners are shown in the midst of their room surrounded by their collection, sometimes to dramatic effect, as in *Anna Sui*. What fascinates Tsuzuki is the degree of attention and expense devoted to a hobby at the cost of other necessities, which he sees as demonstrative of energy rather than what might seem to many as stupidity:

> You are taught that it's nice to have a hobby, but also that you have to think about balance—30% of your income should be spent on your home, 15% on your hobby, 20% on your food, whatever—to have a harmonious lifestyle . . . A harmonious life doesn't have energy. So that sort of imbalance encourages me.
>
> (Tsuzuki 2005)

Nakahira, Homma and Tsuzuki present three different perspectives on the city, one immersed in the perceptual experience, one a calculated observation that focuses on individuals in their immediate environment and one systematically collecting evidence of a phenomenon of living.

The city, mental life and virtuality

> The deepest problems of modern life derive from the claim of the individual to preserve the autonomy and individuality of his existence in the face of overwhelming social forces, of historical heritage, of external culture, and of the technique of life.
>
> (Simmel 1964: 409)

Georg Simmel (1859–1918) wonders about the psychological impact of the city at the turn of the nineteenth century; Homma points to the same question at the turn of the twentieth. He builds a picture of children establishing themselves in contemplation in their preferred space, making a mark, defining themselves as unique individuals within this uniformity. In his essay 'The Metropolis and Mental Life' [1896] Simmel anticipated many of the concerns of social psychology with respect to the difference that living in the city makes to the 'the foundations of sensory life'. This chapter considers the nature of individual experience, taking into consideration the technological advances since Simmel's analysis, which centres the focus for this chapter. Simmel's work contributed to the establishment of a 'sociological viewpoint', the recognition of 'sociological production' and more specifically the significance of the experience of the city on individual psychology (Simmel 1964: xxxi). The city forces a struggle between the individual and the 'super-individual contents of life', which in turn forces an adjustment and a form of protective consciousness in the face of external demands (409–10). Simmel uses the money economy as a metaphor for the sort of exchange that individuals develop to protect themselves from the harsh, rational and anonymous environment. Money exchange demands an impersonal schedule that dictates all aspects of life in the metropolis, reducing everything down to 'how much?' and by extension, to the self-interest of the individual (412–13). We cannot exist in a large city in the same way that we can in a small community where we have a personal relation to everyone to some degree; it is psychologically unsustainable. Living in the city produces the possibility of an extreme condition of not 'knowing' our neighbour at all. We construct a reserve, which gives the individual a kind of personal freedom because we are liberated from the obligation to personally engage with others. In consequence, we retreat to a more primitive social engagement – restricting our social formation to a 'relatively small circle firmly closed against neigh-bouring, strange, or in some way antagonistic circles' (416). This conflict between the crowd and the individual is a theme addressed by Georg Simmel, Charles Baudelaire and Walter Benjamin. The ambivalent *flâneur* seeks solitude in her wanderings and yet is distracted and seduced by the crowd, which offers protection at the same time as making her feel at one with her fellow city-dwellers. Homma's *Tokyo* depicts the city as a combination of effects and influence that extend us in such a way that the individual loses control to a certain extent.

Simmel notes that human existence does not end with the limits of the body or the area immediately surrounding it. The cityscape influences perceptual information and produces particular conceptions of spatiality. For example,

BOX 7.1

Phenomenological geographies

Gaston Bachelard [*The Poetics of Space: The Classic Look at How We Experience Places*, 1958] grounds a phenomenological discussion of our attachment to place and our negotiation of space in the concrete and imaginary dimensions of the 'house' and the 'forest'. 'House' functions as a metaphor for the 'intimate values of inside space' and for shelter from 'the storms of the heavens' or the unknown reaches of space in the 'forest' (Bachelard 1994: 7). He explores the psychological realms of the house, not as an object and not as a geographer or ethnographer might describe it in terms of a type or a class, but as a collection of values, an accumulation of memories.

> The point of departure of my reflections is the following: every corner in a house, every angle in a room, every inch of secluded space in which we like to hide, or withdraw into ourselves, is a symbol of solitude for the imagination: that is to say, it is the germ of a room, or of a house.
>
> (136)

Bachelard attempts a return to a primitive encounter with our surroundings, bringing us back to the experience of formless thought before rational justification and the knowledge of hindsight. He suggests that the *inner immensity* of the daydream gives meaning to the visible world: 'As soon as we become motionless, we are elsewhere; we are dreaming in a world that is immense' (184–5). He uses the immensity of a forest as an example, for which I substitute here the megacity:

> This 'immensity' originates in a body of impressions which, in reality, have little connection with geographical information. We do not have to be long in the [city] to experience the always rather anxious impression of 'going deeper and deeper' into a limitless world. Soon, if we do not know where we are going, we no longer know where we are.
>
> (185)

Bachelard is describing the subject's negotiation of space – private and intimate space. Valérie Jouve's characters negotiate these spaces, extended in public space within the fabric of the city, which can be both familiar and yet dangerous (see Chapter 8). Just as Bachelard

uses examples of writing to illustrate his discussion, we can refer to photographic projects that amplify, for example, his consideration of the corner as a motionless place that provokes 'the dialectics of inside and outside' that occur in daydreams (137): Jouve's extension of the corner is suburbia, which similarly confines mobility and in which her characters hide; Kyoichi Tsuzuki's corners are played out in the cluttered rooms of Japanese youth; Stakle's corners are the abandoned spaces of post-Soviet states; Ellis's corners are the vacant plots of East Manchester, which provoke memories of childhood (see Chapter 4).

the verticality of city, as opposed to the horizontality of landscape, affects our psychology and how we use/or do not use our bodies. Postmodern structures like the Bonaventure Hotel and shopping mall create bodily confusion, where we are locked into another world of experience that extends beyond the visible and which compresses time and distance.

> This latest mutation in space – postmodern hyperspace – has finally succeeded in transcending the capacities of the individual human body to locate itself, to organize its immediate surroundings perceptually, and cognitively to map its position in a mappable external world. It may now be suggested that this alarming disjunction point between the body and its built environment – which is to the initial bewilderment of the older modernism as the velocities of the spacecraft to those of the automobile – can itself stand as a symbol and analogon of that sharper dilemma which is the incapacity of our minds, at least at present, to map the great global multinational and decentred communicational network in which we find ourselves caught as individual subjects.
>
> (Jameson 2009: 44)

Jameson's description of Bonaventure, in which the body is transported in a spectacular way, refers to the intimate yet alienating experience of shopping malls, which surround us with a plethora of commodity and sensation, and embody a sense of timelessness with no access to the outside world. Jameson suggests that human subjects have not kept pace with the evolution of artificial spaces: objects and space and our consequential experience have mutated and yet there is no 'equivalent mutation in the subject. We do not yet possess the perceptual equipment to match this new hyperspace', because our perceptual

habits were formed in the older kind of space of high modernism (Jameson 2009: 38). Celeste Olalquiaga describes the homogeneity of store windows and water fountains as causing a perceptual loss, in which 'shoppers are left wandering around in a maze'. Because we are separated from our relationship to daylight, shopping malls and large complexes such as casinos create an artificial neutralization of real time: 'our sense of time becomes so skewed in this aesthetics of transparency and multiplication that it feels as if time has shrunk' (Olalquiaga 1992: 2). Olalquiaga compares the *postmetropolis* experience to that of psycasthenia, a state in which being is confused with its surroundings. It is as if one is lost in space, or that our body has 'vanished'. This sort of dislocated experience, and that of the virtual world, intrudes on our physical apprehension of the city, affecting everything we do. It ultimately results in a lack of distinction between our body and the surrounding space, which is extended by the computer screen; Google Earth will take us to exact locations, which we can survey from our solitary stations. This is a condition in which it is possible to be anywhere on the planet – virtually – whilst not being anywhere. The psychological separation from reality profoundly affects 'the very constitution of being – the way we perceive ourselves and others' and the places in which we live (xi).

> We might even imagine that one day, having donned a suit of interactive data – the Data Suit – our internaut will launch himself into a new kind of adventure tourism, discovering the ancient world with the assistance of positioning and surveillance satellites overflying him without letup. As though playing a pinball machine, our explorer could then touch the summit of Everest or the slopes of Kilimanjaro with one single gesture.
>
> (Virilio 2005: 141)

Virilio proceeds to speculate how the onslaught of hyperreality impacts on our visual thinking. He expresses concern for our loss of geographical position, where space and time are compressed and instantaneous. The *absolute speed* of message transmission dismisses the consequences of *real time*. As the network surfer can travel across the planet without moving so we are subject to the 'telescopic crushing of landscapes produced by those tele-lenses that have supplanted topographic limits' (2005: 72). The importance of distances has disappeared in the face of global interactivity and the subsequent mutation reverses topology so that the global interior is immediately reachable, whereas access to local space requires that we devote real time and that we walk outside in real space. Space is at once expanded and yet physically constricted:

> If everything is there, already there, within reach, within earshot, then incarceration has achieved its apotheosis, confinement knows no bounds

... the viewer is subject to the enormous *temporal compression* of geophysical distances.

(119)

We are resorting to a substitute reality in which the reality of space simulates the weightlessness of space travel that opens 'the door to an unexplored reality that feels like a dream'. In this other world, without boundaries or nations, everything is possible. Created by the machine for other machines, 'this world is peopled by beings without skin or flesh, known as avatars' (137).

BOX 7.2

Virtual worlds

Kosupure (cosplay) is a practice in which people dress up as *anime* (Japanese animation) characters as a means of escaping their real lives. The 'World Cosplay Summit' (http://www.tv-aichi.co.jp/wcs/e/) was created to promote international exchange through the Japanese youth culture of manga and *anime*. It has since expanded to include fifteen countries from around the world. *Kosupure* sells costumes for the purpose and posted the following message, 'A smile for Japan', on 22 March 2011:

> Because Japan need a smile and the support from that country's lovers where comes that hobby that join us: the cosplay. Kosupure Shop and Kosupure Onlien invite to participate in cosplay mini-photoshoots that we'll made for support 'Prayers from Cosplayers' and let them know that Mexico is with they. If you want to participate just come to Kosupure Shop at 'Plaza San Juan' this next Sunday March 27th at 12 o'clock and we'll take a mini-photoshoot, the idea is to gift a smile and a message to japanese people (in an A4 white sheet with a Japanese flag drawn there), that photos will be sent to: Prayers from Cosplayers and will be published in Kosupure (http://kosupure.com.mx/). ¡We'll be waiting for you!

SimCity is a city-building simulation game, first released in 1989, and designed by Will Wright. It invites us to 'build, play with, and destroy amazing cities with SimCity Creator!'

> Build? Construct amazing cities with a wide variety of choices. Create a New York-style metropolis, a romantic European city, an exotic Asian paradise, a futuristic Cyberscape or combine them to make something truly unique. Destroy? Lay waste to your city with a variety of epic disasters, including earthquakes, meteors, and giant monsters. Prepare for and handle unexpected crises.

The Chinese artist Cao Fei's series *Cosplayers* pictures teenagers acting out Japanese *anime* in the city of Guanzhou. *Cosplayers* chase each other across the city. Her *RMB City* gives full public access to an art community in the 3-D world of *Second Life* – a virtual platform in which participants can realize another dream life on the computer screen (http://www.rmbcity.com/home.html). Users develop an avatar that they can control and interact with others; Cao Fei's avatar 'China Tracy' has constructed a virtual city, which the Serpentine Gallery describes as an amalgam of ancient and modern Chinese icons from the panda to the Beijing Olympic stadium: 'The project explores the potential of an online art community, seeking to create the conditions for an expansive discourse about art, urbanism, economy, imagination and freedom'.[3] She observes that avatars and their behaviour, such as their distance from others, betray a sense of proximity, intimacy or hostility. Cao suggests that avatars project what one really desires, through a persona that is very close to one's own, but perhaps truer – a persona through which one can interpret one's own life and hope to resolve dilemmas.[4]

> Cao's work reflects the fluidity of a world in which cultures have mixed and diverged in rapid evolution. Her new media works explore perception and reality in places as diverse as a Chinese factory and the virtual world of Second Life. Depictions of Chinese architecture and landscape abound in scenes of hyper-capitalistic Pearl River Delta development, in images that echo traditional Chinese painting, and in the design of her own virtual utopia, *RMB City*. Fascinated by the world of Second Life, Cao Fei has created several works in which she is both participant and observer through her Second Life avatar, China Tracy, who acts as a guide, philosopher, and tourist. January 8th, 2010 by Cao Fei: Avatars Wesley Miller.
>
> (http://blip.tv/art21-exclusive/cao-fei-avatars-
> 3081088)

Olalquiaga's and Virilio's are emotive visions. What much of the photographic imaginary does is manifest Virilian extremes in visible form, in forms of fantasy fiction (Cao Fei, Mariko Mori). Another argument is that the impact of Information and Communication Technologies (ICTs) is hugely exaggerated and is much more locally differentiated than Virilio suggests. ICTs extend geographical domains and the dynamics of social interaction but, rather than replacing bodily movement, communication technologies supplement the physical urban experience.

> Whilst ICTs do have important implications for cities, the relationships are much more subtle, complex and contingent than that endlessly repeated world of simple, deterministic substitution, total dematerialization, and a wholesale stampede of urban life into the clean and infinitely extendable domains of cyberspace.
>
> (Graham 2004: 17)

Along with notions of the vanishing body, comes the suggestion that inequalities disappear in the virtual world of interaction, where we escape from the physical body. On a more practical level Nina Wakeford considers the many levels of social interaction in internet cafes, which counter the more dream-like encounter. Wakeford refers to 'landscapes of computing' in which material and the imaginary geographies combine (Wakeford 2004: 264). She itemizes the realities of the location – the machines, the global network, the systems accessed, the people encountered, the atmosphere, the decor and location. Bodies must interact with the space in which the technology is housed as well as the space accessed via the computer and its social spaces.

Bodily confusion: feminist figurations

As we begin to understand the city as an operation that is bigger and more complex than its constituent parts, we begin to believe in the power of the city as an autonomous system. Postmodern views, and feminism in particular, have introduced the need for more localized perspectives. They have emphasized changes in the experience of, and attitude to, the world and others, and have reconsidered the mind/body relationship, male/female opposition and the habitual subservience of one to the other. Feminist thinking has reinvigorated understanding of subjectivity – and of women in particular – and asserted alternative ways of thinking to one defined by a rational and unified subjectivity. It has restored the significance of the individual and the body – particularly with regard to the role of corporeality as being crucial to psychical existence. Feminism has grounded theory in how the world is

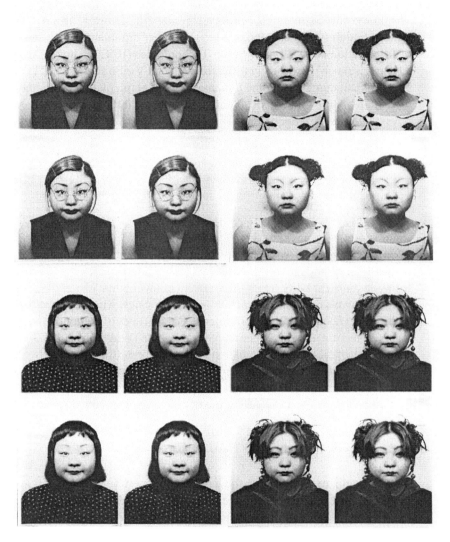

**Figure 7.4a Tomoko Sawada, detail from the series *ID400* (#1–100), 1999.
© Tomoko Sawada. Courtesy of MEM, Tokyo.**

produced through lived experience. Theories concerned with identity have recognized the significance of difference and local specificity, and the individual process of developing personal identity as being in itself political and social. They have challenged the myth that nature was 'natural' or knowledge was fixed, neutral and waiting to be found, and establish that all

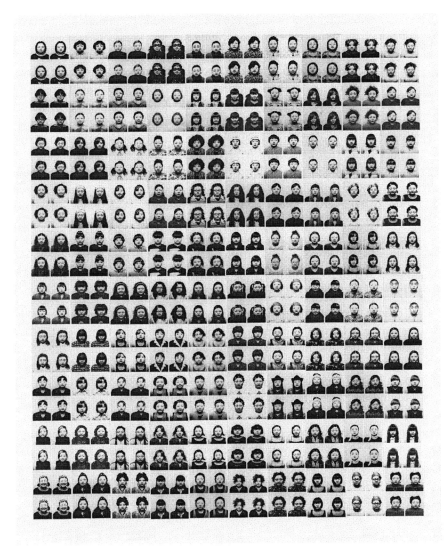

Figure 7.4b Tomoko Sawada, from the series _ID400_ (#1–100), 1999.
© Tomoko Sawada. Courtesy of MEM, Tokyo.

representation and knowledge is constructed – we are fabricators of our culture, but not masters of it. Experience and the subjective process is cyclical – an individual is constructed (culturally) and in turn is empowered to construct her world. Feminists, such as Luce Iragaray, have been central to challenging binary oppositions such as form/matter, bodies/souls, matter/meaning, male/

female, together with the consequent assumptions of hierarchy and processes in which the feminine is excluded. Julia Kristeva challenges the idea of a static subject – a unified whole – and emphasizes a subject that is unpredictable, contradictory, *un*-unified and in a constant process of change. Kristeva's approach accentuates the subject as a '*process* of becoming' (Kristeva 1984: 37). Her emphasis is on the backwards-and-forwards exchange of subject and productive process, as opposed to a system that prefers definition and represses the *process* of signification. Judith Butler extends Kristeva's conception of process in her reconsideration of the material body. In her discussion of the fabrication of gender norms, Butler uses 'performance' as metaphor for a process whereby we perform as individuals in order to establish ourselves and to legitimize the position we assume. She argues that the process of sexuality, gender and desire should not be seen as a continuous process or caused by any stable factors. Her premise is that, rather than being grounded in any essential attributes or 'natural' principles, subjectivity is constructed by a 'script'. In these terms, the body is as much concept as it is material (Butler 1993: 32).

Tomoko Sawada's photographs illustrate, in a very literal way, changing attitudes towards the process of subjectivity and the forming of sexual and cultural identity. She uses a combination of costume and make-up, staged photography and digital manipulation to construct a series of characters that point to different aspects of the subject. For example, *ID400* (1999) presents a hundred passport photographs, in multiples of four, of girls (all versions of Sawada) taken in automatic photo-booths. Whilst each presents an alarmingly direct pose, each is an exaggerated character: some are dishevelled and some are severe or unhappy; some attempt a weak smile, but most do not and are alternatively defiant, determined, grumpy and solemn. Bordering on caricature, we can imagine particular social 'types'. On the one hand they construct an inventory of class and personality and on the other they demonstrate the degree to which individual appearance is transitory and malleable. Individuals perform a role in society, which defines their immediate social group, the city in which they live and the nation of which they are part. That these individuals are presented blandly and in such a matter of fact fashion adds a convincing and humorous edge to their fiction, which at the same time is mildly critical. In the series *Cover* (2004) Sawada makes contrasting references to the symbolic costume and masks of traditional Japanese Noh theatre and to a youth culture, which forces young girls to conform to a recognizable group identity. These images present a series of girls in an array of colourful dress, cute hairstyles, posing in the formulaic and provocative manner of glamour magazines.[5]

Intimate projections

Mika Ninagawa presents a more subtle photographic collection of the nature of conformity and desire in a highly developed consumer society. Ninagawa's world[6] is one of objects but, unlike Tsuzuki's, is an eclectic extravaganza of the synthetically colourful, seductive and cute. It includes a small white rabbit, a lush strawberry in close-up, a religious statue, an assortment of butterflies, flowers of all descriptions, children against the sky, underwater and on the beach, exotic landscapes, strange dappled interiors and dark formless silhouettes in the blue night. Together they accumulate an impression of a sensuous connection to the surrounding world, wholly whimsical and subjective. Ninagawa's vision inherits an autobiographic tradition in Japanese photography, as can be seen, for example, in Daido Moriyama's return (1982) to his birthplace Ikedo 'to anticipate the awakening of memories' (Moriyama 2004: 18) or Seiichi Furuya's search to awaken memory of his wife. Above all she references Nobuyoshi Araki's very subjective celebration of sensual beauty. Araki has consistently photographed Tokyo, from the intimate perspective dominated by his love and obsessions; his series *Sentimental Journey* (1971) and *Winter Journey* (1991) narrate his relationship with his wife at the beginning of their life together and again at her death. Very little of Araki's desires are censored. He says that photographs by their nature are nostalgic and therefore his photographs of Tokyo, the city he loves, must be nostalgic (Liddell 2006). Araki's attitude to the relationship with his subjects is summed up in his declaration: 'If the person I'm photographing is naked, then I too will be naked'. Whilst Araki's approach to photographing women is seen as problematic, a number of female photographers have appropriated the tradition of self-obsessed intimacy and translated it in the context of youth culture. For example, Hiromix (Toshikawa Hiromi) is known in Japan for the popularization of the photo-diary. *Seventeen Girl Days* (1995) present the mundane preoccupations of teenage girls that include pictures of Hiromix and her friends, just as any girl in the world might collect on her mobile phone. Photographs in the *Girls Blue* (1996) series were taken in one night out in Tokyo with her girlfriends. The photographs are at once completely subject specific and globally recognizable in their portrayal of popular culture.

In contrast, Miwa Yanagi's projects visualize a critique of traditional attitudes and gender roles in a series of psychological projections.[7] All her works are fictional constructions that play with symbols of femininity: breasts, dress, make-up, children. Like Sawada, she refers to the dress codes that symbolize attitudes more generally. She speaks about Japanese stereotypical groups and subcultures (Kogal, Ganguro) that are ultimately locked in some form of

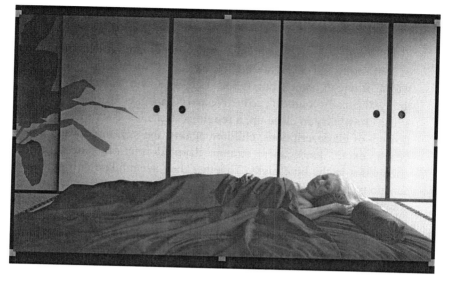

'Thanks to being shown such a wonderful dream, my body and mind have become completely relaxed. By the way is she always asleep like that? Lying next to her while she is asleep is alright, I guess but can't I meet her when she is awake?'

'She cannot wake up Sir. For Grandmother is Sleeping Beauty.'

(Ayumi aka Miwa Yanagi)

Figure 7.5 Miwa Yanagi, *Ayumi*, from *My Grandmothers* series, 2000–09. Courtesy of Miwa Yanagi/Yoshiko Isshiki Office.

female constraint. Digitally manipulated, the *Elevator Girls* series (1994–98) presents young women as subserviently assuming the roles assigned to them marked by their exaggerated bland uniforms. They pose passively in shopping malls, museums and lobbies. For example, in *Eternal City* a number of girls are seated on the floor of a vast, empty city complex around a pristine white model of a city. In the more dreamlike of the series, such as *White Casket*, we see them on the floor of a lift, helpless, at the mercy and disposal of others. The *My Grandmothers* project (2000–09) visualizes the projections of young women asked to imagine their lives 50 years in the future. Yanagi creates a series of theatrical portraits in response to these speculations, which 'stand as collaborative portraits of the idealized, elderly woman'. Whilst the series presents a range of contradictory aspirations and dreams expressed in these tales, her interview betrays an abhorrence of the traditional desire to raise a family (Yanagi 2001). The series is autobiographically informed by her childhood raised by women – three grandmothers – who here manifest the

energy of youth and imagination. Each fictional scene is accompanied by a text that is entirely wrapped in a private world of speculation:

> Even though I thought I had become totally used to living alone by now, yesterday, no matter how hard I tried, I just could not stand being in the house by myself. It seemed as if the winter sunset had overtaken the whole world, and was little by little scorching everything in its path. I up and drove to the airport, and not surprisingly, got on the first plane I could find. I was trying to escape from the sun, but now I was the one chasing it.
>
> (*Sacheko* aka Yanagi 2000, http://www. yanagimiwa.net/e/index.html)

Feminist figurations: nomads and cyborgs

Rosi Braidotti's *Nomadic Subjects* (1994) considers the intersection between identity, subjectivity and the issues of power derived from sexual difference. She outlines a number of figurative terms that incorporate the physical, psychological and the social and which are used to facilitate different conceptions from the established ways of thinking about the nature of the subject. Braidotti's term 'nomad' is a figuration that centres cultural differen-tiations of race, gender, class and age as a concern. She describes 'nomad' as a 'political fiction' that suits a postmodern subjectivity because it can traverse the boundaries divided by philosophical and theoretical definitions (Braidotti 1994: 4). 'Nomadism' is essentially a critical consciousness that refuses to settle into 'socially coded modes of thought and behaviour' and offers another perspective on the existential tradition of walking in the city (5). Elizabeth Grosz's thinking suggests another figuration might be the body as 'equivocal' or 'trangressive' (Grosz 1995: 5). Olalquiaga's conception of a 'psycasthenic' experience, in which the distinction between body and space is confused and the 'body has vanished', suggests that we are processed to lose our identity – a condition that is embodied in the phenomenon that is 'second life'. Donna Haraway (1991) extends the notion of space and the body and its interaction in her conceptualization of cybernetic technologies. The notion of 'cyborg' as a form of hybrid subjectivity provides focus for rethinking a condition that interacts with external reality via the computer. As a conceptual embodiment of body, mind and machine, the 'cyborg' manifests another alternative to the mind/body division (see also Box 8.1: Deleuzian space).

Grosz's essay 'Bodies–Cities' in *Space, Time and Perversion* (1995) considers the body in relation to philosophy, knowledge and desire and provides a bridge between geographical and feminist theories. Grosz translates Virilio's concern

for the significance of the intrusion of the screen interface, to our perception of physical geography:

> The implosion of space into time, the transformation of distance into speed, the instantaneousness of communication, the collapsing of the workspace into the home computer system, will clearly have major effects on the bodies of the city's inhabitants. The subject's body will no longer be disjointedly connected to random others and objects through the city's spatiotemporal layout; it will interface with the computer, forming part of an informational machine in which the body's limbs and organs will become interchangeable parts.
>
> (Grosz 1995: 110)

Grosz is concerned to rethink the fundamental premise for relating to the city. She conceives the encounter with space as primarily a relationship with the body and explores how 'the body is psychically, socially, sexually, and representationally produced', how it is modified by its interaction with what it physically encounters and how that environment fundamentally affects our way of thinking (Grosz 1995: 104). In giving focus to the body as 'socio-cultural artefact', she considers how body and city define each other: how culture has impact on the body, how the built environment, specifically the city, contributes to production of the body and how, in turn, bodily interaction with the city affects the psychical interior. She suggests that the city is one of the crucial factors in the social production of corporeality and identifies the three factors of communication, time and interface as characterizing how we live in the contemporary city. How we communicate with each other, how our environment distorts our connection with time and how we change in the process of that engagement can be seen reflected in how we represent that experience. For example, Tsuzuki scrutinizes the evidence of how we control and order our surroundings; Homma illustrates psychological dislocation by emphasizing the individual as separate and by confusing reality with elements of fiction; Sawada illustrates a process of being by inventing a series of physical appearances.

> As a hybrid, or body-machine, the cyborg is a connection-making machine, it is a figure of interrationality, receptivity, and global communication that deliberately blurs categorical distinctions.
>
> (Haraway 1991: 105)

Haraway considers the physical impact of the contemporary city and the consequences of the body's extension by the machine, and how we can view a world in which technology blurs with nature, and computer science replaces

physical reality with virtual interface. It is a situation that can either be interpreted as a total loss of reality, or it can be seen as a useful opportunity. The relationship between nature and culture has to be renegotiated; we are responsible for technology and, rather than demonizing it, blaming it, we should celebrate and take pleasure in machines; they bring about the necessity to reconstruct the boundaries of everyday life (180). Giving emphasis to communication technologies and biotechnologies as 'the crucial tools recrafting our bodies', she suggests that the dispersal of the home, workplace and public arena by machines has huge consequences for the social relations of women worldwide. Barriers between body and concept, male and female become permeable (163). Haraway breaks down the division between us and machines, which are no longer 'out there', out of reach or inferior. Her metaphor 'cyborg' extends Lefebvre's notion of the production of space to one which incorporates systems logic or biotechnology. Haraway contributes to socialist feminist theory a view that neither capitulates to biological determinism and thereby an inferior social position nor, by seeing 'nature' as the enemy, accepts the ideology of culture against nature. High-tech culture, seen in these terms, confuses traditional boundaries and power relations, and again erodes dualistic ways of thinking about ourselves in the world: we are cyborgs and hybrids.

Virtuality: materiality

Theories, such as Virilio's, Baudrillard's and Haraway's, frame experience in abstract terms and outline an extreme scenario that borders on fantasy. Their description is laden with complex metaphors that circumvent hard physical facts and make use of incidental realities to embellish their vision. Mariko Mori's photographs literalize these speculative visions and attempt a manifestation of fictitious cyberspace. They utilize a playful mix of cultural references including Bhuddist religion, popular consumer culture and the sex industry. They amplify a discourse that encompasses a range of contrasting postmodern concerns: global capitalism, gender politics and their manifestation in computer generated imagery. They visualize not only Virilio's dread of the consequences of technology, but a feminist rethinking of the relationship between body and mind, and more specifically the consignment of the body to the feminine.

Mori's images make use of the popular culture of *kosupure* (cosplay) to manifest a series of fantasy cyborg characters.[8] *Play with Me* (1994) shows a half-human/half-virtual creature waiting demurely outside a Japanese gamestore. She appears content to wait. She is dressed in a hybrid costume

of contemporary leggings and computerized silver attire familiar to Japanese *anime* characters, such as *Sailor Moon* – cute magical-girl cum space-warrior – and reminiscent of Fritz Lang's *Metropolis*. Her head leans to one side in a coquettish manner and her hair, which is caught in two silvery bunches, together with her exaggerated breasts in the style of Madonna, give the impression of a confusing sexuality – of adult seduction together with a childlike innocence. She stands looking shyly askance at the men entering the store, who show no interest in her at all, suggesting that they either do not see her or she is not visible, in which case the photograph shows these two parallel worlds simultaneously. She stands between the reality of contemporary digital economy and the fantasy of desirable and alternative identities made material. As a virtual creature, game players would click and play with her and use her, but as a materialized reality she is of no interest. In *Tea Ceremony III* (1995), Mori places her hybrid hostess in the midst of a business complex, which we can imagine as being at the heart of a city's financial district. In a theatrically subservient stance, the creature offers us

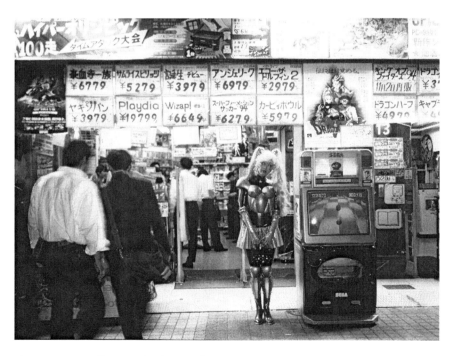

Figure 7.6 Mariko Mori, *Play with Me*, 1994. Fuji super gloss print (304.8 × 365.8 cm). © Mariko Mori, Members Artists Rights Society (ARS), New York/DACS 2012.

tea on a tray. Again no one takes any interest – as she is only a digital projection. The tradition of serving tea represents an age-old heritage with no relevance to contemporary concerns of capitalist finance. Here two different cultures clash and are invisible to each other. The creature's silver leggings and headgear confuse two locations, eras, and contexts: the tradition of the female host – geisha, airline hostess – and the world of digital narration. Both images generate parallel worlds.

Mori's image *Birth of a Star* (1995) describes the outcome of 'reality' or pop idol programmes which promise participants the possibility of becoming a celebrity – the ultimate desire. Joan Kee aligns Mori's cyborg self-portraiture with ideas of an Asian *New Utopia* defined by the disintegration of established boundaries of individual and cultural identity, geography and nations. Kee suggests that rather than metaphors, the images function as a place, a 'corridor' between two worlds, which transcends the 'paradigms of culture, nation and gender' (Kee 2004: 675–8). As cyborgs, the characters are fragmented – literally dis-located and removed from their place of origin – they exist in a sort of nowhere land. Kee points out that perceptions of these images will be different in the West from those in Japan. To a Western imagination, they are not nation-less, but point to a particular Japanese sensibility that embraces technology. In many ways, the images confirm a preconceived stereotyping – a neo-orientalism – a celebration of the quaintness of a particular nationhood, whereas a Japanese audience interprets Mori's characters as merely being further evidence of particular Japanese sub-cultural activity.

Hybridity is significant for this series in several respects. Speaking of her own displaced status – born in Japan, educated in London and resident in New York, Mori says that the multi-ethnic diversity of New York allows her to move between cultures and inhabit both these worlds simultaneously. She states that the process aims to achieve a 'place that is nowhere (dokodemo nai basho)', somewhere where she is not Japanese, but her own identity exists in a space that cannot be defined – nation-less and without history.[9] Her photographs reference cultural traditions of Japanese society and its heritage of Shinto and Buddhist philosophies of life, death and rebirth, which are conflated here with contemporary culture. Mori's images present fictions that are embedded in extremes; they describe an interconnected world of physical truths and psychical/spiritual perspectives and subjective particularity. Whilst Mori's cyborgs reference the past, they demonstrate the technological possibilities of the future: 'Digitalized, synthesized and hybridized', and transgress the boundaries of East/West, male/female, past/ future (Rhee 2004: 8).

Mori makes reference to a mix of religions in her attempt to describe a space that can accommodate an interrelated network of systems, reminiscent of the structures of information technology, and which is religious, technological and virtual. Ultimately, Mori's attitude echoes Haraway's in suggesting that technology can be used to make things better:

> In Mandala it says to have big passions, not small ones. In Buddhism to be human is egoistic and it is told that one must repress desire. But Mandala affirms human desire. Small passion is for the self but big passion is for society or for other people. But I'm not interested in using ancient things; rather I want to connect them with contemporary life through the technology we have now. On the surface it appears high tech but looking into it one feels the genesis of traditional matters.
>
> (Mori, M. Interview with Kunie Sugiura, *Journal of Contemporary Art*, http://www.jca-online.com/mori.html)

On another level, Mori's materializations describe not only the 'body in process' that manifests the past in its behaviour (the *habitus*), but also refer back to the feminine as a shapeless non-thing consigned to fulfilling biological functions and desires. Judith Butler refers to a 'formless femininity' defined by Western philosophy: 'there is a disjunction between a materiality which is feminine and formless and, hence, without a body, and bodies which are formed through – but not of – that feminine materiality' (Butler 1993: 53). Mori's depiction, like Butler's examination of the distinction between body and soul, body and mind and the history of their conception as divided, refers to the boundaries of the subject's body, its encounter with the space around it and its interaction with other subjects.

Mori's cosplay and digital manipulations transform urban space, making virtual possibilities more tangible as photographic manifestations of character – what if the past and the future, which is intermingled in my imagination, were real? And what if my space here, and that space there, which I can experience on the computer screen, were real? The manifestation works both ways; imagined spaces are made literal and literal spaces are made fictional. Written fiction has always created parallel worlds that relate the thoughts and imaginings of different characters. The difference here is that world is visual and because it is a photograph – reference is all the more believable as it embodies the fiction in the perceptual world. Photography translates conceptual imaginings/utopias into a form of reality and digital technologies facilitate conceptual extension. Photographs present disparate elements – physical and conceptual – simultaneously. Constructed identities/photographies provide examples of the complex interaction of the city and psychology and the impact of the spectacular with the individual as a sort of exchange.

The city as interaction

> All living beings are connected at every moment in inner space. Every life form with its own life cycle is part of the outer universe and there is only one planet earth. In the next millennium, the power and energy of the human spirit should unify the world in peace and harmony without any cultural or national borders.
>
> (Mori in an extract from exhibition catalogue, Chicago Museum of Contemporary Art and Serpentine Gallery, London, 1998, quoted in Ippolito 2009: 422)

This chapter has extended the conception that in the event of walking in the city we change the space around us to one of interaction. Conceived as a network, the city is seen as bringing people (bodies) and their activities together: social processes, economies and power networks, forms of management and political organization. City structures maintain order and control and the circulation of information and power. Grosz describes two models for the relationship between bodies and cities that have persisted, both of which accord a cohesive body regulated by reason and systematic organization. One is a top-down process that retains hierarchical opposites, in which bodies are merely subordinate extensions of the mind. The other conception is representational in which the 'body' is metaphor for the populace and rational state operation – the law equates with the body's nerves; the military with its arms, commerce with its legs and stomach etc. This model maintains the dualism of nature/culture in which culture is subordinate. It justifies forms of 'ideal' government and social organization – described as 'natural' – and usually hierarchical. Grosz attempts to turn this dominant form of thinking – whereby precedence is given to either body or city – inside out. In an alternative to causal and representational views, Grosz combines elements of each in which the body and city are mutually defining – they are not distinct. In this model – which appears to echo Lefebvre's triadic space – rather than the city (artifice) mirroring nature, there is an interface between them. Each city, with its different socio-cultural influence, actively directs our perspective and is an active force that leaves its traces on the 'subject's corporeality' (Grosz 1995: 110). The city affects the way we see each other, for example: in the recognition of class structures in domestic architecture; in the way we see others and the way we orient ourselves within space and maintain material sustenance; the city 'seeps' into and affects the body, through familial relationships (108). The city is an interrelation of parts that encompasses irregularities; it is an assemblage that allows for disparate systems, flows, energies, events – able to cross thresholds. An interrelational

view of the city proffers no ideal or natural environment – 'no perfect city' (109). Concepts that accommodate interaction between city structures and the people who inhabit it require flexible systems of representation, which will be the focus of discussion in Chapter 8.

Further reading

Bachelard, G. (1994) 'The House, from Cellar to Garret', in *The Poetics of Space: The Classic Look at How We Experience Places* [1958], Beacon Press: Boston, pp. 3–29.

Grosz, E. (1995) *Space, Time and Perversion*, Routledge: London.

hooks, b. (2009) *Belonging: A Culture of Place*, Routledge: London, New York, pp. 6–24 and 224–30.

Meskimmon, M. (1997) *Engendering the City: Women Artists and Urban Space*, Scarlet Press: London.

Tuan, Y.-F. (2007) 'Body, Personal Relations, and Spatial Values', in *Space and Place: The Perspective of Experience* [1977], University of Minnesota Press: Minneapolis, London, pp. 34–50.

Virilio, P. (2005) *City of Panic* [2004], trans. Julie Rose, Berg: Oxford, New York.

Bachelard [1958] gives an existential account of the personal perception of space in a poetic journey through a house, which demonstrates the deeply embedded nature of experience on our response to the world. The human geographer Yi-Fu Tuan [1977] provides a tangible explanation of the body's occupation of space, which measures direction, location and distance. He describes how we orientate and take charge of our space. hooks (2009) speaks about the difference that geographical location makes to the formation of the psyche. She relates the difference in experience between living in the country and city, between public and private and between 'black folk' and 'white folk'. Grosz's (1995) discussion provides an introduction to body politics and a rethinking of the body in relation to space, knowledge and subjectivity. Meskimmon (1997) provides a straightforward introduction to the notion of embodiment in the context of the city and commentary on some examples of photography.

Further photography

Nobuyoshi Araki (Japan 1940) – there are numerous publications of Araki's work, including: Araki, N. (1996) *Works of Nobuyoshi Araki: Private Diary 1980–1995 v. 8*, Heibonsha: Tokyo; Searle, A. (2001) *Nobuyoshi Araki: Tokyo Still Life*, Ikon Gallery: Birmingham; Araki, N. (1991) *Diary Sentimental Journey*, Shinchosha Company: Tokyo.

Seiichi Furuya (Japan 1950) – Furuya, S. (1995) *Memories*, Fotomuseum, Winterthur, Scalo Publishers: Zurich.

Daido Moriyama (Japan 1938) – Moriyama, D. (2004) *Memories of a Dog*, Nazraeli Press, Berlin; Jeffrey, I. (2001) *Daido Moriyama*, Phaidon Press: London; Munroe, A. and Phillips, S. (1999) *Daido Moriyama: Stray Dog*, D.A.P./San Francisco; Museum of Modern Art: http://www.moriyamadaido.com/english/#.

Mika Ninagawa (Japan 1972) – Ninagawa, M. (2002) *A Piece of Heaven*, Editions Treville: Tokyo: http://www.ninamika.com/.

Yutaka Takanashi (Japan 1935) – Badger, G. and Ladd, J. (2010) *Yutaka Takanashi: Toshi-e (Towards the City)*, Errata Editions: New York.

1 day 1 photo is a collaborative flkr or 'photo blog' project by Szilvi Tóth (1976), Enik_ Hangay, Judit Katalin Elek from Hungary and Lei Ben Ben (China 1977): http://www.1day1photo.com/index.php?page=project&lang=eng.

Musa Nxumalo (Soweto 1986) – describes his series *Sihle* as 'exploring intimacy and sharing of personal space amongst my friends'. 'I find myself photographing situations and spaces that for me should "distinctively" portray desired values such as; comfort, joy, adventure, laughter, growth and transformation. These are values that make sense and that I am anticipating at this point and time in my life, but in these photographs . . . I see contrary.' He describes the series *Alternative-kidz* as exploring 'my community and conveys the notion that the Black youth are altering stereotyped township identity and philosophy by adapting various non-conventional influences into their township lifestyles. Interestingly, these choices or ideas of living complicates and, sometimes, are in conflict with the images, portrayals and meanings of "traditional" and contemporary township and African identity': http://musanxumalo.com/index.php.htm.

Notes

1 Takanashi Yutaka (Tokyo 1935); Shomei Tomatsu (Nagoya, Japan 1930).
2 Takashi Homma (Tokyo 1962); Kyoichi Tsuzuki (Tokyo 1956).
3 http://www.serpentinegallery.org/2008/05/cao_fei_rmb_city.html.
4 http://www.youtube.com/watch?v=Yk4_BsuamLw; http://www.youtube.com/watch?v=5vcR7OkzHkI.
5 Tomoko Sawada (Kobe City 1977): http://www.e-sawa.com/.
6 Mika Ninagawa (Tokyo 1972): http://www.ninamika.com/.
7 Miwa Yanagi (Kobe City 1967): http://www.yanagimiwa.net/e/index.html; http://www.brooklynmuseum.org/exhibitions/global_feminisms_remix/.
8 Mariko Mori (Tokyo 1967): http://www.galerieperrotin.com/artiste-Mariko_Mori-6.html.
9 Interview in the *Journal of Contemporary Art*: http://www.jca-online.com/mori.html.

8 Psycho-geographies and the city

Previous chapters have introduced a shift in thinking about space and subjectivity that looks forward to alternative conceptions of the city, which can incorporate emotional resonance, social condition, political value, bodily memory and poetic or fictional space. This chapter introduces flexible systems of representation such as Benjamin's *Arcades Project*, the Situationist International's psycho-geographic methodology and Deleuze's conception of space. It discusses uses of photography that visualize the city as an event, network or process, in which the conceptual echoes physical attributes and describes a system of relationships rather than objects, or incorporates a dreamlike methodology. The three case studies in this chapter echo Benjamin's *Arcades Project* by resisting synthesis and approaching a totally visual conception. They are each interdisciplinary in their approach, referring to a range of contexts. They are also very different from each other: Aglaia Konrad's appearing very technical and factual, without many people, and Valérie Jouve's fictional and focusing on the subject in space, whilst Walid Raad's makes use of psycho-geographic networks and is politically motivated, and serves as a conclusion.

Spatial networks, conceptual systems

Consider a house and a street, for example. The house has six storeys and an air of stability about it. One might almost see it as the epitome of immovability, with its concrete and its stark, cold and rigid outlines. Now a critical analysis would doubtless destroy the appearance of solidity of this house, stripping it as it were of its concrete slabs and its thin load-bearing walls . . . In the light of this imaginary analysis, our house would emerge as permeated from every direction by streams of energy, which run in and out of every imaginable route: water, gas, electricity, telephone lines, radio and television signals, and so on. Its image of immobility would then be

replaced by a complex of mobilities, a nexus of in and out conduits . . . this piece of 'immovable property' is actually a two-faceted machine analogous to an active body: at once a machine calling for massive energy supplies, and an information-based machine with low energy requirements. The occupants of the house perceive, receive and manipulate the energies which the house itself consumes on a massive scale . . . Comparable observation, of course, might be made apropos of the whole street, a network of ducts constituting a structure, having a global form, fulfilling functions, and so on. Or apropos of the city, which consumes (in both senses of the word) truly colossal quantities of energy, both physical and human, and which is in effect a constantly burning, blazing bonfire. Thus as exact a picture as possible of this space would differ considerably from the one embodied in the representational space which its inhabitants have in their minds, and which for all its inaccuracy plays an integral role in social practice.

(Lefebvre 1991: 92–3)

This passage by Lefebvre articulates the complex network of processes that happen within a house, its position within the bigger system of the city and the power of metaphor to facilitate description of relationships. In Lefebvre's terms, 'space' does not operate independently from the relationships operating within it. He uses the metaphor of the 'conduit' to describe the nature of the house in terms of its different layers of mobility. A house cannot move physically, but Lefebvre introduces the notion that different energies move through it, such as electricity – a physical element that is powerfully metaphoric in terms of the conceptual associations suggested by the elementary power of electrical charge. He distinguishes the significance of the visual appearance of the building from an imaginary conception that incorporates what *happens* within the house. In aligning the house with a body, he emphasizes a level that *touches* us as individual subjects, and focuses the interaction that occurs between the individual, the space, the physical elements and their movement and exchange within the space. He indicates its structures and functions as a result of those interactions, which by extension have both local and global significance. He distinguishes between the physical and social interaction that takes place and the mental image that the occupants may have of it. Lefebvre's development of a critical spatial awareness requires that all spaces are physical, mental and social and must include products of the imagination, projections, symbols and utopias (Lefebvre 1991: 11–12).

Following Lefebvre, urban theories have moved from a focus on structural definition and analysis rooted in the dualism of concrete and imagined space, to methods that explore more flexible and interdisciplinary ways of spatial thinking. They have had to consider new patterns of

communication, new forms of sociability and networked mobility, which have changed the nature of connection between people and places and their relationship with time and space. Responding to Lefebvre's ideas and a Marxist analysis of urbanism, Soja argues for a more radical postmodern politics that confronts the influence of neo-liberalism and the impact of global development. His book *Thirdspace* (1996) responds also to the late twentieth-century thinking of feminist and postcolonial theories that have contributed to breaking down persistent binary divisions such as the local/global, mind/body or social/spatial. *Thirdspace* considers the mental and material dimensions of spatiality and modes of spatial thinking that incorporate the relationships between production, information and creation (see also Box 1.3: Triadic city space). He demands the need for a new sort of imagery that builds on these developments that cross the boundaries of race, class and gender. The city must incorporate both the minutiae of everyday life seen on the streets of the city and the more comprehensive and conceptualized view of the urban condition (Soja 1996: 310).

In his discussion of the network society, Manuel Castells identifies the tension that arises from the different levels of operation in the contemporary city: between the global processes of economy and technology and the distinctly local concerns of the individual. Whilst they exist in tandem, processes on the level of the economy, media and institutionalized authority are organized through global networks, whereas day-to-day work, private life, cultural identity and political participation are essentially local. What Castells terms the 'space of flows' links separate locations in an electronic and interactive network, whereas the 'space of places' organizes experience and individual activity within the confines of locality. The horizontal communication of global networks extends beyond institutional boundaries, and local politics are restricted to operational functions. The operation works outwards globally and within the space of places. But there is increasing conflict between communication that accelerates individualization, life and work and the needs of shared cultural identities ('communalism'). Cities, as communication systems, are supposed to link the local with the global, but this, Castells suggests, is where the problem starts because, when trying to respond to local and global needs simultaneously, these two conflicting logics 'tear cities from the inside' (Castells 2004: 85). And yet a region's prosperity depends on the degree of connectivity to those global networks that drive competition. Consequently, where one lives determines a different frame of reference – the timelessness of internet communication in global markets, or the mechanical time of industrial production in less developed economies.

In all instances what matters is the spontaneity of uses, the density of interaction, the freedom of expression, the multifunctionality of space, and the multiculturalism of the street life. This is not the nostalgic reproduction of the medieval town . . . It is the dissolution of public space under the combined pressures of privatization of the city and the rise of the space of flows that is a historical oddity. Thus, it is not past versus the future, but two forms of present that fight each other in the battleground of the emerging metropolitan regions. And the fight, and its outcome, is of course, political, in the etymological sense: it is the struggle of the polis to create the city as a meaningful place.

(Castells 2004: 91–2)

Tensions, arising from within a network society, between the 'space of flows' and the 'space of places', change the way in which 'function, form and meaning' are produced within contemporary cities. And how cities confront the challenge presented by 'the split between personality and communality brings extraordinary stress upon the social system of cities as communicative and institutionalizing devices' (85). If a city is to keep a balance between its economy and the quality of life of its inhabitants, the whole fabric of the city, specifically its urban design, has to consider the symbolic meaning of its structures as well as the practical necessities of living (90). It must be mindful of the relationship of this symbolism to the realities of the city as a whole. Allan Sekula points to such symbolic tensions in many of his photographic projects, which present the geo-political economies and histories hidden in the urban network – such as the disjunction between the aspirational architecture of the Guggenheim Museum in Bilbao and the declining industry that surrounds it (*TITANIC's Wake*, 1998/2000). Castells argues that restoring culture and meaning to cities is the main challenge; it has to incorporate public spaces for different purposes – beyond the promotion of shopping and consumerism as a leisure activity; the shaping of cities must consider changes in attitude to the roles of men and women, global migration and environmental issues. The process of transformation requires more meaningful consideration than the nostalgic dreams satisfied by the construction of artificial complexes, such as Shanghai's Xintiandi district – the *City's Living Room*. The exhibition and event platform *Talking Cities: The Micropolitics of Urban Space* (2006) is an example of an initiative aiming to confront that which has lost its former meaning (recognizable in cities such as Johannesburg) and to 're-ignite spaces that are undervalued, in transition or at the margins of perception' (Ferguson 2006: 22). It advocates the 'micropolitics of space' recognizable in small locatable spaces that are multi-functional, rather than the large-scale approach that requires us to drive from one functional space to another (shopping, banking, living).

BOX 8.1

Deleuzian space

Lefebvre emphasizes the interdependence of the physical, mental and social in translating abstract visions into concrete reality. Bourdieu describes *habitus* as embodying people's everyday behaviour in response to the complex network of hierarchies and structures. Gilles Deleuze and Felix Guattari's ideas reconfigure these concerns in a context that includes imagination, virtual space and the dimension of time. Their ideas have infiltrated the discipline of architecture to the extent that the term 'becoming-architect', for example, is understood as an attitude that requires the consideration of a space as describing a physical *and* mental space. Architectural practice has adopted a number of Deleuze's abstract concepts and applied them to thinking about buildings, so that a re-conception of the house considers what is performed in the house to be as central as its material structure and the objects within it. In the construction of anything there is the material fact and there are the 'incorporeal forces' that provoke its construction and which determine the approach, belief and manner of construction (Frichot 2005: 66–8). These are not confined to material structure and contain all that has brought us to that present moment in each room, psychologically and ideologically. This attitude acknowledges sensation no less than concept, so that consideration of a space includes also the bodies who inhabit the space and the relationships that develop between them (Deleuze and Guattari 1994: 210–11).

Gilles Deleuze and Felix Guattari's work is concerned to find alternatives to dualistic thinking – they use a number of concepts, such as *deterritorialization, rhizome, smooth space*, to do this. The term *de-territorialization* refers to the process that disturbs our established identity, relations and territories and provokes new ones to develop (Deleuze and Guattari 1994: 67–8). In the context of the contemporary city, and in response to increasing globalization, deterritorialization refers to the dispersal of close communities, either by migration or by conflicts between local and global networks. The process of *re-territorialization* occurs simultaneously, creating new forms of community and space, and different forms of identity. This process is complex and brings to the fore the importance of networks, knowledge and power which impact on relational systems. The significance of Deleuze and Guattari's influence on conceptions of space, is their insistence on

space being not only physical but psychological and spiritual, so that it incorporates social, political, geological, biological, economic and aesthetic dimensions (Buchanan and Lambert 2005: 3–5). Their discussions offer alternative approaches to thinking about the world that are not bound by polarities but are multiplicitous. For example, they differentiate between *smooth* space and *striated* space, whilst emphasizing that these are not conceived as being in opposition but that they operate alongside each other. *Smooth* space is described as a *haptic space* that can be as much visual or auditory as tactile. In contrast, the *striated* relates to a more distant and optical space, recognizably a modernist vision (Deleuze and Guattari 2007: 524). A tree *root* branches off into smaller roots and is bound by a hierarchical system associated with logical thinking, whereas the *rhizome* can emerge at any point and is not bound by an organized hierarchical structure. Both systems operate side by side and in and between each other.

These ideas are echoed by cultural and feminist thinkers such as Braidotti, Grosz and Haraway who identify new models for thinking about our relationship to the spaces we inhabit and which break down binary structures to incorporate mind and body in active, participatory, interrelational ways. Braidotti considers Deleuze's notion of rhizome as better suited to 'a nomadic disjunctive self'. Haraway explores the difference that bio-technologies, networking communications and the consequent multiple interconnections make to the construction of the subject. Grosz's interactive model of the city accommodates Deleuzian thought that recognizes the complex interrelationships that blur established boundaries. Introducing *Deleuze and Space*, Ian Buchanan describes postmodern cities as requiring 'a radical transformation of subjectivity' because 'they repel old fashioned attempts to put down roots, ways of being that sink into the earth in search of a sturdy foundation on which to erect a new life' (Buchanan and Lambert 2005: 22). A Deleuzian form of geography is concerned with virtual spaces:

> In this necessarily growing world it is not enough to explore space, as geographers have traditionally been wont to do. Rather it is necessary to explore the dimensions that make space possible, to experiment whilst pushing knowledge to its nonsensical limits, stretching thought to the tune of this becoming world, creating registers by which we orientate ourselves as a different people and make the world anew.
>
> (Dewsbury and Thrift in Buchanan and Lambert 2005: 97)

Systems of representation

Urban structure is interpreted (after Lefebvre) as a production that comprises a system of interrelationships between physicality, symbolism and habitation. Space results from our activities – it is a social space and is transformed by us. Documentation in the traditional sense suggests testimony of circumstance at a certain moment in time, whereas a Deleuzian influence on thinking about space introduces transdisciplinary, fictional and psychological dimensions to the possibilities of document. So representation of interdependent networks presents a challenge for photographing the city, which most simplistically pictures the world by defining objects. Lefebvre and Deleuze indicate significant difficulties for photographing the city as a network of interdependence. How can representations reflect these 'flows' and flexible systems?

Benjamin's *Arcade Project* [1927–40] is a model of representation that attempts to sustain intersections of meaning, rather than close them down in a linear description or synthesis. Using montage, it gathers together a wealth of material, commentary and quotation in a way that promotes relationships between elements. Benjamin's rhetorical process presents a series of

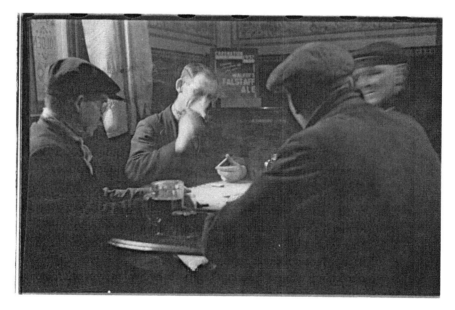

Figure 8.1 Humphrey Spender, 'Pub' from *Mass Observation*, 1937–38.
© Bolton Council from the Bolton Library and Museum Service collections.

references without direct authorial interpretation and demonstrates meaning in what Eiland and McLaughlin describe as a massive and labyrinthine architecture, something like a dream interpretation – a 'dream city' (Benjamin 2002: xi). Montage allows for the coexistence of different elements, rather than their prioritized organization, and promotes a reverberation of symbolic meaning. It does not translate them into a generalized whole and resists narrative resolution. Instead it can represent the world as a network of related elements, sometimes unresolved or contradictory (Highmore 2002: 94). It is a methodology that resists definition, minimizes the author's voice and demands active participation of the reader/viewer in response. Montage counters the conventions of realistic illusion and is therefore particularly significant as a method for presenting photography, which normally gives a convincing illusion of what the world looks like (See also Box 5.1: Politics and photo-juxta-position).[1]

Ben Highmore points out that Benjamin's methodology is echoed in the essentially interdisciplinary Mass Observation project, founded in 1937 by Charles Madge (poet and journalist), Tom Harrisson (anthropologist) and Humphrey Jennings (film-maker). Mass Observation documented everyday life and the processes of social and political change through written and photographed observation. It was concerned 'to describe as exactly as possible how people behave' (Mass Observation 1983: A26, 2, quoted in Highmore 2002: 77). It also used the method of montage in its non-linear presentation of disparate material and its participatory approach in gathering data (111–12). Invited to go to Bolton to record life in a northern industrial town, the photographer Humphrey Spender recounts how the minutiae of subject-matter was prompted by Harrisson:

> For instance, how people hold their hands, the number of sugar lumps that people pop into their mouths in restaurants, how much people stole things like teaspoons in restaurants, matches, bits of paper. Anything. Every day started with a kind of lead, and then you were working on your own, and one thing led to another. Overall there was a general brief to produce information about people's behaviour in all kinds of situation – bus queues, football crowds, people in restaurants, people in pubs, people in church, people walking about the streets, people talking to each other, what they were wearing, whether they wore hats, what they wore on their feet – the list was endless, and a great mixture.
>
> (Spender in interview with Jeremy Mulford 1982: 15)

Mass Observation was characteristic of British social documentary, but uncharacteristic in its patchwork logic of fragments and impressions, rather than a systematic or thematically categorized collation. It challenged the

assumption that documents must gather similarities together and generalize in order to be useful or intelligible. It included the subjective accounts of individual people as well as the more objective accounts of work, leisure and civic events. As such it acknowledged the importance of small individual gestures, echoing Lefebvre [1947] who recognized the significance of 'the original little event':

> I see the humble events of everyday life as having two sides: a little, individual, chance event – and at the same time an infinitely complex social event, richer than the many 'essences' it contains within itself.
>
> (Lefebvre 2008a: 57)

Mass Observation's methods test the norms in structuring knowledge and information. For example, its horizontal cross-section survey of one day in 1937 (12 May) from a number of perspectives (diaries, photographs, observations) forces a different relationship to the text which requires the reader to make their own connections between elements that appear to have no ordering principle (Highmore 2002: 95).[2]

Systems of representation: psycho-geography

Situationist International (SI), of which Guy Debord was a founding member in 1957, was concerned to overturn established cultural and political practices and to develop a new kind of urbanism. The SI's attitude parallels ideas discussed by Lefebvre and de Certeau – principally those that consider social interaction as central to production of the city. They were looking for a practical and critical geography to 'change the way of seeing the street'. In reaction to the more statistical aspects of geographic study, their notion of *psycho-geography* emerged alongside the development of social geography that studies the behaviours and operations of individuals in the city. For example, Kevin Lynch's *The Image of the City* [1960] indicated the role of the imagination as a kind of 'cognitive mapping' in our interaction with the city (Sadler 1999: 92). However, *psycho-geography* attempted an alternative to a social geography that writes histories affirming the dominant ideology, and aimed instead to incorporate differences, deviations and contradictions within the city, making use of playful or dilatory behaviour. Rather than a logical topography, it attempted to transform representation of the city, by developing cartography that responded to emotions, ambience and conceptual configurations (Debord, *The Naked City*, 1957). The SI shunned anything that could be said to be spectacle and celebrated derelict or blank façades, or what would be described as ugly in modernist terms. It was therefore at odds with abstract and rational idealism such as Le Corbusier's. For example,

Figure 8.2 Ralph Rumney, from *Psychogeographic Map of Venice*, 1957. © Éditions Allia, 2012.

Ralph Rumney's *Psychogeographic Map of Venice* (1957), which attempted a psycho-geographic photographic record of Venice by following the beat author Alan Ansen around the city, failed to meet the SI's strict criteria for psycho-geography, because he was too seduced by the beauty of the city and what Ansen was doing.[3]

SI employed the tactic of *dérive* (drift) to deliberately forge a different relationship with the city, one that sought out these differences and deviations. *Dérive* was an urban exploration calculated in its intentional lack of goal or destination – a 'dialectical wandering' in which walking in the city is influenced by what the city presents. '*Dérive* is a technique of locomotion without a goal. It depends on the influence exerted by the setting' (Debord [1954] quoted in McDonough 2009: 46). Unlike a journey that moves toward somewhere, or strolling that delights in the air and spectacle in a passive way, *dérive* harnesses spontaneity and chance with serious attention. *Dérive* differs from the solitary *flâneur*'s stroll in that it is more ideologically purposeful and collective in its aimlessness. Debord describes the spatial field of *dérive* as depending on the starting base determined by a subject's residence or a group's meeting point. He uses technical terms such as 'axes of passage', 'exits' and 'defences' and suggests that it should take about a day with ideally two or three people:

> The maximum extent of this spatial field does not exceed the entirety of a metropolis and its suburbs. Its minimum extent may be limited to a small unitary ambience: a single quarter, or even a single block of houses . . . The exploration of a fixed spatial field thus presupposes the setting up of bases, and the calculations of directions of penetration . . . *Dérive*'s lessons permit the drawing up of the first surveys of the psychogeographic articulations of the modern city.
>
> (Debord, 'Theory of the Dérive' [1956]
> quoted in McDonough 2009: 82–4)

The *dérive* has since been criticized in several respects because, in its enjoyment of the strangeness of 'others' (Algerian and Jewish quarters in Paris, for example), it tended to romanticize the poorest quarters of the city, regardless of the condition of living there. It appeared indifferent to a feminist perspective and the fact that women cannot 'drift' at will in all areas of a city in safety. Ultimately, a drifter can discover secrets of the city found in the extraordinary and the exotic 'other'. Sadler likens this to a 'possession' of the street and to a fetishization of the city that satisfies some psychological compulsion (1999: 80–1). This apparent haphazard encounter with the city, together with a purpose of revealing the secrets of the city, is commonplace in 'street photography'.

Photographic systems

In simple terms, psycho-geography combines subjective with objective methods of study, so that any photographic project that includes elements of subjective encounter with the city inherits aspects of psycho-geography. Such projects tend to emphasize the characteristics of: journey, topography, pursuit, network, political system or horizontal mapping. 'Journeying' also works metaphorically to represent 'becoming' or the 'subject in process' and is a form of auto-ethnography. The simplest examples describe a personal journey, such as: Robert Frank's *The Americans* [1958], which is subtly critical, or Stephen Shore's *Uncommon Places* (1982) and *American Surfaces* (1972), which interpret the everyday as banal idiosyncrasy, or Philip-Lorca di Corcia's series *A Storybook Life* (1983–2003), which Highmore describes as presenting a form of ethnography (Highmore 2002: 140). Alnis Stakle's *Lost: Paris* (2010) is recognizably psycho-geographic for its rejection of modernist principles, its aimlessness and its acceptance that the subject cannot be separated from his urban environment:

> [*Lost: Paris*] is both documentary & autobiographical psychogeography based investigation into complicated ties between human beings and their physical environment. I discovered that the sense of being lost is the most common meaning that describes the existence of a contemporary human being in a self-created urbanized environment. My moving about the city environment can be described as irrational and often aimless. I do not look for tourist attractions, the beautiful or the ugly. Instead I allow the urban environment with its constituent elements (buildings, signs, people, etc.) to 'guide me', becoming familiar with the environment. I would describe my approach to experiencing the urban environment as one based in contemplative experiences at the basis of which lies a peculiar merging with the surroundings. With my works I do not wish to recount a particular event in a specific space and time. My practice explicitly includes the search for new methods of apprehending urban environment. The most important reason for my choosing this approach to studying urban environment is to construct subjective experience and knowledge that is visually and conceptually not based on a traditional editorial approach or documentary storytelling strategies used in photography.
>
> (www.alnisstakle.com)

Mobile systems of representation are echoed in explorative methods of photography that visually present ideas and arguments in dialectical images or series. For example, Takuma Nakahira and the Provoke group, Allan Sekula and Jo Spence, in varied ways, resist the modernist ideal of the definitive

'moment' and elevation of the object as fetish. If a psycho-geographical approach is to be useful in rethinking the city, it must address more than an individual's psychology. As a commentary on 'the wider social fabric in which we are all locked', Stephen Willats's *Brentford Towers* (1985) documents a series of personal experiences of living in a tower block apartment in London. His documentation incorporates a range of perspectives: a photograph of an object selected for its personal significance, a view from the picture window, the participant's photograph and comment taken from a recorded discussion. The series of resulting display boards were situated within the tower.[4] Projects can parallel theoretical ideas by combining any number of geographical and political perspectives, as seen in Sekula's works. And there are those that are geo-political and also incorporate the imagined and metaphorical, such as Raad's *Sweet Talk: Commissions*. Focusing on the *experience* of the city or concerned to depict systems and networks encourages documents that do not present logical or linear organization. Literal montage (Rumney's *Psychogeographic Map of Venice*) and, more conceptually, photographs in series, can present numerous dimensions of process and thinking. Series can be chronological as they track a procedure or activity in space, or travel through space and different locations, or can catalogue one timeframe across different locations (as with Mass Observation's 12 May). Sometimes single images conflate systems such as Andreas Gursky's photography, which insinuates consumption or systems of capitalism, and visually explicates de Certeau's suggestion that a social phenomenon can be sometimes hidden within its own production.[5]

Lefebvre's thinking is echoed in Naoya Hatakeyama's *Lime Works* (2002), which is a conceptual documentation of the city that works horizontally across contexts, and historically in terms of cause and effect. It depicts jagged limestone cliffs formed millions of years ago, stop-motion images of quarry blasts, cement factories, and panoramic urban vistas; it demonstrates the impact of the Japanese city and its construction on the environment, on industry and labour and on the appearance of cities. Martha Rosler's *In the Place of the Public* (1990) is more theoretically complex and critical of globalism. It uses the 'airport' as an extended allegory for space, the manipulation of space and our relationship to it. Airports are neutral, ambiguous spaces, another form of heterotopia, which like hotels and shopping malls, actively avoid specific cultural features, so that when we pass through them we are disconnected from place and time, physically and emotionally. The airport is an interstitial space through which we pass between cities. It can be used as metaphor for 'passage' in its many forms or 'network', 'system' or 'connection' that embodies a Deleuzian conception of space. *In the Place of the Public* uses numerous photographs of airport space taken over many years, to address many of the key ideas provoked by the city and urbanism – *flânerie*, utopian space, public

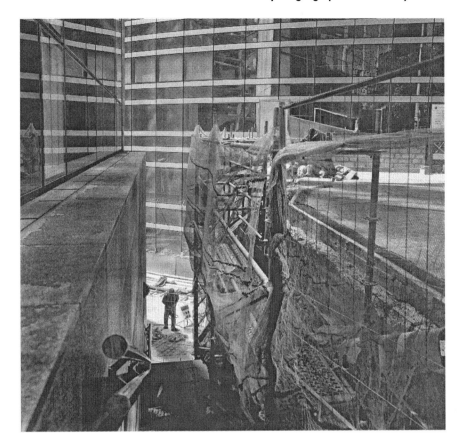

Figure 8.3 Alnis Stakle, from the series *Lost: Paris*, 2010. Courtesy of the artist.

and private space, consumption, the anonymous structures of modernism and notions of control and surveillance. Rosler points out that airports are 'both consequences and causes of a shrunken public space', which function as circulators of consumption and 'answer the needs of capital above all' (Rosler 1998: 77).[6]

Global systems

> Aglaia Konrad's works refer to the premises of modernism and their concrete implementation – the discrepancy between utopia and utilitarianism in the realm of architecture and urban planning . . . We see a balance between fascination with the architectural and urban-planning ideas of modernism and attention to the collateral damage caused by the

fundamental changes due to the processes of globalization. Her pictures from numerous cities around the world evidence the fact that modernism is a global system that eludes definition by rigid boundaries . . . Viewed as a whole [the photographs] generate a global picture of the urban sphere with remaining local references that nevertheless do not denote any actual place, nor do they reveal any comprehensible pattern of ordering at first glance.

(Gau 2004: 7, 16)

Aglaia Konrad is interested in the centres, the peripheries and the urban infrastructure of cities. Her photography is not architectural in the traditional manner of Marville's pictures of Paris, but they are documents of urban structures that mark a city in constant process. Unlike Marville, she does not seek out deserted street corners, and unlike street photography, she does not wait for uncanny juxtapositions of circumstance to occur. Instead, she depicts the material, topographical and social forms that construct urban space (Gau 2004: 7). Her method of compilation displays an array of different factors impacting on city structures and the dynamics that operate within them.

Konrad's book *Iconocity* accompanied the exhibition of the same name held at de Singel International Arts Centre, Antwerp (2005). The collation of black and white photographs examines city spaces, such as Mexico City, Dakar, Berlin, Shanghai, from a number of perspectives: from the tops of buildings, from a Boeing aeroplane, from the street, from a distance and in close-up; of motorways, workplaces, cafeterias, streets, windows, building sites, tunnels. It presents an extensive series of themes ranging from the general and panoramic to the particular significance of place, such as the twin towers in New York, and from the concerns of public architecture to the differentials of singular *habitus*. *Iconocity* is a montage in the manner of Benjamin's *Arcades Project*: a complex juxtaposition of multi-perspectives. We are forced to look again at the production of space, the objects that we construct *in* space, the occupation *of* space, its inhabitants and the use and destruction of space. We are not told where every city space is (unless we refer to the index) but can understand the features that distinguish one nation from another by recognizing what is common and what is locally different: for example, the particular construction of market stalls, the content of market stalls and the dress of the market traders. *Iconocity* visualizes the different dimensions of communication in cities: libraries of knowledge, lobby encounter, market exchange and e-communications. From the air, we see the organized production of space represented by airstrips, tracks, highways, buildings, the repetitious regularity of street planning and the impact of habitation evident in the detritus on rooftops. Vistas that show the geometry

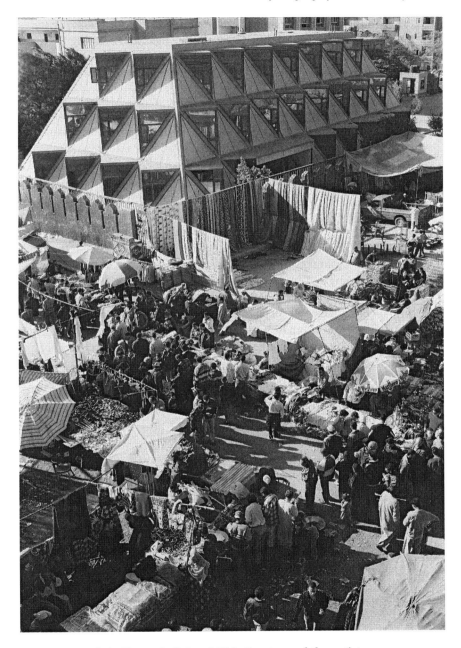

Figure 8.4 Aglaia Konrad, *Cairo*, 2004. Courtesy of the artist.

of city structures and communication networks contrast with the passage of inhabitants walking at ground level. We see the same building from different perspectives and angles. The repetition of structural elements/types of buildings bears the legacy of Berndt and Hilla Becher's topographies that demonstrate the difference between structures by focusing on their similarity.[7]

Iconocity demonstrates structure and history in the representations of modernist ideals and cities in the making. It focuses the debate between visionary utopias and the reactive expediency of rapid urbanization. Photographs are punctuated by fragments of text from a variety of newspapers, magazines, books, which are repeated in different contexts. The use of image with text from *China Today* (July 2000), echoes Castells's argument regarding the impact of e-commerce and the tensions between local and global economies, and between symbolic vision and practical needs. The article discusses shifts in China's market economy – the change from production to marketing, and from product-oriented to customer-oriented philosophies, and their consequent impact on global economy and exports (Konrad 2005: 10–11). The impacts of information and communication technologies are confirmed visually in local, global and virtual consequences – on street corners, in the markets and in world trading. A fragment of text from Robert Venturi's book (*Learning from Las Vegas*, 1972) considers architecture and the philosophies attached to the difference between

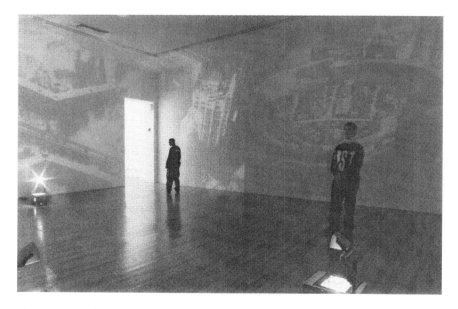

Figure 8.5 Aglaia Konrad, *Exhibition view: Cities on the Move, PS1,* **1998. Courtesy of the artist.**

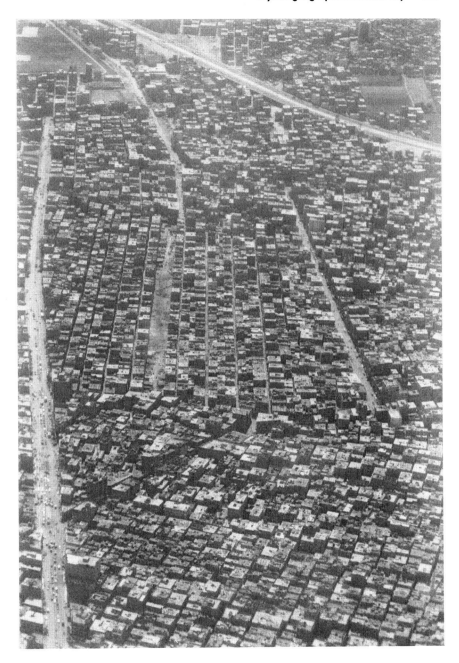

Figure 8.6 Aglaia Konrad, *Cairo*, 2001. Courtesy of the artist.

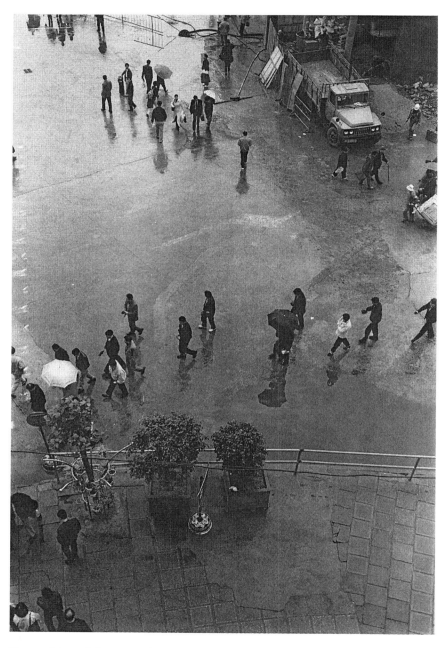

Figure 8.7 Aglaia Konrad, *Beijing*, 2000. Courtesy of the artist.

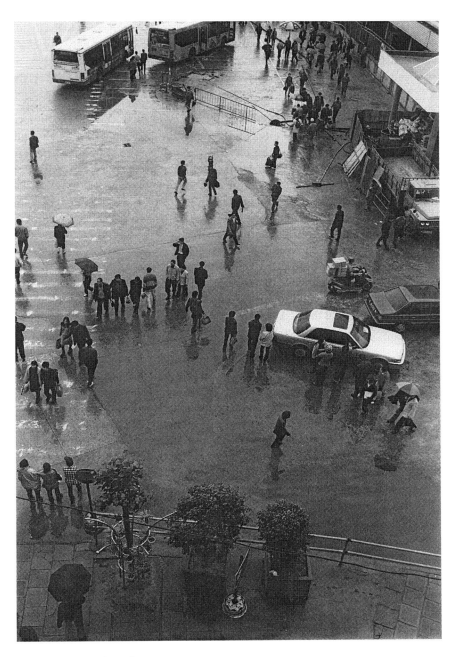

Figure 8.7 *continued . . .*

modernist ideals and contemporary urban sprawl. Its reference to the distinction between the 'ugly and the ordinary' focuses the contrast between expedient construction and utopian vision, between the process of haphazard expansion and the 'totally designed' city, and between the aspirations of Disneyland and the ideal piazza.

Konrad's presentation as installation (*PS1*, New York, 1998) forces a confrontation with the city. Photographs are projected onto each wall of a room so that images of the city fill the space. The experience therefore is intended to be immersive – like walking in the city. Except here, the experience is selected for us. Instead of viewing photographs as objects, which our vision can encompass without turning our heads, here the images are bigger than us, well beyond our cone of vision, so that we are able to wander around the room and scrutinize enlarged fragments of the city. It is a totally different kind of immersion from that of the *flâneur*, who translates the immersive experience into a form of objectivism and spectacle. As the installation amplifies the experience of not being able to see the city as a whole, it changes the nature of 'walking in the city' and reverses spectacle to a form of immersion, and the distanced view of the voyeur becomes a form of *flânerie*.

Iconocity manipulates an awareness of our perception by blowing up details – we view the street in all directions and at different magnitudes. Compilations are cinematic in that they are extensive and multiple, but do not tell stories and engender endless sequences. Focus on different aspects amplifies the construction of space and the construction of our understanding by the perspective from which we look – from a distance, as a traveller and as a participant. The approach is similar to a model explored by Bruno Latour and Peter Weibel's curatorial project *Making Things Public* (2005), which demonstrated multifarious facets in terms of a range of disciplines (historical, geographical, political) and from both macro and micro perspectives. Conceiving 'object' as a metaphor for 'issue' or 'concern', the project explored the way a political or public concern is *represented* 'to the eyes and ears of those who have been assembled around it' (Latour and Weibel 2005: 16). It attempted to present 'matters-of-concern' rather than 'matters-of-fact', which are problematic when exhibited as 'objective' information. Matters-of-concern (objects) are more variegated, uncertain, far reaching and invite dispute (19–21):

> Each object gathers around itself a different assembly of relevant parties
> . . . objects – taken as so many issues – bind all of us in ways that map
> out a public space profoundly different from what is usually recognized
> under the label of 'the political'. It is this space, this hidden geography
> that we wish to explore through the catalog and exhibition.
>
> (15)

This conception of gathering together numerous factors across disciplines and through history, emphasizes representation as a coalescence of things that *re*present the object of concern. It presents the possibility of representation 'without any provisional assertions, without any imperfect proof, without any opaque layers of translations . . .' (26). Konrad's photographs coalesce ideas/issues around the gathering of images. They function as *re*presentations of thoughts/issues in all their local and differential variety. Konrad's presentations avoid an 'objectivity', a point of view that hides its mediation. Each assembly is provisional and mutable; different exhibitions present the photographs differently and in different order. Where *Making Things Public* considered politics, not just as an arena, a profession or a system, but a concern for things brought to the attention of the expansive constituency of the public, *Iconocity* considers the city not just as a visual phenomenon, but as an operational system of structures that cross and recross each other. The method articulates elements of image and concept, illustrated in Konrad's quotation from Kevin Lynch's index (*The Image of the City*, 1960) that lists the constituents of images as: frames of reference . . . continuity . . . distortion . . . function, and the definitions of Jersey City by: district . . . edge . . . gradient . . . view. Just as *Making Things Public* examines the conditions of mediation and politics evident in technologies and networks and considers the many techniques of representation in politics, science and art, so Konrad ranges round what is possible in a city and attempts an extended and comprehensive 'view' of urban infrastructures using photographs. The aspirations of both projects echo Deleuzian thinking that conceives 'incorporeal forces' driving material fact and emphasizes the impact of networks of knowledge on relational systems.

Portrait of a city: irrational sensation

The city: a machinery, but also a chemistry, a reality that is impossible to embrace or grasp, an irrational sensation. Photograph: an abstract inscription, a captivating process, but also a mechanical vision of the world, an authority of verisimilitude and thus a certain authenticity. Photography is the instrument most adapted to the urban machinery, for it accompanies it in the general acceptance of control. And yet there are several works that pull in different directions. The city is in the constant process of production: spaces, people who do not move in the same direction – singular bodies that affirm themselves in the presence, their posture, their consciousness. Yet, for the moment, one voice silences the other. Will order have the last word? 'Characters' (in the fictional sense of the word) raise questions and simultaneously invent and construct utopian cities and their own projection.

(Jouve in Inkster 2002: 4)

This quote by Valérie Jouve reiterates elements introduced in this chapter. She describes the city as chemistry, a physical operation, whereby its elements in different combinations, react and produce other elements and effects. She suggests that her photographs depict sensation, rather than optical appearance, and yet also provide some sort of control or organization for that 'irrational sensation'. She uses the metaphor of 'space' to represent subjectivity and the psychological, and aligns the production of space with individual consciousness represented by behaviour and posture.

As an oblique form of documentation, the series presents the city of Paris as a montage of visual fragments, juxtaposing individual portraits besides simple images of apartment blocks, a wholly different vision from that of Marville, Atget or Brassai. It is a portrait of a city represented by the different moods, gestures and faces of a series of 'characters', who project different imaginary possibilities for experiencing the city. As with Konrad, we see signs of the city that extend into the distance behind, but here the focus is on the operations within the city at various levels of transportation, consumerism, industry and service: traffic jams, residential streets, industrial sites, wasteland. Where

Figure 8.8 Valérie Jouve, *Untitled, No. 6* (100 × 130 cm), 1994–95. Courtesy of the artist.

Konrad's images are remote, systematic and seemingly transparent, Jouve's represent the layers of symbolic function evident in pictures of work and leisure, welfare systems and civic operations. The individual appears as the apparatus of industry and labour: people go about their business in the city, enter and leave up and down the steps of public institutions; wait for social service; smoke a cigarette at lunch-time. Distant shots of people, or when cropped and isolated from the paraphernalia that surrounds them, become merely signs of their function – of 'work' and 'play'.

And within this document of city functions, we are presented with a series of close-up studies – glimpses of individuals in unexplained stances, which force us to ask questions about specific social circumstance and motivation. These are not the candid shots of street photography, but staged portraits that describe psychologies betrayed by gesture and position. Each portrait indicates a history, a fictional puzzle and a possible narrative: a bemused man seen reflected in a polished façade; a man in a pink shirt looks over his shoulder to his right, he has his back to us and behind him – the ever present apartment blocks; a young man leans forward with arm outstretched toward some unknown purpose; a woman moves forward speaking with self-assurance; a young boy, standing in front of what looks like a construction site, drops his head forward with extraordinary perplexity, completely wrapped in self-absorption; a girl in a pink and flimsy dress, without coat or handbag looks darkly suspicious and with disgust at something to her left; a girl leans on a bridge overlooking a street; a young girl is slumped or asleep against a pillar in a peculiarly vulnerable position suggested by her hands, one above the other and slightly open, nails varnished and relaxed in a gesture of supplication. And yet the body seems tense, her feet braced against the ground. These are statements about the subject's phenomenological encounter with its surroundings (see also Box 7.1: Phenomenological geographies).

The deliberate layout in book form announces the photograph's construction and photographer's agency. There is no attempt to make a statement about 'reality'. It starts with two obviously 'authored' images of the same apartment block cropped to echo the symmetry of the building's structure. The dilapidated balconies recount the many different people living in the city in close proximity, but effectively doing much the same sort of thing – washing and organizing their daily routine. Below this pair is another cropped image in complete contrast to the geometry of architectural structure. It shows a man presented squarely within the frame. The deliberate gesture of the individual who is yelling or singing in a particularly confrontational way contrasts with the unremarkable signs of everyday life visible in the apartments. Because they are artificial positions, they avoid the cuteness or irony of much street photography.

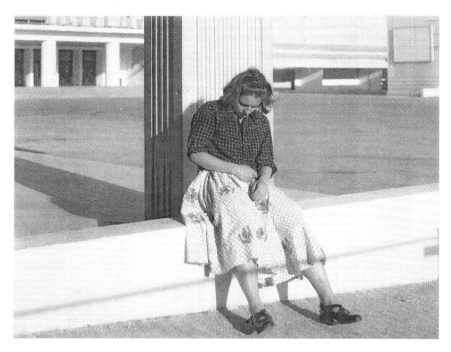

Figure 8.9 Valérie Jouve, *Untitled, No. 17* (120 x 150 cm), 1996.
Courtesy of the artist.

This focus on the peripheral suburban city is a theme in contemporary projects, which make reference to Foucault's heterotopias: '"the kinds of places that are outside all place", sites that are at once functional, utopian and critical' (Poivert in Jouve 1998: 13). Like Homma's series, the description of urban space directs focus on the subject in the suburbs. However, unlike *Tokyo*, Jouve's spaces are devoid of reference to commodity or history. These peripheral spaces focus on what we imagine to be the mental preoccupations of subjects expressed by their gestures. They reference Simmel's concern for the mental health of those living in the postmetropolis. They reference the subject's struggle to orientate itself in space (Bachelard). They illustrate the dichotomy between the individual and the crowd of which they are part – the communal (Castells), between being seduced by the crowd and remaining separate within the crowd, between independent existence and engaging with others in social space. They depict a setting of blankness and uneventful urbanity and seem to concentrate on how each person occupies their space. We are given no answers. What are they doing and what is the significance? They comment, if anything, on the individual's apparent lack of control or awareness. The economic gestures are concentrated studies

and, although quirky, they are not caricatures but atoms of behaviour. Jouve's subjects amplify that contrast between transience and individual reality, which, while appearing to be rooted in place, also exists independently from it. These gestural studies, or performative episodes, fix the subject in their space, where each becomes a kind of contemplative tableau that establishes its presence, its contribution to the process of the city. All a photographer can do is generate meaning by restricting the information that the viewer has to organize, by giving us glimpses and fragments that imply a sequence of events. Jouve makes use of this in a very deliberate and isolated series of portraits, which each suggest individual motivation.[8]

Hysterical documents

Walid Raad's work provides a suitable case study to conclude this book. It brings together many of the issues discussed thus far: documentary authenticity and deceit, fact and fiction, networks of information, mediated communication, contradictory perspectives, political agency of photography and, specifically, the problematic of documenting a city's history.

> The truth of the documents we research does not depend solely on their factual accuracy. We are concerned with facts, but we do not view facts as self-evident objects that are already present in the world. One of the questions we find ourselves asking is, How do we approach facts not in the crude facticity but through the complicated mediations by which they acquire their immediacy? The Atlas Group produces and collects objects and stories that should not be examined through the conventional and reductive binary of fiction and nonfiction. We proceed from the consideration that this distinction is a false one – in many ways, not least of which is that many of the elements that constitute our imaginary documents originate from the historical world – and does not do justice to the rich and complex stories that circulate widely and that capture our attention and belief. Furthermore, we have always urged our audience to treat our documents as 'hysterical documents' in the sense that they are not based on any person's actual memories but on 'fantasies erected from the material of collective memories'.
>
> (Raad in Gilbert 2002: 3–4)

Raad's project *The Atlas Group* has provided a frame within which to gather a number of documents: collated and fictional, appropriated and reappropriated, or attributed to others who may be imaginary (Dr. Fadi Fakhouri, Souheil Bachar, Lamia Hilwé). Raad's work undermines the conventions of logical procedure and testament and makes use of our expectation of factual accuracy.

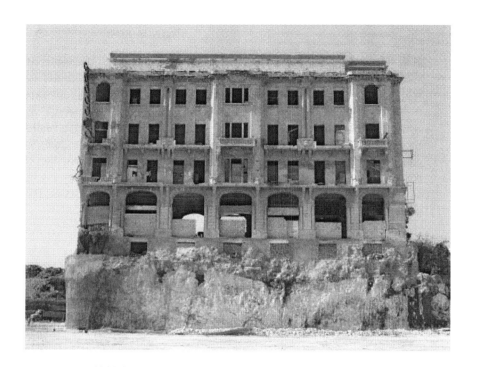

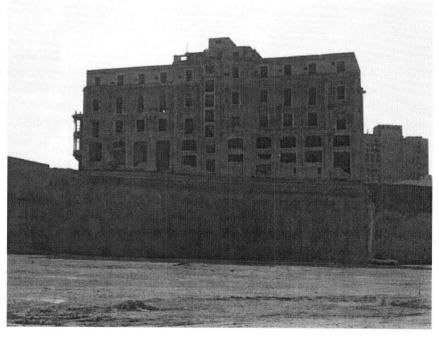

Figure 8.10 Walid Raad, *Sweet Talk Commissions (Beirut) Plate 101*, 1987/ 2010. Digital photographic print (111.8 × 188 cm). Edition of 7 + 1AP. Copyright the artist, courtesy Anthony Reynolds Gallery, London.

The work consistently looks 'authentic', whilst it and its 'author' may be a fabrication. It is not always clear. What is clear is the committed political agenda in the methods used that examine 'what happens to cities when they succumb to the threat of assault' and address the consequences of conflict in the Lebanese capital of Beirut (Raad 2005). We detect that images are politically subversive but cannot exactly pinpoint where the subversion is located. In a lecture (*Home Works III*, 2005) he relates, with heavy irony, a number of anecdotes that betray a critical, but almost fond, attitude to national security – his performance too demonstrates that nothing is simple. As a collection of works, the *Atlas Group* project 'locates, preserves, displays, produces and studies' documents that attempt to 'shed light' on the 'unexamined dimensions' of the history of Lebanon with particular emphasis on the wars (1975–91) and the subsequent ongoing conflicts.

Sweet Talk: Commissions (Beirut) (1987–present) relates a physical and psychological history that is interrupted by war. Setting himself a series of 'commissions', he attempts to record a city in the midst of urban economic, political and social transformation. A number of very different layers comprise this document that includes elements that vary between a collage of single shots constructing cinematic panoramic vistas (*Downtown Beirut*, 1989), and black and white images of the intrusion of nature on buildings torn by warfare and subsequently abandoned – the tangle of branches amid piles of rubble (*Tree Scene*, 1991). *Building, Beirut* (1997) presents straight topographical studies in the simple and factual manner of a series of ravaged and emptied buildings. In the *Hilwé Commission* (1992–2004) buildings are presented, but literally cut from their context and pasted on the white space of the page. In 2005, buildings are presented again separately, and give the impression of a city, at least in the process of post-war reconstruction. In contrast, *Sweet Talk: Commissions* Plate 445 is presented in the manner of an amateur document of seemingly unrelated incidental events, nearly all are severely cropped and giving glimpses of trivial incidents: two smiling men, both wearing glasses, one in a T-shirt and the other bare-chested, facing the camera in front of a vivid red night sky; a woman (no head, no feet) in a pink dressing gown, arms folded round and clasping her body; a family engrossed in cooking in the kitchen; a family driving in the city, the one in the back grabs the passenger's arm and demands to know the time; another driving in the sun, shades his eyes from the glare with his hand.

Sweet Talk is catalogued as an archive through history encompassing a range of subject matter, time frames and contexts. The project engages with historic conventions of representation. For example, the recurrence of architecture and

Figure 8.11 Walid Raad, *Sweet Talk: Commissions (Beirut) Plate 445*, 1987/2010. Digital photographic print (111.8 × 188 cm). Edition of 7 + 1AP. Copyright the artist, courtesy Anthony Reynolds Gallery, London.

Figure 8.12 Walid Raad, *My Neck is Thinner Than a Hair: Engines* [cat. AGP] Thin Neck Photographs_001–100, 2000/2003. Digital prints, 100 plates (25 × 35 cm). Edition of 5 + 1AP. Copyright the artist, courtesy Anthony Reynolds Gallery, London.

Figure 8.13 Walid Raad, Untitled, 1982–2004, from the series *We Decided To Let Them Say 'We Are Convinced' Twice. It Was More Convincing This Way.* Inkjet print (121 × 179 cm). Edition of 3 + 1AP. Copyright the artist, courtesy Anthony Reynolds Gallery, London.

streets, deserted and derelict despite the parked cars (*Street Scenes (Beirut)*, 1991–92) refer to Marville's and Atget's device of photographing the empty streets of Paris. *Portrait, Beirut* (1997), which depicts different people (a soldier, a golfer, a mother) looking at the camera, in the context of doing something that defines them at that moment, is reminiscent of August Sander's catalogue of *People of the Twentieth Century* (1910–40). *Sweet Talk* is an author's document in its construction, a social document in its reference and a collective one in its collation of fragments and memories from different sources. Raad describes the project as a 'despairing' (and futile) compulsion to record Beirut's history, by concentrating on its 'residents, buildings, streets, storefronts, gardens and other objects, situations and spaces' (Raad 2011: 79). However, on reflection, he is perplexed by the fact that his images 'were less and less referential to the persons, situations, objects and spaces' that were in front of him at the time, and questions what it is that he is actually documenting (Raad 2010: 41). He problematizes his use of photography as documents and questions how their meaning might be translated.

> I say things at different times and in different places according to personal, historical, and political considerations with regard to geographical location and my personal and professional relation with the audience and how much they know about the political, economic, and cultural histories of Lebanon.
> (Raad in Gilbert 2002: 3)

This attitude transfers to his use of photographs that investigate how histories are written and believed as factual, and questions how any one history is possible (Gilbert 2002). His projects exploit the convention of photographic documentation to demonstrate this impossibility and the contradictions thereof. They refer to the associations of photographic document with testimony, evidence and authenticity – ultimately to authority and power. The legitimacy of contradictory facts and perspectives validated by photographs 'at different times and in different places'. Stimson sums up the effect:

> The work of time becoming space is everywhere . . . in its compulsive *dérives* from car to car, sign to sign, monument to monument, in his freezing of moments and plotting of distances, in its concretization of language and de-focusing of vision, in its labyrinthine elaborations of archive, authorship, analysis and institutionality.
> (Stimson 2011: 128–9)

Raad's body of work addresses a concern with history that confronts concepts of time in relation to when an event takes place, to the past events that impact

on present events, and to their consequences on the future. Documenting an understanding, reminiscent of Deleuze's thinking, requires a presentation that is not linear. Raad states that he produces images 'by "borrowing" historical facts' (2011: 14) by which he means that any telling of history is transitory and unreliable. The project is committed to exposing historiographical issues and its 'complicated mediations'. Any presentation of facts will be only a fragment. The photographs navigate back and forth between present, past and memory and offer alternative 'views' of the complex experience of Beirut. He deliberately displaces history and obfuscates facts. Different texts give different dates and authorship. Stimson (2011) describes Raad's transmission of information as a 'stammering form of glossalalia', which he constantly interrupts. He starts telling a story and we are convinced, and then we find it is fantasy or memory. In an interview with Walid Raad (aka *Zeina Traboulsi*), Alan Gilbert suggests that the use of 'strategic misadventure' counters the despair felt in the face of loss and mourning associated with the city's history and the fact that history can never be told with any reliability. Cities such as Beirut manifest the interactions between any number of factors. Situations are not simple, neither are they one dimensional or solely about geography or buildings or even people. The documents and their fictional descriptions use humour and irony to drive home the absurdity of an unresolved conflict. Raad's practice addresses the 'tangled historical knot' that characterizes the political mess, resulting from the consequences of hundreds of years of previous conflict and the effects on the physical and mental lives of people living there.

> The documents in this imaginary archive do not so much document 'what happened', but what can be imagined, what can be said, taken for granted, what can appear as rational or not, as thinkable and sayable about the civil wars. They focus on some of the un-examined effects of the wars as they are manifest in photographic and videographic reproductions. Some of the questions I want to ask with this project are the following: How do we represent traumatic events of collective historical dimensions when the very notion of experience is itself in question? How do we approach the facts of the war, not in their crude facticity, but 'through the complicated mediations by which facts acquire their immediacy?' How does one witness the passing of an extremely violent present? What particular conceptions of experience, of modes of assimilating the data of the world can we presuppose when we speak of the physical and psychic violence of the civil war? What conception of time, evidence, testimony, history, and writing do we invoke?
>
> (Raad, ZKM (Centre for Art & Media, Karlsruhe) *The Rhetoric of Surveillance* (2002): http://ctrlspace.zkm.de/e/)

Concluding remarks

> Images haunt language like a shadow, they line language and give it
> substance, and in some cases, they bring about the expansion of language.
>
> (Takuma [1970] 2010: 5)

I have aimed to promote uses of photography as contributing another way of
'thinking' about the city and urbanism. I suggest that photographs, and
photographic series in particular, say as much about what we imagine cities
to be or what we consider to be important about cities, as literature or theory
do. Thomas Annan demonstrated the appalling living conditions in Glasgow
in the nineteenth century as necessitating some action, and in the twenty-first
century Guy Tillim presents the ironic fact that, post-apartheid in the face of
the unstoppable march of urbanization, the detail of government policy
requires some reconsideration. Konrad's simultaneous presentation of global
uniformity and local diversity focuses attention on the recognition that local
needs and desires have to be addressed in the face of global forces.

Photography emphasizes what is valued and what is neglected in society. It
tells stories in a very direct and sometimes visceral way. My approach to
commentary in the main has been one of a rational response to the content of
photographs. As we cannot be confronted with the physical and material impact
of photographs within the pages of a book, I have not given attention to the
undoubted difference that size, colour and luminosity can make to the
subsequent emotional immediacy of photography. Andreas Gursky's presenta-
tion of the *Hong Kong Shanghai Bank* (1994) is a thing of wonder: all those
people going about their business, looking very much the same, yet each with
their own trivial or tragic concerns, and each contributing to a market economy
that affects us all. Besides the implications of its conceptual content, we are
simultaneously visually assaulted by the photograph's powerful presence that
is also abstract and beautiful. In contrast, the horror of David Goldblatt's *Cosmo
City* (2009) assaults us with the impersonal uniformity of newly built dwelling
shells laid out in grid formation, stretching across and beyond the frame of
an immaculately constructed photograph. We are doubly horrified when we
see an alternative vision in the photograph that is hung alongside it (*The
Women's Hostel, Alexandra, Johannesburg*, 2009). This photograph graphic-
ally contrasts the prison-like structure of the hostel with details of the informal
settlement that surrounds it: the running water through the mud 'streets', the
precariously constructed dwellings and the portaloos placed strategically
(and cynically) here and there. And in contrast again, the awakening of a
fascination, or a different sort of horror, which marvels at Cao Fei's *RMB City*,

in which two formulaic heroic protagonists (Masala and Nemeth) engage in armed pursuit, fantasy love trysts and flight over futuristic cityscapes. This ambivalent portrayal, projecting either our ultimate desires or our worst fears, is echoed by Masala's declaration 'I don't know where I am.'

A central theme of this book has been the individual's encounter with the enormity of the city. The photograph shows us how the very minutest action – what we eat, how we appropriate space, how we engage with technology – must have some impact on the unseen forces that organize the city. The photograph has the potential to demonstrate instantly, and more efficiently than a thousand words, condition, desire, celebration and curiosity. It can suggest alternative ways of living by example. The photograph hovers somewhere between accountable facts and hidden fictions, but it always parallels some aspect of living, some social phenomenon, some attitude or political irony. In simple terms, photography offers another way of describing the fabric and conception of cities and the fact of their habitation. I have discussed the difficulty in 'picturing' living in the megalopolis, of which we still hold idealized visions, modelled on historical city centres such as Paris or New York. Contemporary photography of the city has moved from the centre, beyond the panorama that gives us comfortable access, and presents more challenging conceptualizations that endeavour to describe a condition or a process such as the re-appropriation of space, or the tensions that inhabit a space.

As I contend that the photograph is a useful tool and possibly underused, I have attempted to demonstrate its potential rather than reiterated a history of its testament to a city's fabric. I have given examples of photography's ironic play (López), its immersive possibilities (Konrad) and its imaginative use (Mlangeni) that give an added dimension to facts. I have not dwelt on aesthetic formalism, but the power of the visually poetic as a method for provoking discussion. And, fascinated with the tension between the politics and aesthetics that photography always invokes, I have fore-fronted its use for political purpose, either by demonstration (Annan) or more subtly by devious means (Raad).

Further reading

Atkins, M. and Sinclair, I. (1999) *Liquid City*, Reaktion Books: London.

Buchanan, I. (2005) 'Space in the Age of Non-Place', in Buchanan, I. and Lambert, G. (eds) *Deleuze and Space*, Edinburgh University Press: Edinburgh, pp. 16–35.

Ferguson, F. (2006) *Talking Cities: The Micropolitics of Urban Space*, Birkhauser: Basel, Boston, Berlin.

Latour, B. and Weibel, P. (eds) (2005) *Making Things Public: Atmospheres of Democracy*, MIT Press: Cambridge, MA, London.

Paglen, T. (2008) 'Experimental Geography: from Cultural Production to the Production of Space', in Thompson, N., *Experimental Geography: Radical Approaches to Landscape, Cartography and Urbanism*, Independent Curators International: New York. See also: http://www.paglen.com/.

Rosler, M. (1998) *In the Place of the Public: Observations of a Frequent Flyer*, Cantz: Ostfildern.

Sadler, S. (1999) *The Situationist City*, MIT Press: Cambridge, MA.

These suggestions extend many of the themes introduced in this book, particularly with regard to alternative ways of thinking about cities. Buchanan (2005) contemplates a 'new type of space' post-postmodernity and Deleuze and Guattari, and extends some aspects of discussion introduced, such as orientalism, deterritorialization and non-place. Sadler (1999) is an accessible and illustrated survey of the Situationist International's thinking, and Atkins and Sinclair (1999) present a more contemporary psycho-geographic exploration of London using essays, poems and photographs. Described as an artist-geographer, Paglen's work offers an interdisciplinary and provocative engagement with geography and global politics in the context of a number of works by artists, collectives and geographers. Ferguson (2006) results from a trans-disciplinary exhibition characterizing the impact of Deleuzian thinking on urban design. Reflecting the fragmented condition of living in cities, it presents a collage of statements, design and photographs and aims to shift our perceptions of contemporary city spaces. Rosler (1998) and Latour and Weibel (2005) are examples of ambitious projects that investigate concepts, rather than objects or places, and which both utilize the photograph to productive effect.

Further photographic projects

Arab Image Foundation: www.fai.org.lb/.

Taysir Batniju (Gaza, Palestine 1966) – *GH0809* (2011) is a photographic series of destroyed houses in Gaza presented as a real estate window. The description states 'Al-Quirim Area, east of Jabaly, Al-Salam Street, Area: 200m. Building on stilts (Mezallah), open ground floor . . . inhabitants 40 people . . .': http://taysir.b.free.fr/; http://fashionandartmiddleeast.com/2011/06/18/palestinian-artist-taysir-batniji-venice-biennale-2011/.

Broken City Lab – 'Things worth saving': http://www.brokencitylab.org/blog/things-worth-saving-recap/.

Chicago UrbanLab – a research-based architecture and urban design practice: http://www.urbanlab.com/.

Sophie Calle (France 1953) – Calle's series *The Hotel Room* (1981) and *Gotham Handbook* (1998) (in which fact is indistinguishable from fiction as she followed

instructions given to her by the writer Paul Auster for 'How to Improve Life in New York City') are typical of her diaristic approach to recording the conceptual and psychological dimensions of living. Some projects such as *Gotham Handbook* mix fact and fiction. Publication blurb states: 'Taking on multiple roles – detective, documentarian, behavioral scientist and diarist – Calle turns the interplay between life and art on its head.' Bois, Y., Macel, C. and Rolin, O. (2004) *Sophie Calle: Did You See Me?*, Prestel Publishing: London: http://www.galerieperrotin.com/artiste-Sophie_Calle-1.html#.

Crispin Hughes, *Unquiet Thames* series (2006): http://www.crispinhughes.co.uk/index.html.

The Invisible City exhibition: http://www.pixelache.ac/helsinki/festival-2010/programme/the-invisible-city/the-invisible-city-exhibition/.

Rut Lees Luxemburg (Germany 1967) – explores the public spaces of cities and the way that space has become an ideological manifestation of power and control. Bracewell, M. and Luxemburg, R. (2001) *London: A Modern Project*, Black Dog Publishing; Heidelberg; Liebscher, M. and Luxemburg, R. (2000) *Visurbia*, Verlag Das Wunderhorn: http://updates.rutbleesluxemburg.com/; http://www.martinliebscher.com/.

Aglaia Konrad (Salzburg 1960) – see also Franzen, B. and Glendinning, M. (2008) *Aglaia Konrad: Desert Cities*, JRP Ringier: Zurich. Konrad's photographs taken from the air, show the ever-increasing and unregulated expansion into the desert around Cairo of uniform developments that threaten the preservation of archaeological sites.

Susan Meiselas (America 1948) – best known for her documentation of the insurrection in Nicaragua (1978–79) and human rights in Latin America. She is recognized for her participation in the questions of ethics raised by documentary practice. More recently her interactive website is described as a borderless space that builds a collective memory with a people who have no national archive: http://www.akaKURDISTAN.com/. Lubben, K. and Meiselas, S. (2008) *Susan Meiselas: In History*, Steidl/ICP: New York; Meiselas, S. (2008) *Nicaragua*, Aperture/ICP: New York: http://www.susanmeiselas.com/ and http://www.magnumphotos.com/.

Mabel Palacin (Barcelona 1964) – *180°* (2011) presents one panoramic photograph of the Zarttere, Venice simultaneously with a slide show of close-ups of gestures, fragments and detailed extensions originating from that one moment in the street: http://www.false-emotion.de/mabel.htm; http://www.youtube.com/watch?v=Mv14uvQio7w.

Walid Raad (Lebanon 1967) – *Home Works III, Beirut* (2005): http://www.youtube.com/watch?v=caOO-b6uQ-s; http://www.theatlasgroup.org/. Gilbert, A. (2002) 'Walid Ra'ad', *BOMB* 81, Fall: http://bombsite.com/issues/81/articles/2504; Raad, W. (2011) *Miraculous Beginnings*, Whitechapel Galleries Ventures, London.

Martha Rosler (America); Rosler, M. (1998) *In the Place of the Public: Observations of a Frequent Flyer*, Cantz: Ostfildern; http://courses.washington.edu/hypertxt/cgi-bin/book/wordsinimages/mrairport/roslerview.html; http://www.MarthaRosler.net/.

Stephen Shore (America 1947) – Shore, S. (2008) *American Surfaces*, Phaidon: London, New York; Shore, S. (1982) *Uncommon Places*, Aperture: New York: http://www.303gallery.com/artists/stephen_shore/. Interview with Jean Wainwright: http://www.theartnewspaper.tv/content.php?vid=544.

Michael Weseley (Germany 1963) – *Open Shutter Project*, The Museum of Modern Art (2004). Weseley's photographs can sometimes result from exposures lasting up to two years, for example, *Potsdamerplatz*, Berlin documented the construction being done at Potsdamer Platz in Berlin between 1997 and 1999: http://www.wesely.org/wesely/gruppe.php?var=potsdamerplatz.

Notes

1 Deleuze and Guattari also offer a representation of thinking that defies linear chronology. We are invited to read the chapters in *A Thousand Plateaus* in any order; it is an assemblage.
2 The Mass Observation archive is available online: http://www.massobs.org.uk/index.htm.
3 See examples of contemporary psycho-geographies: Detroit Unreal Estate Agency: http://detroitunrealestateagency.blogspot.com/; Networked Cultures: http://www.networkedcultures.org/; Urban-think tank describes Informal Urbanism: http://www.u-tt.com/projectsMenu_All.html. Accessed 10 June 2011.
Sophie Calle's *Suite Venetienne* (1980) is a more conceptually driven pursuit that references surveillance and Rumney's psycho-geography. Purposeful in her pursuit of a stranger to Venice, it is uncompromisingly indifferent to the fabric of the city photographed.
4 http://stephenwillats.com/work/brentford-towers/; http://stephenwillats.com/; http://www.controlmagazine.org/play.php.
5 See Andreas Gursky, *Hong Kong Shanghai Bank* (1994) or *99 Cent* (1999) or *Chicago Board of Trade II* (1999).
6 http://courses.washington.edu/hypertxt/cgi-bin/book/wordsinimages/mrairport/roslerview.html.
7 Bernd Becher (Germany 1931–2007) and Hilla Becher (1934) are known for their photographic typologies of industrial buildings: http://www.moma.org/visit/calendar/exhibitions/95.
8 Valérie Jouve (France 1964): http://www.valeriejouve.com/#.

Selected bibliography

Aperture Foundation (2010) Zwelethu Mthethwa and Okwui Enwezor: http://vimeo.com/10913725.

Arts Council of Great Britain (1981) *The British Worker: Photographs of Working Life 1839–1939*, Exhibition catalogue. Arts Council: London.

Atkins, M. and Sinclair, I. (1999) *Liquid City*, Reaktion Books: London.

Auzins, V. (2003) 'Diving in Reality', *Imago* 16, Summer: 30–1.

Bachelard, G. (1994) *The Poetics of Space: The Classic Look at How We Experience Places* [1958], Beacon Press: Boston.

Bal, M. (1998) 'Seeing Signs', in Cheetham, M., Holly, M. and Moxey, K., *The Subjects of Art History: Historical Objects in Contemporary Perspectives*, Cambridge University Press: Cambridge.

—— (2001) *Looking In, the Art of Viewing*, G+B Arts International: Amsterdam.

—— (2002) *Travelling Concepts in the Humanities*, University of Toronto Press: Toronto, Buffalo, London.

Barthes, R. (1967) *Elements of Semiology* [1964], Jonathan Cape: London.

—— (1977) *Image: Music: Text*, Fontana Press: London.

—— (1993a) 'The Great Family of Man' [1957], in *Mythologies*, Vintage: London, pp. 100–2.

—— (1993b) *Camera Lucida* [1980], trans. R. Howard, Vintage: London.

Batchen, G. (1999) 'Spectres of Cyberspace' [1995], in Mirzoeff, N. (ed.), *The Visual Culture Reader*, Routledge: London, New York.

Bate, D. (2006) 'Kinship with Dream', *Source* 46, Belfast.

—— (2009) *Photography: The Key Concepts*, Berg: Oxford, New York.

Baudelaire, C. (1964) *The Painter of Modern Life and Other Essays*, trans. Jonathan Mayne, Phaidon Press: London.

Baudrillard, J. (1983) *Simulations*, trans. P. Foss, P. Patton *et al.*, Semiotext[e]: New York.

—— (1995) *America* [1986], trans. Chris Turner, Verso: London, New York.

—— (1996) *Cool Memories II, 1987–1990* [1990], trans. Chris Turner, Duke University Press: Durham.

—— (1999a) *The System of Objects* [1968], trans. James Benedict, Verso: London, New York.

—— (1999b) 'Poetic Transference of Situation', in Delahaye, L., *L' Autre*, Phaidon: London.

—— (2003) *Passwords*, Verso: London, New York.

Baxandall, M. (1985) *Patterns of Intention: On the Historical Explanation of Pictures*, Yale University Press: New Haven, CT, London.

Benjamin, W. (1980) 'A Short History of Photography' [1931], in Trachtenberg, A. (ed.), *Classic Essays on Photography*, Leete's Island Books: New Haven.

—— (1999) 'On Some Motifs on Baudelaire' [1939], in *Illuminations*, Pimlico: London.

—— (2002) *The Arcades Project* [1927–40], trans. Howard Eiland and Kevin McLaughlin, Belknap Press of Harvard University Press: Cambridge, MA, London.

—— (2005) 'The Work of Art in the Age of Mechanical Reproduction' [1936], in Harrison, C. and Wood, P. (eds), *Art in Theory 1900–2000: An Anthology of Changing Ideas*, Blackwell: Oxford, pp. 520–7.

Berger, J. and Mohr, J. (1995) *Another Way of Telling* [1982], Vintage Books: New York.

Bhabha, H.K. (1994) *The Location of Culture*, Routledge: London, New York.

Bieber, J. (2007) 'Jodi Bieber', *Camera Austria* 100: 56–63.

Biemann, U. and Holmes, B. (2006) *The Maghreb Connection: Movements of Life Across North Africa*, Actar: Barcelona.

Bois, Y. and Krauss, R. (1997) *Formless: A User's Guide*, Zone Books: New York.

Bourdieu P. (1990) *Photography: A Middlebrow Art* [1965], Polity Press: Cambridge.

—— (1999) 'The Social Definition of Photography' [1965], in Evans, J. and Hall, S., *Visual Culture: The Reader*, Sage Publications, The Open University: London, Thousand Oaks, New Delhi.

—— (2010) *The Logic of Practice* [1980], trans. Richard Nice, Polity Press: Cambridge, Malden, MA.

Braidotti, R. (1994) *Nomadic Subjects: Embodiment and Sexual Difference in Contemporary Feminist Theory*, Columbia University Press: New York.

Breman, J. and Agarwal, R. (2002) 'Down and Out: Labouring under Global Capitalism', *Critical Asian Studies* 34: 1, 116–28: http://dx.doi.org/10.1080/146727102760166626.

Breton, A. (1969) *Manisfestoes of Surrealism*, trans. H.R. Lane and R. Seaver, University of Michigan Press: Ann Arbor.

—— (1994) *Nadja* [1928], trans. Richard Howard, Grove Press: New York.

—— (2003) *Selections*, ed. Mark Polizzotti, University of California Press: Berkeley, Los Angeles, London.

—— (2005) 'First Manifesto of Surrealism' [1924], in Harrison, C. and Wood, P. (eds), *Art in Theory 1900–1990: An Anthology of Changing Ideas*, Blackwell: Oxford, pp. 447–53, also available at: http://www.poetryintranslation.com/PITBR/French/Manifesto.htm.

Buchanan, I. and Lambert, G. (eds) (2005) *Deleuze and Space*, Edinburgh University Press: Edinburgh.

Burgin, V. (ed.) (1982) *Thinking Photography*, Macmillan Press: London.

—— (1995) 'Chance Encounters: *Flâneur* and *Détraquée* in Breton's *Nadja*', in Stephen Melville and William Readings (eds), *Vision and Textuality*, Macmillan: London.

—— (1996) *Some Cities*, Reaktion Books: London.

Butler, J. (1990) *Gender Trouble: Feminism and the Subversion of Identity*, Routledge: New York, London.

—— (1993) *Bodies that Matter: On the Discursive Limits of 'Sex'*, Routledge: New York.

—— (1997) 'Performative Acts & Gender Constitution: An Essay in Phenomenology & Feminist Theory', in Conboy, K., Medina, N. and Stanbury, S. (eds), *Writing on the Body*, Columbia University Press: New York.

Calvino, I. (2009) *Invisible Cities*, trans. William Weaver, Vintage Classics: London.

Campbell, R. (1979) 'America: The (Workers') Film and Photo League', in Dennett, T. and Spence, J. (eds), *Photography/Politics: One,* Photography Workshop: London.

Cartier-Bresson, H. (1981) 'The Decisive Moment' [1952], in Goldberg, V. (ed.), *Photography in Print, Writings from 1876 to the Present*, Simon & Schuster: New York.

Castells, M. (1977) *The Urban Question: A Marxist Approach*, London: Arnold.

Castells, M. (1996) 'The Reconstruction of Social Meaning in the Space of Flows', from 'The Informational City' [1989], in Gates, R.T. and Stout, F. (eds), *The City Reader*, Routledge: London, New York, pp. 493–8.

—— (2004) 'Space of Flows, Space of Places: Materials for a Theory of Urbanism in the information Age', in Graham, S. (ed.), *The Cybercities Reader*, pp. 82–93.

Davis, B. (2007) 'Globalized Feminism', *Artnet Magazine*: http://www.artnet.com/magazineus/reviews/davis/davis7–19–07.asp.

Davis, M. (2000) *Magical Urbanism*, Verso: London, New York.

—— (2002) *Dead Cities and Other Tales*, The New Press: New York.

—— (2006) *City of Quartz: Excavating the Future in Los Angeles* [1990], Verso: London, New York.

Dear, M.J. (2000) *The Postmodern Urban Condition*, Blackwell Publishers: Oxford.

Debord, G. (1992) *Society of the Spectacle* [1967], trans. Ken Knab, Rebel Press: London.

de Certeau, M. (1988) *The Practice of Everyday Life* [1980], trans. S. Randall, University of California Press: Berkeley, Los Angeles, London.

Delahaye, L. (1999) *L'Autre*, Phaidon: London.

Deleuze, G. and Guattari, F. (1994) *What is Philosophy?* [1991], trans. G. Burchill and H. Tomlinson, Verso: London, New York.

—— (2007) *A Thousand Plateaus: Capitalism and Schizophrenia* [1980], trans. B. Massumi, Continuum: London, New York.

Demos, T.J. (ed.) (2006) *Vitamin Ph: New Perspectives in Photography*, Phaidon: London.

Dennett, T. (1979) 'England: The (Workers') Film and Photo League', in Dennett, T. and Spence, J. (eds), *Photography/Politics: One*, Photography Workshop: London.

Dennett, T. and Spence, J. (eds) (1979) *Photography/Politics: One*, Photography Workshop: London.

Deutsche, R. (1991) 'Alternative Space', in Wallis, B. (ed.), *If You Lived Here: The City in Art, Theory, and Social Activism*, Bay Press: Seattle.

—— (2000) 'Alternative Space' [1991], in Miles, M., Hall, T. and Borden, I. (eds), *The City Cultures Reader*, Routledge: London, New York; in Wallis, B. (ed.), *If You Lived Here: The City in Art, Theory, and Social Activism*, Bay Press: Seattle.

Dewsbury, J.D. and Thrift, N. (2005) 'Genesis Eternal': After Paul Klee, in Buchanan, I. and Lambert, G. (eds), *Deleuze and Space*, Edinburgh University Press: Edinburgh, pp. 89–108.

Donald, J. (1999) *Imagining the Modern City*, University of Minnesota Press: Minneapolis.

Doy, G. (1979) 'The Camera Against the Paris Commune', in Dennett, T. and Spence, J. (eds), *Photography/Politics: One*, Photography Workshop: London.

Eco, U. (1982) 'Critique of the Image' [1970], in Burgin, V. (ed.), *Thinking Photography*, Macmillan Press: London, pp. 32–8.

—— (1986) *Travels in Hyperreality*, trans. William Weaver, Picador: London.

Edwards, E. (2001) *Raw Histories: Photographs, Anthropology and Museums*, Berg: Oxford, New York.

Edwards, S. (2006) *Photography: A Very Short Introduction*, Oxford University Press: Oxford.

Elkins, J. (2007) *Photography Theory*, Routledge: London.

Engels, F. (1968) *The Condition of the Working Class in England in 1844* [1845], George Allen and Unwin: London.

Englander, D. (1981) 'Working Life in Britain 1839–1939', in Arts Council of Great Britain, *The British Worker: Photographs of Working Life 1839–1938*, Exhibition catalogue, Arts Council: London, unpaginated.

Enwezor, O. (2007) 'The Indeterminate Structure of Things Now: Notes on Contemporary South African Photography', *Bedeutung Magazine, Issue 1/Nature & Culture*: http://www.bedeutung.co.uk/.

—— (2008a) 'Specious Modernity: Speculations on the End of Postcolonial Utopia', Lecture, Tate Britain, 24 April 2008: http://channel.tate.org.uk/media/310677 49001.

—— (2008b) 'On Snap Judgments, Contemporary African Photography', interview with Arne Doornebal, *Power of Culture*: http://www.powerofculture.nl/en/current/2008/july/snapjudgments.

Evans, J. and Hall, S. (eds) (1999) *Visual Culture: The Reader*, Sage Publications: London, Thousand Oaks, New Delhi.

Evans, W. (1994) 'Lyric Documentary', transcript of lecture delivered at Yale University Art Gallery, New Haven, 11 March 1964, in *Walker Evans Archive*, Metropolitan Museum of Art: New York.

Ferguson, F. (2006) *Talking Cities: The Micropolitics of Urban Space*, Birkhäuser: Basel, Boston, Berlin.

Fini, C. and Maggia, F. (eds) (2010) *Contemporary Photography from Eastern Europe: History Memory Identity*, Skira Editore: Milan.

Foster, H. (ed.) (1985) *Postmodern Culture* [1983], Pluto Press: London.

Foucault, M. (1977) *Discipline and Punish* [1975], trans. Alan Sheridan, Penguin Books: London.

—— (1982) 'The Subject and Power', *Critical Inquiry* 8, Summer: 777–95.

—— (1984) 'Of Other Spaces' [1967], published in *Architecture/Mouvement/ Continuité*, October: http://foucault.info/documents/heteroTopia/foucault.hetero Topia.en.html.

—— (1998) 'What is an Author?' [1969], in Preziosi, D. (ed.), *The Art of Art History; A Critical Anthology*, Oxford University Press: Oxford, pp. 299–314.

—— (2003) *The Order of Things* [1966], Routledge: London, New York.

Fox Talbot, W.H. (1980) 'A Brief Historical Sketch of the Invention of the Art' [1834], in Trachtenberg, A. (ed.), *Classic Essays on Photography*, Leete's Island Books: New Haven, CT, pp. 27–36.

Frank, R. (1998) *The Americans* [1958], Scalo: Zurich.

Franzen, B. and Glendinning, M. (2008) *Aglaia Konrad: Desert Cities*, JRP Ringier: Zurich.

Freud, S. (2002) *The Psychopathology of Everyday Life* [1901], trans. A. Bell, Penguin Books: London.

Frichot, H. (2005) 'Stealing into Gilles Deleuze's Baroque House', in Buchanan, I. and Lambert, G. (eds), *Deleuze and Space*, Edinburgh University Press: Edinburgh.

Friday, J. (2002) *Aesthetics and Photography*, Ashgate: Aldershot.

Fried, M. (2008) *Why Photography Matters as Art as Never Before*, Yale University Press: New Haven, CT, London.

Furuya, S. (2000) *Portrait*, Fotohof Edition: Salzburg.

Gau, S. (2004) 'Aglaia Konrad: Floating Images', *Camera Austria* 87: 7–18.

Gilbert, A. (2002) 'Walid Ra'ad', *BOMB* 81, Fall: http://bombsite.com/issues/81/ articles/2504.

Goldblatt, D. and Vladislavic, I. (2010) *TJ: Johannesburg Photographs 1948–2010 Double Negative*, Contrasto: Rome.

Graham, S. (ed.) (2004) *The Cybercities Reader*, Routledge: London, New York.

Gregory, C. (2004) 'Stranded Economies', in Kellner, D. and Homer, S. (eds), *Fredric Jameson: A Critical Reader*, Palgrave Macmillan: Basingstoke.

Grosz, E. (1995) *Space, Time and Perversion*, Routledge: London.

Habermas, J. (1985) 'Modernity – An Incomplete Project' [1981], in Foster, H. (ed.), *Postmodern Culture* [1983], Pluto Press: London.

Haraway, D.J. (1991) *Simians, Cyborgs, and Women: The Reinvention of Nature*, Free Association Books: London.

Harvey, D. (1975) *Social Justice and the City* [1973], Edward Arnold: London.

—— (1990) *The Condition of Postmodernity: An Enquiry into the Origins of Cultural Change*, Blackwell: Cambridge, MA, London.

—— (2003) *Paris, Capital of Modernity*, Routledge: New York, London.

—— (2006) *Spaces of Global Capitalism*, Verso: London, New York.

Hayes, P. (2007) 'Visual Emergency? Fusion and Fragmentation in South African Photography of the 1980s', *Camera Austria* 100: 18–22.

Hayles, N.K. (1995) *Engineering Cyborg Ideology*: http://www.altx.com/ebr/ebr1/hayles.htm.

Heron, L. (1979) 'Hackney Flashers Collective: Who's Still Holding the Camera?', in Dennett, T. and Spence, J. (eds), *Photography/Politics: One*, Photography Workshop: London.

Highmore, B. (2002) *Everyday Life and Cultural Theory: An Introduction*, Routledge: London, New York.

Holland, P., Spence, J. and Watney, S. (eds) (1986) *Photography/Politics: Two*, Photography Workshop, Comedia: London.

Homma, T. (2008) *Tokyo*, Aperture Foundation: New York.

Hooks, B. (2009) *Belonging: A Culture of Place*, Routledge: London, New York.

Hooper, B. (2000) 'Bodies, Cities, Texts: The Case of Rodney King', in Soja, E., *Postmetropolis: Critical Studies of Cities and Regions*, Blackwell: Malden, Oxford, Carlton, pp. 359–69.

Hornsby, A. and Mars, N. (eds) (2008) *The Chinese Dream: A Society under Construction*, Dynamic City Foundation; 010 Publishers: Rotterdam.

Howarth, S. and McLaren, S. (eds) (2010) *Street Photography Now*, Thames & Hudson: London.

Hubbard, P. (2006) *City*, Routledge: London, New York.

Huggan, G. (2003) 'Decolonizing the Map' [1989], in Ashcroft, B., Griffiths, G. and Tiffin, H. (eds), *The Post-colonial Studies Reader*, Routledge: London, New York.

Hughes, A. and Noble, A. (2003) *Phototextualities: Intersections of Photography and Narrative*, University of New Mexico Press: Albuquerque, NM.

Hung, W. and Phillips, C. (2004) *Between Past and Future: New Photography and Video from China*, Smart Museum: Chicago; International Center of Photography: New York.

Hutcheon, L. (2003) *The Politics of Postmodernism* [1989], Routledge: London, New York.

Inkster, D. (2002) *Valérie Jouve*, Hazan: Paris.

Ippolito, J.M. (2009) 'Words, Images and Avatars: Explorations of Physical Place and Virtual Space by Japanese Electronic Media Artists', *Leonardo* 42 (5), October: 421–6.

Ito, T. (2003) 'The Topology, the Edges and the Islands of Contemporary Japanese Photography', *Camera Austria* 84: 9–12.

Jameson, F. (1984) *Forward* [1982], in Lyotard, J.F., *The Postmodern Condition: A Report on Knowledge* [1979], trans. G. Bennington and B. Massumi, University of Minnesota Press: Minneapolis.

—— (1985) 'Postmodernism and Consumer Society' [1982], in Foster, H. (ed.) *Postmodern Culture* [1983], Pluto Press: London.

—— (2009) *Postmodernism, or The Cultural Logic of Late Capitalism* [1991], Verso: London, New York.

Jouve, V. (1998) *Valérie Jouve*, Centre National de la Photographie: Paris.

Katz, L. (1981) 'Interview with Walker Evans' [1971], in Goldberg, V. (ed.), *Photography in Print, Writings from 1876 to the Present*, Simon & Schuster: New York, pp. 358–69.

Kee, J. (2004) 'Trouble in New Utopia', *Positions: East Asia Cultures Critique* 12 (3), Winter: 667–86.

Keiller, P. (2003) 'The Poetic Experience of Townscape and Landscape and Some Ways of Depicting it', in Danino, P. and Maziere, M. (eds), *The Undercut Reader*, Wallflower Press: London, New York, pp. 75–83.

Kollar, M. (2002) *Slovakia*, in *Imago* 13, Winter: 26–33.

Konrad, A. (2005) *Iconocity*, Verlagder Buchhandlung Walther König: Köln.

Körner, W. and J. Stüber (1979) 'Germany: Arbeiter-Fotografie', trans. David Evans/Sylvia Gohl, in Dennett, T. and Spence, J. (eds), *Photography/Politics: One*, Photography Workshop: London.

Krauss, R. (1985) *L'Amour Fou, Photography and Surrealism*, Abbeyville Press: New York, London; The Corcoran Gallery of Art: Washington, DC.

Kristeva, J. (1984) *Revolution in Poetic Language* [1974], Columbia University Press: New York.

Kuraishi, S. (2003) 'Unknown Rules: Notes on Takuma Nakahira's Experiments in the Early Seventies', *Camera Austria* 84: 36–40.

La Grange, A. (2005) *Basic Critical Theory for Photographers*, Focal Press: Amsterdam, Oxford.

Latour, B. and Weibel, P. (eds) (2005) *Making Things Public: Atmospheres of Democracy*, MIT Press: Cambridge, MA, London.

Lefebvre, H. (1991) *The Production of Space* [1974], trans Donald Nicholson-Smith, Blackwell: Oxford, Cambridge, MA.

—— (2003) *The Urban Revolution* [1970], trans. Robert Bononno, University of Minnesota Press: Minneapolis, London.

—— (2008a) *Critique of Everyday Life, Volume 1* [1947], Verso: London, New York.

—— (2008b) *Critique of Everyday Life, Volume 2* [1961], Verso: London, New York.

—— (2008c) *Critique of Everyday Life, Volume 3* [1981], Verso: London, New York.

Leong. S. (2006) Interview with Josh Jones, *Guernica: a magazine of art & politics*: http://www.guernicamag.com/interviews/265/unintelligent_design_1/.

Levi-Strauss, D. (2003) *Between the Eyes, Essays on Photography and Politics*, Aperture: New York.

Lewis, P. (2006) 'The Evacuated Field', in Ferguson, F., *Talking Cities: The Micropolitics of Urban Space*, Birkhäuser: Basel, Boston, Berlin, pp. 27–30.

Liddell, C.B. (2006) 'Intimate Photography: Tokyo, Nostalgia and Sex', Interview with Nobuyoshi Araki, *The Japan Times*, 23 November: http://search.japantimes. co.jp/cgi-bin/fa20061123a1.html.

López, M. (2011) Interview with Josefina Licitra, trans. Ted O'Callahan, *Nuestra Mirada Revista*: http://revistanuestramirada.org/en/galleries/marcos-lopez-pop-latino. Accessed 2 May 2011.

Lynch, K. (1996) 'The City Image and its Elements', from *The Image of the City* [1960], in Gates, R.T. and Stout, F. (eds), *The City Reader*, Routledge: London, New York, pp. 98–102.

Lyotard, J.F. (1984) *The Postmodern Condition: A Report on Knowledge* [1979], trans. G. Bennington and B. Massumi, University of Minnesota Press: Minneapolis.

Mack, M. (2003) *Paul Graham: American Night*, Steidl Verlag: Gottingen.

Marcus, A. and Neumann, Dietrich (eds) (2007) *Visualising the City*, Routledge: London, New York.

Marx, K. (1990) *Capital Volume 1* [1867], Penguin: London.

McDonough, T. (2009*) The Situationists and the City*, Verso: London.

McDowell, L. (ed.) (1997) *Undoing Place? A geographical reader*, Arnold: London.

—— (1999) *Gender, Identity and Place: Understanding Feminist Geographies*, Polity Press: Cambridge.

Mdand, S. (2007) 'Sabelo Mlangeni at Warren Siebrits Modern and Contemporary Gallery', *Artthrob* 123, November: http://www.artthrob.co.za/07nov/reviews/wsmca2.html.

Mellor, D.A. (2007) *No Such Thing as Society: Photography in Britain 1967–1987*, Hayward Publishing: London.

Melville, S. and Readings, B. (1995) *Vision & Textuality*, Macmillan Press: Basingstoke, London.

Meskimmon, M. (1997) *Engendering the City: Women Artists and Urban Space*, Scarlet Press: London.

Miles, M., Hall, T. and Borden, I. (eds) (2000) *The City Cultures Reader*, Routledge: London, New York.

Mirzoeff, N. (ed.) (1999) *The Visual Culture Reader*, Routledge: London, New York.

Mitchell, W.J.T. (1987) *Iconology: Image, Text, Ideology*, University of Chicago Press: Chicago, London.

—— (1995) *Picture Theory*, University of Chicago Press: Chicago, London.

Moholy-Nagy, L. (1989) 'Unprecedented Photography' [1927], in Phillips, C. (ed.) *Photography in the Modern Era, European Documents and Critical Writings, 1913–1940,* The Metropolitan Museum of Art: New York.

MOMA (2001) *Open City: Street Photographers since 1950*, Museum of Modern Art: Oxford; Hatje Cantz Verlag, Ostfildern-Ruit.

Moorhouse, P. (2004) 'The Computerised Local Image Collection at Manchester Archives and Local Studies', *Manchester Region History Review*, 17: 62–9: http://www.mcrh.mmu.ac.uk/pubs/pdf/mrhr_17i_archives_moorhouse.pdf.

Mori, M. Interview with Kunie Sugiura, *Journal of Contemporary Art*: http://www.jca-online.com/mori.html.

Moriyama, D. (2004) *Memories of a Dog*, Nazraeli Press: Berlin.

Mulhearn, K. (2006) 'Guy Tillim', in Enwezor, O., *Snap Judgments: New Positions in Contemporary African Photography*, Steidl: Göttingen; ICP: New York: ICP: http://fansinaflashbulb.wordpress.com/2010/04/16/guy-tillims-joburg/.

Naef, W. (1995) *The J. Paul Getty Museum Handbook of the Photographs Collection*, Christopher Hudson: Santa Monica.

Newbury, D. (2009) *Defiant Images: Photography and Apartheid South Africa*, Unisa Press: Pretoria.

Newhall, Beaumont (1949) *History of Photography: From 1839 to the Present*, Museum of Modern Art: New York.

Ninagawa, M. (2002) *A Piece of Heaven*, Editions Treville: Tokyo.

Olalquiaga, C. (1992) *Megalopolis: Contemporary Cultural Sensibilities*, University of Minnesota Press: Minneapolis, Oxford.

Paetzold, H. (2000) 'The Philosophical Notion of the City' [1997], in Miles, M., Hall, T. and Borden, I. (eds), *The City Cultures Reader*, Routledge: London, New York.

Paglen, T. (2008) in 'Experimental Geography: from Cultural Production to the Production of Space', in Thompson, N., *Experimental Geography: Radical Approaches to Landscape, Cartography and Urbanism*, Independent Curators International: New York.

Pan Wei (2008) 'Utopian Cities', in Hornsby, A. and Mars, N. (eds), *The Chinese Dream: A Society under Construction*, Dynamic City Foundation; OIO Publishers: Rotterdam.

Parr, A. (ed.) (2005) *The Deleuze Dictionary*, Columbia University Press: New York.

Phaidon editors (2002) *Blink*, Phaidon: London.

Phillips, C. (1989) *Photography in the Modern Era: European Documents and Critical Writings, 1913–1940*, The Metropolitan Museum of Art, Aperture: New York.

Pinder, D. (2005) *Visions of the City*, Edinburgh University Press: Edinburgh.

Pink, S. (2007) *Visual Interventions: Applied Visual Anthropology*, Berghahn Books: New York, Oxford.

Plato, (2003) *The Republic*, Penguin Books: London.

Poivert, M. (1998) *Valérie Jouve*, Centre Nationale de la Photographie: Paris.

Pospech, T. (2003) 'Socialist Realism in Czech Photography', *Imago* 15: 9–15.

Raad, W. (2005) Home Works III, Beirut: http://www.youtube.com/watch?v=caOO-b6uQ-s.

—— (2010) 'Sweet Talk: Commissions (Beirut)', *Camera Austria* 111, September.

—— (2011) *Miraculous Beginnings*, Whitechapel Galleries Ventures: London.

Ractliffe, J., McKenzie, P. and O'Toole, S. (2007) 'Pre-Post: A Trajectory in South African Photography. A Conversation', *Camera Austria* 100: 130–5.

Ranciere, J. (2010) *Dissensus: On Politics and Aesthetics*, Continuum: London, New York.

Rhee, J. (2004) 'From Goddess to Cyborg: Mariko Mori and Lee Bull', *n. paradoxa: international feminist art journal* 14 (Dreams of the Future): 5–12.

Roberts, J. (1998) *The Art of Interruption, Realism, Photography and the Everyday*, Manchester University Press: Manchester and New York.

Robinson, H.P. (1980) 'Idealism, Realism, Expressionism' [1896], in Trachtenberg, A. (ed.), *Classic Essays on Photography*, Leete's Island Books: New Have, CT, pp. 91–8.

Rogoff, I. (1999) 'Studying Visual Culture', in Evans, J. and Hall, S. (eds), *Visual Culture: The Reader*, Sage Publications: London, Thousand Oaks, New Delhi.

Rose, G. (1993) *Feminism and Geography: The Limits of Geographical Knowledge*, Polity Press: Cambridge.

—— (2001) *Visual Methodologies: An Introduction to the Interpretation of Visual Materials*, Sage: London.

Rosenblum, W. and Trachtenberg, A. (1997) *America and Lewis Hine: Photographs, 1904–1940*, Aperture and MOMA: New York.

Rosler, M. (1991) 'Fragments of a Metropolitan Viewpoint', in Wallis, B. (ed.), *If You Lived Here: The City in Art, Theory, and Social Activism*, Bay Press: Seattle.

—— (1998) *In the Place of the Public: Observations of a Frequent Flyer*, Cantz: Ostfildern.

—— (2004) 'In, Around, and Afterthoughts (On Documentary Photography)' [1981], *Decoys and Disruptions*, MIT Press: Cambridge, MA, London.

Rowell, M. and Weinberg, A.D. (2006) *Ed Ruscha, Photographer*, Steidl: London.

Sadler, S. (1999) *The Situationist City*, MIT Press: Cambridge, MA.

Said, E. (2003) 'Orientalism' [1978], in Ashcroft, B., Griffiths, G. and Tiffin, H. (eds), *The Post-colonial Studies Reader*, Routledge: London, New York.

Sanders, M. and Waplington, N. (2002) *Safety in Numbers: Nick Waplington*, Booth-Clibborn Editions: London.

Sekula, A. (1982) 'On the Invention of Photographic Meaning' [1975], in Burgin, V. (ed.), *Thinking Photography*, Macmillan Press: London, pp. 84–109.

—— (1984) *Photography Against the Grain, Essays and Photo-works, 1973–83*, The Press of the Nova Scotia College of Art & Design: Halifax.

—— (1995) *Fish Story*, Richter Verlag: Rotterdam.

—— (1999a) *Dismal Science: Photo Works 1972–1996*, University Galleries, Illinois State University: Normal.

—— (1999b) 'Reading the Archive: Photography between Labour and Capital' [1983], in Evans, J. and Hall, S. (eds), *Visual Culture: The Reader*, Sage Publications: London, Thousand Oaks, New Delhi.

—— (2003a) *Performance Under Working Conditions*, General Foundation: Wien; Hatje Cantz Verlag: Ostfildern.

—— (2003b) *TITANIC's Wake*, Liege: SNEL.

Shore, S. (2008) *American Surfaces*, Phaidon: London, New York.

Simmel, G. (1964) *The Sociology of Georg Simmel*, trans. K. Wolff, The Free Press of Glencoe, Collier-Macmillan: London.

—— (1968) 'Sociological Aesthetics' [1896], in *The Conflict in Modern Culture and other Essays*, trans. K. Peter Etzkorn, Teachers College Press: New York.

Smith, N. (2003), in Lefebvre, H., *The Urban Revolution* [1970], trans. Robert Bononno, University of Minnesota Press: Minneapolis, London, pp. vii–xxiii.

Soja, E. (1989) *Postmodern Geographies: The Reassertion of Space in Critical Social Theory*, Verso: London, New York.

—— (1996) *Thirdspace: Journeys to Los Angeles and Other Read-and-Imagined Places*, Blackwell: Malden, Oxford, Carlton.

—— (2000) *Postmetropolis: Critical Studies of Cities and Regions*, Blackwell: Malden, Oxford, Carlton.

Sontag, S. (1979) *On Photography*, Penguin: London.

—— (2003) *Regarding the Pain of Others*, Hamish Hamilton: London.

Spence, J. (1986) *Putting Myself in the Picture: A Political, Personal and Photographic Autobiography*, Camden Press: London.

—— (1995) *Cultural Sniping: The Art of Transgression*, Routledge: London, New York.

—— (2005) *Beyond the Perfect Image: Photography, Subjectivity, Antagonism*, Museu d'Art Contemporani de Barcelona: Barcelona.

Spender, H. (1982) *Worktown People: Photographs from Northern England 1937–38*, Falling Wall Press: Bristol.

Stakle, A. (2005) 'Living Space – Daugavpils', *Camera Austria* 90: 70.

—— (2010): www.alnisstakle.com.

Stimson, B. (2011) 'The True and the Blurry', in Raad, W., *Miraculous Beginnings*, Whitechapel Galleries Ventures: London.

Stoll, K. and Lloyd, S. (eds) (2010) *Infrastructure as Architecture*, Jovis Verlag: Berlin.

Strand, P. (1980) 'Photography and the New God' [1917], in Trachtenberg, A. (ed.), *Classic Essays on Photography*, Leete's Island Books: New Haven, CT, pp. 141–53.

Streuli, B. (1999) *Beat Streuli: City*, Hatje Cantz: Ostfildern.

Swain, M. (2006) Curatorial statement for Alnis Stakle exhibition at the Museum of Modern Art, Oxford: http://www.alnisstakle.com/reviews.php.

Szarkowski, J. (1980) *Looking at Photographs: 100 Pictures from the Collection of the Museum of Modern Art* [1973], Idea Editions: Milan.

Tagg, J. (1988) *The Burden of Representation: Essays on Photographies and Histories*, Macmillan: London.

—— (1992) *Grounds of Dispute: Art History, Cultural Politics and the Discursive Field*, University of Minnesota Press: Minneapolis.

—— (2003) 'The Camera at Work', in conversation with Steve Edwards on the occasion of the *Cruel and Tender* exhibition, Tate Modern, London.

Takuma, N. (2010) *For a Language to Come* [1970], Osiris: Tokyo.

Thompson, N. (2008) *Experimental Geography: Radical Approaches to Landscape, Cartography and Urbanism*, Independent Curators International: New York.

Tillim, G. (2004) Jo'burg': http://www.michaelstevenson.com/contemporary/exhibitions/jhb/jhb1.htm.

Trachtenberg, A. (ed.) (1980) *Classic Essays on Photography*, Leete's Island Books: New Haven, CT.

Trottenberg, A.D. (1963) *A Vision of Paris: The Photographs of Eugene Atget, the Words of Marcel Proust*, Macmillan: New York.

Tsuzuki K. (1999) *Tokyo: A Certain Style*, Chronicle Books: San Francisico.

—— (2005) In interview with John H. Lee, *Theme Magazine* 2, Summer: http://www.thememagazine.com/stories/kyoichi-tsuzuki/.

Tuan, Y.-F. (2007) *Space and Place: The Perspective of Experience* [1977], University of Minnesota Press: Minneapolis, London.

Tupitsyn, M. (1992) *The Soviet Photograph, 1924–37*, Yale University Press: New Haven, CT.

Vearey, J., Oliveira, E., Madzimure, T. and Ntini, B. (2011) 'Working the City: Experiences of Migrant Women in Inner-city Johannesburg', *Gender and Media Diversity Journal* 9: 221–33: http://www.genderlinks.org.za/article/the-southern-africa-media-and-diversity-journal-issue-9-2011-03-24.

Vilnis, A. (2003) 'Between Visual Fetishes and Reality', *Kvartalnik Fotografia* 13, Poland: http://www.alnisstakle.com/reviews.php.

Virilio, P. (2002) *Ground Zero*, trans. Chris Turner, Verso: London, New York.

—— (2005) *City of Panic* [2004], trans. Julie Rose, Berg: Oxford, New York.

Wakeford, N. (2004) 'Gender and Landscapes of Computing in an Internet Café', in Graham, S. (ed.), *The Cybercities Reader*, Routledge: London, New York, pp. 263–6.

Walker, I. (2002) *City Gorged with Dreams: Surrealism and Documentary Photography in Interwar Paris*, Manchester University Press: Manchester.

Walker, J.A. (2002) *Red Shift: Radical Art in 1970s Britain*, I.B. Tauris: London, New York.

Wallis, B. (ed.) (1991) *If You Lived Here: The City in Art, Theory, and Social Activism*, Bay Press: Seattle.

Watney, S. (1982) 'Making Strange: the Shattered Mirror', in Burgin, V. (ed.), *Thinking Photography*, Macmillan Press: London, pp. 154–76.

—— (1999) 'On the Institutions of Photography' [1986], in Evans, J. and Hall, S. (eds), *Visual Culture: The Reader*, Sage Publications, Open University: London, Thousand Oaks, New Delhi.

—— (2006) 'Tunnel Vision: Photographic Education in Britain in the 1980s', *AfterImage* 33 (4) Jan./Feb.: 32–6.

Weegee (American, b. Arthur Fellig Poland 1899–1968) (2002) *Naked City* [1945], Da Capo Press: Cambridge, MA.

Weiss, G. (1998) *Body Images: Embodiment as Intercorporeality*, Routledge: London.

Wells, L. (ed.) (2000) *Photography: A Critical Introduction*, Routledge: London.

—— (ed.) (2002) *The Photography Reader*, London: Routledge.

Werge, J. (1995), in Naef, W. (ed.), *Handbook of the Photographs Collection*, The J. Paul Getty Museum: Malibu, California.

Westerbeck, C. and Meyerowitz, J. (2001) *Bystander: A History of Street Photography*, Bullfinch Press: Boston, New York, London.

Whisnand, Tyler (2005) 'Place for Dreams', *Eyemazing* 7, Summer, Brains Unlimited: Amsterdam.

Whitechapel Gallery/Fotomuseum (2010) *Where Three Dreams Cross*, Steidl: London.

Wilding, F. (2001) 'Where is Feminism in Cyberfeminism?': http://faithwilding.refugia.net/wherefem.html.

Wilson, C. (2005) 'Memory and the Politics of Forgetting: Paris, the Commune and the 1878 Exposition Universelle', *Journal of European Studies* 35 (1): 47–63.

Yanagi, M. (2001) Interview with Mako Wakasa, 19 August: http://www.jca-online.com/yanagi.html.

Index

activism 72, 102, 124–6, 141; environmental 74
advertising 57, 77
aesthetics 11, 44, 46, 47, 51, 52, 58, 123, 130, 131; and politics 129–31
Agarwal, R. 72–5; *Alien Waters* 74–5; *Another Place* 74; and Breman, J. *Down and Out: Labouring under global capitalism* 72–3
agency: exhibitions 70–1; social 63–76
airports 224
allegory: and metaphor 80–1, 85
analysis 33–42; formal 30, 31
Annan, T. 62, 64, 65–6, 244, 245; *Close No.118 High Street, Glasgow* 65–6, 69
anthropology 14, 21, 69
Antwerp: de Singel International Arts Centre 226
Apóstol, A. 165, 170; *Residente Pulido: Ranchos* 170, 171; *Royal Copenhagen* 168, 169
Appert, E.E. 39–41; *Crimes de la Commune* 39–41
Araki, N. 183, 201; *Sentimental Journey* 201; *Tokyo Still Life* 183; *Winter Journey* 201
architecture: art and photography 44, 45, 47, 48–50
Argentina: Buenos Aires 163–5, 166
art: and photography 44, 45, 47, 52, 74, 78, 129
Association of Artists of Revolutionary Russia (AKhRR) 45–6, 54
Atget, E. 29, 43, 48–50, 107, 242; Proust, M. and Trottenberg, A.D., *A Vision of Paris* 50; *Shop front, Quai Bourbon* 43
Atlas Group 237, 239
auteur 99

authenticity: and photography 29, 47, 66, 237, 239
author: and interpretation 48–50
Auzins, V. 111, 113
avatars 195–6

Bachelard, G. 192–3, 236; *Poetics of Space* 192–3
Bal, M. 25, 42
Baltic nations 111–16
Barthes, R. 33, 36, 37, 38, 70; *Camera Lucida* 37
Bate, D. 113
Baudelaire, C. 4, 51, 93, 100, 191
Baudrillard, J. 8, 158–60, 162, 165, 166, 167, 205
Baxandall, M. 38
Becher, B. and Becher, H. 228
Beijing 175
Beirut 241, 242, 243
Benjamin, W. 6, 48, 49, 51, 53, 92–4, 100, 129, 191; *Arcades Project* 12, 212, 218–19, 226; *Work in the Age of Mechanical Reproduction* 47
Bentham, J. 82
Berger, J. 32, 37
Bhabha, H.K. 172
Bieber, J. 135–6
Bilbao: Guggenheim Museum 215
Boiffard, J-A. 106
Bonaventure Hotel 193
Borda, S.G. 81; *Capital Cities* 81
Bourdieu, P. 20–1, 25, 72, 76–7, 78, 80, 102–3, 216; *Outline of a Theory of Practice* 21
Braidotti, R. 203, 217; *Nomadic Subjects* 203
Brecht, B. 47

Breman, J. 72; and Agarwal, R., *Down and Out: Labouring under global capitalism* 72–3
Breton, A. 105–6, 110
Brik, O. 51
British Worker exhibition 70–1
Buchanan, I. 157, 217; and Lambert, G., *Deleuze and Space* 217
Buenos Aires: Cosmopolis 163–5
Burgin, V. 32, 34, 34–5, 104; *Looking at Photographs* 34–5; *Thinking Photography* 32
Butler, J. 200, 208

Cao, F. 196, 244–5; *Cosplayers* 196; *RMB City* 244–5
Caracas 172; Polaricity 168–71
Carceral cities: term 157, 167–8
Cartier-Bresson, H. 32, 96
Castells, M. 15, 157, 214–15, 228, 236; *The Urban Question* 15
Certeau, M. de 18, 20, 24–5, 92, 99, 100, 104, 115, 153, 220, 224; *The Practice of Everyday Life* 18, 20; *Walking in the City* 92
chemistry: and cities 234
China 174–80, 228
Chongqing 176
Clark, K. 38–9
Cole, E. 140
connotation 36
context 38, 47, 57, 67, 69, 78
Corcia, P-L. di 223
Cosmopolis: Buenos Aires 163–5; term 157
cosplay 195–6, 205, 208
Coulthurst, S. 60, 61, 62, 64, 92; *Blackfriars Street* 62, 69
Couthurst, S.: *Angel Street, Rochdale Road* 60, 61
culture 8–9, 10, 38, 52, 66, 173; cultural analysis 25–6, 78, 79; visual 79
cyborgs 203–5, 207

Davis, M. 168, 173; *City of Quartz* 168; *Magical Urbanism* 173
de Singel International Arts Centre: Antwerp 226
Debord, G. 159–60, 166, 220, 222; *Society of the Spectacle* 159–60
deception: and the photograph 39–41, 124, 162, 237
Delahaye, L. 100–2; *Metro* 100–2

Deleuze, G. and Guattari, F. 216–27
Dennett, T. 128; and Spence, J.; *Re-Modelling Photo-History* 128, 131
denotation 36
dérive: theory 222
Derrida, J. 38
deterritorialization 216
Deutsche, R. 113
discursive narratives 141
documentary 74, 111–12, 125, 130, 135; Photojournalism and Documentary Photography Programme (PDP) 132
Doy, G. 39–40
dreams: and memories 107–10, 160, 192–3, 219
Drum magazine 140
dystopias 116

Eco, U. 36
Edwards, E. 67, 69
Eiland, H.: and McLaughlin, K. 219
Ellis, P. 108–10; *Bradford, Manchester* series 108–10
Engels, F. 53, 59, 74; and Marx, K., *Principles of Communism and the Communist Manifesto* 59
Englander, D. 71
environmental activism 74
Enwezor, O. 145–8
Evans, W. 97, 100
everyday: significance 4, 18, 20, 23–4, 42, 45, 51–4, 79, 110, 115, 189, 220
exhibitions: agency 70–1
exopolis: term 157, 171

Fanon, F. 23
Farm Security Administration 103
feminism 11, 22–3, 24, 131, 197–201, 208, 222; identity 200, 201, 203; nomads and cyborgs 203–5
flâneur 4, 24, 51, 92–4, 105, 111, 158, 191, 232
Flaubert, G. 4, 51
Flexcity: term 157
Foucault, M. 11, 20, 38, 64, 66, 78, 79, 80, 116, 129, 236; *Discipline and Punish* 82; *The Order of Things* 66
Fox Talbot, W.H.: *Pencil of Nature* 42
Frank, R. 96, 223; *The Americans* 96, 223
Freud, S. 53; *Psychopathology of Everyday Life* 53
functions: photography 57–8, 69

Gau, S. 225–6
geography 14–15, 21, 24; feminist 23
Gilbert, A. 243
Glasgow 62, 64, 65–6
global systems 225–33
globalization 15, 17, 157, 164, 167, 214, 216, 224
Goldblatt, D. 132, 244; *Cosmo City* 244
Google Earth 194
Graham, P. 168; *American Night* 168
Grosz, E. 203–4, 209, 217; *Space, Time and Perversion* 203–4
Guattari, F.: and Deleuze, G. 216–17, 218
Guggenheim Museum (Bilbao) 215
Gulf War 162
Gursky, A. 224, 244; *Hong Kong Shanghai Bank* 244

Habermas, J. 4, 5, 7–8, 10
habitus 102, 103, 118, 216; notion 20–1
Hackney Flashers 128; *Who's Holding The Baby?* 126–7, 128
Haraway, D. 203, 204–5, 208, 217
Harvey, D. 6, 8, 10–11, 14–15, 17, 39, 149, 150; *Social Justice and the City* 14–15
Hatakeyama, N. 224; *Lime Works* 224
Haussman, G-E. 5, 6, 9, 19, 24, 41
Hayes, P. 140
Heartfield, J. 127
heterotopia 116–17, 236
Highmore, B. 219, 223
Hine, L. 30–1, 32, 33–4, 35, 36, 130; *Immigrants going down gangplank* 130; *Self Portrait with Newsboy* 30–1, 33–4, 35, 36, 37
Hiromix 201; *Girls Blue* 201; *Seventeen Girl Days* 201
Höllering, F. 124
home 22–3
homelessness 130–1
Homma, T. 183, 186–8, 191; *McFlurry* 187; *Tokyo* 186–7, 236; *Tokyo Children III* 187, 188; *Tokyo Suburbia* 186; *Tokyo Teens II* 187
Hooper, B. 22
Hornsby, A.: and Mars, N. 176; *The Chinese Dream: A Society under Construction* 175–6
Hubbard, P. 15
hybrid urbanism 173–4
hybridity 172, 207

hyper-simulation 162
hyperreality 158, 162, 173, 178, 194

icon 35
imaginative economy 67
index 35
India 72–5
institutional agency: in the city 58, 63
interaction: city 8–9, 209–10
intimacy 201–3
Iragaray, L. 199

Jameson, F. 5, 8–10, 13, 16, 26, 193–4; *Postmodernism, or The Cultural Logic of Late Capitalism* 9
Japan 183–211; conformity and desire 201; cosplay 195–6, 205–6, 208; intimacy 201–3; younger generation 189–90; youth culture 200
Jiang, Peng-yi 179
Johannesburg: *Jo'burg* (Tillim) 139, 142–6, 148, 150, 153–4; Market Photo Workshop 132–9; migrant women 134–7; transitory experience 137–9
journeying 223
Jouve, V. 192, 212, 233–7

Kee, J. 207
kinship 115
knowledge: and photography 66, 67, 69
Konrad, A. 212, 225–33, 234, 235; *Beijing* 230–1; *Cairo* 227, 229; *Cities on the Move* 228; *Iconocity* 226–33
Kristeva, J. 200
Kuyas, F. 176; *Chinese Smokers* 176

late capitalism 9–10
Latin America 155, 164–5, 168–71, 173–4, 174; hybridity 173
Latour, B.: and Weibel, P. 232–3; *Making Things Public* 232–3
Latvia 111
Le Corbusier 5, 8, 19, 24, 220; *City of Tomorrow* 5, 8
Ledochowski, C. 141
Lefebvre, H. 5, 14, 15–20, 91–2, 115, 149–53, 205, 209, 216–18, 220; *The Production of Space* 15–16
Leong, S.T. 99, 176–9; *Cities* 176; *History Images* 177; *Nan Shi* 178
Levitt, H. 97, 98
Lewis, P. 114

Libanius 38
living/lived space 19, 110–13
López, M. 163–5, 166, 174, 187–8, 245;
 Plaza de Mayo 163, 164, 165, 166; *Pop
 Latino* 163–4, 165, 174
Los Angeles 157, 168, 172, 173; shopping
 mall 13; SimCity 158–60, 162; Westin
 Bonaventure Hotel 13
Lyotard, J-L. 5

McDonald's 187
McDowell, L. 22
McKenzie, P. 141
McLaughlin, K.: and Eiland, H. 219
Mafokeng, S. 140–1
Magagane, M. 137
Magubane, P. 140
Manchester 58, 59–62, 64, 65, 69, 92, 108,
 109; high-rise estates 5; Manchester City
 Council (MCC) 58, 63, 64, 67, 69;
 Manchester Photographic Society
 (MAPS) 61; *Manchester Ship Canal
 construction* 68, 70
Mandel, E. 9
Manet, E. 51
Market Photo Workshop (MPW)
 (Johannesburg) 132–9
Mars, N.: and Hornsby, A. 176; *The Chinese
 Dream: A Society under Construction*
 175–6
Marville, C. 6, 7, 41, 48, 226, 242
Marx, K. 16; and Engels, F., *Principles of
 Communism and The Communist
 Manifesto* 59
mass communication 166–7
Mass Observation project 218, 219–20
Matta-Clark, G. 116–17
meaning 8, 22, 31, 32, 34, 35, 36, 66, 69, 76,
 81, 129, 215; social production 76–8
mediation: and transparency 29–33, 37, 74
memories: and dreams 107–10
mental life: virtuality and city 190–1, 193–5,
 197
Meskimmon, M. 22
metaphor 22, 24–6, 100, 145, 153–4, 159,
 170, 183, 192, 200; and allegory 80–1,
 85, 154; power and surveillance 82–4
metonymy 80, 85, 102, 104
Meyerowitz, J. 95, 161
migration: *Working the City: Experiences of
 Migrant Women in Johannesburg* 134
Mitchell, W.J.T. 79

Mkhobeni, M. 137–9; *Trolley Pushers* 137–9
Mlangeni, S. 135–7; *Invisible Women* 135–7
modernity 24, 58, 135; and postmodernity
 3–13; specious 145–9
Mofokeng, S.: *Black Photo Album/Look At
 Me* 140–1
Moholy-Nagy, L. 44, 46, 124
montage 218, 219, 224; photo-montage 123,
 127–8
Mori, M. 205–9; *Birth of a Star* 207; *Play
 with Me* 205, 206; *Tea Ceremony III*
 206–7
Moriyama, D. 201
Mthethwa, Z. 148
Mu, C. and Shao, Y., *Assembly Halls* 179

Nadja (Breton) 105–6
Nakahira, T. 183–6, 223; *For a Language to
 Come* 184–5
narrative: discursive 141
naturalness 32
neo-liberalism 214
network 26, 214, 217; global 157; spatial
 212–15
New Objectivity (*Neue Sachlichkeit*)
 (Weimar Germany) 45
New York 96, 97, 98, 99
Ninagawa, M. 201
nomadism 203–5, 217
nostalgia 162
Nyagudjara, B.: *Living in Limbo* 135

objectivism: and voyeur 99–103
objectivity 29, 42, 45, 103
October Photo Section 46–7, 54, 107, 125
Olalquiaga, C. 173, 174, 194, 197, 203

Pan Wei 175
Panopticon 82, 83
Paris 5, 21, 48–50, 93, 105, 226, 234; arcades
 12; Commune 39–40; modernity 6, 12
Parr, M. 97; *Think of England* 97
Peirce, C.S.: *Collected Writings* 35
perceived space 19
performative term 69
phenomenological geographies 192–3, 235
Phillips, C. 44, 45; *Photography in the
 Modern Era* 44
photographic juxtaposition 96–7, 107; and
 politics 127–9
photographic signification 36
photographic systems 223–5

Photography Workshop 131–2
Pierce, C.S. 35
Pink, S. 103
Plato 21
Poe, A.E. 43
Polaricity: term 157, 167–71
Polidori, R. 131; *Beirut* 131
politics 127, 128, 132, 245; and aesthetics
 129–31; and photographic juxtaposition
 127–9; and photography 44–51;
 propaganda 125; and protest 123–6;
 representation 132; socio-political 10
postcolonialism 22, 23, 38
postmetropolis 164, 165, 183, 194; term
 155–8
postmodernity: and modernity 3–13
power 17–18, 20, 216; abuse 164; social
 agency and photography 63–9, 76;
 surveillance and metaphor 82–4
primitivism 4
promotion: and photography 58, 63
protest: and politics 123–6
Proust, M.: Atget, E. and Trottenberg, A.D.,
 A Vision of Paris 50
Provoke group 183, 223
psycho-geography: notion 220–4
psychology 78, 107, 191, 193
punctum: term 37

Raad, W. 212, 224, 237–43, 245; *Portrait,
 Beirut* 242; *Sweet Talk: Commissions*
 224, 238, 239–42
Renger-Pasch, A. 45, 46
representation 22, 38, 51, 66, 102, 160, 223;
 different orders 91–5; politics 132;
 systems 218–20
resistance 20, 23
rhetorical codes 36
rhizome 216, 217
Roberts, J. 51, 52–3
Robinson, H.P. 54
Rodchenko, A. 45, 46, 123, 124; *Assembling
 for a Demonstration* 46
Rogoff, I. 25, 80
Rosler, M. 85, 130–1, 137, 224–5; *In the
 Place of the Public* 224–5; *The Bowery in
 Two Inadequate Descriptive Systems* 85,
 131, 137
Rumney, R. 221, 224; *Psychogeographical
 Map of Venice* 221–2
Ruscha, E. 85, 116–17; *Building on the
 Sunset Strip* 85

Said, E. 23–4; *Orientalism* 23
Sander, A. 43–4
Saussure, F. de 35, 36; *Course in General
 Linguistics* 35
Sawada, T. 198, 199, 200, 201; *Cover* 200;
 ID400 198, 199, 200
Second Life 196
security 168
Sekula, A. 32, 67, 70, 76, 81, 129–30, 215,
 223; *Fish Story* 81; *Reading the Archive*
 67; *Titanic's wake* 81
semiology 35, 36, 79
sentimentality 125
Shanghai 162, 175; Xintiandi district 215
Shao, Y.: and Mu, C., *Assembly Halls* 179
Shenzhen 99–100
Shore, S. 223; *American Surfaces* 223
Siden, A-S. 83–4
signification 35, 57, 127
Simcities: term 157, 158–60
SimCity 195–6
Simmel, G. 14, 183, 190, 191–2, 236; *The
 Metropolis and Mental Life* 191
Situationist International (SI) 220, 222
Smith, N. 17
smooth space 216, 217
social agency: power and photography 63–9,
 76
social division 168
social justice 15, 17
social production: meaning 67, 76–8
social space: and city 15–21
social surveys 59–62
Socialist Realism 124–5
sociology 14, 21, 72, 77, 102
Soja, E. 11, 13, 19, 20, 155–8, 165, 170, 214;
 Thirdspace 214
Sontag, S. 160–1
Source: The Photographic Review 132
South Africa 132–9; photography 140–1
Soviet Union 124–5
space 10, 16–18, 22, 28, 114, 116–18,
 192–3, 204, 213–16, 236; conceived 19;
 dialectical character 91; first 19; lived
 19; living 110–13; perceived 19;
 production 17; second 19; striated
 217; third 20, 214
spatial networks: and conceptual systems
 212–15
specious modernity 145–9
spectacle 159–60, 162, 163, 166; and
 surveillance 79

spectatorship: nature 79, 99
Spence, J. 127–8, 223; and Dennett, T., *Re-Modelling Photo-History* 128, 131
Spender, H. 218
Stakle, A. 110–13, 114, 115, 117, 223, 225; *Lost: Paris* 223, 225; *L.S.D. Living Space – Daugavpils* 111–12; *Place for Dreams* 115–16
Station 10 and Back Again (Siden) 83–4.
Steichen, E. 70; *Family of Men* exhibition 70
Stieglitz, A. 130, 176; *The Steerage* 130
Stimson, G. 242, 243
Stone, B. 62
Strand, P. 45
Street: perspectives 99
street photography 95–9
subjectivity 22–3, 42, 85, 87, 91–2, 100, 139, 145, 192–3, 200–4, 209, 217
Surrealism 106, 107–8
surveillance: metaphor and power 82–4; and spectacle 79
Swain, G. 111
symbol 35
systems 115; conceptual 212; photographic 223–5; representation 218

Tagg, J. 36–7, 63, 64, 66–7, 70, 76, 78
Talking Cities: The Micropolitics of Urban Space 114, 215
Ten 8 magazine 131
Tiege, K. 45
Tillim, G. 139, 142–5, 149, 150, 153–4, 244; *Jo'burg* 139, 142–6, 148, 150, 153–4
Tokyo 154, 183–90, 201
transcoding 9
transitory resistance 113–15, 118
transparency: and mediation 29–33, 43
treachery: and image 160–2
Tretyakov, S. 123–4
triadic city space: concept 19–20, 209
Trottenberg, A.D.: Proust, M. and Atget, E.; *A Vision of Paris* 50
truth 8, 29, 32, 38, 40, 42, 43, 57, 58; telling 140; and untruth 180
Tsuzuki, K. 183, 188–9, 201, 204; *Anna Sui* 189, 190; *Happy Victims* 189–90; *Tokyo: A Certain Style* 183, 189

Uncommon Places (Shore) 223
unconscious 53, 78, 107
Unregistered Cities (Jiang) 179
Urban Revolution (Lefebvre) 17
urban studies 14–15
urbanism 3–28, 17, 72, 173
utopias 5, 21, 116–17, 158, 175, 232

Vearey, J. 133, 134
Venezuela 168–71
Venturi, R. 228
Virilio, P. 8, 157, 166–8, 194–5, 197, 203–4, 205
virtuality: materiality 205–8; mental life and city 190–1, 193–5, 196, 197; virtual worlds 195–6
visual culture 79; spectacle and surveillance 79
visual studies 80
voyeurship: and objectivism 92, 93, 99–103, 232

Wakeford, N. 197
walking: city 91–121; immersion 104–6, 111
Wang, Q. 156; *Look Up! Look Up!* 156, 180
Watney, S. 69, 76, 77, 78
Weibel, P.: and Latour, B. 232–3
Wentworth, R. 107
Westin Bonaventure Hotel (Los Angeles) 13
Willats, S. 224; *Brentford Towers* 224
Winogrand, G. 95–6, 97; *Central Park Zoo* 97
Wolff, K. 14
worker photography movement (Germany) 124
Workers' Film and Photo Leagues (WFPL) 125–6, 132
World Trade Center 105, 159, 160–1
Wu Tien-Chang 174

Xintiandi district (Shanghai) 215

Yanagi, M. 201–3; *Elevator Girls* 202; *Eternal City* 202; *My Grandmothers* 202–3; *White Casket* 202

Zimbabwe 142